Georgia O'Keeffe

Georgia O'Keeffe

Art and Letters

JACK COWART · JUAN HAMILTON

Letters selected and annotated by

SARAH GREENOUGH

National Gallery of Art, Washington

This exhibition is made possible by a grant from Southwestern Bell Foundation.

Exhibition dates:

National Gallery of Art, Washington
1 November 1987–21 February 1988

The Art Institute of Chicago
5 March–19 June 1988

Dallas Museum of Art
31 July–16 October 1988

The Metropolitan Museum of Art, New York
19 November 1988–5 February 1989

Los Angeles County Museum of Art
March 30–June 18, 1989

Some of the paintings and more fragile works on paper published in this catalogue have not been extended to the Los Angeles County Museum of Art installation. Various new loans of important O'Keeffe works have been arranged, however, to complete the exhibition program.

The exhibition *Georgia O'Keeffe: 1887–1986* is organized by the National Gallery of Art.

Cover:
Cat. 35, *Music—Pink and Blue, II,* 1919.

Frontispiece:
William Clift, *Georgia O'Keeffe in Abiquiu,* 1981, © 1981, Collection of William Clift.

Photographs by Malcolm Varon, except: cats. 57, 73, 75, and 95, which were provided by The Art Institute of Chicago.

The hardcover edition of this book is published and distributed by New York Graphic Society Books.

New York Graphic Society Books are published by Little, Brown and Company (Inc.).
Published simultaneously in Canada by Little, Brown & Company (Canada) Limited.

Cataloging-in-publication data will be found on the last page of this book.

Contents

Lenders to the Exhibition *vi*

Foreword *vii*

Acknowledgments *viii*

Art and Artist *Jack Cowart* I

In O'Keeffe's World *Juan Hamilton* 7

Catalogue 13

From the Faraway *Sarah Greenough* 135

 Note to the Reader 139

 Letters: 1915–1918 141
 1919–1929 169
 1929–1946 189
 1947–1981 245
 Notes to the Letters 274

Chronology 291

Bibliography *Laura Coyle* 295

Index 304

Lenders to the Exhibition

Estate of Georgia O'Keeffe

ACA Galleries

American National Bank

Amon Carter Museum

Mr. and Mrs. Harry W. Anderson

The Art Institute of Chicago

The Brooklyn Museum

Mr. and Mrs. George K. Conant III

Des Moines Art Center

Nancy Ellison and Jerome Hellman

Mr. and Mrs. James A. Fisher

Carl van Vechten Gallery of Fine Arts
 at Fisk University

Juan Hamilton

Hirshhorn Museum and Sculpture Garden

Indianapolis Museum of Art

Janet and Robert Kardon

Mr. and Mrs. Gilbert H. Kinney

Collection of Calvin Klein

Emily Fisher Landau

Collection Loretta and Robert K. Lifton

Menil Foundation

The Metropolitan Museum of Art

Milwaukee Art Museum Collection

The Museum of Modern Art

Nebraska Art Association, Sheldon Memorial
 Art Gallery, University of Nebraska–Lincoln

Collection of James and Barbara Palmer

Philadelphia Museum of Art

The Phillips Collection

Private Collections

The Regis Collection

San Diego Museum of Art

Collection of Paul and Tina Schmid

Warren and Jane Shapleigh

University Art Museum, University of
 Minnesota, Minneapolis

Wadsworth Atheneum

Washburn Gallery

Whitney Museum of American Art

Mr. and Mrs. J. Carrington Woolley

Yale University Art Gallery

Foreword

THE EXHIBITION *and this book celebrate the profound creative life of a remarkable American artist. Georgia O'Keeffe's art has shown us new ways to see, and new ways to think of our own modern art. The association between Miss O'Keeffe and the National Gallery of Art began in 1949, when she entrusted the most comprehensive set of Alfred Stieglitz's photographs to the National Gallery's keeping. Her generosity to this institution continued through the years, resulting in her additional gift of Stieglitz's photographs in 1980. Her support greatly assisted our 1983 exhibition* Alfred Stieglitz. *In 1985, Juan Hamilton, her assistant and confidant from 1973 until her death, initiated discussions with the National Gallery, which resulted in the present exhibition. This led to another period of intense activity between Washington, Abiquiu, and Santa Fe, and I shall always value the time I spent with her in New Mexico discussing this project. The experience of her New Mexico world—the isolation of Ghost Ranch and the grandeur of its setting, the spareness and the visual poetry of her house in Abiquiu, and her own taut and incisive personality—all made an unforgettable impression. Although her death has deprived us of her vast spirit, talent, and fine wit, her memory will live on in her designation of selected American museums, including the National Gallery, as favored recipients of her bequest. Through this exhibition and catalogue of her magnificent art, we pay tribute to one who deserves it richly.*

Juan Hamilton, with Jack Cowart, head of the department and curator of twentieth-century art at the Gallery, selected the brilliant works in this exhibition. Jack Cowart has traveled the country in search of O'Keeffe's best art, achieving a remarkable presentation with a number of important discoveries. Juan Hamilton's suggestion that some of O'Keeffe's writings be included in this book has resulted in the publication here of 125 letters, chosen and annotated by National Gallery research curator Sarah Greenough. Our exhibition assistant Laura Coyle has supported the curators' activities while contributing her own research. With the cooperation and encouragement of the O'Keeffe family, notably O'Keeffe's sister Catherine Klenert, and Klenert's daughter and grandson, Catherine and Raymond R. Krueger, and O'Keeffe's niece June Sebring, as well as the great generosity of many additional private and public collections, this project has become a reality.

The exhibition and its related programs are supported by a generous grant from the Southwestern Bell Foundation. I want to thank especially Zane E. Barnes, chairman and chief executive officer of Southwestern Bell Corporation, Gerald D. Blatherwick, vice chairman of Southwestern Bell Corporation and president of Southwestern Bell Foundation, and Norman D. Baxter, assistant vice president, corporate communications, Southwestern Bell Corporation, for their enthusiasm and participation.

I am delighted that my colleagues James N. Wood, director of The Art Institute of Chicago; Harry Parker, director, at the time these decisions were being made, of the Dallas Museum of Art; and Philippe de Montebello, director of The Metropolitan Museum of Art; and their institutions and staffs have joined us in this O'Keeffe celebration. It is appropriate that these museums should share the exhibition, because all are institutions where O'Keeffe had a special sentiment and whose collections focus on her art. One hundred years is an appropriate moment for a new look and a celebration of O'Keeffe, who came so very close to being here to be fêted in person. It is hoped that this exhibition will provide some measure of the extraordinary vitality of her work.

J. Carter Brown
Director

Acknowledgments

GEORGIA O'KEEFFE is held close to the hearts of many generous people who tirelessly aided our project. We were received with openness, mutual enthusiasm, and hospitality, and it seemed that there was a universe of interest and excitement. A debt of gratitude is due the generous lenders to this exhibition who made this celebration possible. At the National Gallery, Laura Coyle excelled as exhibition assistant. Without her energies, constant momentum, and initiative, the project would have been visibly diminished. In New Mexico, Miss O'Keeffe's former secretary Agapita Lopez was invaluable in providing documentation and sources, and the Abiquiu staff gave particular assistance in the handling and shipment of the Estate works to Washington.

We want to acknowledge the patience, support, and positive responses of our museum counterparts, Neal Benezra of The Art Institute of Chicago, Steven A. Nash, Dallas Museum of Art, and William S. Lieberman, The Metropolitan Museum of Art. Together with their departmental staffs, all made the exhibition tour and various loans from their institutions a reality. For essential assistance at the National Gallery we thank: Debra Easterly and Viretta King, department of twentieth-century art; Carolyn Mitchell in the editors office; D. Dodge Thompson and Anne Bigley, exhibition programs; Mary Suzor and Anne Halpern, registrar's office; Hugh Phibbs and Jenny Ritchie, conservation department; Thomas McGill, library; and most especially, Gaillard F. Ravenel, Mark A. Leithauser, and Gordon Anson in the department of installation and design. We are particularly indebted to Frances Smyth and Mary Yakush of the editors office for their wise counsel and thoughtful editing. We also thank Lisa Messinger, curatorial assistant, twentieth-century art, The Metropolitan Museum of Art; Anita Duquette, manager of rights and reproductions, Whitney Museum of Art; and Jeffrey Harrison, research assistant, Phillips Collection. We gratefully acknowledge the design of this catalogue by Bert Clarke and the many new transparencies made by photographer Malcolm Varon.

The publication of O'Keeffe's letters would not have been possible without the continuing support of the Estate. In addition, several of O'Keeffe's friends and their heirs kindly searched through their papers to locate her letters, including: Aaron Copland, Dr. Constance Friess, Diana S. Heller, Olga Hirshhorn, Caroline Keck, Katherine Kuh, Louise March, Mr. and Mrs. David H. McAlpin, C. Wickham Moore, Mr. and Mrs. Lewis Mumford, Richard Pritzlaff, Geneireve Roach, Phillip Sills, Mrs. Herbert J. Seligmann, Mrs. John R. Stevenson, Mrs. Claire Sykes, and Todd Webb. Many of O'Keeffe's letters are now on deposit in the Collection of American Literature, Beinecke Rare Book and Manuscript Library, Yale University, and we are particularly grateful to them and to Steve Jones and Christa Sammons for their assistance. We wish also to thank Donald Gallup, agent for the Stieglitz/O'Keeffe Archive at the Beinecke Library, who granted us permission to use O'Keeffe's letters in that collection. Several other institutions also assisted us in our search and graciously extended permission to use their O'Keeffe letters: Garnett McCoy, Archives of American Art; Susan Godlewski and Cathy Stover, The Art Institute of Chicago; Violette de Mazia, The Barnes Foundation; Alice Overby, Chatham Hall School; Amy Rule, Center for Creative Photography; Georgina Toth, Cleveland Museum of Art; Cathy Henderson, Harry Ransom Humanities Research Center, University of Texas at Austin; Eloise Ricadelli, Museum of Modern Art; Newberry Library; Manuscript Collection, New York Public Library; Michael Hoffman and Naomi Rosenblum, Paul

Strand Archive; Special Collections, Van Pelt Library, University of Pennsylvania; and Bruce Brooks Pfeiffer, Taliesin West, and The Frank Lloyd Wright Foundation. We wish to thank Mary Alinder, Linda Ayres, Emilio Caballero, Herbert Cahoon, Lawrence Campbell, William Clift, Andrew Crispo, Thelma Dougart, Paula Freedman, Stephen B. Jareckie, Laurie Lisle, Sue Davidson Lowe, Sarah Martin, Sarah W. Peters, Louise Rossmassler, William Bennett Schauffler, Joseph Solomon, and Elizabeth Sussman for answering numerous questions. Special recognition should also be given to research assistants Christina Kelly and Lisa Sharon for their excellent help in the preparation of the notes and transcriptions of the letters.

Finally, we gratefully acknowledge the support of those close to us, who endured the difficulties and the long evolution of this project. We can now share the joys of this enterprise with them, with thanks.

Jack Cowart
Sarah Greenough
Juan Hamilton

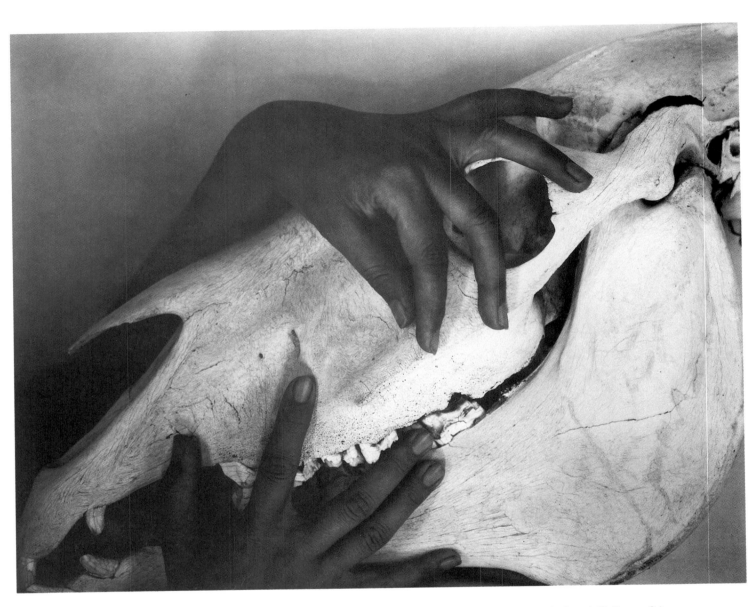

Alfred Stieglitz, *O'Keeffe's Hands with Skull*, 1930, The Alfred Stieglitz Collection, National Gallery of Art

Georgia O'Keeffe: Art and Artist

JACK COWART

O'Keeffe, together with her art, helped establish a relationship between the American modern movement and the pioneering European vanguard of the early twentieth century. She was a member, emotionally and professionally, of the group surrounding Alfred Stieglitz and his progressive New York galleries: 291, The Intimate Gallery, and An American Place. Other artists who were part of the Stieglitz circle (Charles Demuth, Arthur Dove, John Marin, Marsden Hartley), as well as their predecessors and successors, helped bridge the gap between American and European art. O'Keeffe drew inspiration from the *avant-garde* on both sides of the Atlantic but at the same time fed influence and especially the energy of her particular imagery back into the art of her time. On the one hand, she nurtured Stieglitz and he reciprocated. It was a delicate symbiosis because O'Keeffe's art was her livelihood, dependent upon sales. On the other hand, she also challenged him, giving vent to her forceful creative personality, expression, and sense of rebellion and independence.

It was neither O'Keeffe's art, boxed as it has always been into a limited critical category, nor O'Keeffe the artist, but rather her personality that received the most attention over the years. We are reminded that the cumulative effect of sixty years of art criticism and exhibitions of O'Keeffe's work has resulted in an idea of the person that is larger than life. O'Keeffe herself is at least partially responsible for this situation. As she grew older especially, O'Keeffe knew she filled a void in American art, that her images were becoming icons, and that her deportment was legendary. Events conspired to produce for the public not an informed awareness but a stark cliché, a stereotype.

In 1985 Juan Hamilton, on Miss O'Keeffe's behalf, asked the National Gallery to begin the organization of the next major exhibition of her work. It was quickly agreed that we would attempt to present not an inclusive retrospective but, rather, a select and focused survey of her art, one that would highlight those areas where O'Keeffe made her greatest contributions to art and our vision. The full extent and impact of her dialogue with the world are not yet known. The evaluation process is only now beginning with this exhibition, with a concentrated look at O'Keeffe's remarkable charcoals, watercolors, pastels, drawings, and paintings. Approximately one-third of the works have been chosen from the artist's own collection, while the remaining two-thirds of the works included are almost equally divided between private and public collections.

Every attempt has been made to select the very best works available, whose supreme aesthetic qualities define and illuminate O'Keeffe's lasting, inventive contributions. Emphasis is given here to her art of the 1910s through the 1940s, with several special themes from the 1950s and early 1960s. Although O'Keeffe's late works from the 1960s and 1970s provide moving testimony to her full and resonant life, our purpose here is to assemble her greater, earlier achievements, the ones that most forcefully struck the art world. Early on, the artist had distilled signs, symbols, and a palette quite unlike any other in American modern art. She also displayed a rather "modern" unpredictability. From year to year, she might change her emphasis from abstraction to the figure, followed by a return to abstraction, or another major set of subjects. Often these run in series or creative groupings, figurative/nonfigurative jumps and collisions. Yet a common visual spirit and compositional sense

remain, binding together the disparate elements. After all, O'Keeffe's abstractions can look like her landscapes, flowers, or close-up still lifes. Selections for this exhibition were made on the basis of such kinships as well as their parallel perfection in execution.

Following her death in 1986, the project took on another dimension. It became the first major exhibition after her death, as well as the centennial celebration of her birth. The Gallery's relationship with the Estate of Georgia O'Keeffe, to which their generous loans attest, as well as the presentation here by Sarah Greenough of numerous O'Keeffe letters to friends and fellow artists, ensure a strong sense of the artist's presence. With this exhibition, we turn to her art freshly, and find the artist and her art more than picturesque. We look beyond impressions of O'Keeffe as the romanticized, naive *savante*, the Southwestern recluse—impressions that are only half-truths, because her letters provide a more accurate point of access to her daily life and a tangible record of her time and place. Their crisp wording reminds one of her clean paint edges. Their expansive images are like one of her "Pelvis" compositions where we peer through a controlling aperture to the limitless beyond. Paintings and letters by O'Keeffe are immediate and nearby but they are addressed to the future from the "far-away." With the aid of these letters we can now see her art as the major correlative to her life.

O'Keeffe's art refers to determinants, to those things or events that have caused her, provoked her, to create. These necessities obliged her to make art, as she tried to portray sensations, ideas, and situations that for her could be expressed no other way. She wrote to William M. Milliken in 1930, "I see no reason for painting anything that can be put into any other form as well—" (letter 55). To her aesthetic world she was compelled to bring her life and actual experiences, expressed through her direct phenomenological point of view. She leaves us the record of all this in her art. Rarely a strict narrative, her art allows us to remember things she had seen, experienced, or sensed, images grounded in authenticity. She consciously nurtured her memories of events, giving them new life as art.

A phrase O'Keeffe used in a letter to Anita Pollitzer, "Tonight I walked into the sunset . . ." (letter 14, 11 September 1916), is like all of her best art: immediate, concrete, all-encompassing, with a surprising syntax. Sunset is the time when the world appears least structured, when forms tend to dissolve and are replaced by new colors and sensations. O'Keeffe acted to suspend time, producing art that would capture the transient. For example, O'Keeffe made of a flower, with all its fragility, a permanent image without season, wilt, or decay. Enlarged and reconstructed in oil on canvas or pastel on paper, it is a vehicle for pure expression rather than an example of botanical illustration. In her art, fleeting effects of natural phenomena or personal emotion become symbols, permanent points of reference.

O'Keeffe preferred to distance herself from critics, biographers, art historians, or others who probed. Each work represented an intense and above all, personal investment. With her closest friends, however, she was more open. In the letter to Anita Pollitzer, she described an event, but with an extension to the fantastic. O'Keeffe's imagery is concrete, but the consequence of her concise recounting shocks us to a new awareness. We quickly see her entering the vividly colored sky, becoming one with its greater forces. She does not write of the dust of the trail, the rocks on the road, the length or toil of the walk, but of an effortless, transcendent event. The same happens in her best art—as she suspends the mundane laws of reality and reason. Then she reveals new edges of vision, new attitudes of direct experience, put down in rich color with energetic line in carefully ordered brushstrokes or markings. Each work is self-sufficient, a miniature world with its own rules, bending to her own will. Contrasts of the near and far, both in time and space, distinguish O'Keeffe's art. She has no aerial perspective, but treats everything in focus, ignoring impressionistic values, the actual envelope of the

air, or the limits of human (and even mechanical) vision. O'Keeffe gives us a new world made sharp in all of its large and small parts. The strong ordering, a result of her clear optical and mental vision, can intimidate as well as inspire and challenge.

Although O'Keeffe has been an influential figure in American art history for the past seven decades, she has also been a target for criticism by outrageous, outraged critics and writers over the years. She had superior internal resolve to withstand Clement Greenberg's words, ". . . the greatest part of her work adds up to little more than tinted photography. The lapidarian patience she has expended in trimming, breathing upon, and polishing these bits of opaque cellophane betrays a concern that has less to do with art than with private worship and the embellishment of private fetishes with secret and arbitrary meanings" (review, *The Nation* 162, 15 June 1946, 6). She endured a lifetime of sycophants' and novelists' fascination with her personal life, her relationships, her status as role model, her every deep or shallow breath.

Even now the critics are divided in their views on O'Keeffe's art. Some admire her abstractions, others esteem her figurative works. The former group presents the artist as a progressive. The latter places her within the honored, conservative tradition. The two groups challenge each other for critical control, and there is a struggle within O'Keeffe's work as well. She herself alternated, blending abstraction and representation, to arrive at a mature, dynamic synthesis, calling it "that memory or dream thing I do that for me comes nearer reality than my objective kind of work" (letter 60, to Dorothy Brett, 15? February 1932). In late February 1924 she wrote to Sherwood Anderson, "My work this year is very much on the ground—There will be only two abstract things—or three at the most—all the rest is objective—as objective as I can make it— . . . I suppose the reason I got down to an effort to be objective is that I didn't like the interpretations of my other things—" (letter 30). She felt the abstractions allowed too much room for misinterpretation, as the critics wrote their own fixations or autobiographies into hers. She felt "invaded," unable to accept the point of view that art can also be a resonating membrane for the viewer, who holds the lasting right to its reflections.

O'Keeffe's art experienced a distinctly New World freedom, largely in response to the open spaces of rural America. After the claustrophobic beauty of Lake George, she would freely occupy and explore wide-open stretches of the Southwest. This was at a time when the roads of New Mexico were treacherous, if they existed at all, and electricity, telephones, or other utility services were years away. She would test her physical and psychological independence by living beyond the fringe of civilization. This almost biblical exile was her fundamental path to sustained revelation. It was as if she were laying claim to the "faraway" regions, taking hold of their remarkable presences, seeking discoveries for her art. In the Southwest she was free to pursue the fantastic effects of nature, the forces of the elements, and the geological history so dramatically evident in its canyons and stratified hills. She could travel for miles without human contact or traces of development, accepting the risks posed by weather and wild animals. She could also experience the contradictory overlapping of the rituals of the native Americans and those of the colonial Spanish. In this exotic, foreign atmosphere, the artist was, simultaneously, daredevil, participant, and *voyeur*.

Her art is memorable. A clear, indelible core image of each work is retained in our mind's eye after even the briefest glimpse. This is not to say, however, that we remember the profusion of her nuanced details or artful manipulations. O'Keeffe often obscured the hard work and intense thinking that preceded the finished object. These were subordinated to the direct hard punch of the form, the astonishing key of her color, and the unprecedented juxtapositions. It is not enough to quote Alon Bement or Arthur Dow whose teachings and writings influenced the young artist and who held that the highest goal of art was to fill space in a beautiful way. Neither can one credit everything to the

emergence of modern photographic vision, despite the notable contributions of Imogen Cunningham, Edward Steichen, Paul Strand, or the turn-of-the-century German Karl Blossfeldt. Despite O'Keeffe's deep pleasure in Chinese and Japanese art and, indeed, much of the history of art, one still lacks an explanation why her work remains so memorable. Perhaps it is because it is ecstatic, as ecstatic as her relationship to the very real, very visible world around her. To this she adds a distinctive, urgent, and disciplined personal vision. This inner eye of the artist controlled, tightened, made taut the best of her works. O'Keeffe was mad for work. She was adventurous and she had the egotistic notion that she could, in fact, capture an unknown and make it known. Whether O'Keeffe's work was the result of naive folly or inspired genius, her art bears dramatic witness to her wonder in life and the world.

In its visual scale relative to literal size, O'Keeffe's art deceives us. She brilliantly monumentalized her subjects, whether she treated them in a 48×40-inch or a 5×7-inch canvas. Her small works, though, are among her best and most striking ones. Special effort has been made here to present several dozen of these jewel-like paintings. In each we find emphatic color, composition, clear conception, and visible signs of execution—the trace of her brush, the delicate ridges of pigment. These elements are then put down without compromise or contrivance.

Her art also speaks about color and its effects. Even the early black-and-white charcoals have a full range, from the highlit whites to the velvety blacks. We supply our own polychromy as we plunge into these charcoals, alluding to her self-described mental visions. The forms are like flickering flames or jewels held aloft by waterspouts. They become animated by our imagination, stimulated by O'Keeffe's curious effects. The academic tradition of monochrome drawing before the use of color is followed, but a quick shift to expressive color comes in the early 1917 paintings, the so-called "Specials." These works are abstract swirls, fantasy renderings, strong forces with multiple associations to states of being, dream influences, and the birth of abstraction in early twentieth-century art. O'Keeffe used her color both to seduce and repel. There are paintings, pastels, and watercolors of overwhelming beauty, where delicate hues delight our eye and a luxurious feeling permeates. But in an equal number of works she created harsh collisions of saturated colors whose initial garish appearances deny our appreciation. These recall the spirit of her words to Waldo Frank, "I would like the next [exhibition] to be so magnificently vulgar that all the people who have liked what I have been doing would stop speaking to me—My feeling today is that if I could do that I would be a great success to myself" (letter 38, 10 January 1927).

O'Keeffe admitted carrying shapes around in her mind for a very long time until she could find the proper colors for them. When found, those colors would release an image from her mental catalogue and allow it to become a painting. O'Keeffe used color as emotion. Through color she would transfer the power and effects of music to canvas. In her abstractions, O'Keeffe wrapped color around the ethereal. Whether her images are abstract or figurative, O'Keeffe gives the viewer a profound lesson in emotional and intellectual coloring. No reproduction will ever do justice to the intensity, the solidity, or the high pitch of these colors, for the notion of local or topical color in her work is only relative, just the beginning point. Indeed, as we return to reality after looking at O'Keeffe's depictions of landscapes, sunsets, rocks, shells, flowers, any of these natural determinants, we are disappointed. We have come to appreciate and think about those things around us under the spell of her work, but the truth becomes less impressive, milder.

The artist was finely attuned to the sounds of the natural world. In her letters she describes the wild, blowing wind, the deep stillness, the animal sounds, the rustling of trees. All these seem to penetrate the senses of the artist and find expression in her work. These formed for O'Keeffe a kind of natural music, made up of the life and rhythms of the earth. She made art that alludes to sounds,

with references to the audible world, from the din of Manhattan to the pure songs of the prairie. She accomplished this through the form and dynamics of her composition and the pitch of her colors.

O'Keeffe's earliest mature works, after c. 1915, are abstractions, dreams and visions made concrete. She would enter periods of mad, crazy work, periods when she knew she had "something to say and feel[ing] as if the whole side of the wall wouldn't be big enough to say it on and then sitt[ing] down on the floor and try[ing] to get it on a sheet of charcoal paper" (letter 5, to Anita Pollitzer, 13 December 1915). As she followed a compulsive need to get something down in paint, watercolor, or charcoal, she questioned her art and formulated long, rhetorical letters, devaluing, revaluing, looking for the point of personal balance, wondering whether she was to be master or slave.

The open-ended, exhausting, but exciting works of her period of artistic self-discovery found a point of focus by the early 1920s. Now her observations of landscapes, flowers, or other natural shapes were made inventively ambivalent. They became both abstract and figurative, with elements merged so that colored streaks played across the plains, water rose in a siphon contrail, botanical details suggested human anatomy. O'Keeffe, standing firmly behind her work, found the balance that would inform, fuel speculation, and inspire. The strength of these marriages of forms remains evident in all the best work, regardless of date.

By 1929 O'Keeffe confirmed that her truest, most consistent visual sources were in the American Southwest. These sources refreshed her physically, mentally, artistically. The sky, the vastness, the sounds, the danger of the plains, Badlands, canyons, rocks, and bleached bones of the desert, struck her as authentic and essential to her life as well as to her art. She wrote to Henry McBride from Taos in 1929, "You know I never feel at home in the East like I do out here—and finally feeling in the right place again—I feel like myself—and I like it— . . . Out the very large window to rich green alfalfa fields—then the sage brush and beyond—a most perfect mountain—it makes me feel like flying—and I don't care what becomes of art" (letter 44). In the Southwest she found primal mystery, foreign even to this daughter of Sun Prairie, Wisconsin. And it was from the Southwest that O'Keeffe would so forcefully try to capture the wild, unusual essences in her art as it turned more figurative. In search of the marvelous, she advised Russell Vernon Hunter, "Try to paint your world as though you are the first man looking at it—The wind and the heat—and the cold—The dust—and the vast starlit night . . . When the spring comes I think I must go back to [the Southwest] I sometimes wish I had never seen it—The pull is so strong—so give my greetings to the sky" (letter 65, 21 October 1933). Her letters mention Taos, Abiquiu, the Chama River, the Pedernal, "Black Place," "Red Hills," "Gray Hill," "Lawrence Tree," all particular sites, points of personal experience that O'Keeffe wove into her art. She wanted to show her wonder. Indeed, it is her wonder, her razor-sharp vision, and her response to that vision that continue to astonish us.

No artist has seen and painted like O'Keeffe, whose spiritual communion with her subject was of a special quality, unparalleled, and irreducible. In the 1930s and 1940s, her ceaseless searching out and intelligent use of the materials of the Southwest enlivened the potentials of her art. The best of her works cross over to abstraction ("that dream thing," as O'Keeffe called it), and then loop back to the figurative, engaging the viewer's full imagination regardless of one's regional bias. In the 1950s and 1960s O'Keeffe's sources would become her immediate world of the Abiquiu patio door, the Ghost Ranch post ends, the courtyard flagstones, and her airplane flights above the clouds. She increased her scale to make a number of six-foot-wide paintings and the striking twenty-four-foot wide mural *Sky Above Clouds IV* (cat. 120). The artist was responding to the younger generation of post-World War II artists as they, too, expanded their works to an environmental proportion. Through the late 1960s and 1970s O'Keeffe's large sky and river paintings, and smaller still-life images of

rocks or other natural forms, plus her colorful and broadly brushed watercolors, document her still-vital creative energy.

Throughout her life, O'Keeffe was as demanding of herself as she was of others. She forcefully edited her oeuvre, critically "grading" the paintings and works on paper. Her highest mark was a star with her initials in the center written on the backboard of the painting. Less favored works were accorded just initials or her signature. She destroyed new work as well as old if it failed to satisfy. Works on paper must have undergone the same judgment process. It was her right, of course, and such acts were consonant with her wish to be mentioned "first or not at all." If the art did not stand the test of time then O'Keeffe might have, could have made herself disappear.

The study of O'Keeffe is just beginning. A catalogue raisonné project is needed to document the works—many of which remain unpublished and unknown—and a need remains to establish more accurate titles and firmer dates for all of the works. A close examination of her material collections would improve our understanding of her personal interests and influences. She was a compulsive saver of objects and things that we might sense to be talismans. Her library of books and records offers promise of further illumination of her intellectual patterns and sources. All this must be considered before O'Keeffe's place in the history of art and culture can be fully defined. She is indeed a proper candidate for wider discovery by the world's public, since the artist is all but unknown outside the United States. In the context of personal idealism and the exemplary breakthrough to artistic freedom achieved by Gauguin and Van Gogh, for example, O'Keeffe provides a distinctly twentieth-century American point of reference. Her art reflects not only her time but aspects of our contemporary art environment, and seems to prefigure qualities fundamental to the future of art.

In O'Keeffe's World

SEVEN MONTHS after I arrived in New Mexico, in the summer of 1973, I was working at Ghost Ranch doing carpentry and other jobs. Ray McCall, who was head of maintenance there, said he was going to fix something at Miss O'Keeffe's house, and asked if I'd like to go along. I said "Sure." Since arriving, I'd never seen her drive by in the car. I'd never seen a sign of her. I was starting to wonder whether Georgia O'Keeffe existed.

We drove over in Ray's old yellow pick-up with the red dust blowing behind us. The first thing I noticed when entering her world was how completely different it was. The house was U-shaped, with a patio facing south—looking out to the flat-topped Pedernal mountain. There were smooth adobe plastered walls, buff-colored flagstones laid out across the courtyard with silver-green sagebrush set against the sky. There was a simplicity in the courtyard. Just a few skulls and pelvis bones on a cedar shelf, a small bell ringing in the breeze, some flagstone tables with her favorite rocks. Red rocks and black obsidian, river rocks, and a stone once used for grinding corn. Neatly stacked piñon wood for the various fireplaces in the house. Inside there was a whiteness all around—white walls, white-stained floors and ceilings, simple white cotton curtains.

It was a wonderful and pure world that she lived in. In the kitchen was a basket of dark green watercress that had been freshly picked from a mountain stream. Her small table was in a corner with big windows facing out on the red hills and cliffs where an occasional blackbird would fly by.

When I walked into the studio, Georgia O'Keeffe was standing there. I was overwhelmed. Her silver hair outlined a beautiful face engraved with lines of experience, time, and the effects of much sun. I was lost, I didn't know what to say. She made it easy for me—she completely ignored me or the fact that I existed. She said hello to Ray and looked right past me as if I were transparent.

The second meeting was not much better. Jim Hall, director of Ghost Ranch, said, "I am going to Miss O'Keeffe's house. She wants me to help her unload a Franklin stove from the back of her car." So we went. He introduced me. He knew I was an artist and wanted to get to know her. He tried to break the ice. He said, "Miss O'Keeffe, this is Juan Hamilton. He used to live in Vermont and had antique wood stoves he actually used to heat and cook on." She turned around and said, "This is *not* an antique wood stove."

The third meeting occurred after I had met a writer, Virginia Kirby, who lived in the valley and worked for O'Keeffe. She said, "Well, just go on your own. Don't try to get anyone to introduce you. Go to the back door. Go at 5:30 or 6:00. She's up early. The earlier the better."

So one day, when I was feeling particularly good, I went to the back screen door of the kitchen. I told Candelaria Lopez, the housekeeper, that I was interested in work. She went to the studio and called Miss O'Keeffe. Finally we spoke on a one-to-one basis. I asked her if she had any work.

She said, "*Work*? I don't have any work."

I started to turn around and leave. "Wait a minute," she said, "Can you pack a shipping crate?"

I said I thought I could.

The next day as we worked she said, "You speak pretty good English. Did you finish high school?" I said I had, and that I had gone to college and two semesters of graduate school. She said, "Can you type?"

I think it took several months before she was interested in me—and remembered my name. For a long time, she would call Santa Fe and say, "I'm going to send my boy down." Or, introducing me, she would say, "This is . . . what's your name?"

When she learned I was a potter, she said I had better get to work if I was going to stay around. A large kiln was ordered and brought to the Ranch. A big red Mack truck with a crane was unloading it when the whole thing started to tip over. Miss O'Keeffe stepped swiftly out of the way. It was the beginning of one of our many adventures.

When she saw me work with clay she became very interested. She told me of a book on cuneiform writing, called *They Wrote on Clay*. In time she began to make pots of her own—she loved the feel of the clay—cool and smooth. Her eyesight had begun to fail, but her sense of touch was as strong as ever.

One day while eating lunch she said, "It speaks to me." What speaks to you? "The softness of the breeze blowing through the piñon tree outside my window." What does it say? "It tells me about the weather and other things."

At the Ranch Miss O'Keeffe had a corral and shed where she kept her horses for the summer. One day a big wind came along and picked the shed up and blew it thirty yards to the west. She thought that was great.

There were many rattlesnakes at the Ranch. She had Frank build a fence to keep them out of the courtyard. "Though I feared them, I was fascinated," she said, "I had the feeling it was their land. I felt I was intruding."

In the evening we would listen to records. She had recordings of Beethoven's piano sonatas performed by Sviatoslav Richter. She listened to them over and over. We would sit there in the white studio at the Ranch and listen. It was the only sound around.

She loved her chow dogs and felt that in many ways they were her best friends. Jingo and Inca accompanied her on her walks out to the red hills. Jingo was a majestic red chow with a mane like a lion. She would ride in the back seat of the car with her front leg on the arm rest, looking like a queen. Inca was called a "blue" chow because of his blue-gray coat and blue-black tongue. He always slept just outside Miss O'Keeffe's bedroom door and would come in the morning and sit with her by the fire while she had her tea.

The kitchen was a very important part of the house to Miss O'Keeffe. In earlier years she had loved to cook. She wrote an introduction to a book of recipes that stated: "There is a bit of bitch in every good cook." O'Keeffe would take great care in what she ate and in how it was prepared. She thought about her food in a simple and clear way, the way she liked a room to look, the way she liked to dress. It was unpretentious and, to some people, austere.

To her, isolation was welcome after the difficulties she'd had living in the city, being a student, being in the Stieglitz circle with all the demands that were made of her. Stieglitz liked to have an audience. He liked to have a lot of people around. Stieglitz would often have eight or nine people to dinner. Then he would go off to bed and leave O'Keeffe to entertain them.

She was famous when I met her, but that did not matter. She did not know who the celebrities were. She did not care for famous people. Once while traveling in France, her friend Mary Callery wanted to introduce her to Picasso. She said, "But Mary, I don't speak French and he doesn't speak English. What would be the sense in meeting him if we couldn't speak!"

She had been cast into the center of the art world at a fairly early stage in her career. Her expression through painting was private, intense, and personal. To paint she needed to be alone. And to find that space in New York wasn't always easy.

She was beautiful because she was what she was and didn't try to make herself something else.

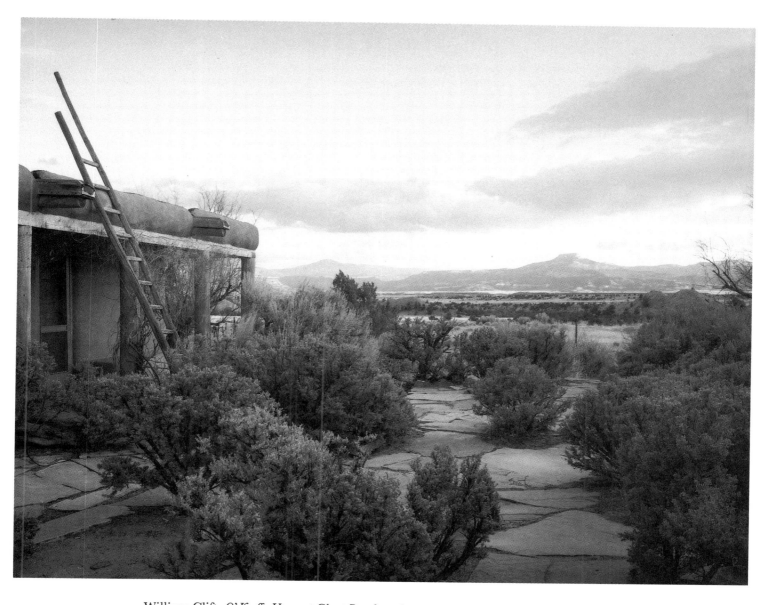

William Clift, *O'Keeffe Home at Ghost Ranch*, 1981. © 1981, Collection of William Clift

She said she'd once gone to Elizabeth Arden in New York and they'd made up her face. When she got home and looked in the mirror she was horrified. She washed it all off and said she would never do that again. She would never boast about being good-looking. She'd say, "Well, I wasn't bad to look at." When she was a baby, her mother thought she was unattractive and would put her in the back room when company came.

She was too smart to be considered anti-intellectual. She was an earthy person in some ways, a well-grounded person, and because of the simplicity of her language, it appeared to some that she was unsophisticated. But she was extremely sophisticated in her own way. She treasured her library, and some of her favorite reading included *The Conquest of Mexico* by Hernando Cortes, *The Secret of the Golden Flower, a Chinese Book of Life*, and volumes of haiku and Noh plays, along with a wide range of American authors, as well as James Joyce and D.H. Lawrence. She corresponded with many people she understood and was interested in. She did not try to become part of their world. She could interact with a wide range of people and retain her own identity.

Her sense of accepting things the way they were, of not fighting against the world, was remarkable. When she first got the house at Ghost Ranch, there had been a lawn and a rose garden in the courtyard, which wasn't very desertlike at all. You had to water it a lot. She left the water on for a long time. Because of the soil conditions, the courtyard sank three feet into a huge saucer. Instead of getting upset, she just took it out, put flagstones in, and let the wild sagebrush grow.

When it came to her work or Stieglitz's, however, she was very particular about the way it was presented. Once she was meeting with the head of the print department at the Metropolitan Museum and discussing the possibility of giving them a large group of Stieglitz's photographs. Stieglitz had mounted and matted his prints meticulously so that each print had a mat size that he felt suited it best. The head of the print department wanted to cut them all to the same size so that they would fit his solander boxes. When O'Keeffe objected, he said, "This is the way we do our Rembrandt prints." O'Keeffe answered curtly, "Well, Mrs. Rembrandt isn't around."

There was a directness and simplicity in her world, her way of thinking, a very powerful and important element. She took things as they were, not as they could have been. She didn't work for the sake of working. She had to have an idea. She enjoyed process. She enjoyed effort. She'd get an idea in the night and in the morning she couldn't wait to get started. In later years, she'd get one of her gardeners, Belarmino Lopez, to help her with sculpture and painting. She was never totally satisfied with the results. But she was engaged by the idea, by the ability to make an effort. And that was probably the most stoic thing about Georgia O'Keeffe—that she never gave up trying. She never lost interest in shapes and forms—the creative process.

She never tired of a single idea. She painted the Pedernal over and over again. She was fascinated by this mountain. She told me jokingly, "God told me if I painted that mountain enough, he'd give it to me." She also said, "I've traveled all over the world and I don't think there's anything as good as this."

There was an Oriental quality to some of her work. The Eastern way of looking at things fit more clearly with her vision than much of the art of the Western world. She could also portray conflict and tension. She saw the object as having an inherent beauty. A beautiful thing was a beautiful thing. The world of abstraction and realism were one to her.

We went to the island of Antigua in 1975. There was a lovely white sandy beach, a crescent with palm trees outlining the coast. She enjoyed walking that beach collecting seashells, and when it got hot she'd sit under the palm trees in the shade. She thought about doing something with that. She took her felt-tip pen and sketched the palms. Then when she returned home, she made some

charcoal drawings. She never felt compelled to create. We went other places where she did not make any drawings. She only worked when she had an idea.

When we were in Guatemala, we found a dirt road that led over the mountains to the beach. We traveled about fifty miles before we saw the Pacific coast. There were oil tankers anchored there. The National Guard was everywhere. Men with machine guns riding around in jeeps. At the end of the road we found a huge white hotel against the dark blue sea. It was hot—100 degrees or more. We were hungry and wanted lunch. We could see no one—the place looked deserted. Finally, we found someone and ordered lunch. We sat out under a thatched umbrella eating shrimp as the waves rolled against the sand.

On Columbus Day in 1976, we were in Washington, D.C. All the offices of the museums were closed. So we went around to look at art. It was a beautiful day. The sky was blue. The leaves were yellow. People were flying kites on the Mall. We went to the Hirshhorn Museum and looked through their collection, which we hadn't seen. She liked some of it. There was a good deal she had no interest in. We went through the Freer and saw Chinese bronzes, jades, and some very good screens. But it was the wideness of the sky and the openness of the Mall that appealed to her most. We walked for most of the afternoon. We ended up at the Lincoln Memorial. She wondered what Lincoln would think of himself sitting up there so big. We had a hard time getting a taxi. She sat on the curb, waiting while I tried to flag one down. We tried on one side. Then the other. We were there about forty-five minutes before we got a ride to the old Fairfax Hotel, which had a good Spanish restaurant.

The Washington Monument was particularly exciting to her. She knew it was tall and could see it clearly against the sky. She could see gradations of light in the column. She would hold onto me so she wouldn't lose her balance when looking up at it. It was something simple, like a patio door. The simplicity was what attracted her. She had an idea from it. And when she had an idea for something her inspiration would build. She would see it in a variety of forms or formats. She worked on the Washington Monument series, first in a line drawing, and then in pastel. One day I found her on the phone to her shipper in New York. She was ordering her material. Getting the best kind of linen canvas, lead white paint, cerulean blue for the sky. Taking what in another painting might have been the shading of a leaf or the side of a mountain, and creating another statement. She did not paint the whole monument with a point at the top. She just did a section of it. It was going up, an upward bound feeling against the dark blue sky. It was a metaphysical statement, done in a very simple way. It was about the relationship of light and color.

Her genius was her oneness with herself. Her ability to generate an aura of honesty and directness. There was a connection between her internal and external world that was full of truth. It appealed to a lot of people. So her flowers are flowers in their own way. They don't allude to other flowers. When she painted the West, it was the West she sensed. There is an openness in the pictures, and a magic sense of light. Other painters would come West and paint the hills of New Mexico in such a way that they looked like Connecticut. They would bring their own styles and assumptions and pin them on the work they did. She was an open person, open to new experience, in a fresh and honest way that was unique. She didn't have all of her past floating around. Well up into her nineties, her world continued to be her own. She still would do some writing and work with clay, she would enjoy a walk, a record, a bottle of wine with dinner, the fireplace, and being with her dogs. Just being herself in her world. Napping when she was tired, going about her business, checking the garden and receiving visitors when she felt like it.

She planned to live to be 100. I don't think she was ever concerned about death because I don't think she ever thought she would die. When she was close to 100, she started to tell people she

intended to live to 120 so she would be sure to make 100. In many ways, her spirit is still alive through her work. Her work is a mirror of the person we have lost.

One shouldn't feel sadness at the thought of O'Keeffe's death, because that would not be in her spirit. There was a naturalness to her death, just the way there is a naturalness to the bleached bones she found in the red hills of the desert and the beauty of the wildflowers.

She will always be misunderstood because there are so many levels to her work and the way it came about. But *she* took hold of the things she knew existed, the rocks and the "Blue that will always be there as it is now after all man's destruction is finished."

This exhibition is not a traditional retrospective. It is not a definitive or final statement about Georgia O'Keeffe's work. It is a transition. It is an attempt to exhibit things in a way in which they have not been seen before. We hope she will look kindly upon our efforts as she moves on to the unknown.

JUAN HAMILTON
Abiquiu, New Mexico
1987

CATALOGUE

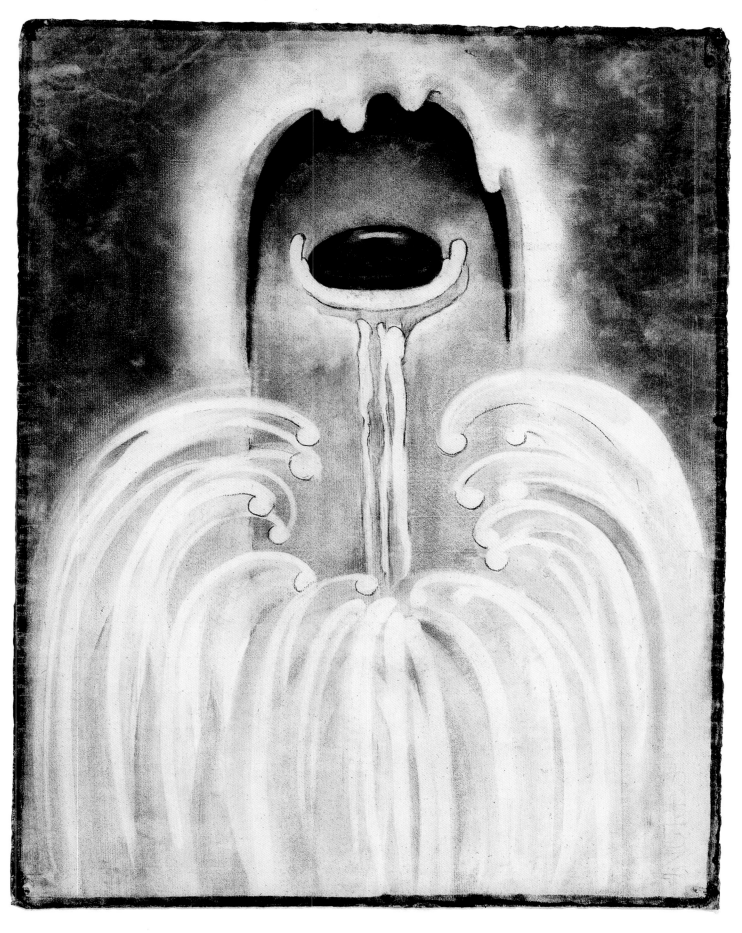

1 SPECIAL NO. 2, 1915, charcoal on paper, 23¾ × 18½,
Estate of Georgia O'Keeffe

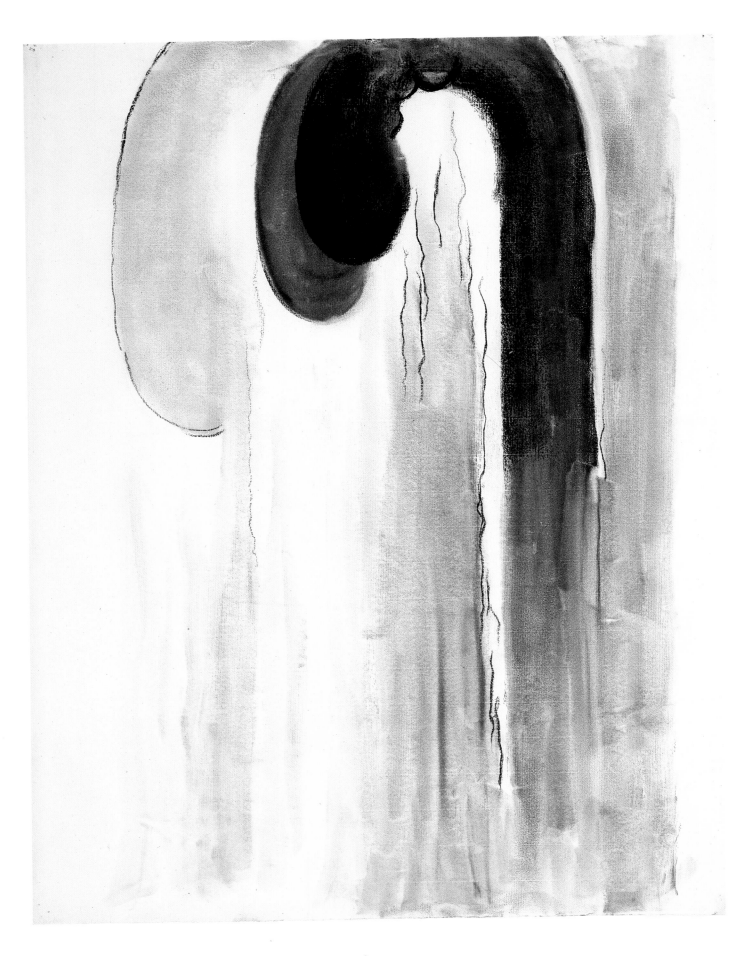

2 SPECIAL NO. 4, 1915, charcoal on paper, 24¼ × 18½,
Estate of Georgia O'Keeffe

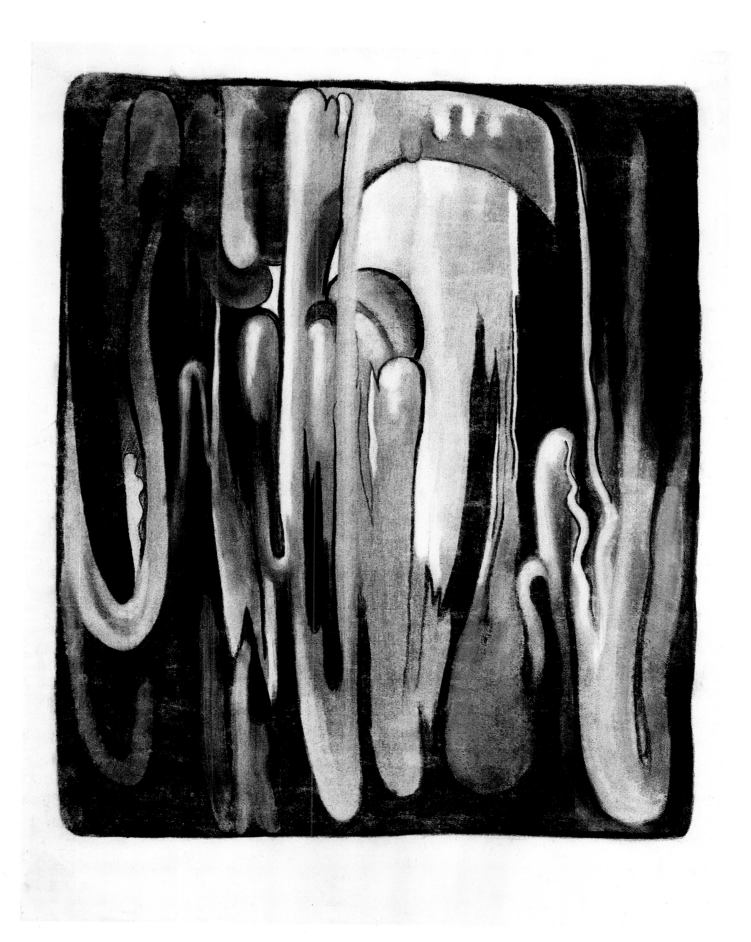

3 SPECIAL NO. 5, 1915, charcoal on paper, 24 × 18½,
Estate of Georgia O'Keeffe

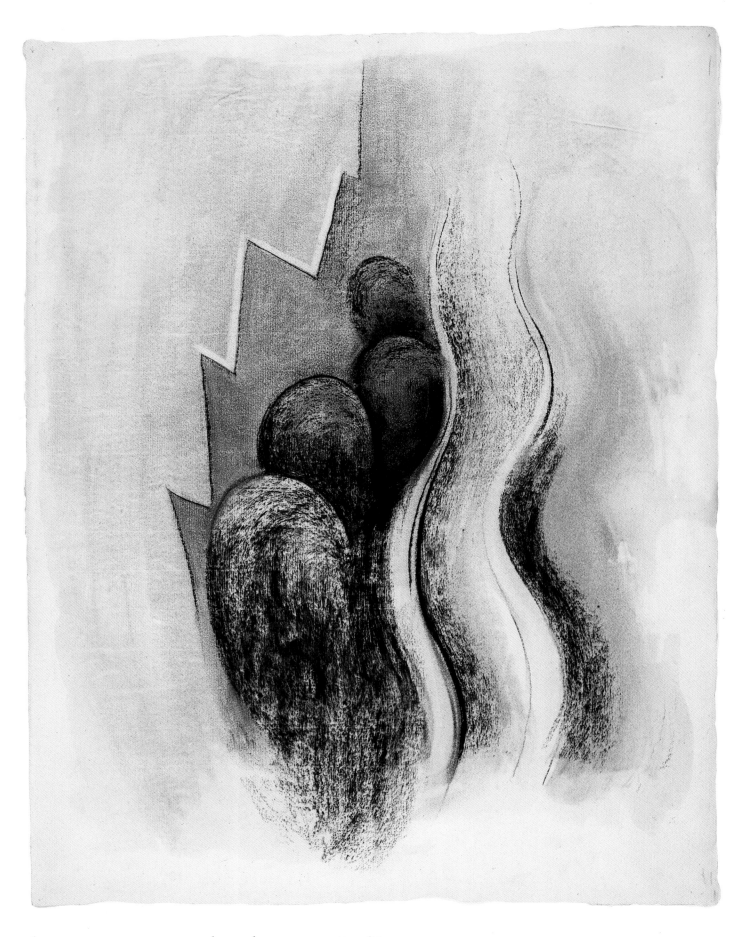

4 SPECIAL NO. 13, 1915, charcoal on paper, 24⅜ × 18½,
The Metropolitan Museum of Art, Alfred Stieglitz Collection, 1950

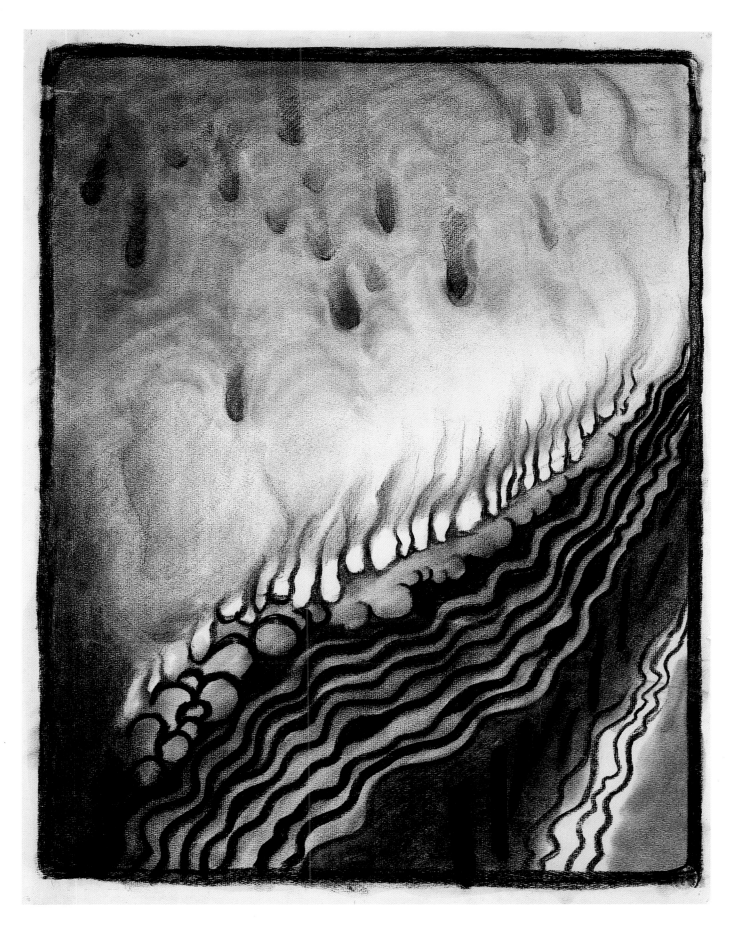

5 SPECIAL NO. 9, 1915, charcoal on paper, 25 × 19,
Menil Foundation

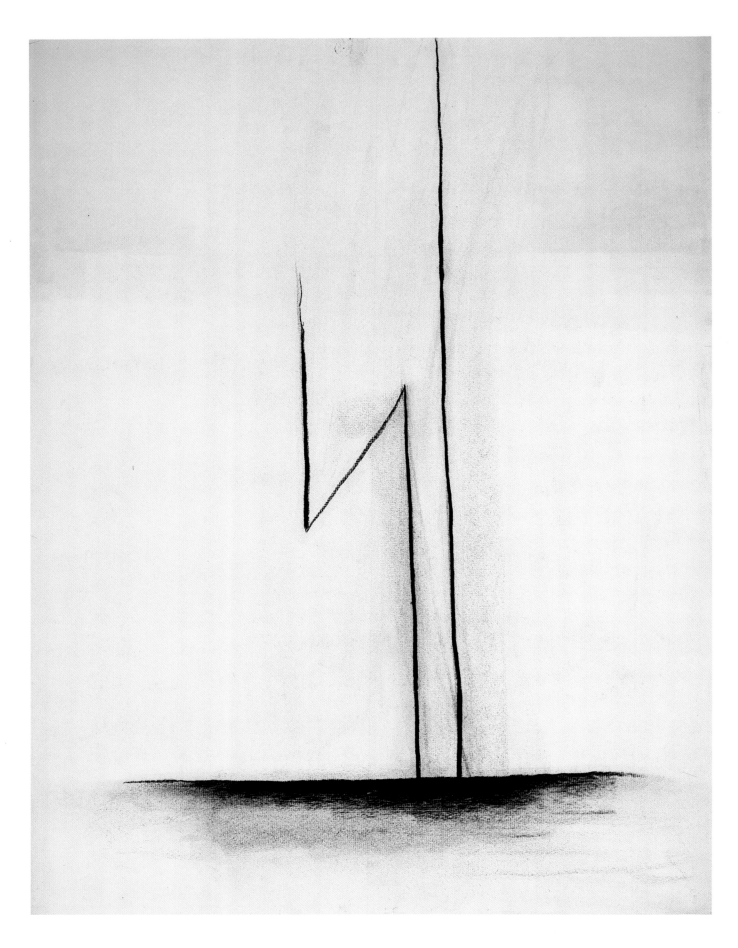

6 FIRST DRAWING OF BLUE LINES, 1916, charcoal on paper, 25 × 19,
 Estate of Georgia O'Keeffe (not exhibited in Washington)

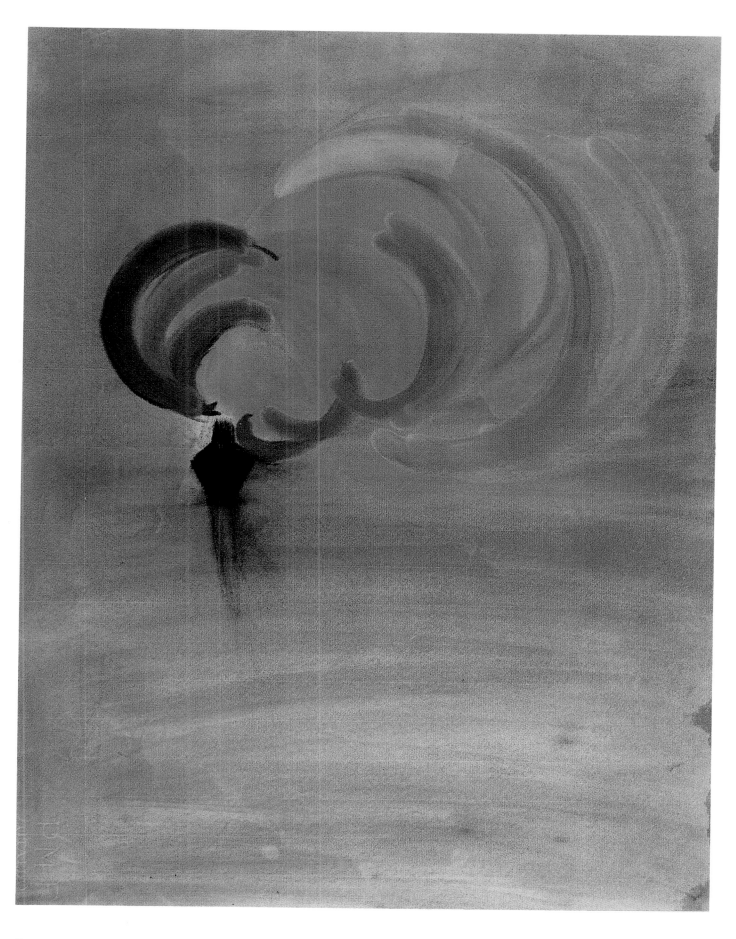

7 TRAIN IN THE DESERT, 1916, charcoal on paper, 23 × 18,
 Private Collection

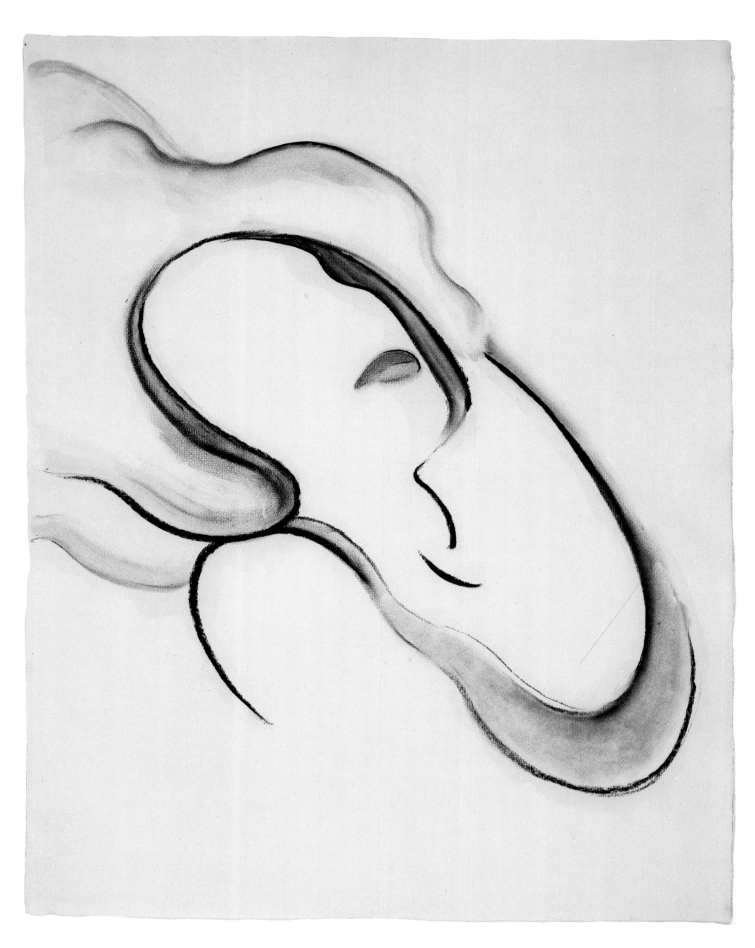

8 ABSTRACTION IX, 1916, charcoal on paper, 24¼ × 18¾,
 The Metropolitan Museum of Art, Alfred Stieglitz Collection, 1969

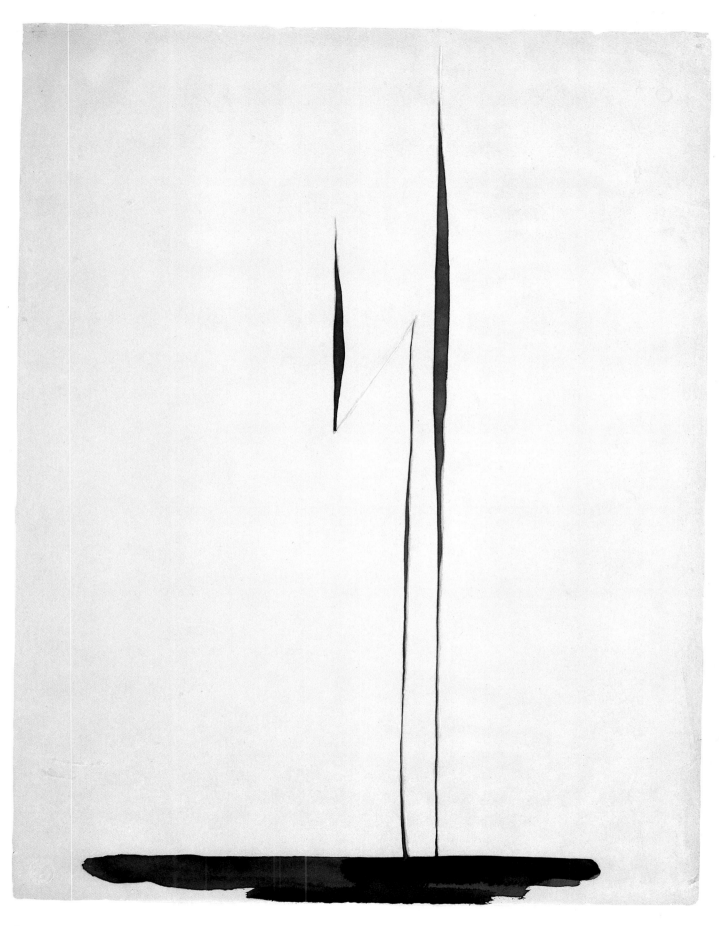

9 BLUE LINES X, 1916, watercolor on paper, 25 × 19,
 The Metropolitan Museum of Art, Alfred Stieglitz Collection, 1969

10 SPECIAL NO. 15, 1916, charcoal on paper, 19 × 24½,
Estate of Georgia O'Keeffe

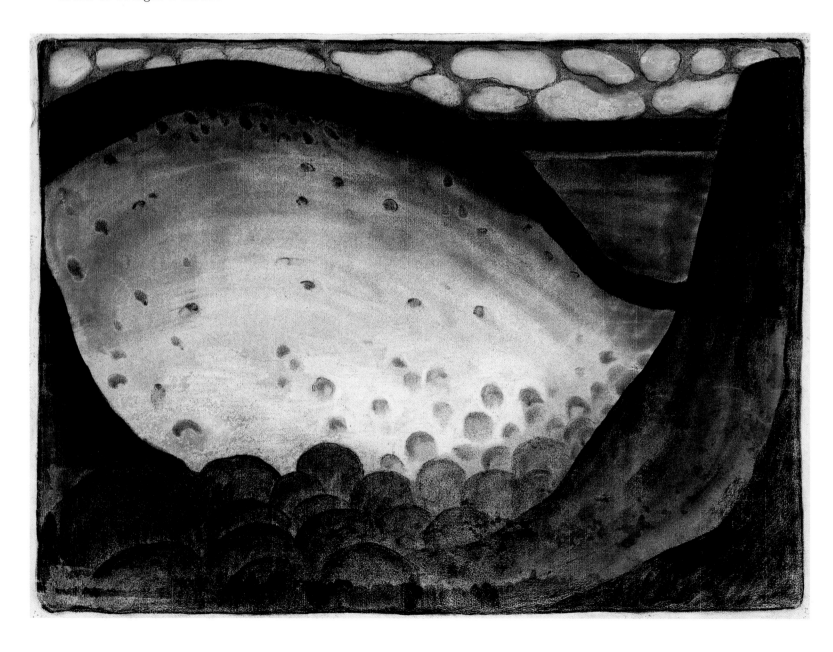

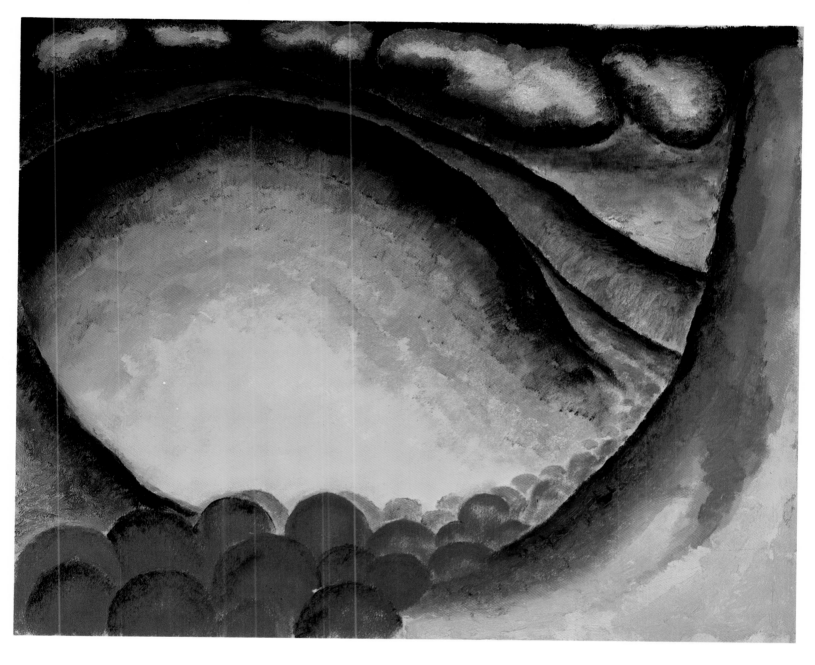

11 SPECIAL NO. 21, 1916, oil on board, 13⅜ × 16⅛,
Estate of Georgia O'Keeffe

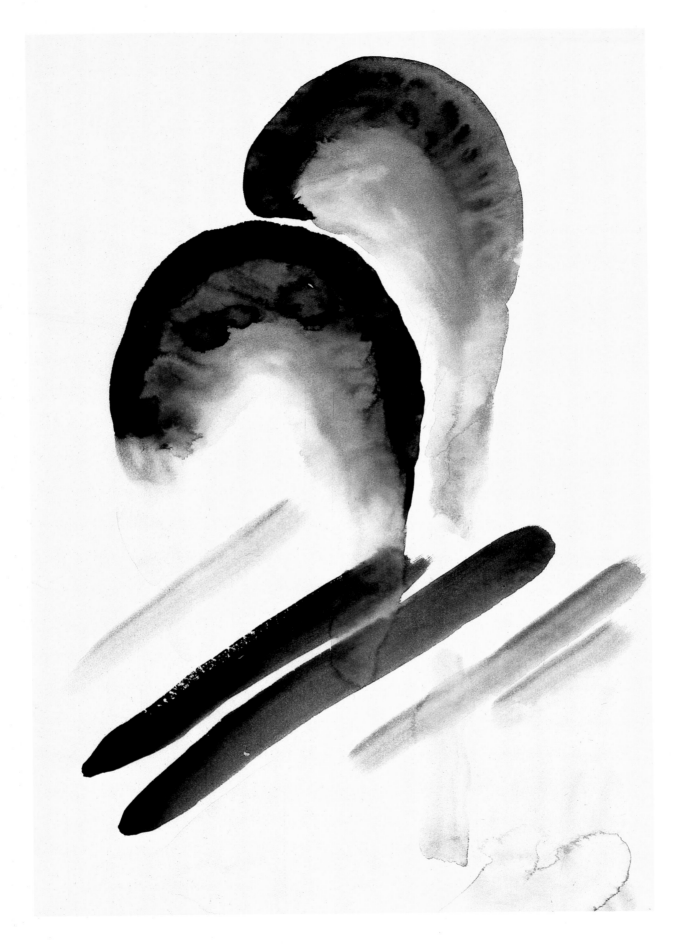

12 BLUE NO. III, 1916, watercolor on tissue paper, 15⅞ × 10¹⁵⁄₁₆,
The Brooklyn Museum, Dick S. Ramsay Fund, 58.75 (exhibited in Washington only)

13 BLUE NO. IV, 1916, watercolor on tissue paper, 15¹⁵⁄₁₆ × 10¹⁵⁄₁₆,
The Brooklyn Museum, Dick S. Ramsay Fund, 58.76 (exhibited in Dallas only)

14 EVENING STAR NO. IV, 1917, watercolor on paper, 9 × 12,
Estate of Georgia O'Keeffe

15 EVENING STAR NO. VI, 1917, watercolor on paper, 9 × 12,
Estate of Georgia O'Keeffe

16 LIGHT COMING ON THE PLAINS II, 1917, watercolor on paper, 11⅞ × 8⅞,
Amon Carter Museum, Fort Worth, Texas (exhibited in Washington only)

17 LIGHT COMING ON THE PLAINS III, 1917, watercolor on paper, 11⅞ × 8⅞,
Amon Carter Museum, Fort Worth, Texas (exhibited in Chicago only)

18 STARLIGHT NIGHT, 1917, watercolor on paper, 9×12,
Estate of Georgia O'Keeffe

19　SUNRISE AND LITTLE CLOUDS II, 1916, watercolor on paper, 9 × 12,
Estate of Georgia O'Keeffe

20 CANYON WITH CROWS, 1917, watercolor on paper, 9 × 12,
Estate of Georgia O'Keeffe

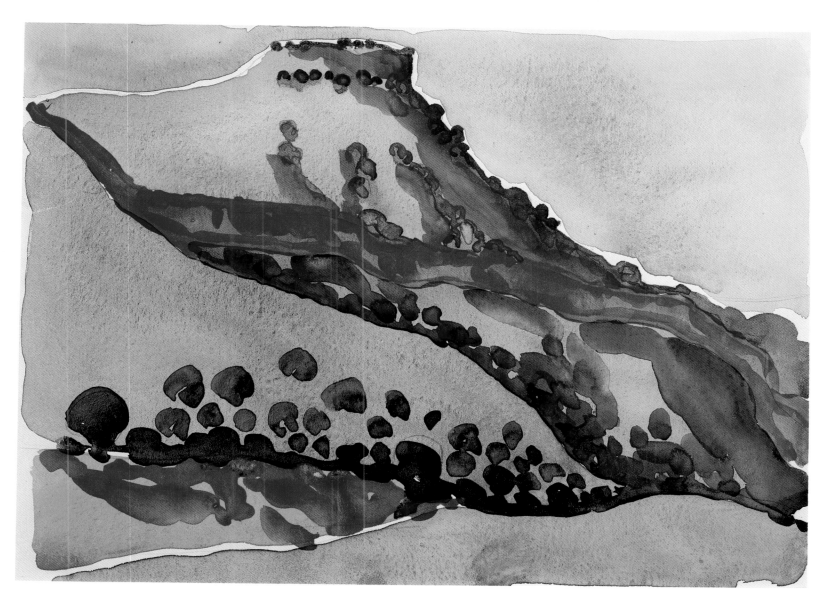

21 RED MESA, 1917, watercolor on paper, 9 × 12, Estate of Georgia O'Keeffe

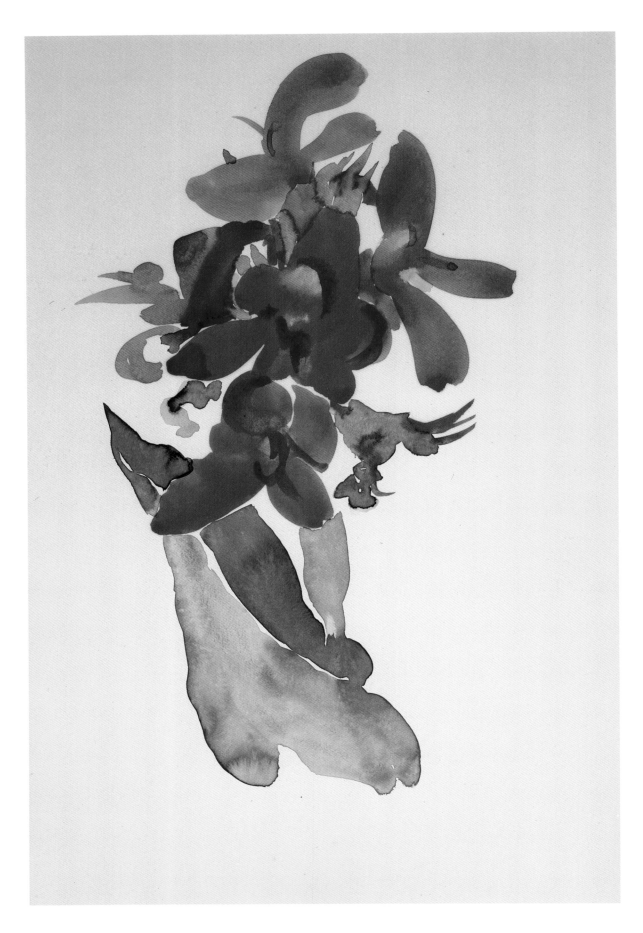

22 RED CANNAS, 1919, watercolor on paper, 19⅜ × 13,
 Mr. and Mrs. James A. Fisher, Pittsburgh, Pennsylvania
 (exhibited in Washington and New York only)

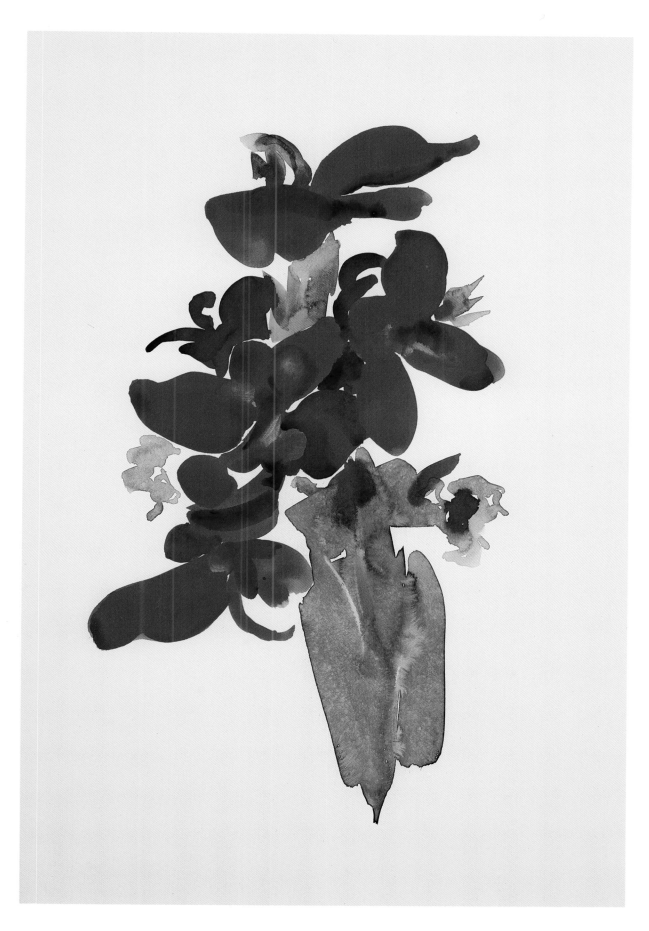

23 RED CANNA, c. 1920, watercolor on paper, 19⅜ × 13,
 Yale University Art Gallery, Gift of George Hopper Fitch, B.A. 1932, and Mrs. Fitch
 (exhibited in Chicago and Dallas only)

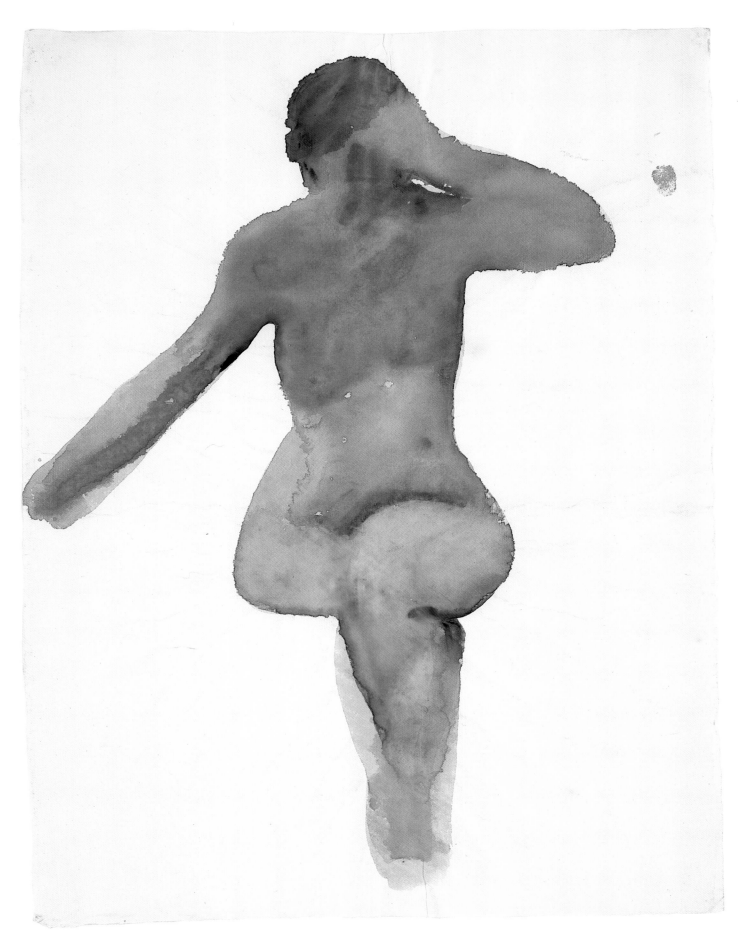

24 NUDE SERIES VIII, 1917, watercolor on paper, 18 × 13½,
Estate of Georgia O'Keeffe

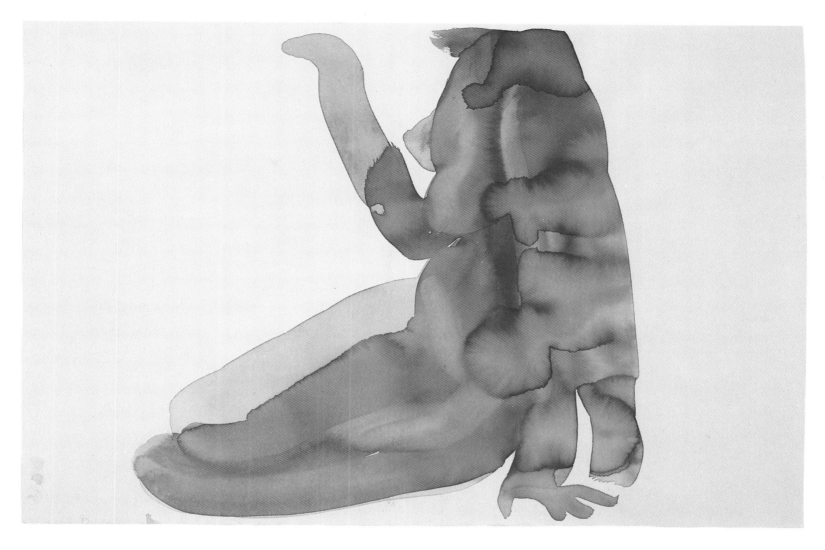

25 NUDE SERIES XII, 1917, watercolor on paper, 12 × 18,
 Estate of Georgia O'Keeffe

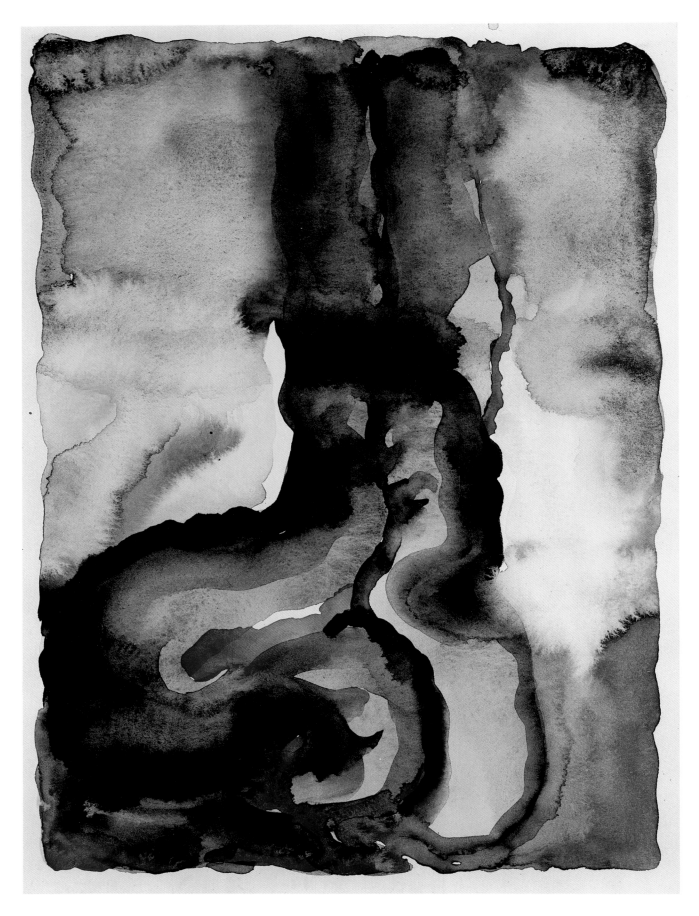

26 PORTRAIT-W-NO. III, 1917, watercolor on paper, 12 × 9,
Estate of Georgia O'Keeffe

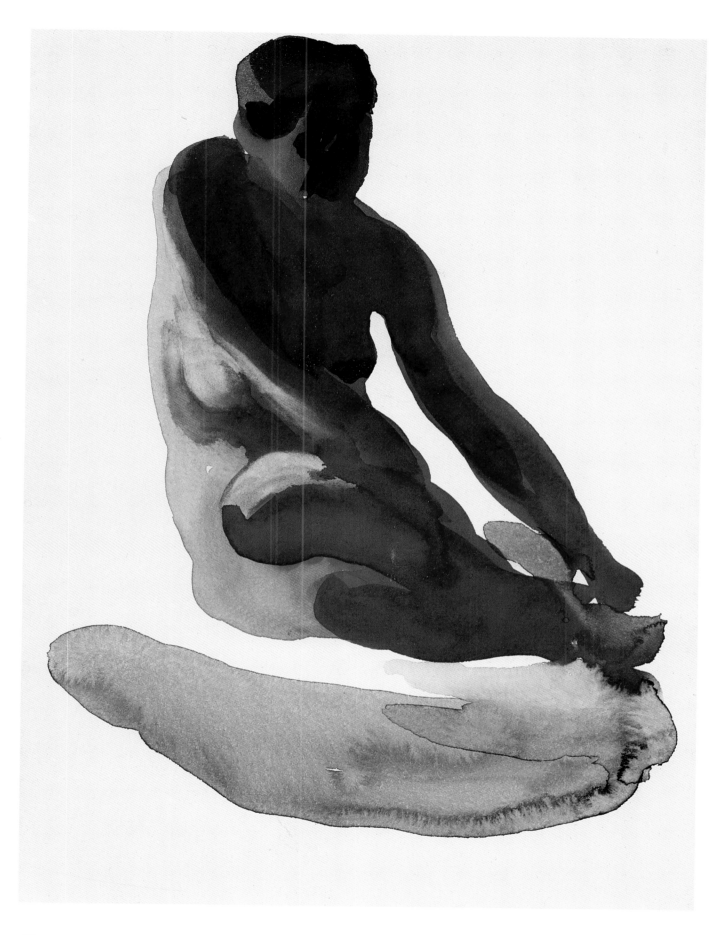

27 NUDE SERIES, 1917, watercolor on paper, 12 × 8⅞,
Estate of Georgia O'Keeffe

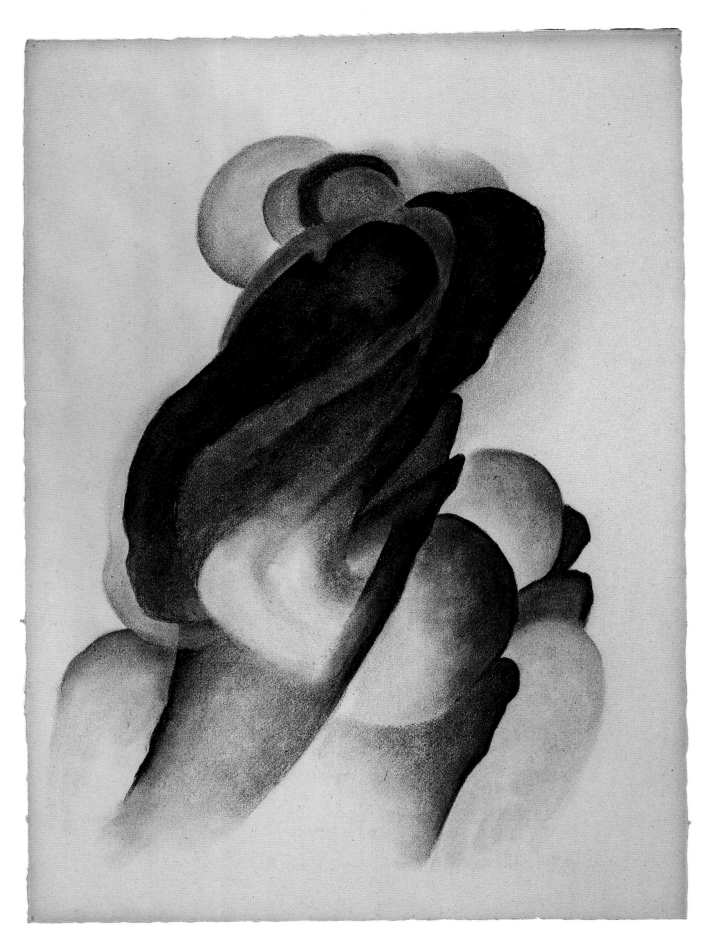

28 SPECIAL NO. 16, 1918, charcoal on paper, 24½ × 17¾,
Estate of Georgia O'Keeffe

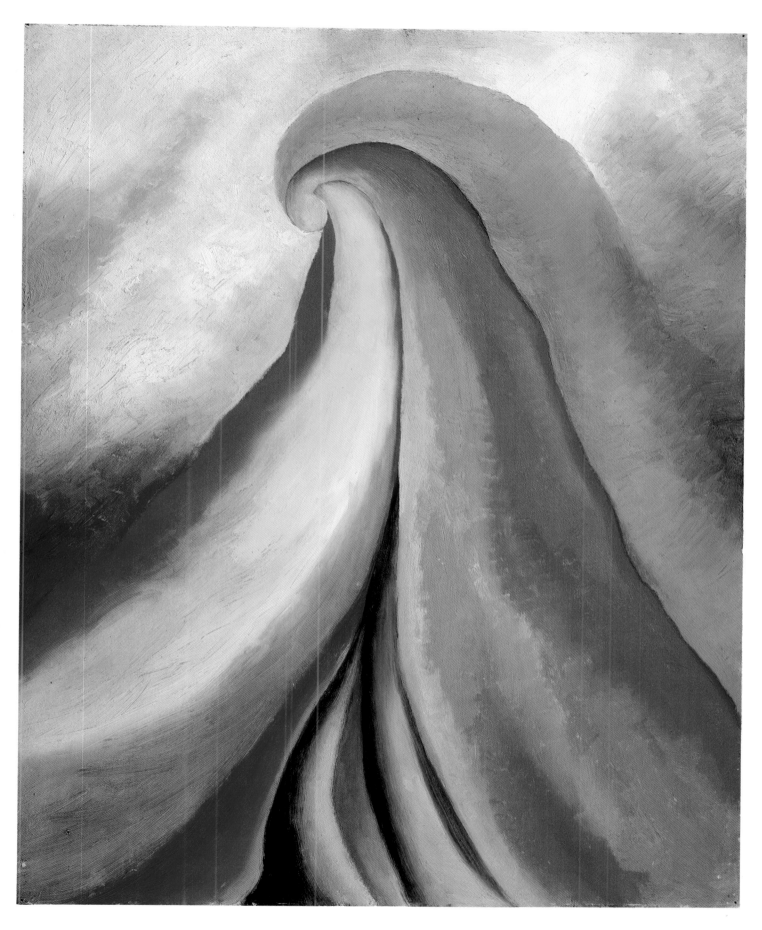

29 SERIES I, NO. 4, 1918, oil on canvas, 20 × 16,
Estate of Georgia O'Keeffe

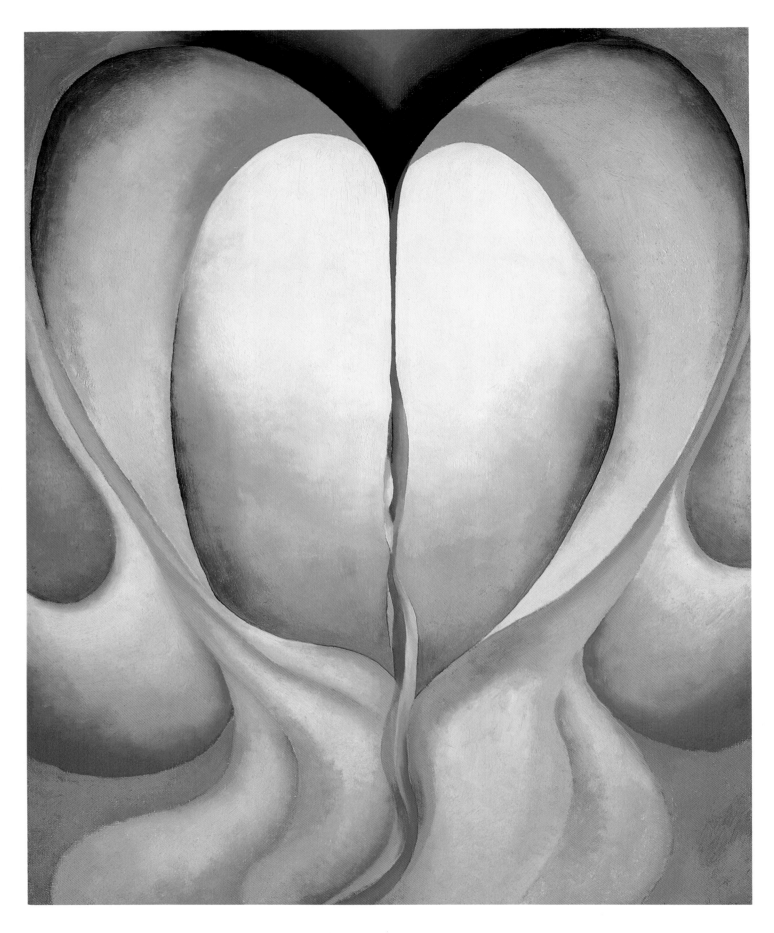

30 SERIES I, NO. 8, 1919, oil on canvas, 20 × 16,
Estate of Georgia O'Keeffe

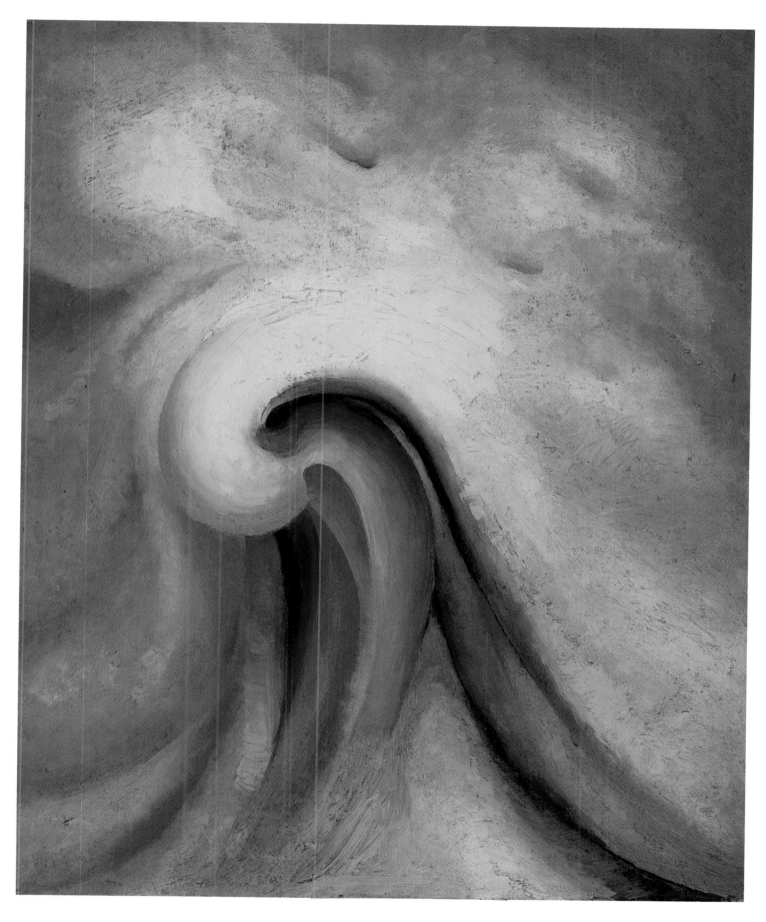

31　SERIES I, NO. I, 1918, oil on canvas, 20 × 16,
　　American National Bank

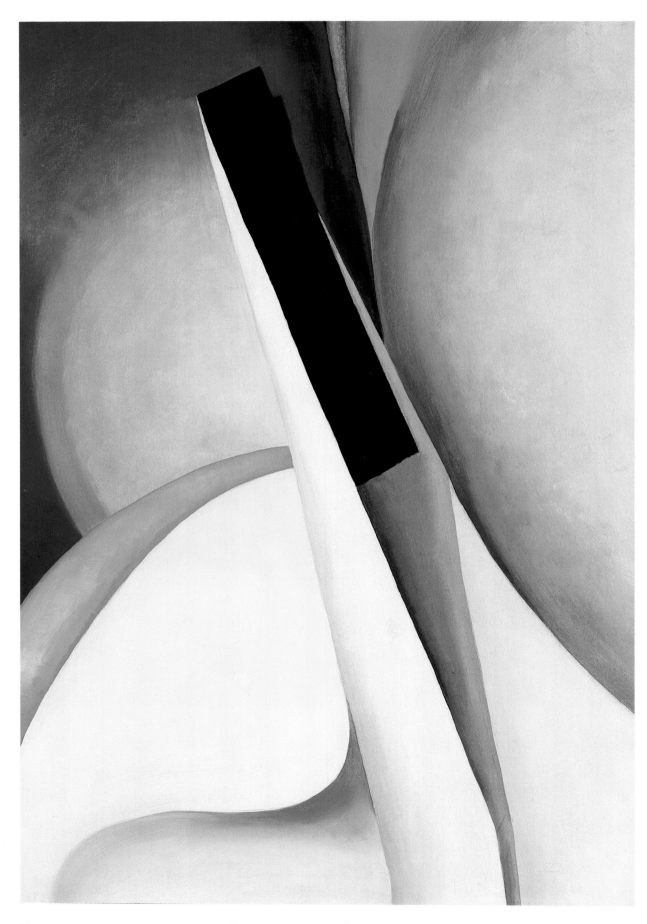

32　BLACK SPOT NO. 2, 1919, oil on canvas, 24 × 16,
　　Collection Loretta and Robert K. Lifton

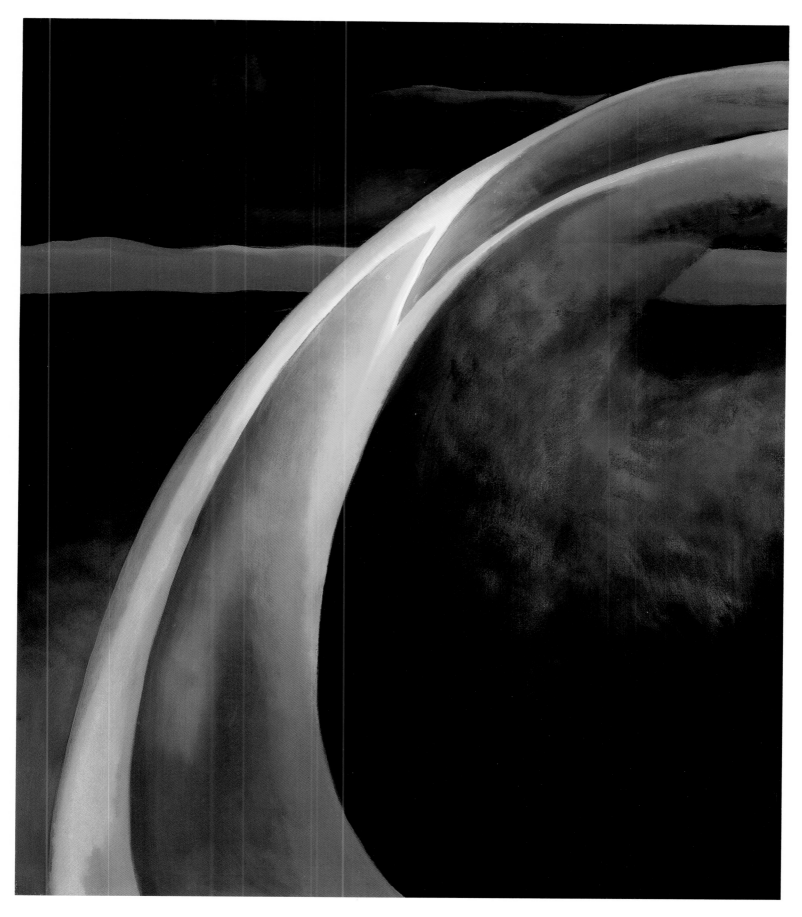

33 RED AND ORANGE STREAK, 1919, oil on canvas, 27 × 23,
Estate of Georgia O'Keeffe

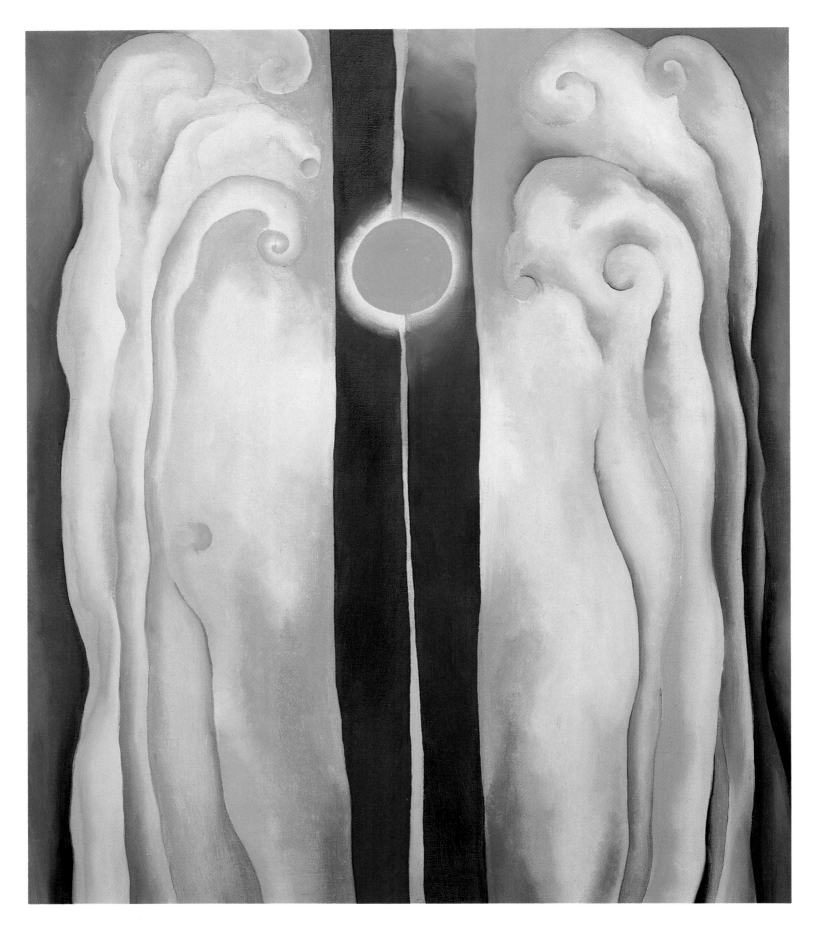

34 PINK MOON AND BLUE LINES, 1923, oil on canvas, 26×22,
Janet and Robert Kardon

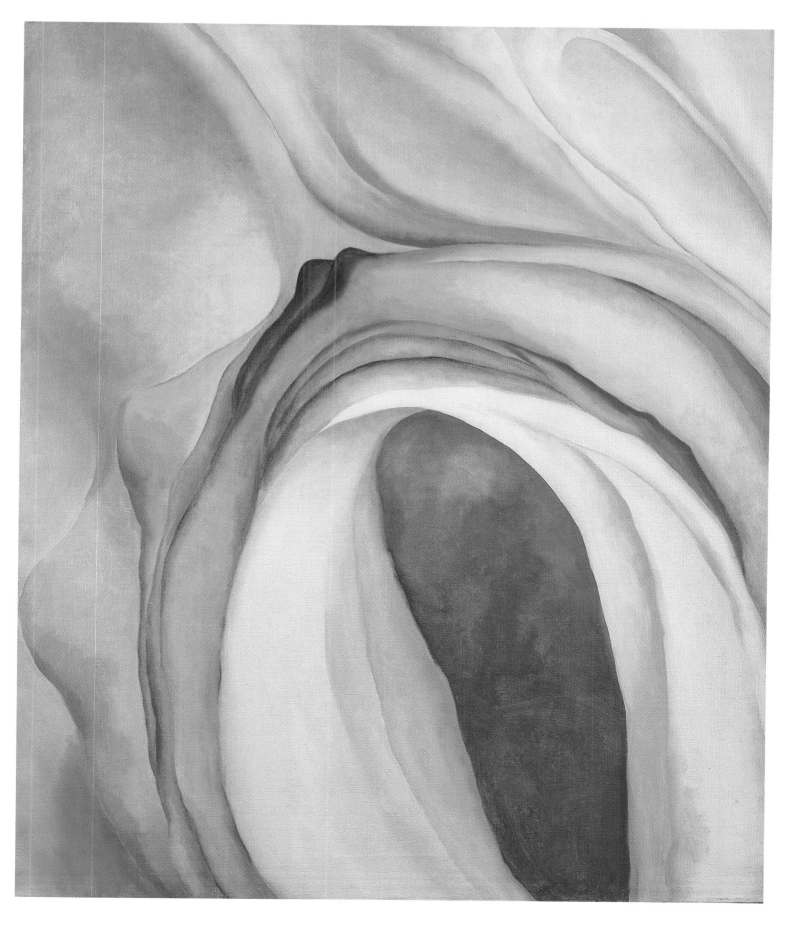

35 MUSIC — PINK AND BLUE, II, 1919, oil on canvas, 35½ × 29,
Emily Fisher Landau

36 GRAPES ON WHITE DISH — DARK RIM, 1920, oil on canvas, 9 × 10,
Mr. and Mrs. J. Carrington Woolley

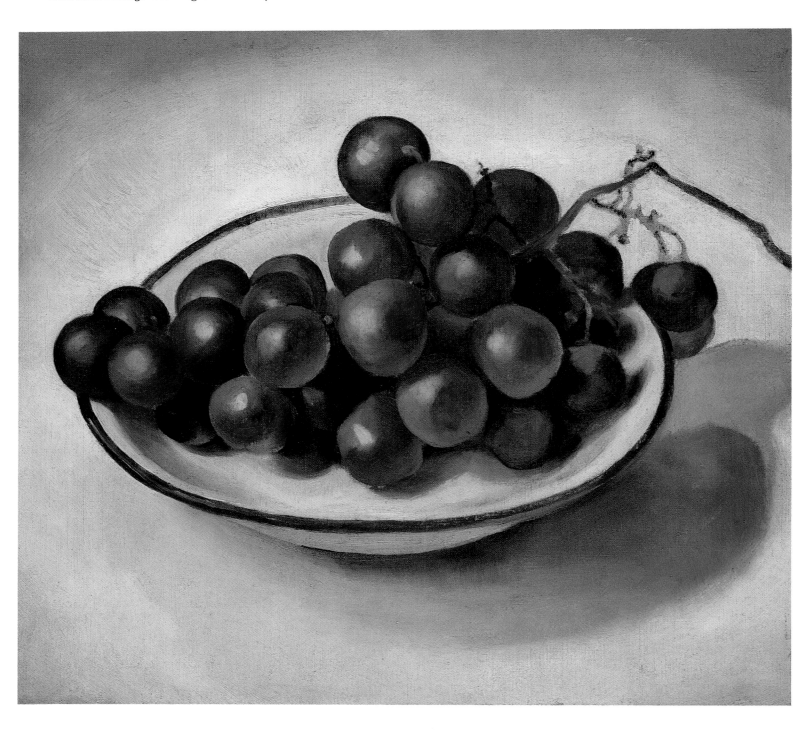

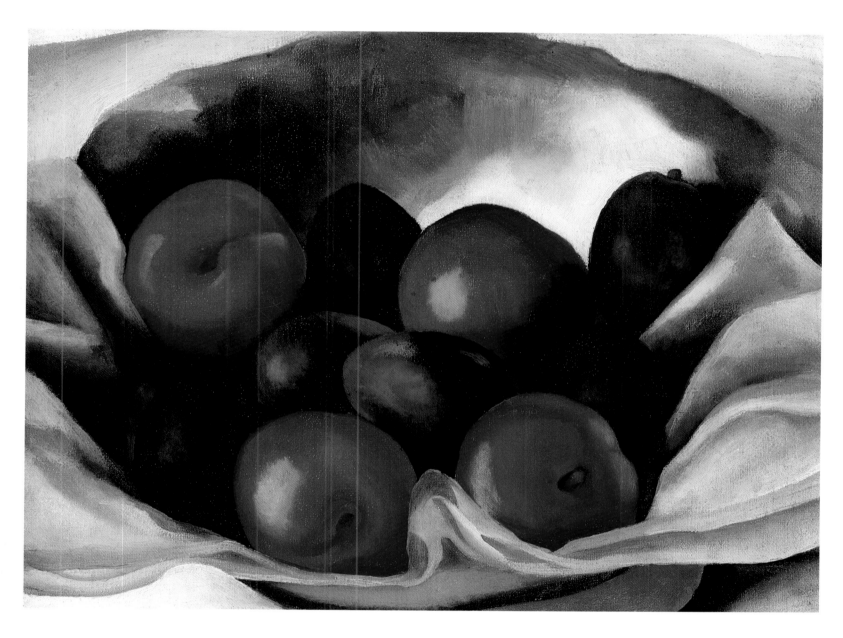

37 PLUMS, 1920, oil on canvas, 9 × 12,
Collection of Paul and Tina Schmid

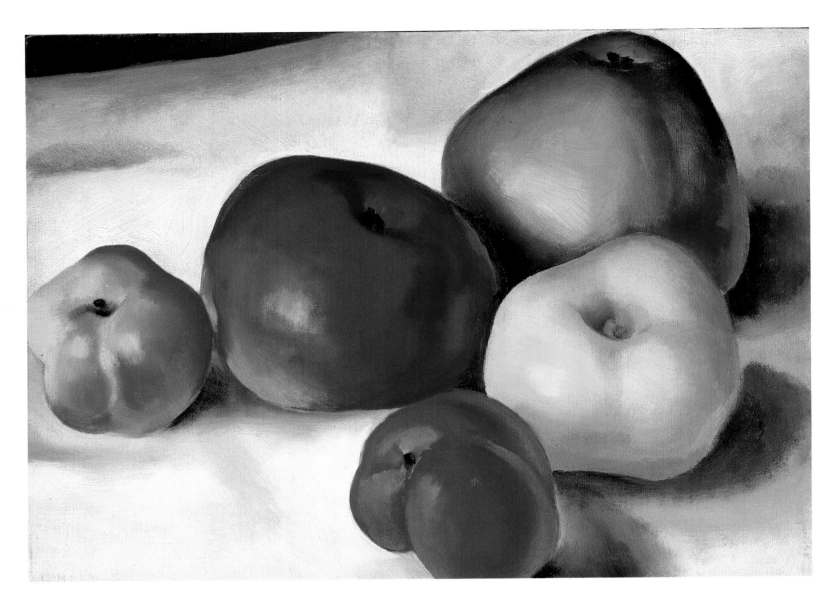

38　APPLE FAMILY III, 1921, oil on canvas, 8 × 11,
Estate of Georgia O'Keeffe

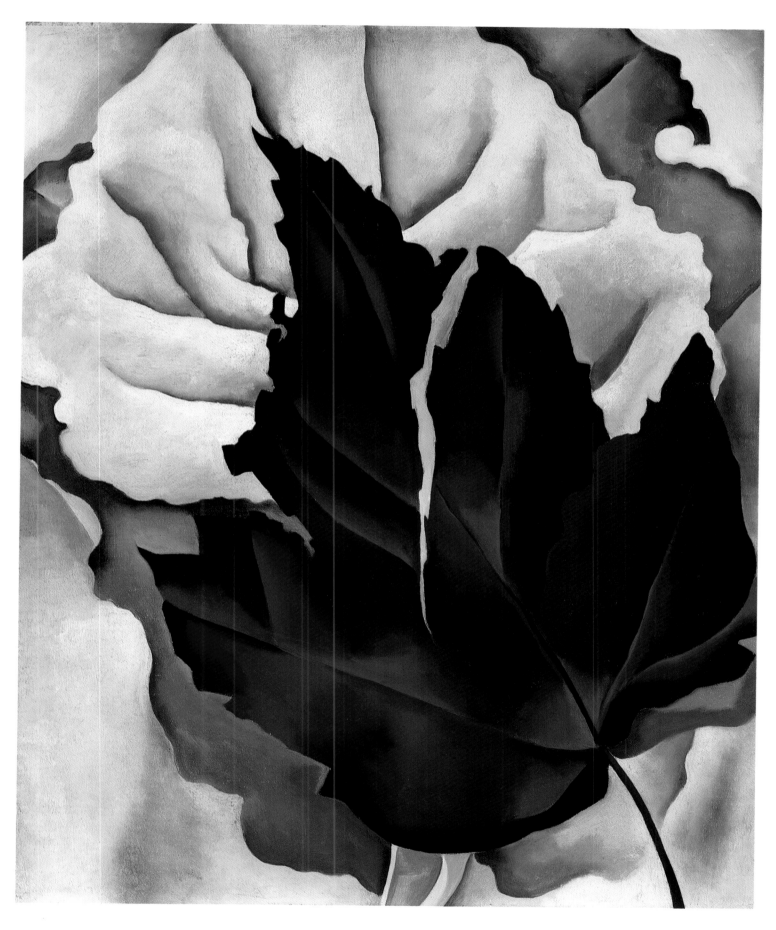

39 PATTERN OF LEAVES, c. 1923, oil on canvas, 21⅛ × 18⅛,
The Phillips Collection, Washington, D.C.

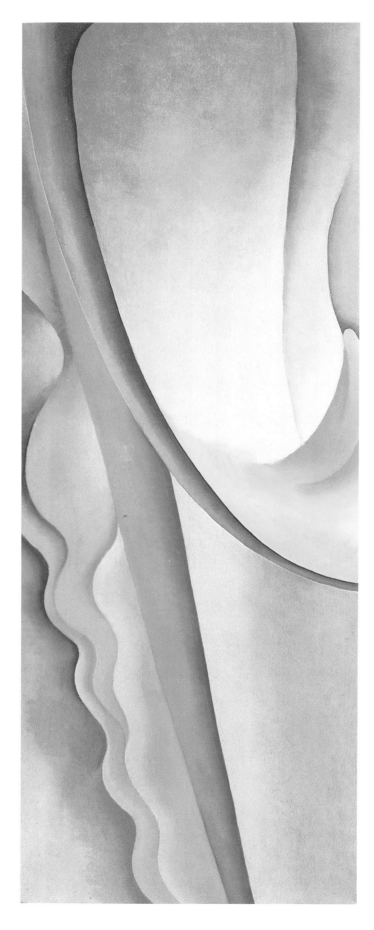

40 ABSTRACTION NO. 77 (TULIP), 1925,
oil on canvas, 32 × 12, Emily Fisher Landau

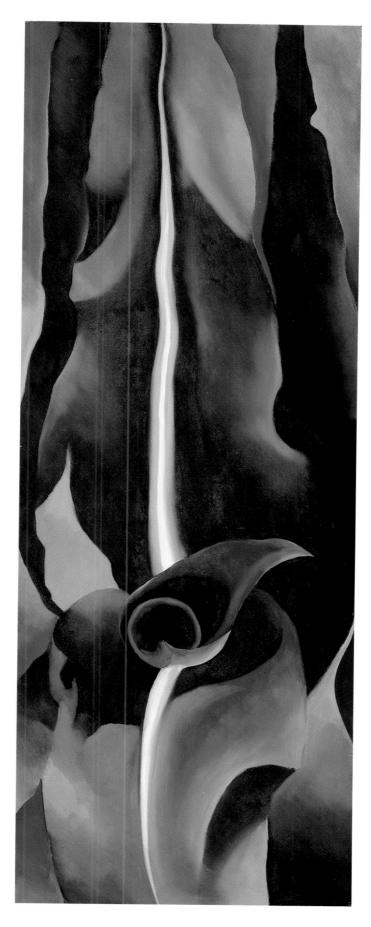

41 CORN, DARK I, 1924, oil on composition board,
 31¾ × 11⅞, The Metropolitan Museum of Art,
 Alfred Stieglitz Collection, 1950

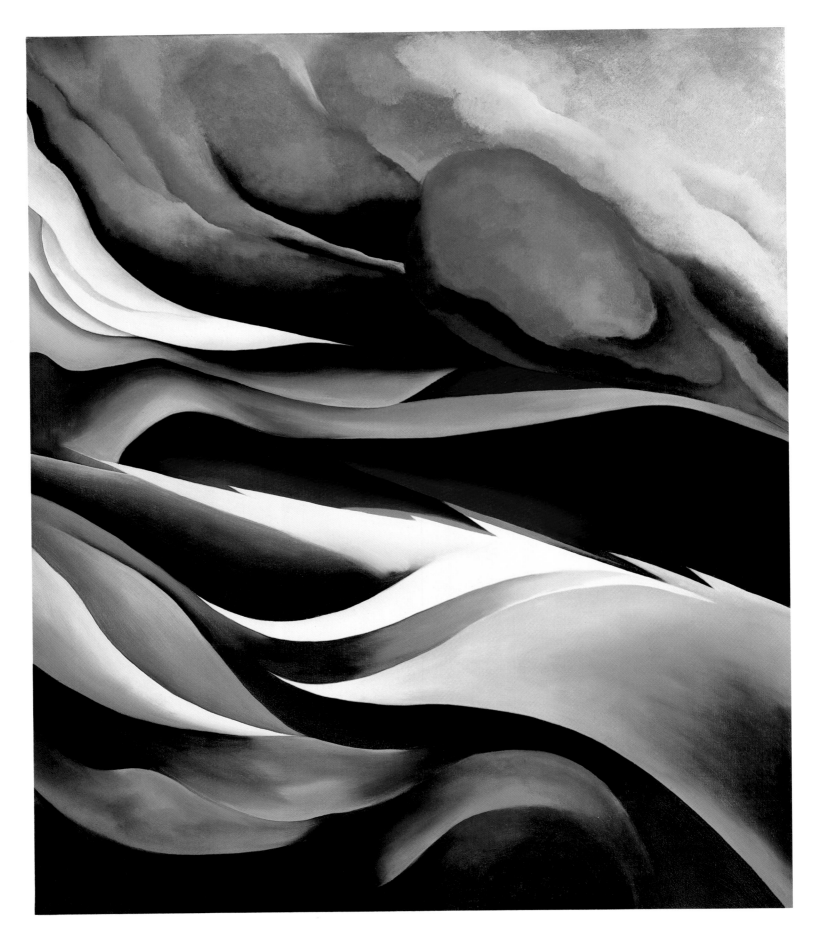

42 FROM THE LAKE NO. 1, 1924, oil on canvas, 37⅛ × 31,
Des Moines Art Center, Coffin Fine Arts Trust Fund

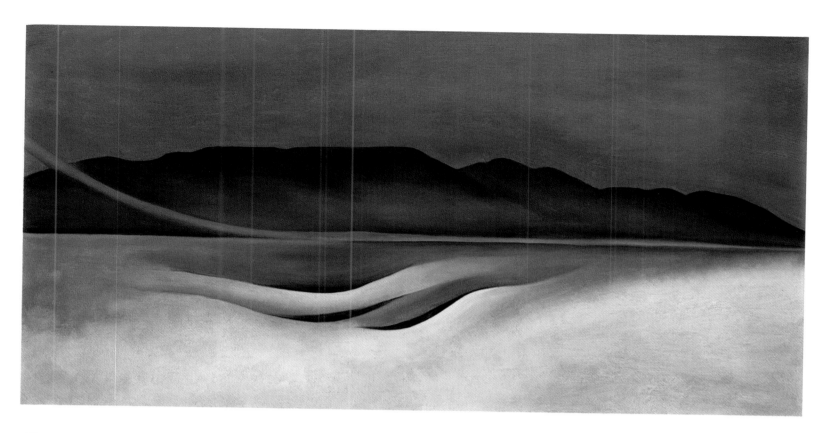

43 LAKE GEORGE, 1924, oil on canvas, 18×35,
 Collection of James and Barbara Palmer

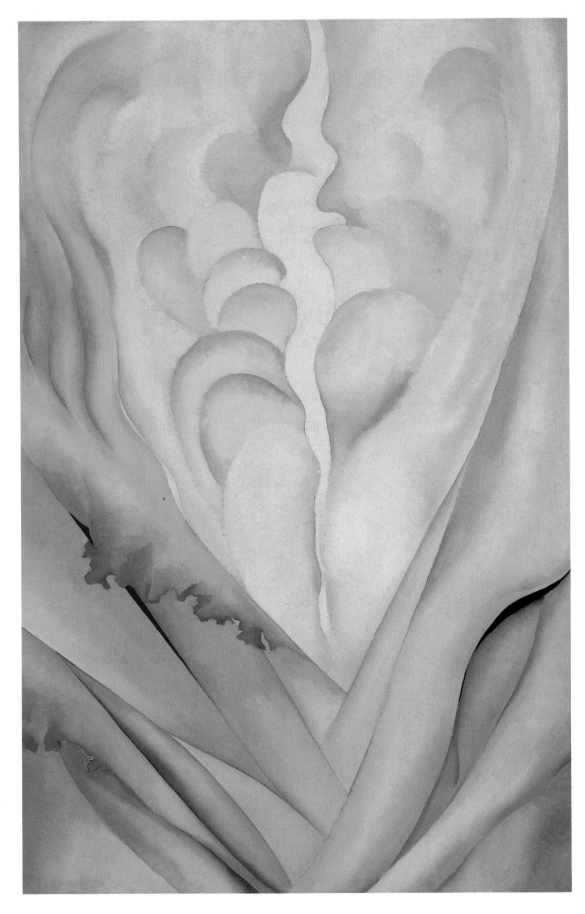

44 FLOWER ABSTRACTION, 1924, oil on canvas, 48 × 30,
 Lent by the Whitney Museum of American Art, New York;
 50th Anniversary Gift of Sandra Payson, 85.47

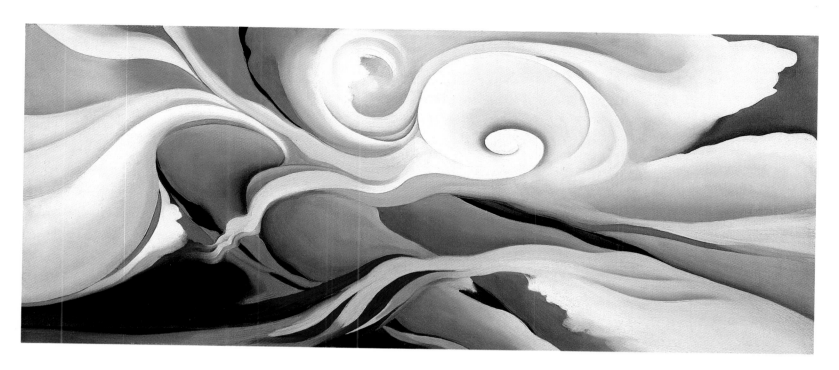

45 NATURE FORMS, GASPÉ, 1932, oil on canvas, 10×24,
 Estate of Georgia O'Keeffe

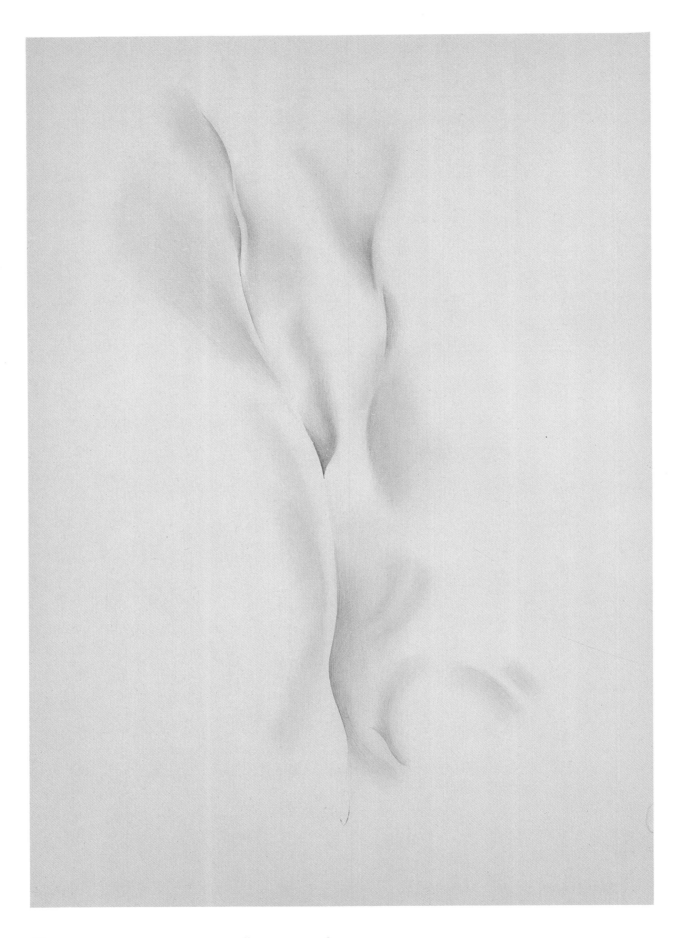

46 SPECIAL NO. 40, 1934, pencil on paper, 16 × 11,
Estate of Georgia O'Keeffe

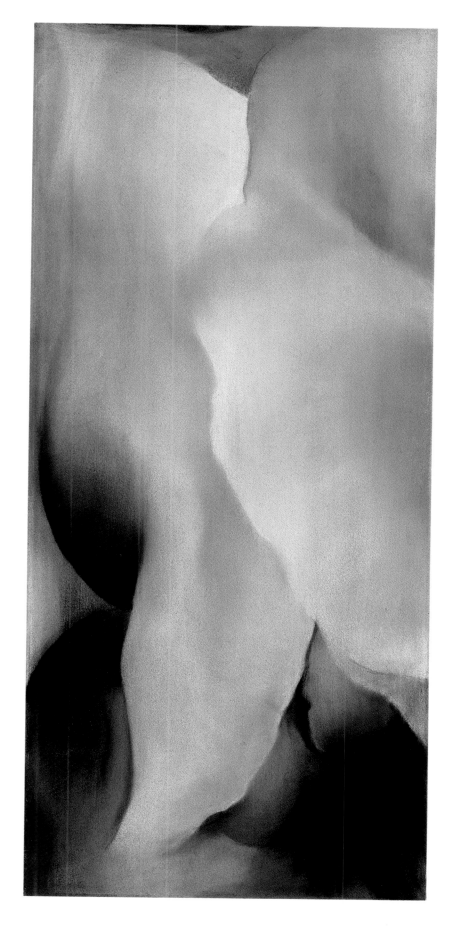

47 DARK IRIS NO. 3, 1927, pastel on paper-covered board, 20×9,
Estate of Georgia O'Keeffe

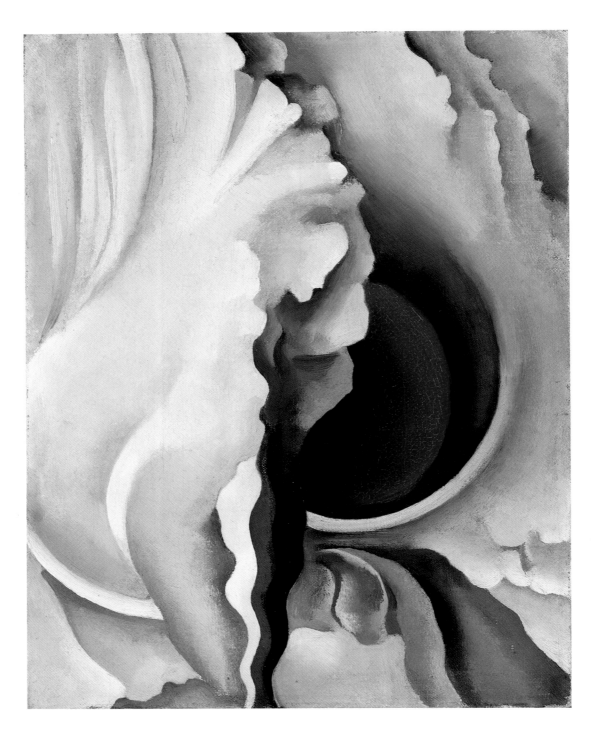

48 THE DARK IRIS NO. II, 1926, oil on canvas, 9 × 7,
Washburn Gallery, New York

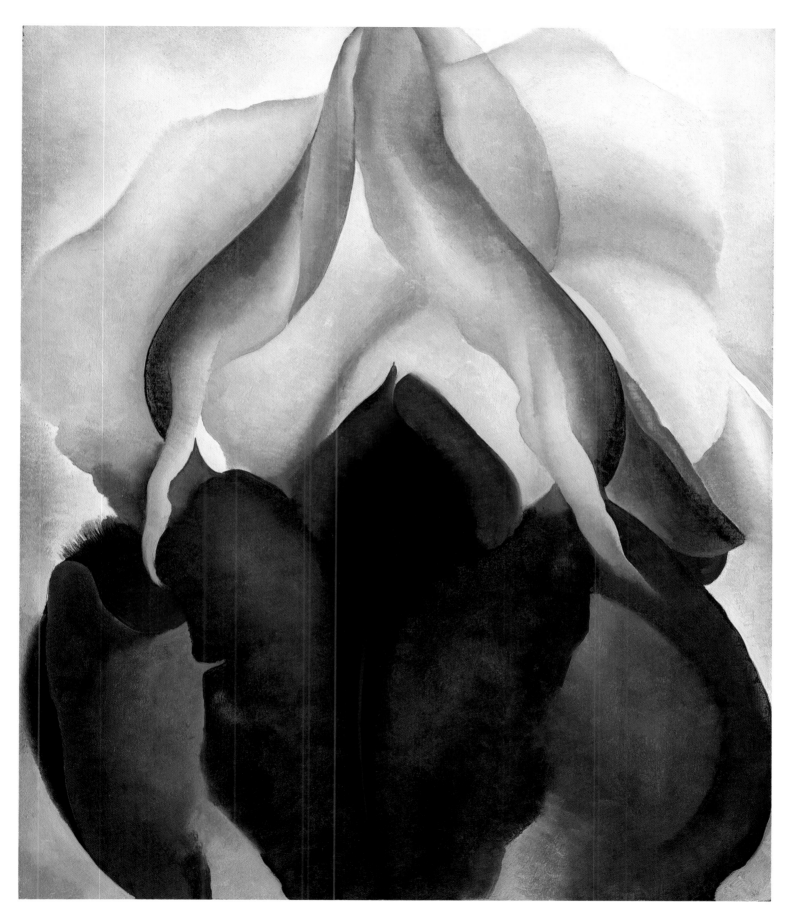

49 BLACK IRIS III, 1926, oil on canvas, 36 × 29⅞,
The Metropolitan Museum of Art, Alfred Stieglitz Collection, 1969

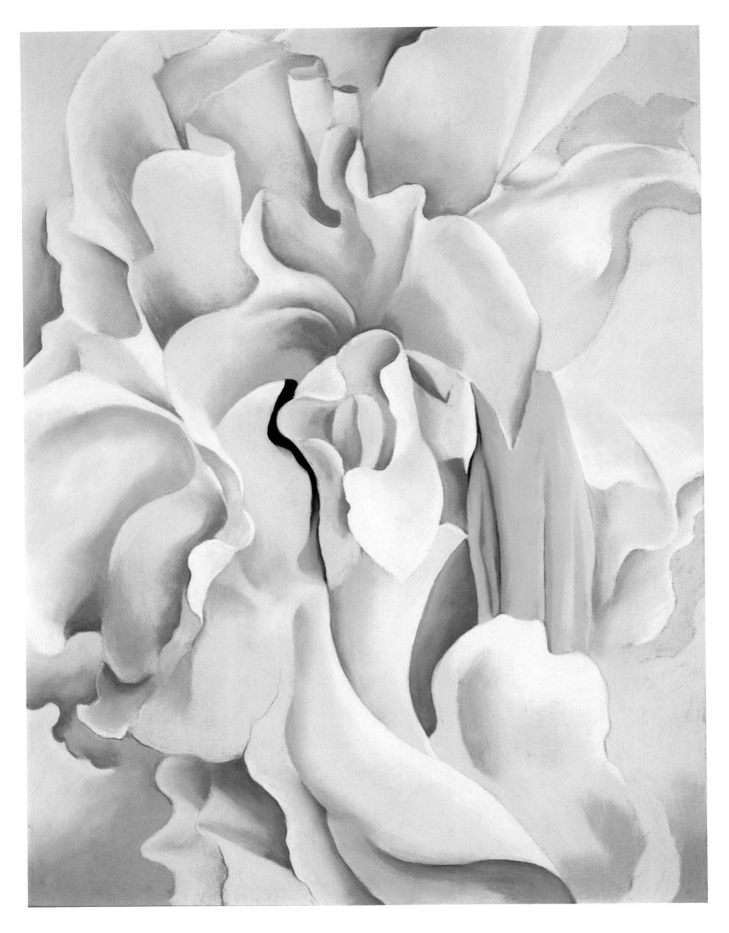

50 WHITE SWEET PEAS, 1926, pastel on paper, 25 × 19,
Collection Loretta and Robert K. Lifton

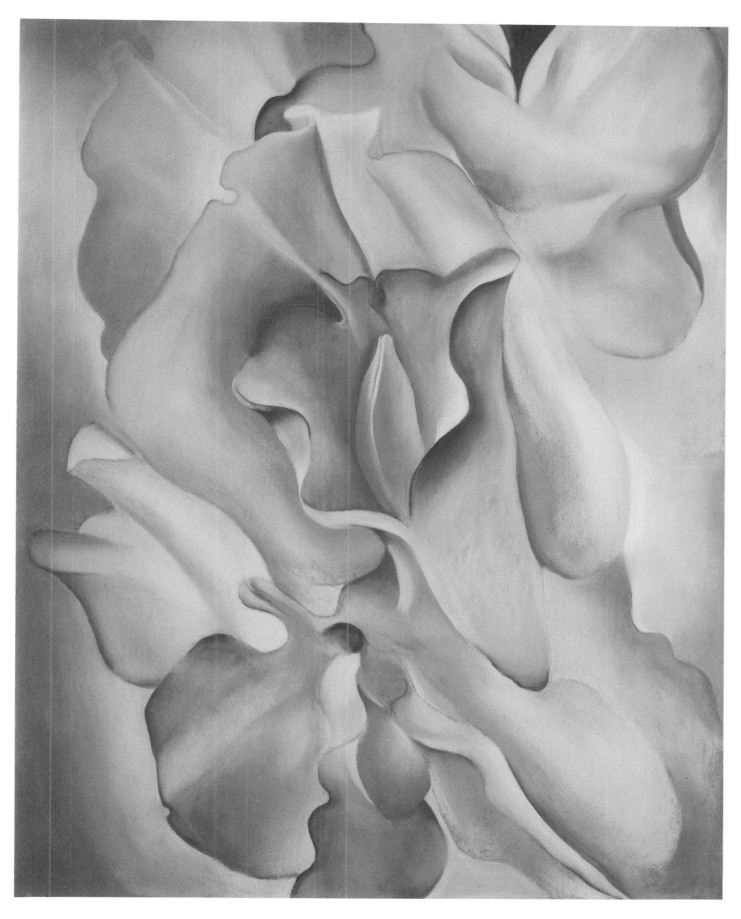

51 PINK SWEET PEAS, 1927, pastel on paper, 28×21,
 Warren and Jane Shapleigh (exhibited in Washington and Chicago only)

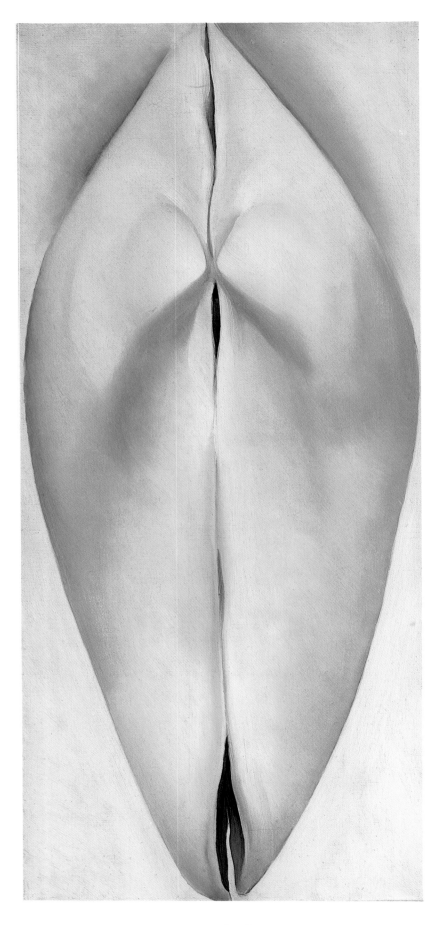

52 CLOSED CLAM SHELL, 1926, oil on canvas, 20 × 9,
Private Collection

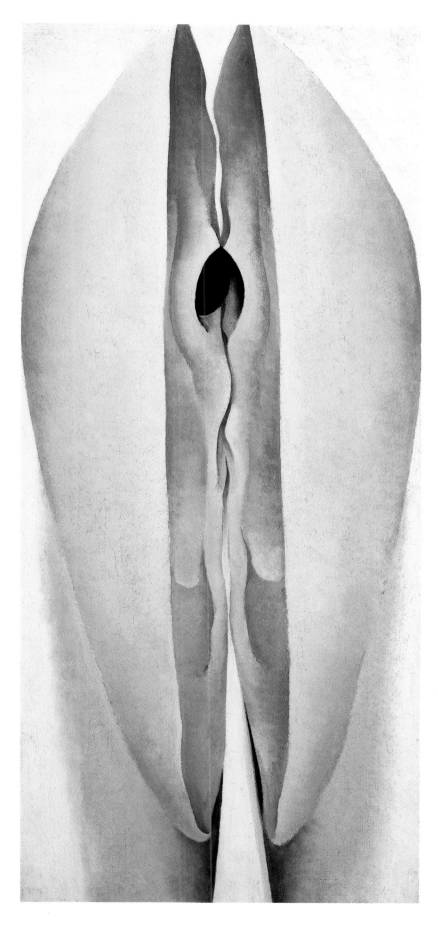

53 OPEN CLAM SHELL, 1926, oil on canvas, 20 × 9,
Private Collection

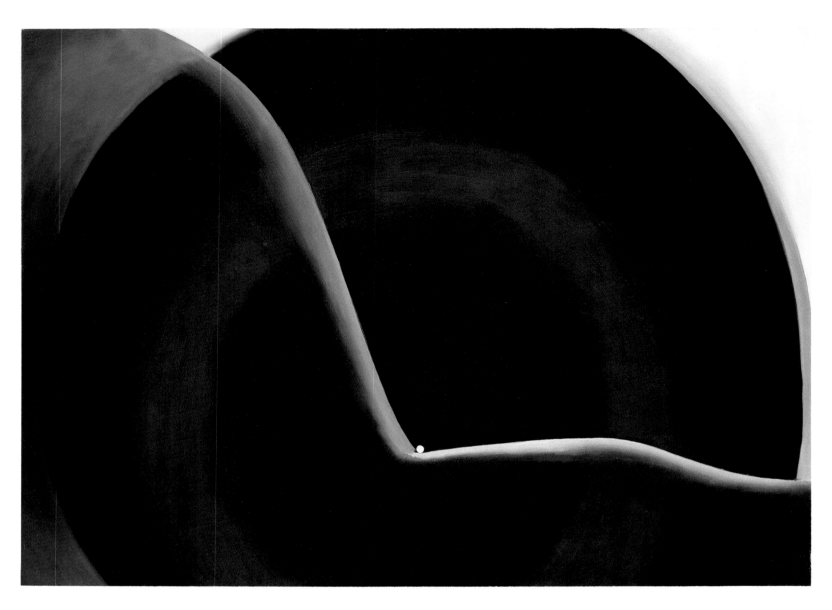

54 BLACK ABSTRACTION, 1927, oil on canvas, 30 × 40¼,
The Metropolitan Museum of Art, Alfred Stieglitz Collection, 1969

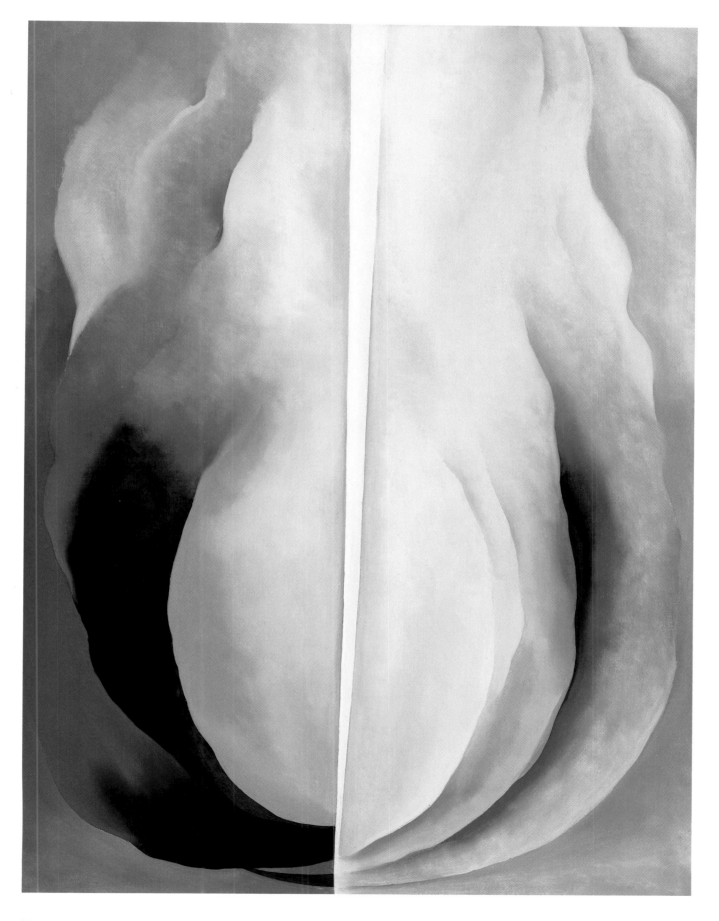

55 ABSTRACTION, BLUE, 1927, oil on canvas, 40¼ × 30,
The Museum of Modern Art, New York, Acquired through the Helen Acheson Bequest, 1979

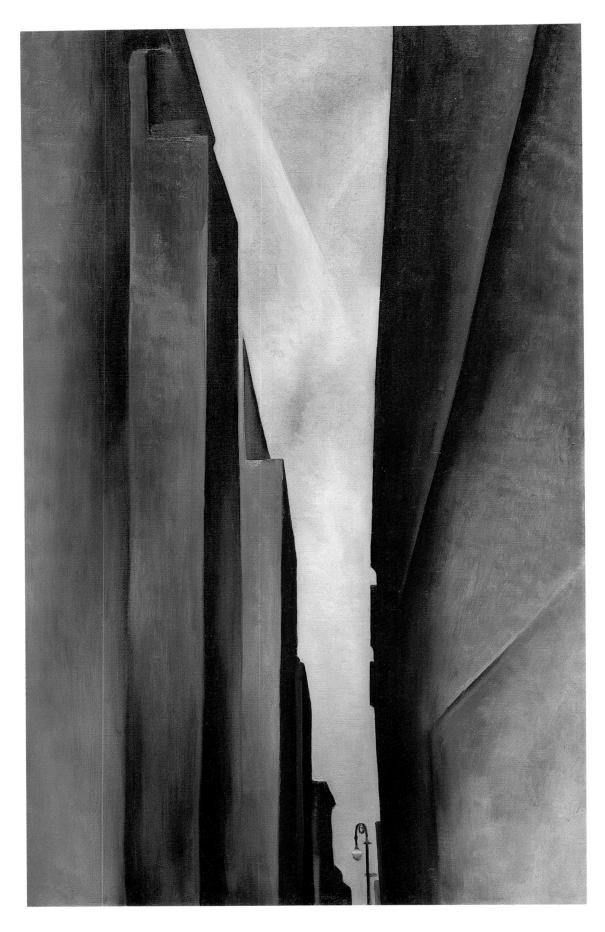

56　STREET, NEW YORK NO. 1, 1926, oil on canvas, 48⅛ × 29⅞,
Mr. and Mrs. Harry W. Anderson

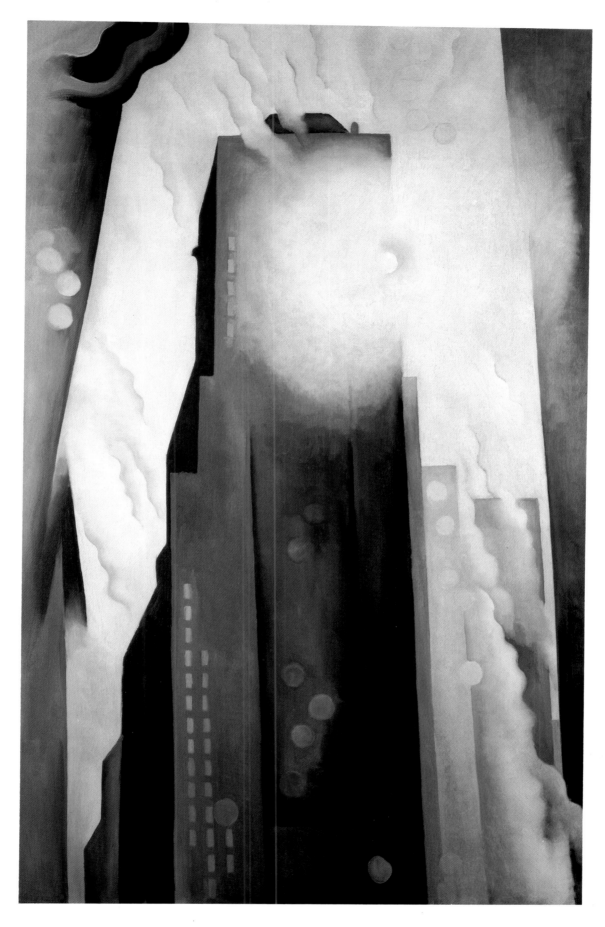

57 THE SHELTON WITH SUNSPOTS, 1926, oil on canvas, 49×31,
The Art Institute of Chicago, Gift of Leigh B. Block

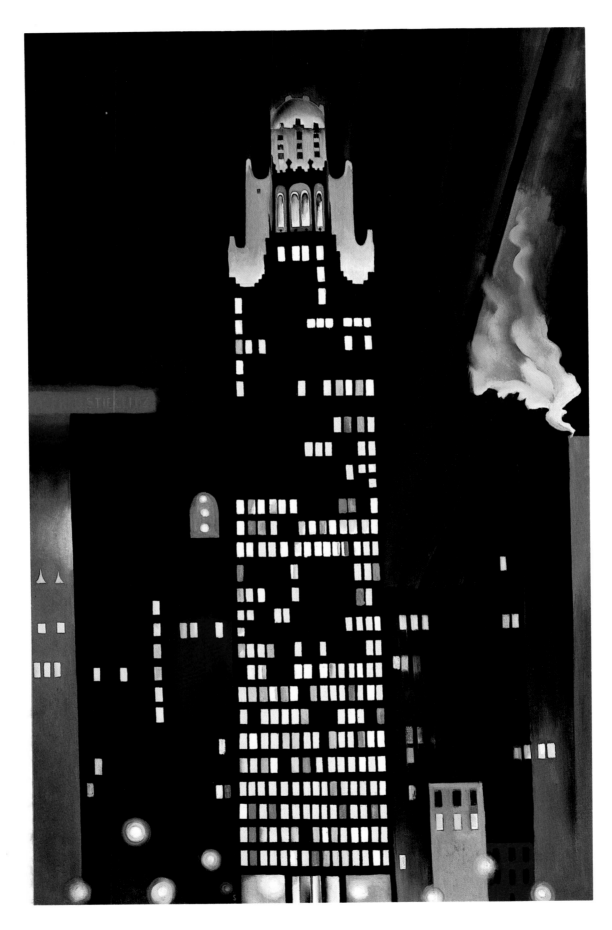

58 RADIATOR BUILDING — NIGHT, NEW YORK, 1927, oil on canvas, 48 × 30,
Alfred Stieglitz Collection, Carl van Vechten Gallery of Fine Arts at Fisk University

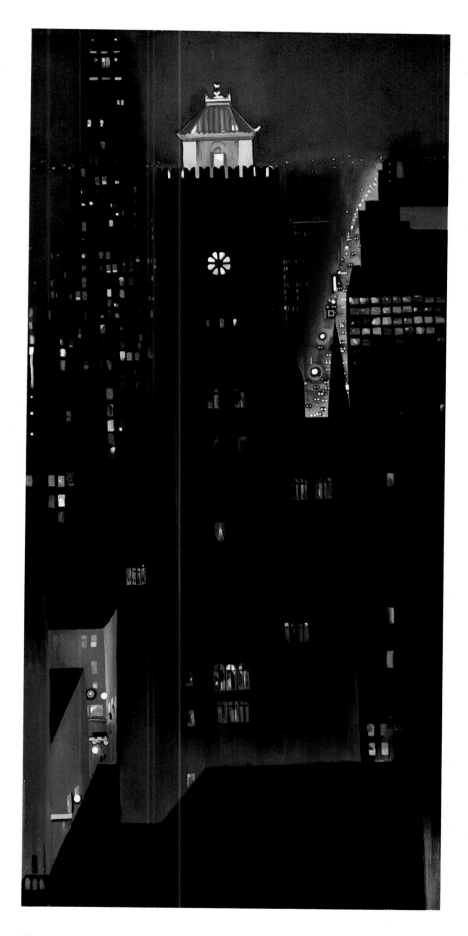

59 NEW YORK, NIGHT, 1929, oil on canvas, 40 × 19,
Nebraska Art Association, Thomas C. Woods Collection,
Courtesy of Sheldon Memorial Art Gallery, University of
Nebraska-Lincoln (not exhibited in Washington)

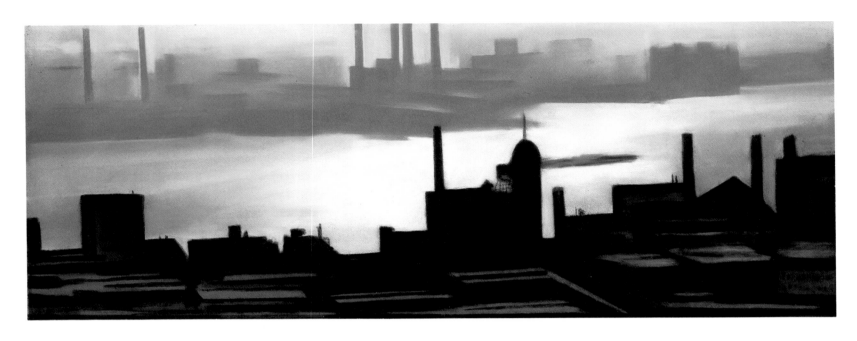

60 EAST RIVER, NEW YORK, NO. 2, 1927, pastel on paper, 10¾ × 28,
Private Collection (exhibited in Washington and New York only)

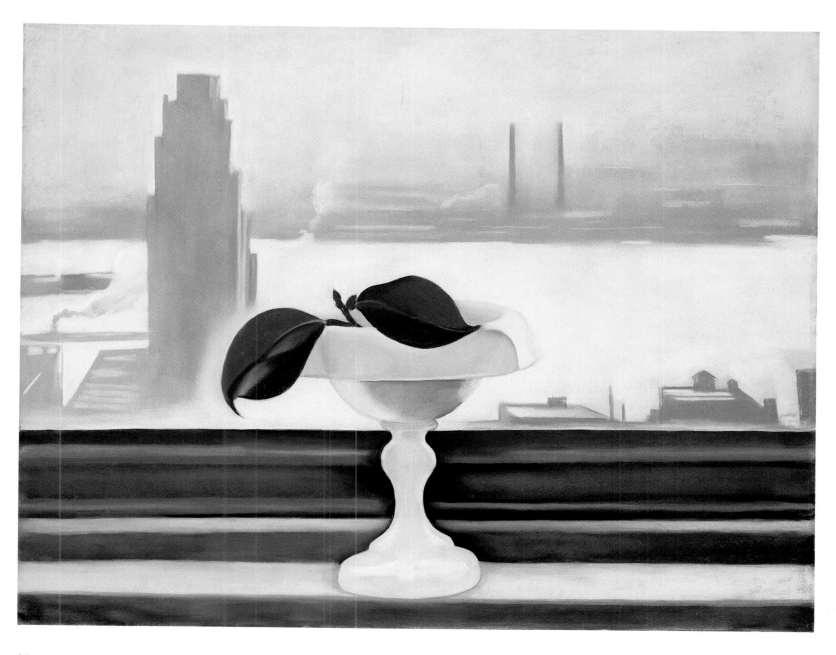

61 EAST RIVER FROM THE SHELTON, 1928, pastel on paper-covered board, 21½ × 27¾,
Estate of Georgia O'Keeffe

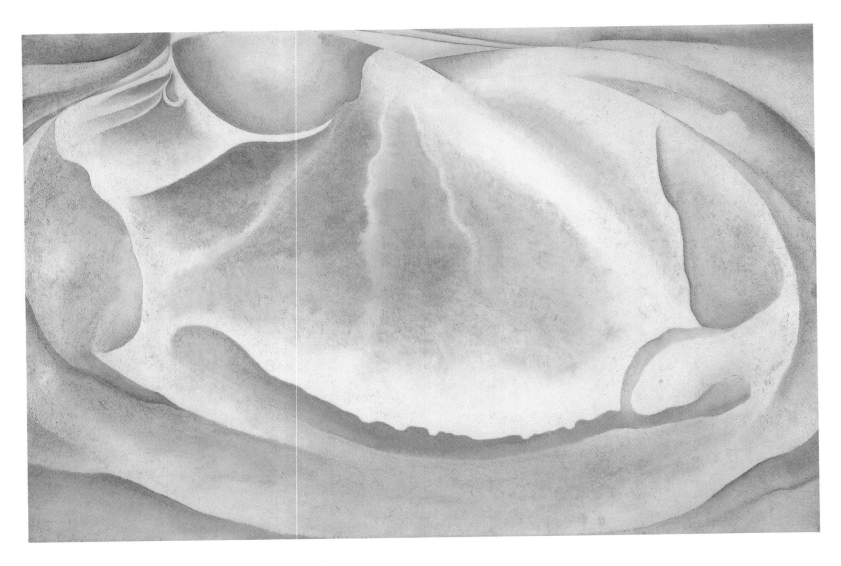

62 FROM A SHELL, 1930, oil on canvas, 24 × 36,
 Nancy Ellison and Jerome Hellman

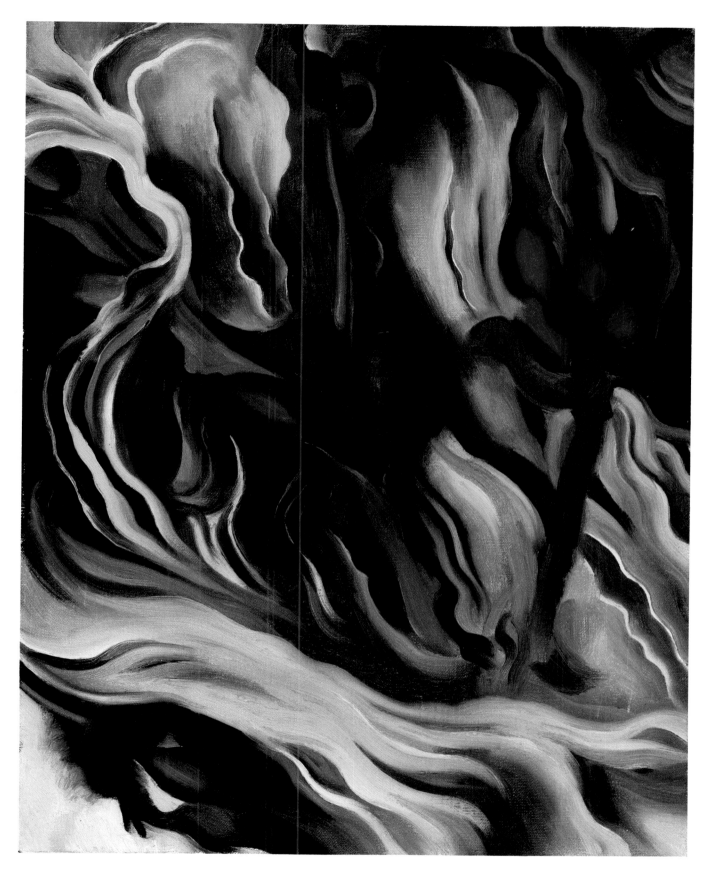

63 SEAWEED, 1927, oil on canvas, 9 × 7,
Estate of Georgia O'Keeffe

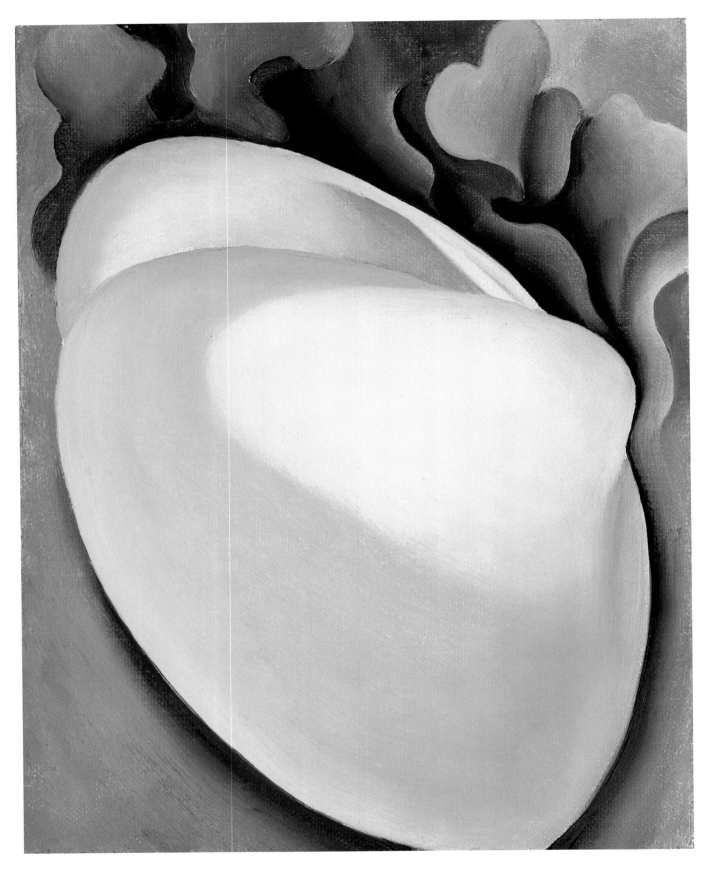

64 TAN CLAM WITH SEAWEED, 1926, oil on canvas, 9 × 7,
Estate of Georgia O'Keeffe

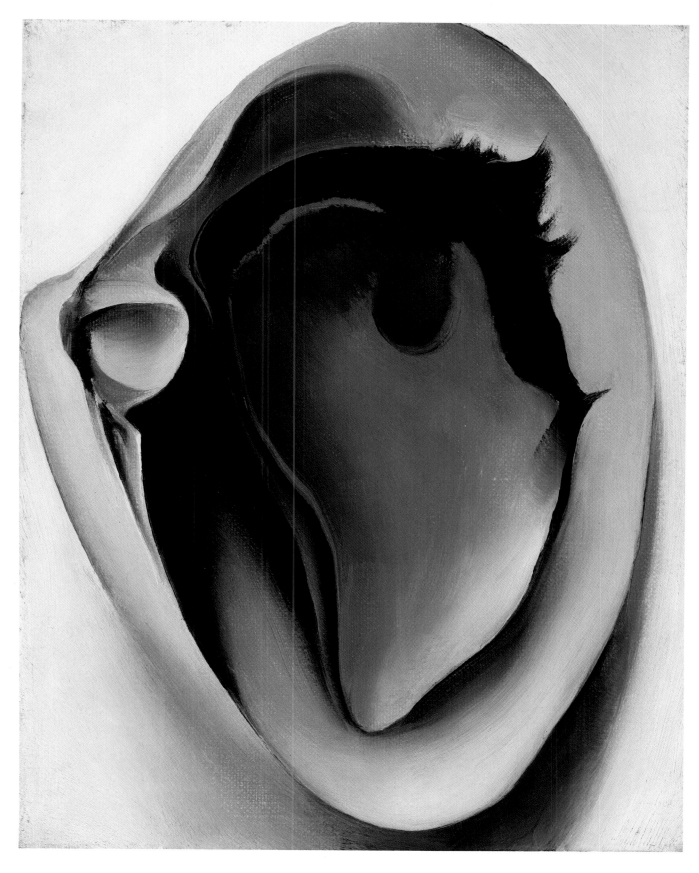

65 CLAM AND MUSSEL, 1926, oil on canvas, 9 × 7,
Estate of Georgia O'Keeffe

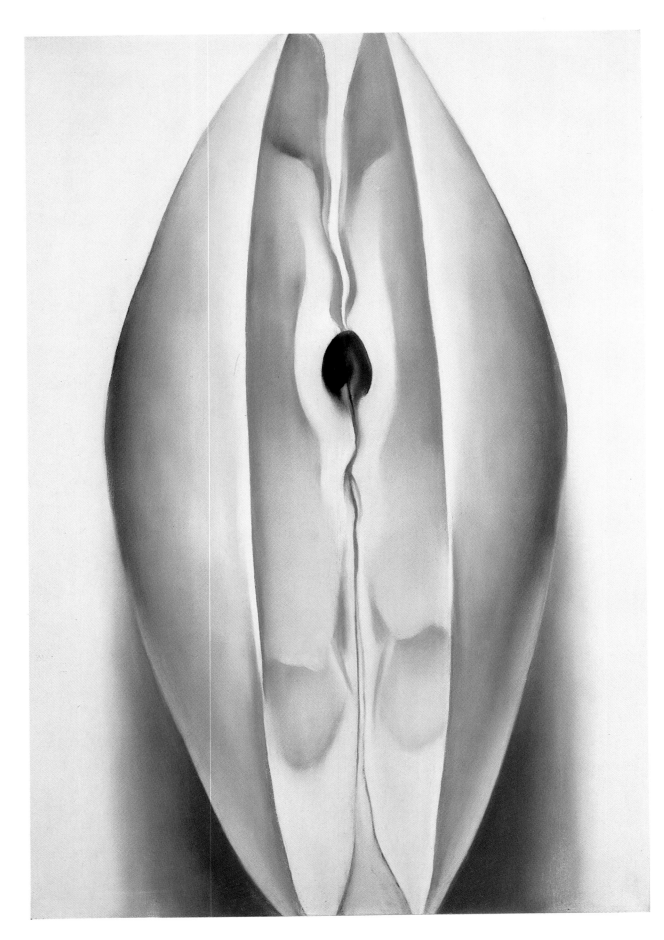

66 SLIGHTLY OPEN SHELL, 1926, pastel on paper, 18½ × 12¾,
Private Collection, New York

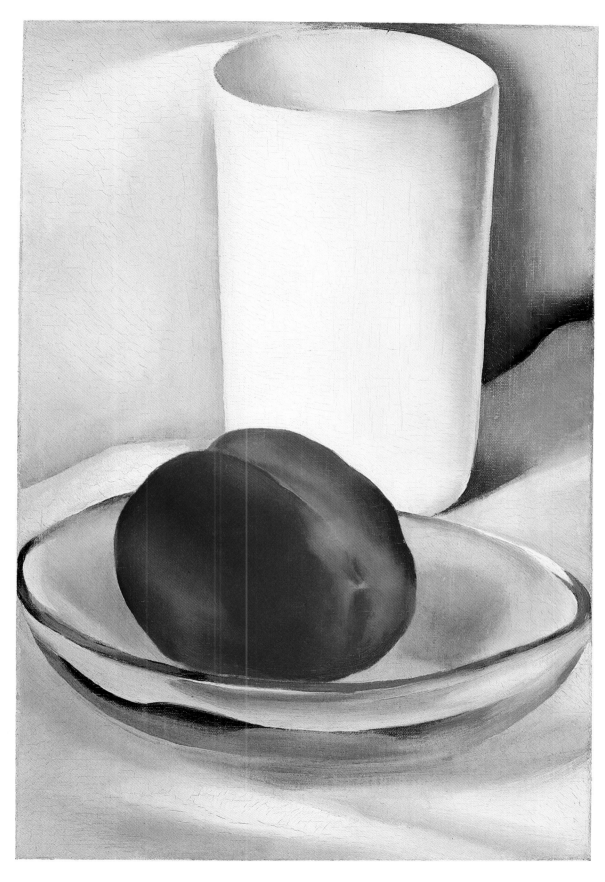

67 PEACH AND GLASS, 1927, oil on canvas, 9×6,
Philadelphia Museum of Art, Gift of Dr. Herman Lorber

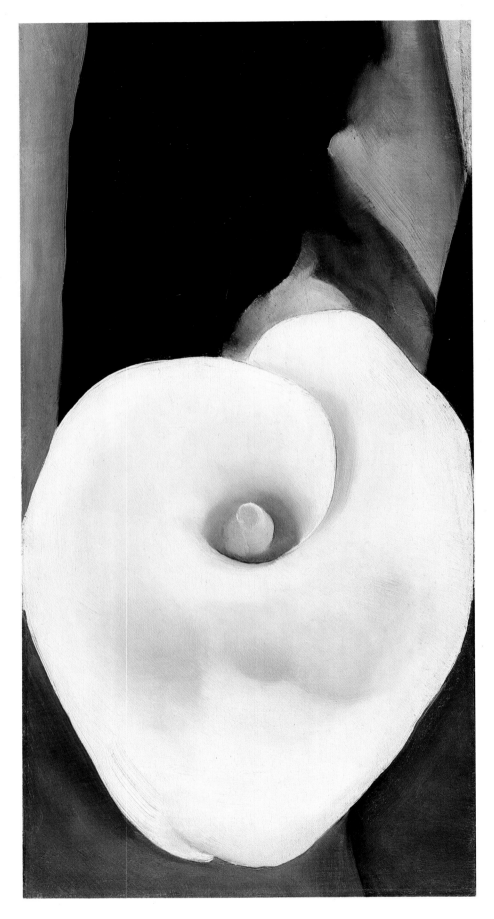

68 LILY — WHITE WITH BLACK, 1927, oil on board, 12×6,
Estate of Georgia O'Keeffe

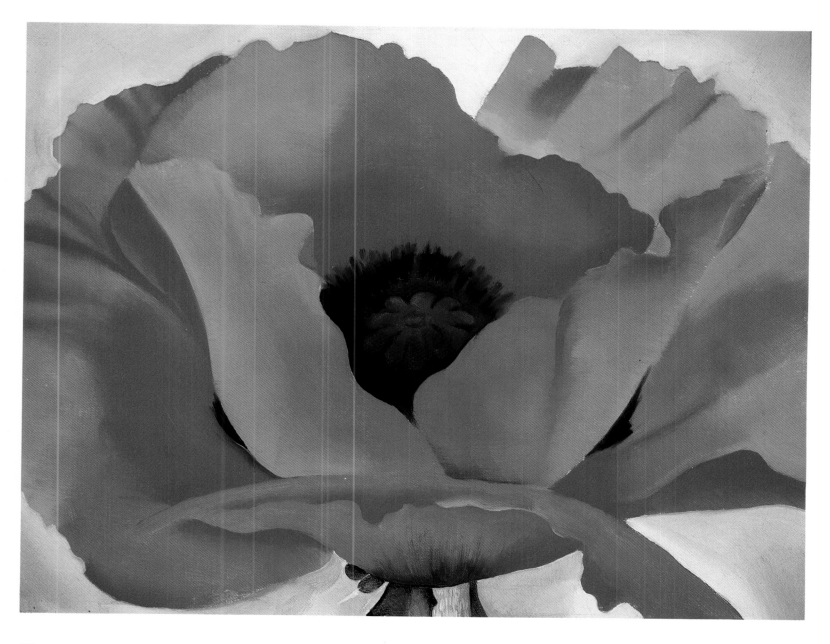

69 RED POPPY, 1927, oil on canvas, 7×9,
Private Collection, Geneva

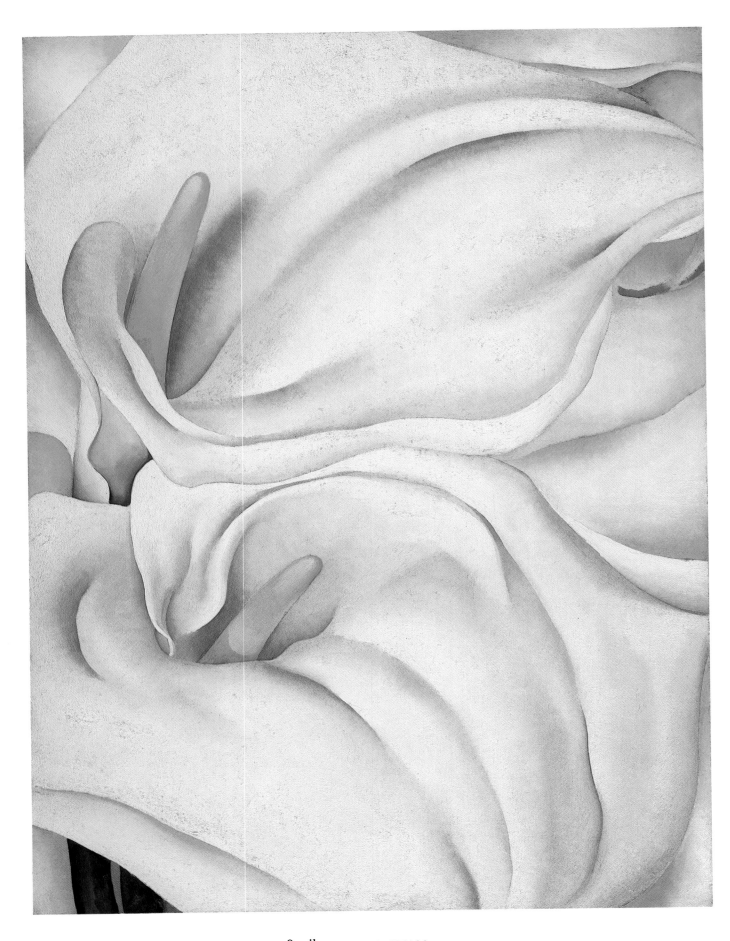

70 TWO CALLA LILIES ON PINK, 1928, oil on canvas, 40 × 30,
Estate of Georgia O'Keeffe

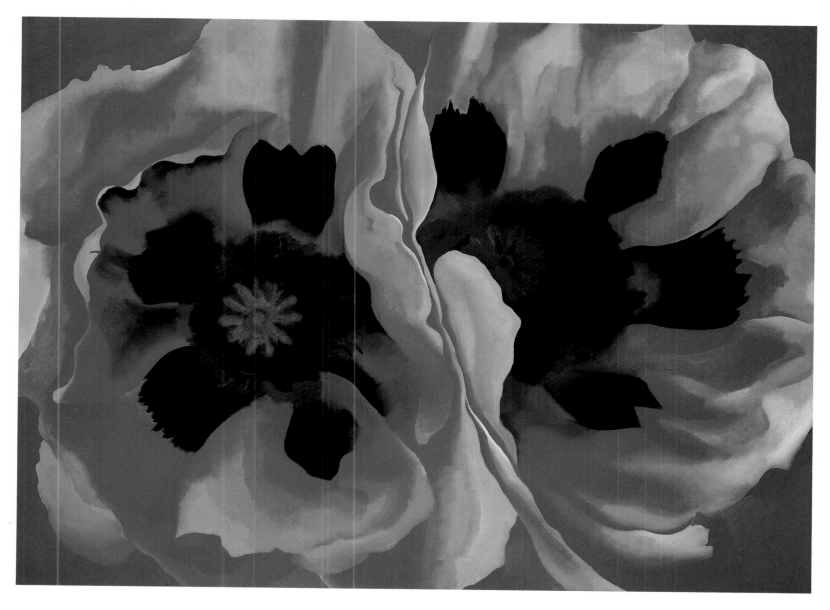

71 ORIENTAL POPPIES, 1927, oil on canvas, 30 × 40⅛,
 University Art Museum, University of Minnesota, Minneapolis, Purchase, 37.1

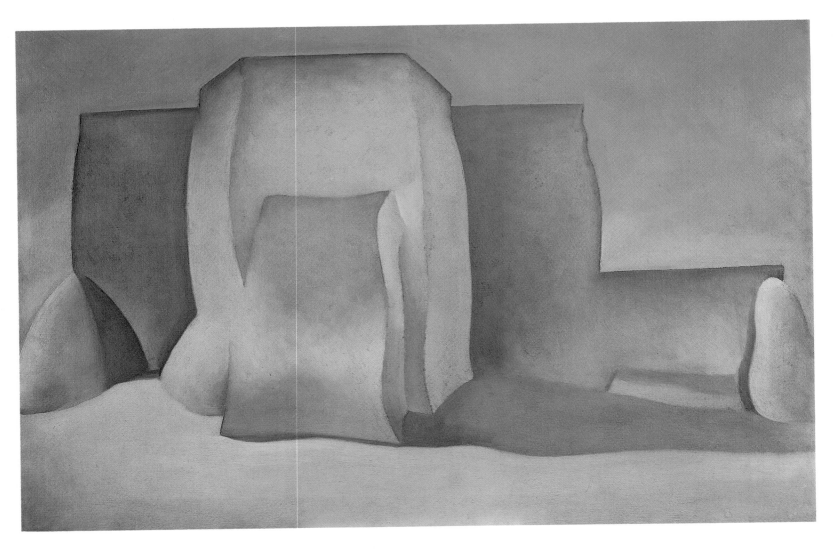

72 RANCHOS CHURCH, 1929, oil on canvas, 24 × 36,
The Phillips Collection, Washington, D.C. (exhibited in Washington only)

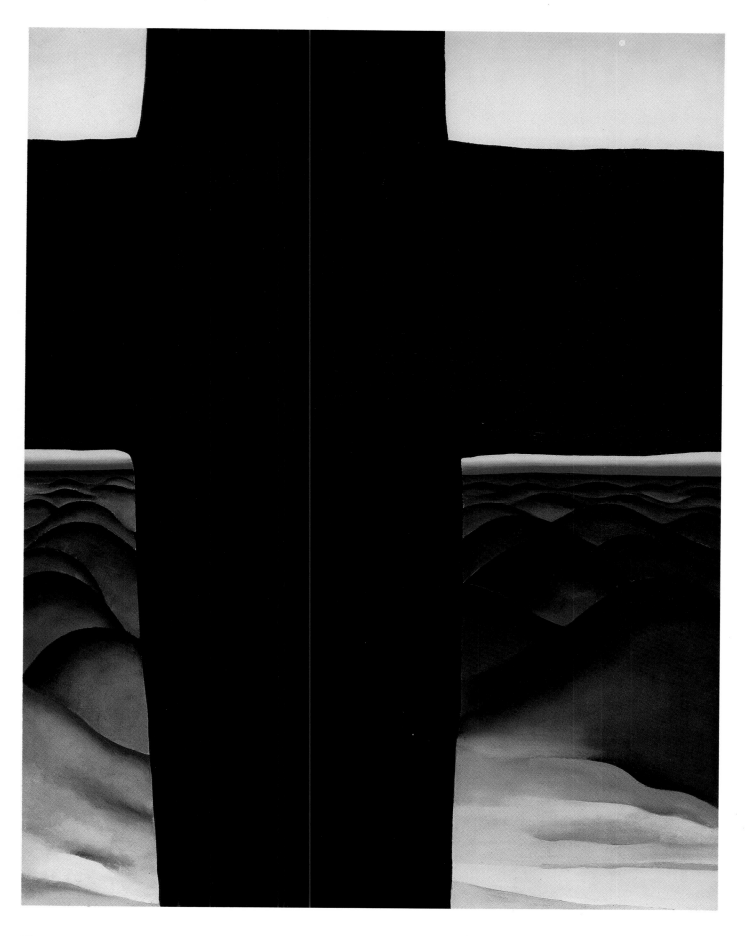

73 BLACK CROSS, NEW MEXICO, 1929, oil on canvas, 39 × 30 ⅟₁₆,
 The Art Institute of Chicago, Art Institute Purchase Fund (exhibited in Chicago only)

74 RANCHOS CHURCH, 1930, oil on canvas, 24 × 63,
 The Metropolitan Museum of Art, New York, Alfred Stieglitz Collection, 1961
 (not exhibited in Washington)

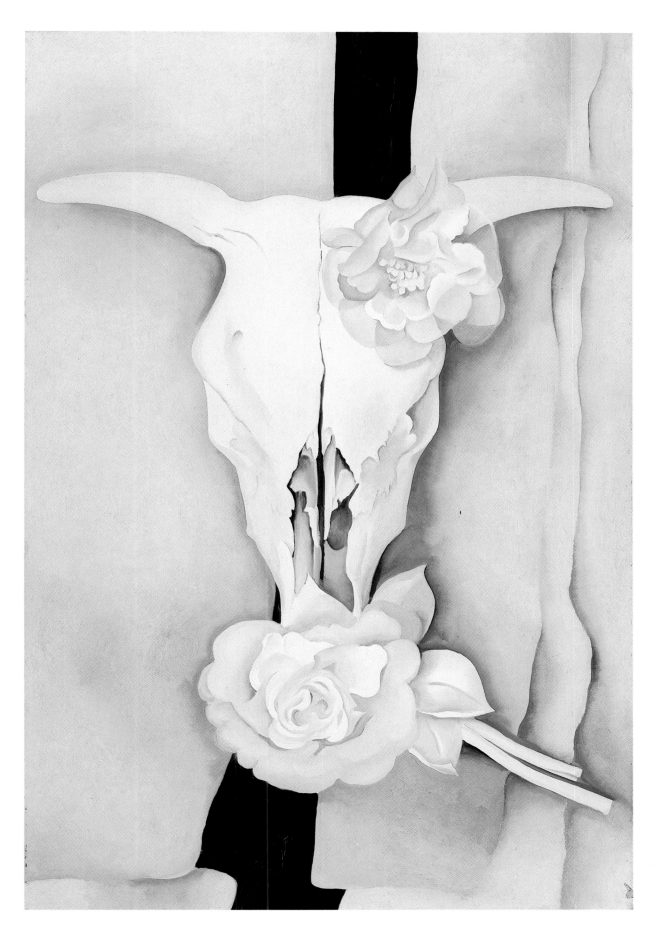

75 COW'S SKULL WITH CALICO ROSES, 1931, oil on canvas, 36 $\frac{5}{16}$ × 24 $\frac{1}{8}$,
 The Art Institute of Chicago, Gift of Georgia O'Keeffe

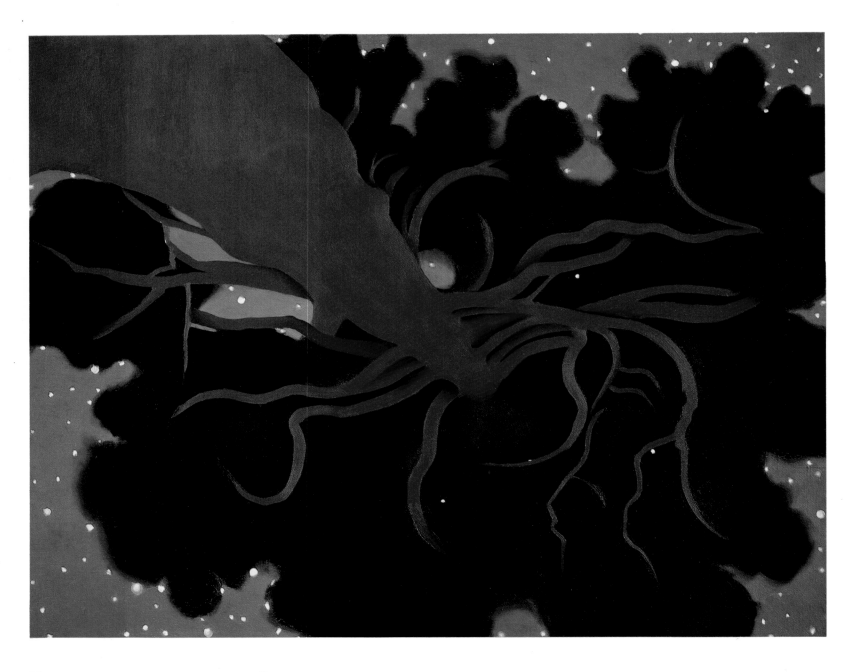

76 THE LAWRENCE TREE, 1929, oil on canvas, 30×40,
 Wadsworth Atheneum, Hartford, The Ella Gallup Sumner and Mary Catlin Sumner Collection

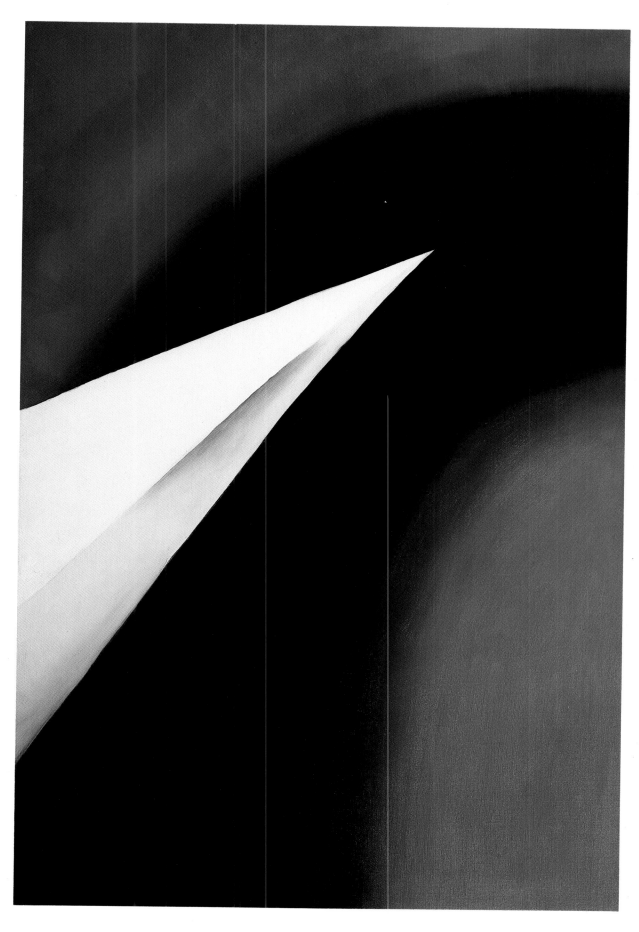

77 BLACK AND WHITE, 1930, oil on canvas, 36×24,
Lent by the Whitney Museum of American Art, New York,
50th Anniversary Gift of Mr. and Mrs. R. Crosby Kemper, 81.9

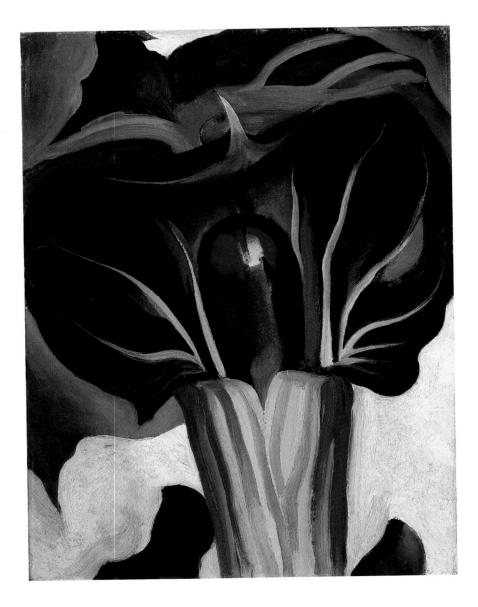

78 JACK-IN-THE-PULPIT, 1930, oil on canvas, 12 × 9,
 Courtesy ACA Galleries

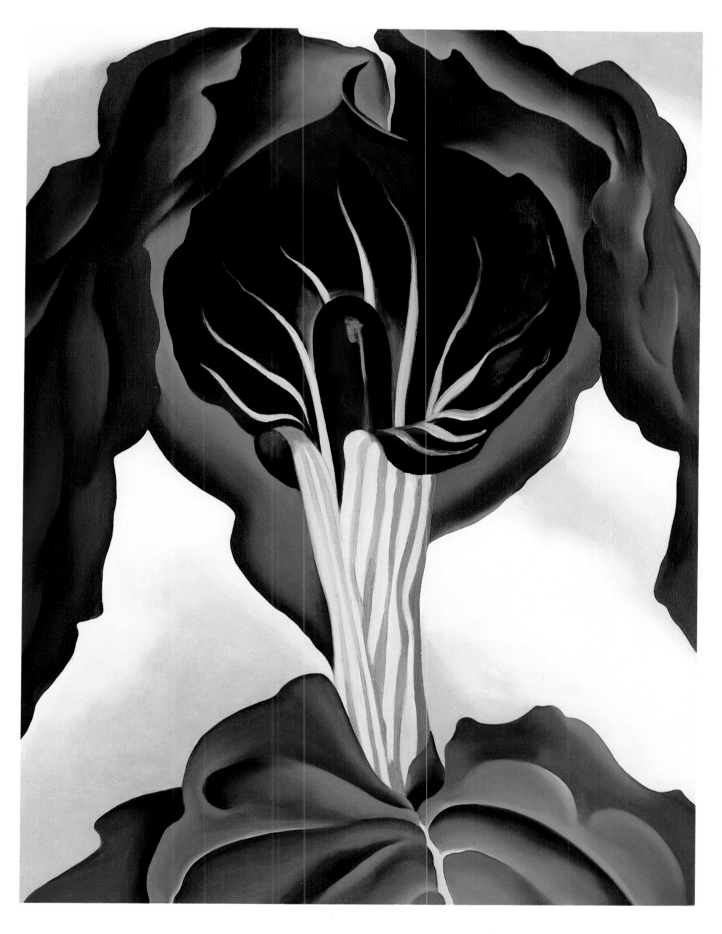

79 JACK-IN-THE-PULPIT NO. III, 1930, oil on canvas, 40 × 30,
Estate of Georgia O'Keeffe

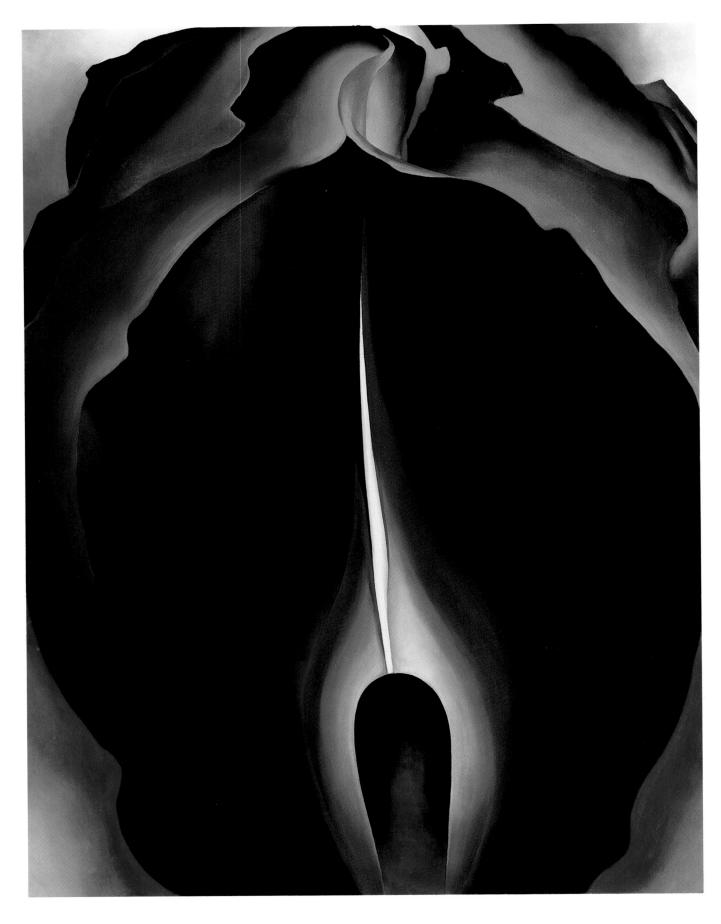

80 JACK-IN-THE-PULPIT NO. IV, 1930, oil on canvas, 40×30,
Estate of Georgia O'Keeffe

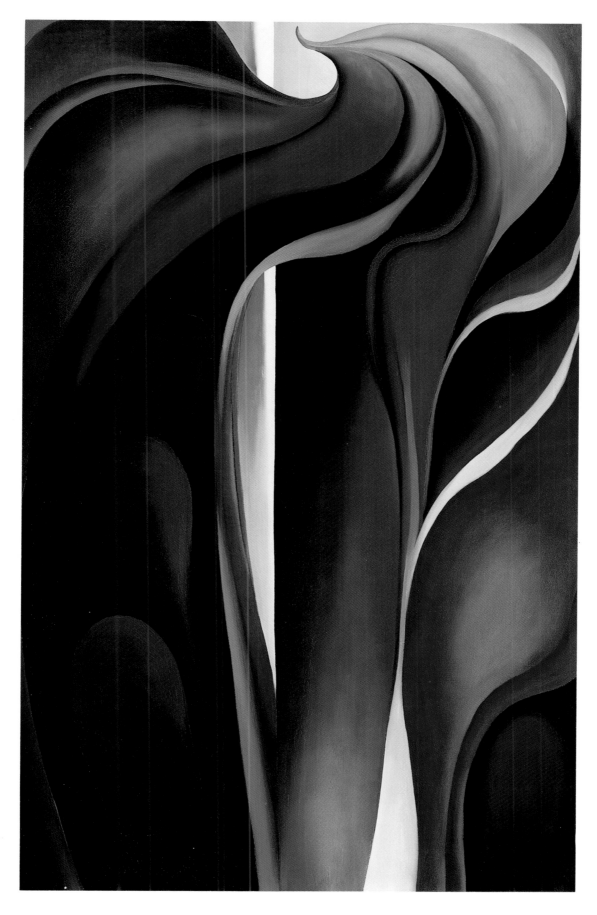

81 JACK-IN-THE-PULPIT NO. V, 1930, oil on canvas, 48×30,
 Estate of Georgia O'Keeffe

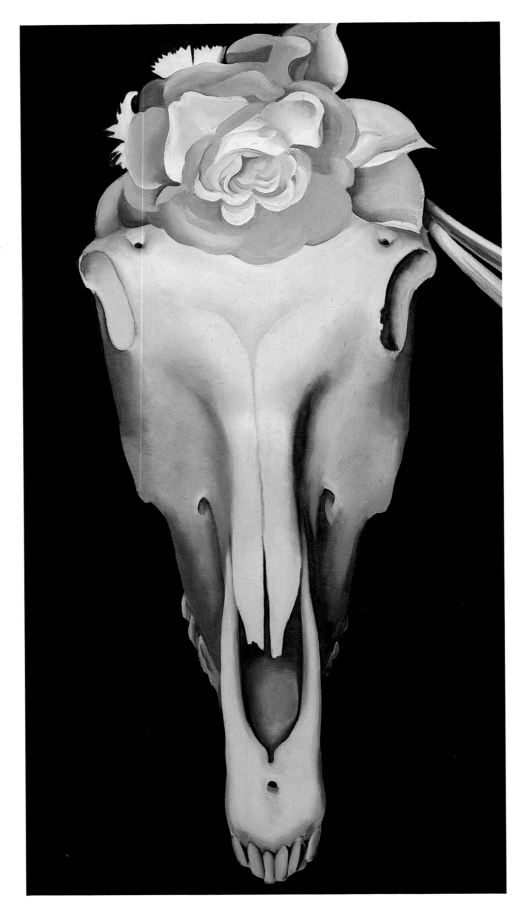

82 HORSE'S SKULL WITH WHITE ROSE, 1931, oil on canvas, 31 × 17,
Private Collection

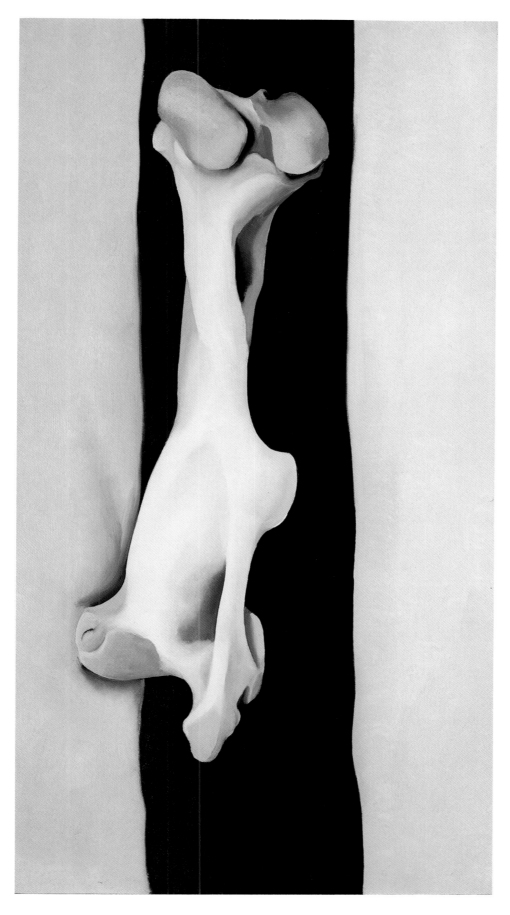

83 THIGH BONE WITH BLACK STRIPE, 1930, oil on canvas, 30 × 16,
Private Collection, Courtesy Washburn Gallery, New York

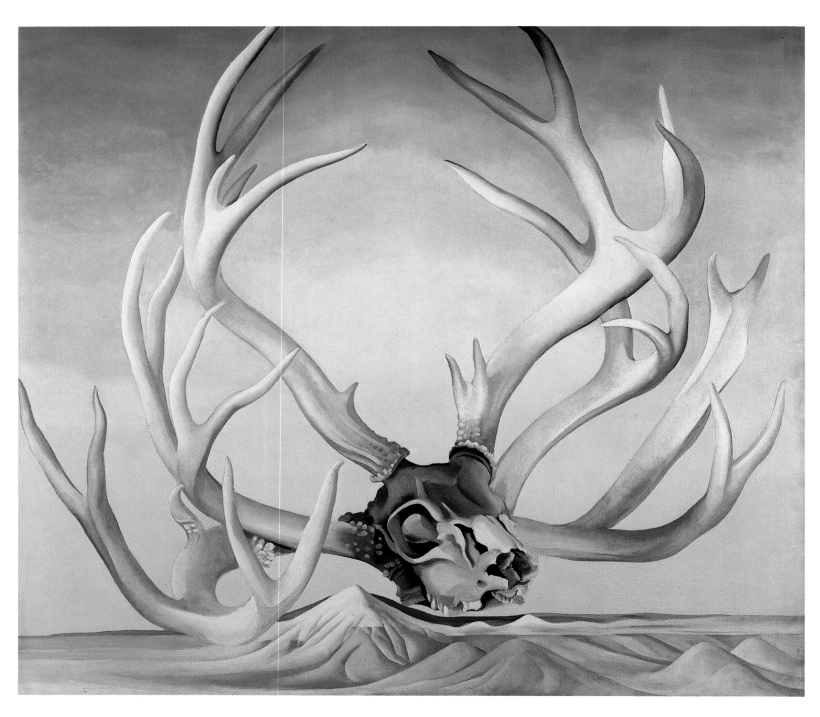

84 FROM THE FARAWAY NEARBY, 1937, oil on canvas, 36 × 40⅛,
 The Metropolitan Museum of Art, Alfred Stieglitz Collection, 1959

85 SMALL PURPLE HILLS, 1934, oil on board, 16 × 19¾,
 Estate of Georgia O'Keeffe

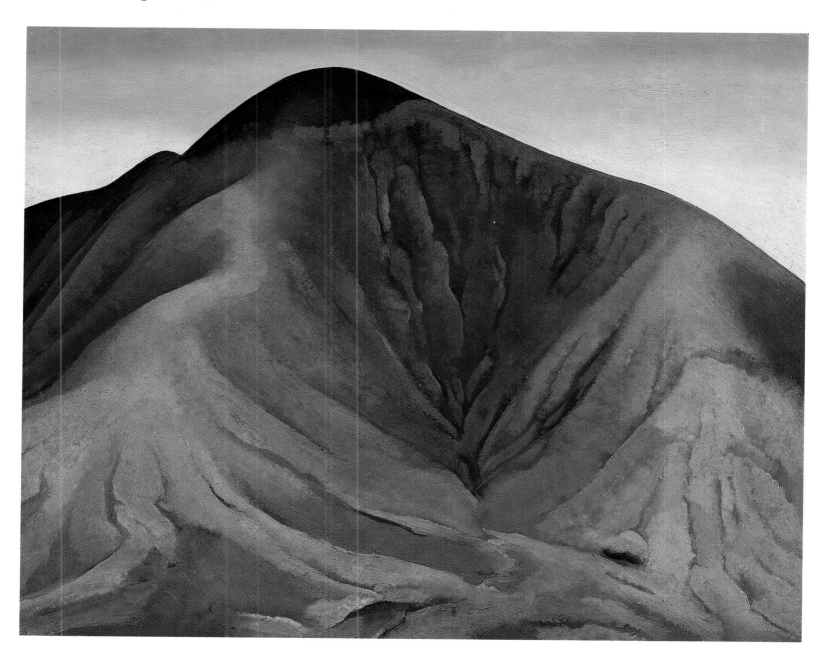

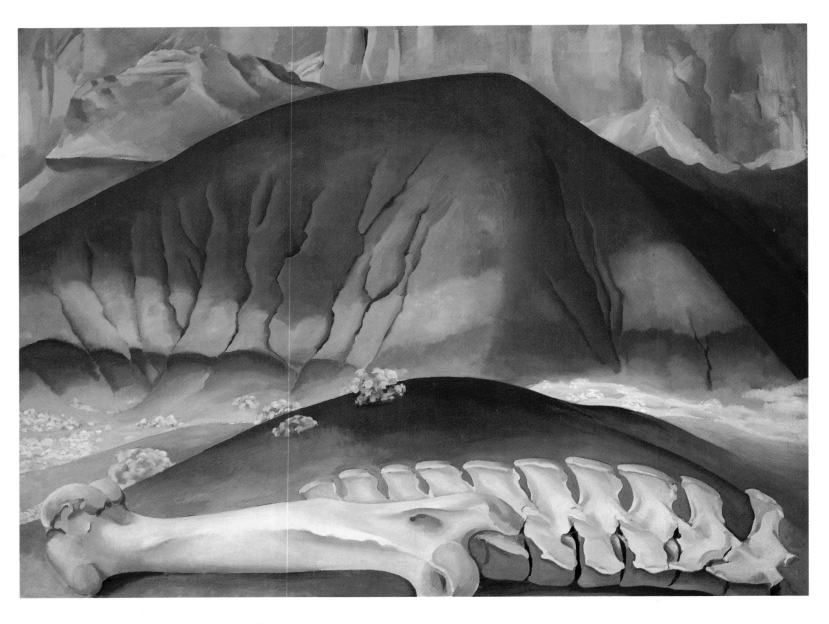

86 RED HILLS AND BONES, 1941, oil on canvas, 30×40,
Philadelphia Museum of Art, The Alfred Stieglitz Collection

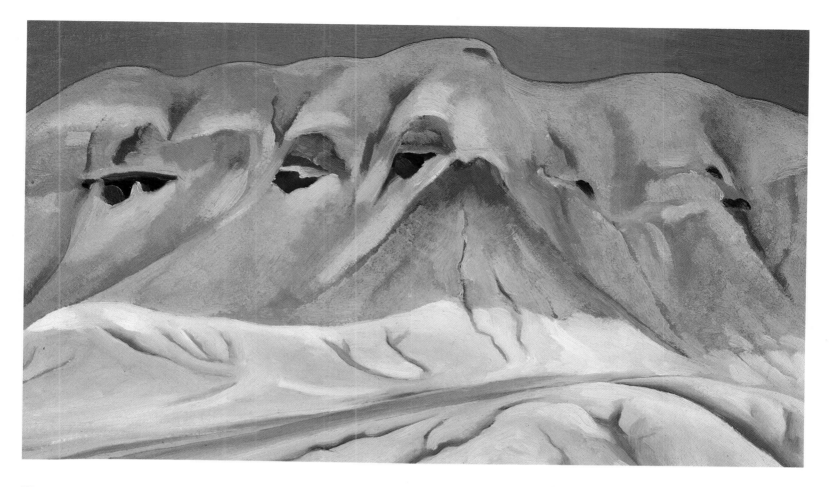

87 HILLS — LAVENDER, GHOST RANCH, NEW MEXICO II, 1935, oil on canvas,
8 × 13 ¼, Mr. and Mrs. George K. Conant III

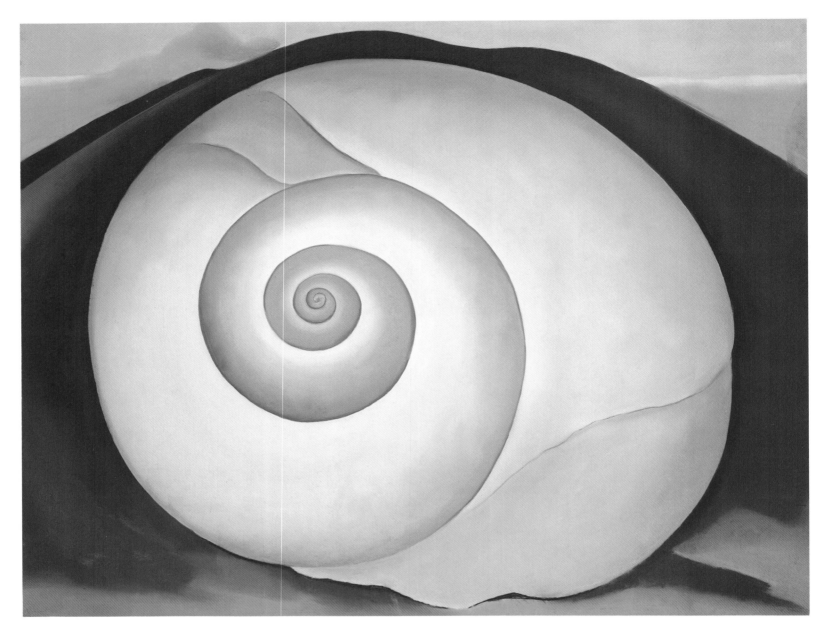

88 WHITE SHELL WITH RED, 1938, pastel on paper-covered board, 21½ × 27½,
Estate of Georgia O'Keeffe

89 RED HILL AND WHITE SHELL, 1938, oil on canvas, 30 × 36¼,
Private Collection, Houston, Texas

90 RIB AND JAWBONE, 1935, oil on wood, 9×24,
Estate of Georgia O'Keeffe

91 THE BROKEN SHELL — PINK, 1937, oil on canvas, 12 × 10,
Estate of Georgia O'Keeffe

92　EAGLE CLAW AND BEAN NECKLACE, 1934, charcoal on paper, 19×25⅛,
The Museum of Modern Art, New York 19.36
(exhibited in Washington and New York only)

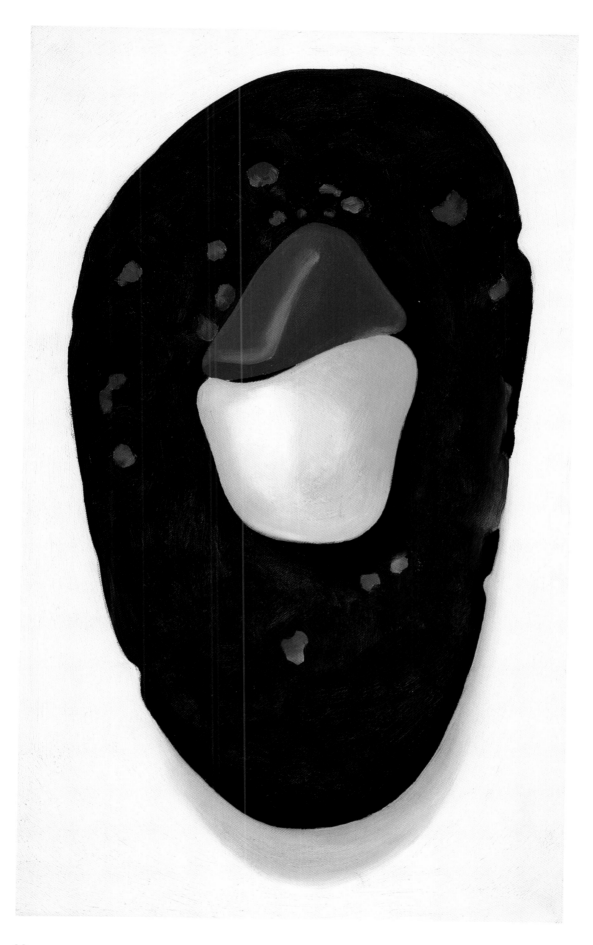

93 THREE SMALL ROCKS BIG, 1937, oil on canvas, 20×12,
Philadelphia Museum of Art, Gift of George Howe

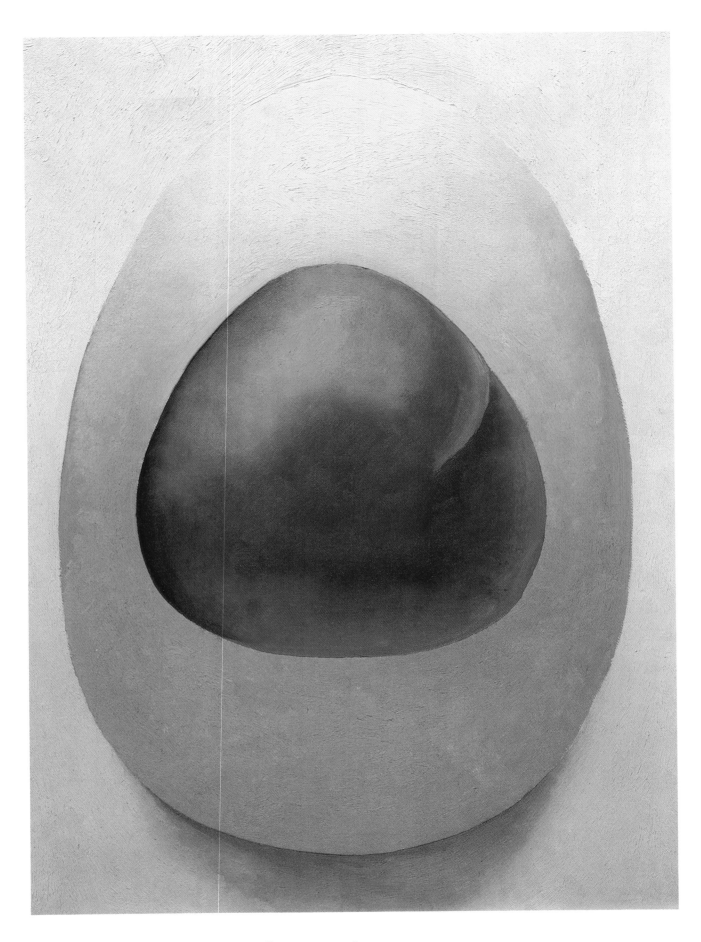

94 RED AND PINK ROCKS, 1938, oil on canvas, 18 × 13,
Collection of James and Barbara Palmer

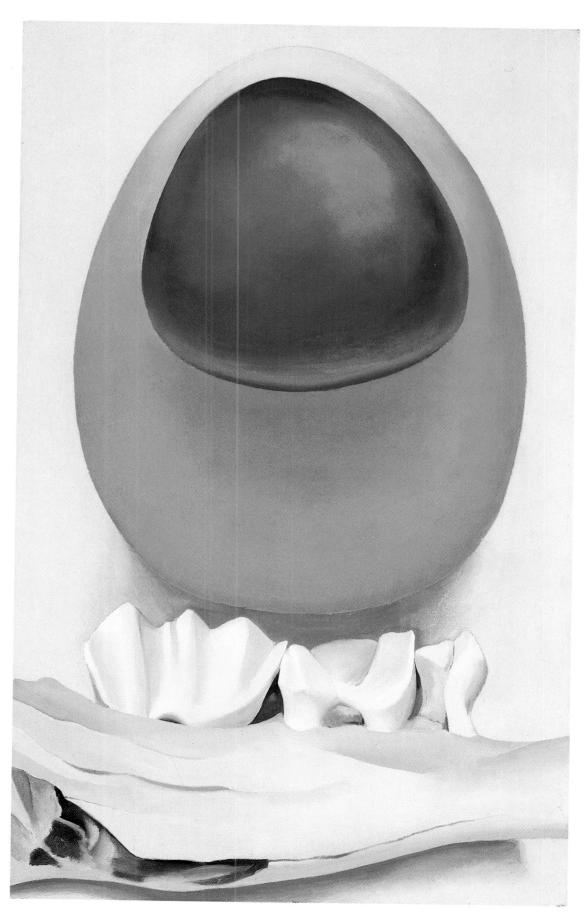

95 RED AND PINK ROCKS AND TEETH, 1938, oil on canvas, 21 × 13,
The Art Institute of Chicago, Gift of Georgia O'Keeffe

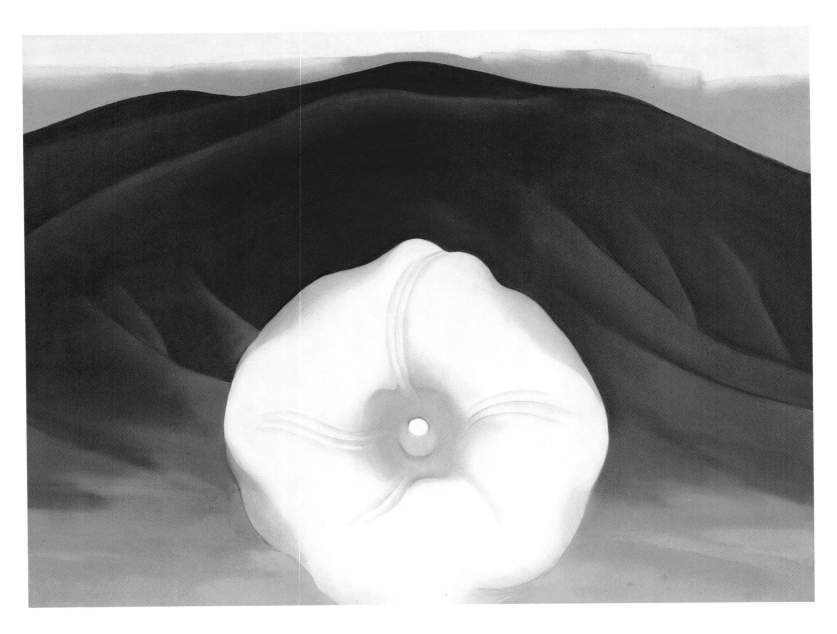

96 RED HILLS AND WHITE FLOWER, 1937, pastel on paper-covered board, 19¼ × 25½,
Estate of Georgia O'Keeffe

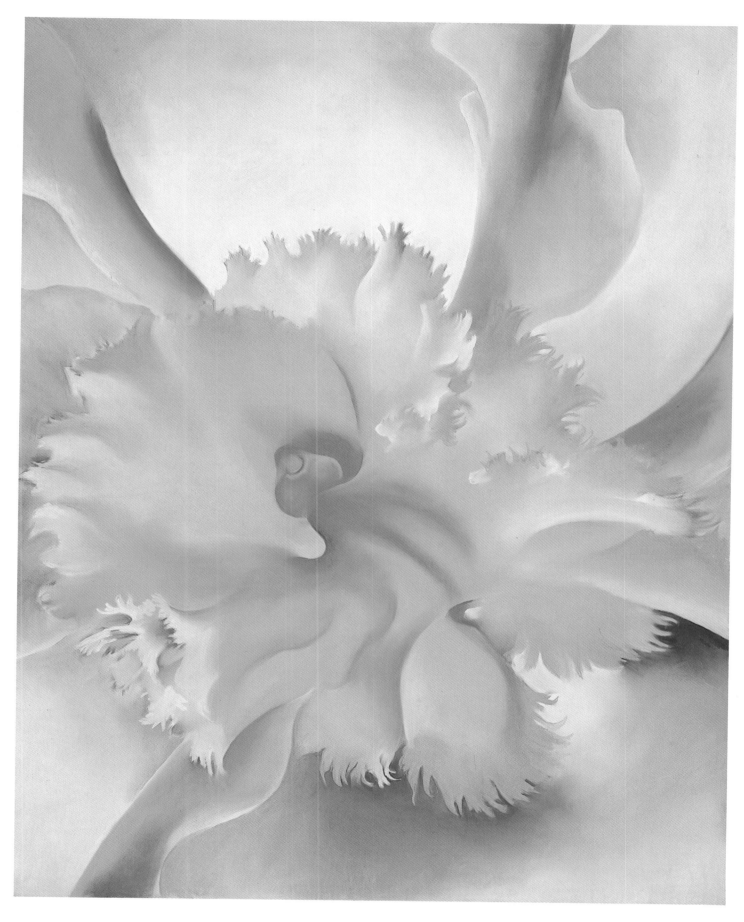

97 AN ORCHID, 1941, pastel on paper-covered board, 27½ × 21½,
Estate of Georgia O'Keeffe

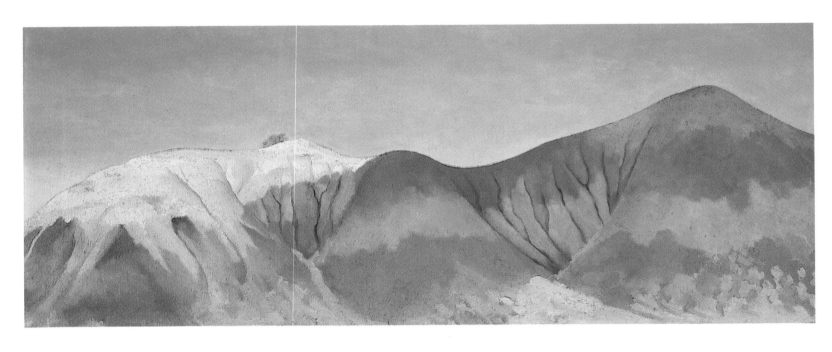

98 SERIES: NEAR ABIQUIU, NEW MEXICO — HILLS TO THE LEFT, 1941,
oil on canvas, 12 × 30, Private Collection, Courtesy Ira Spanierman Gallery
(exhibited in Washington and New York only)

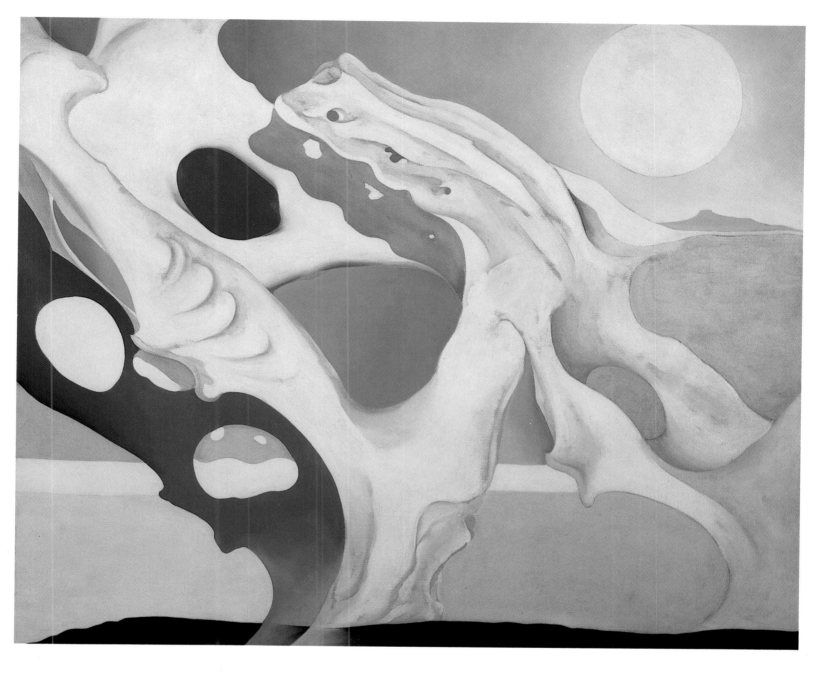

99 PELVIS WITH SHADOWS AND THE MOON, 1943, oil on canvas, 40×48¾,
Frank Lloyd Wright Foundation
(not in exhibition)

100 GREY HILLS, 1942, oil on canvas, 20 × 30,
 Indianapolis Museum of Art, Gift of Mr. and Mrs. James W. Fesler

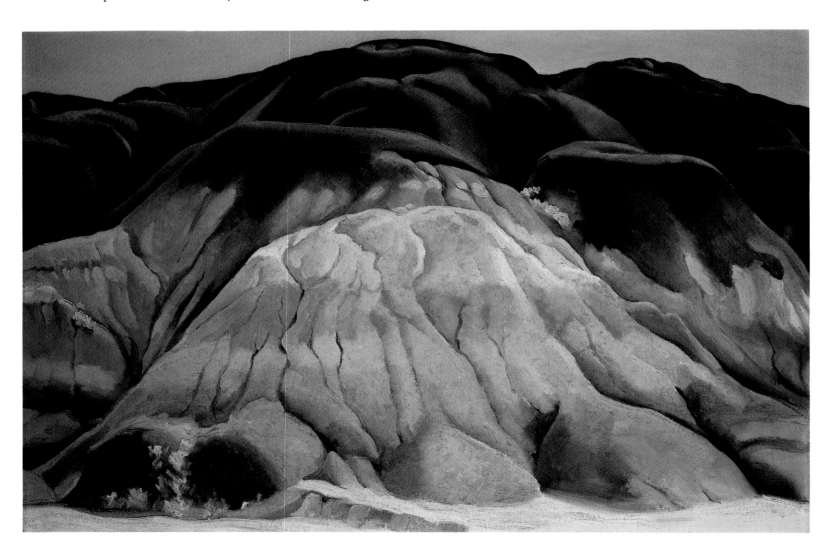

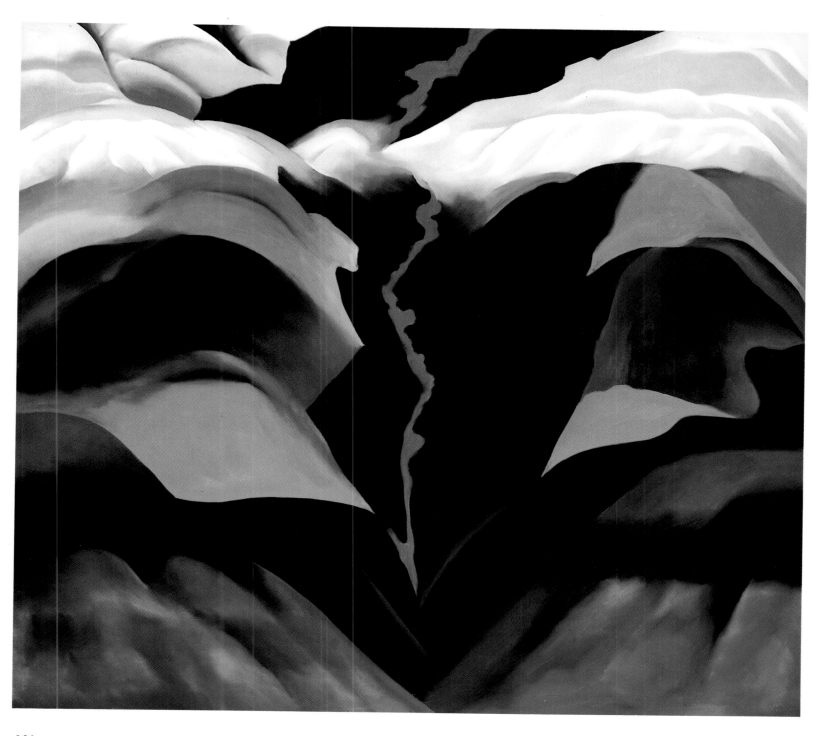

101 BLACK PLACE — III, 1944, oil on canvas, 36×40,
Estate of Georgia O'Keeffe

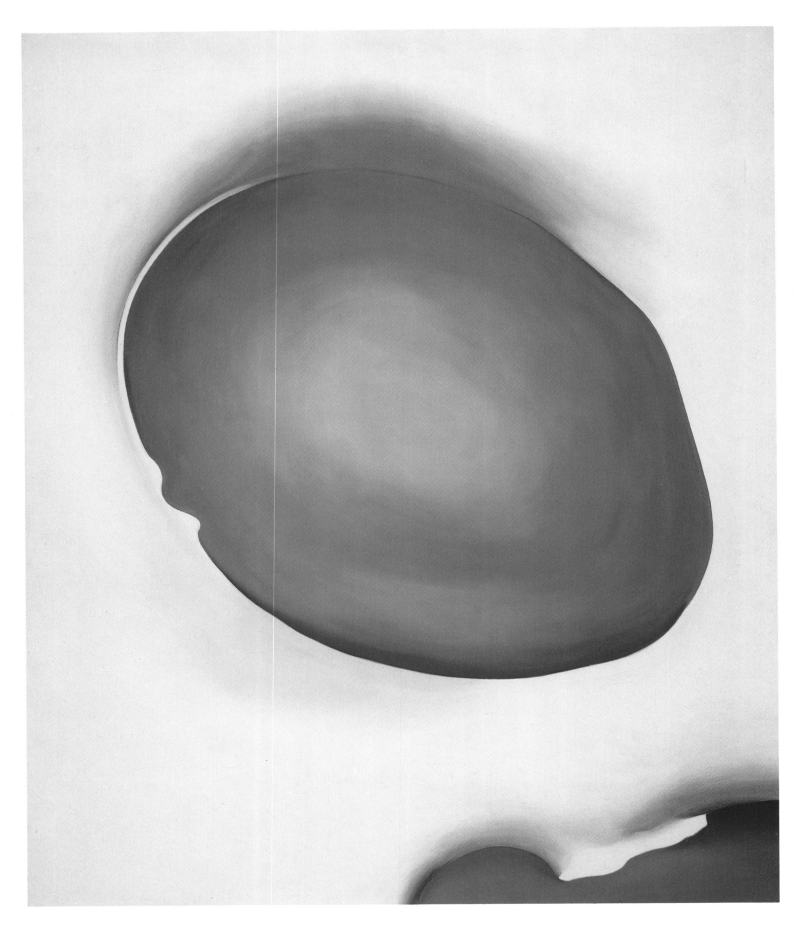

102 PELVIS WITH BLUE (PELVIS I), 1944, oil on canvas, 36 × 30,
Milwaukee Art Museum Collection, Gift of Mrs. Harry Lynde Bradley

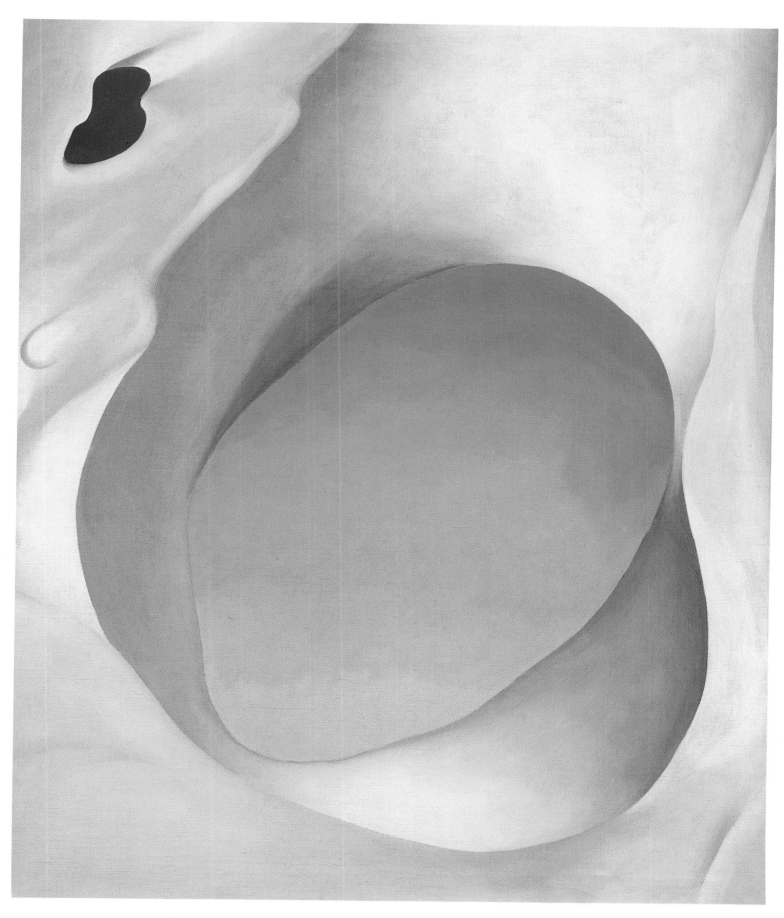

103 PELVIS III, 1944, oil on canvas, 48×40,
 Collection of Calvin Klein

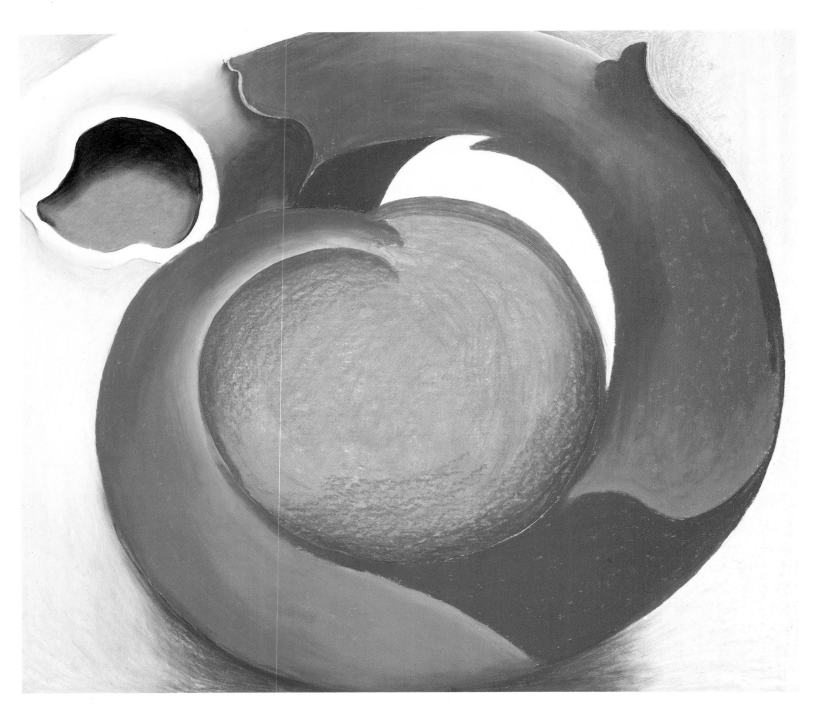

104 GOAT'S HORN WITH RED, 1945, pastel on paper, 27⅞ × 31 ¹¹⁄₁₆,
Hirshhorn Museum and Sculpture Garden, Smithsonian Institution,
Gift of Joseph H. Hirshhorn, 1972 (exhibited in Washington only)

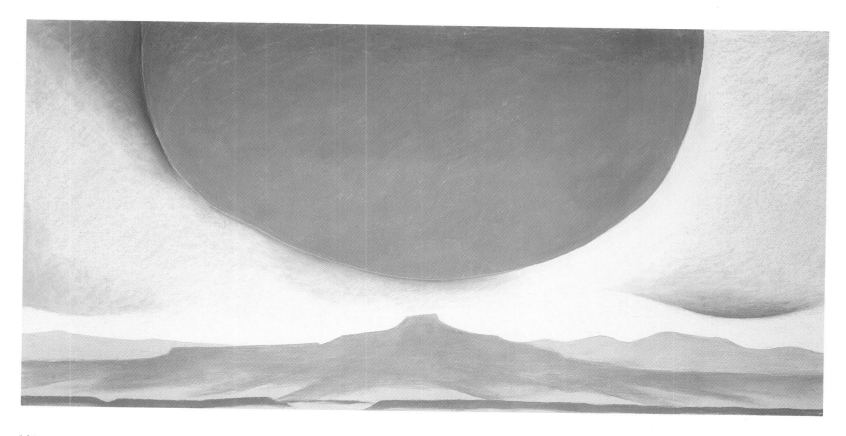

105 PEDERNAL, 1945, pastel on paper, 21⅜ × 43¼,
Estate of Georgia O'Keeffe

106 PELVIS SERIES — RED WITH YELLOW, 1945, oil on canvas, 36×48,
 Private Collection

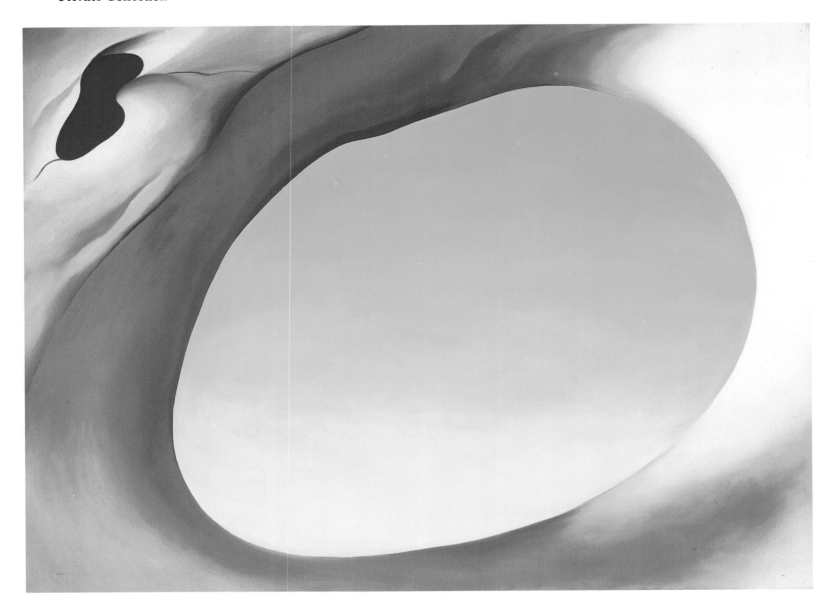

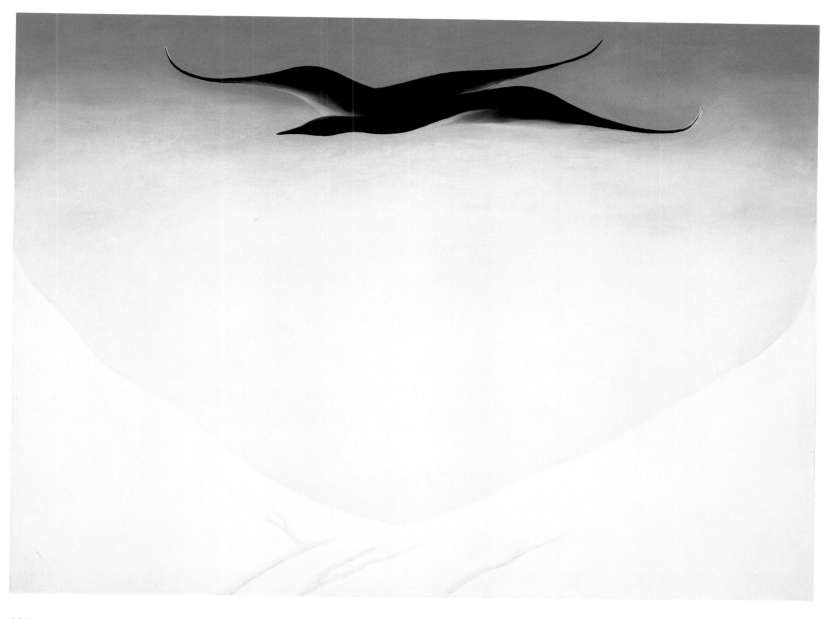

107 A BLACK BIRD WITH SNOW-COVERED RED HILLS, 1946, oil on canvas, 36×48,
Private Collection

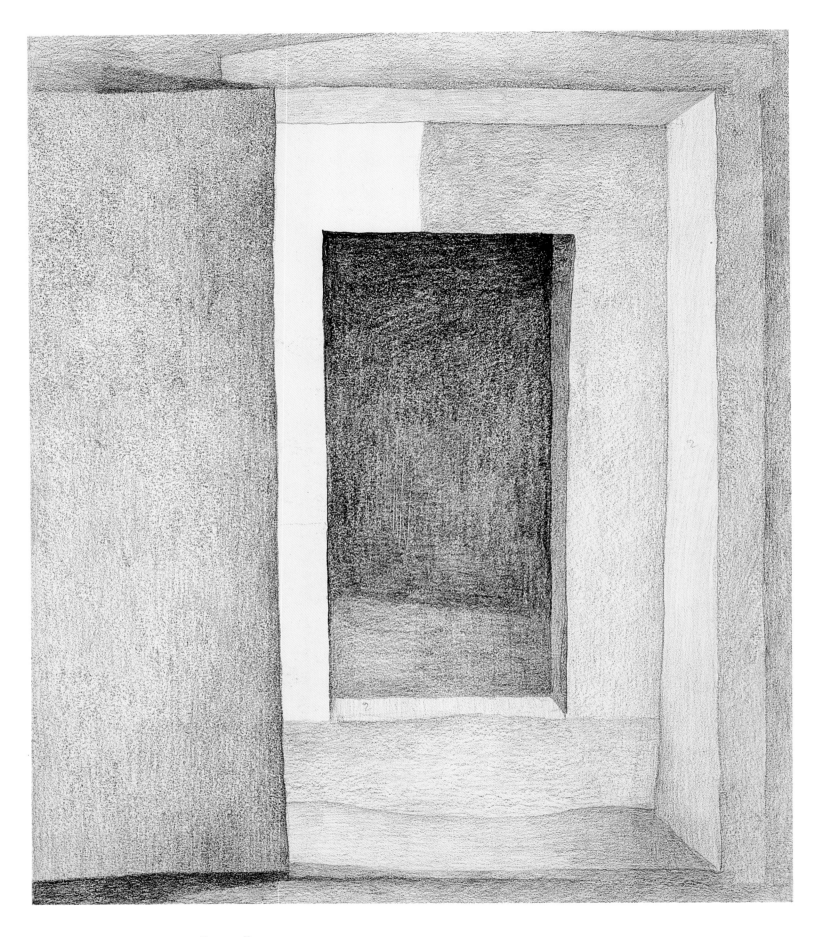

108 PATIO DOOR, c. 1946, pencil on paper, 17 × 13,
Juan Hamilton

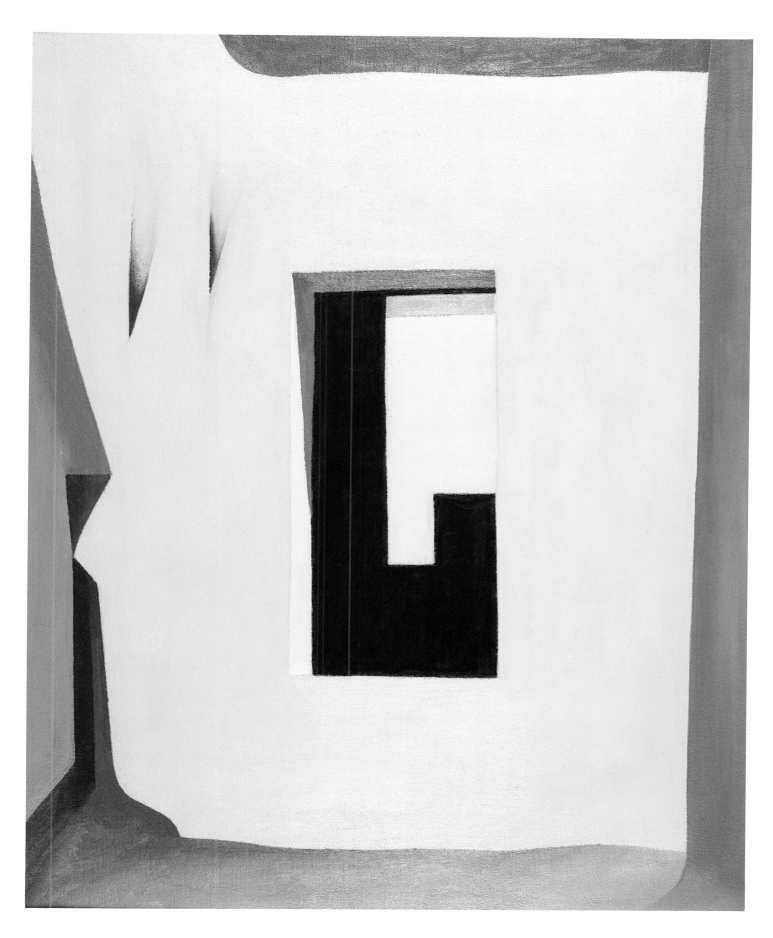

109 IN THE PATIO I, 1946, oil on paper, mounted on paperboard, 29¾ × 23¾,
San Diego Museum of Art, Gift of Mr. and Mrs. Norton S. Walbridge

110 WHITE PATIO WITH RED DOOR, 1960, oil on canvas, 48×84,
The Regis Collection, Minneapolis, Minnesota

111 MY LAST DOOR, 1954, oil on canvas, 48 × 84,
 Collection of Calvin Klein

112 DRAWING III, 1959, charcoal on paper, 18⅝ × 24⅝,
Estate of Georgia O'Keeffe

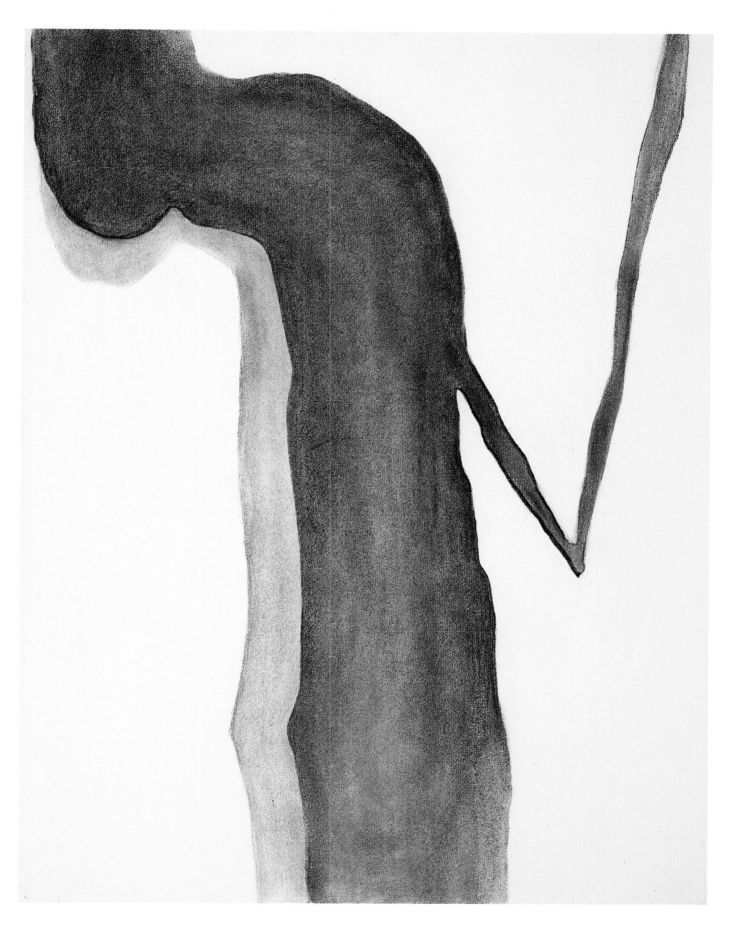

113 DRAWING V, 1959, charcoal on paper, 24⅝ × 18⅝,
Estate of Georgia O'Keeffe

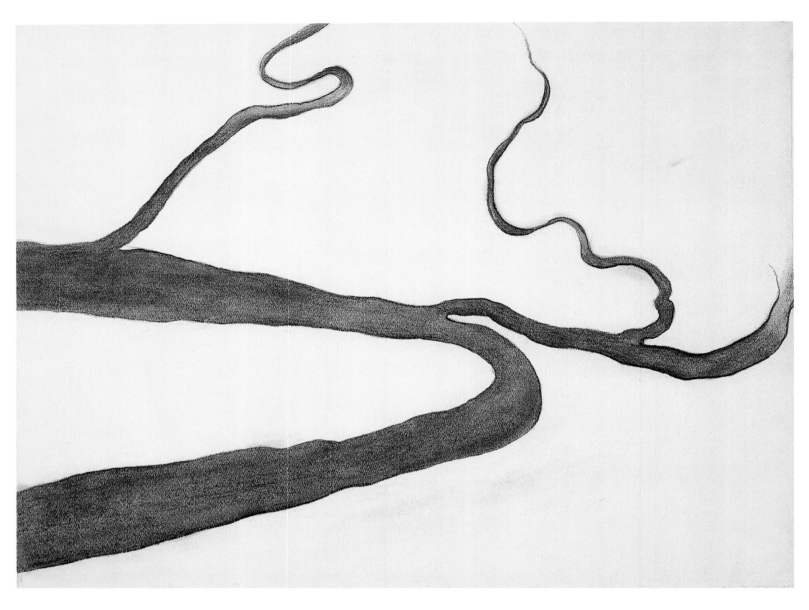

114 DRAWING IX, 1959, charcoal on paper, 18⅝ × 24⅝,
Estate of Georgia O'Keeffe

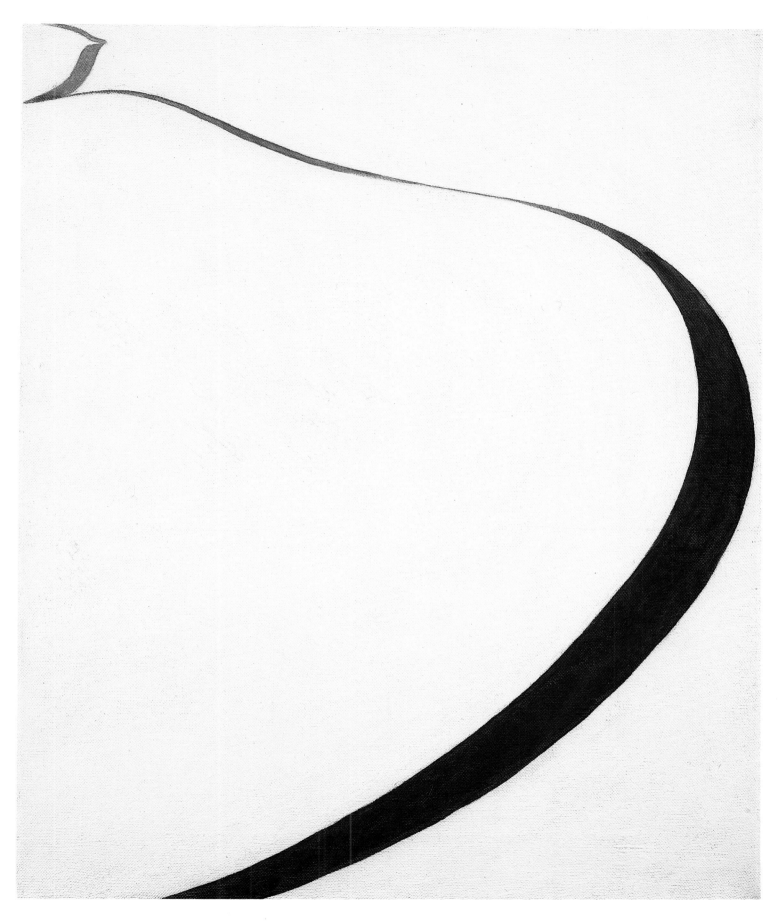

115 WINTER ROAD I, 1963, oil on canvas, 22 × 18,
Estate of Georgia O'Keeffe

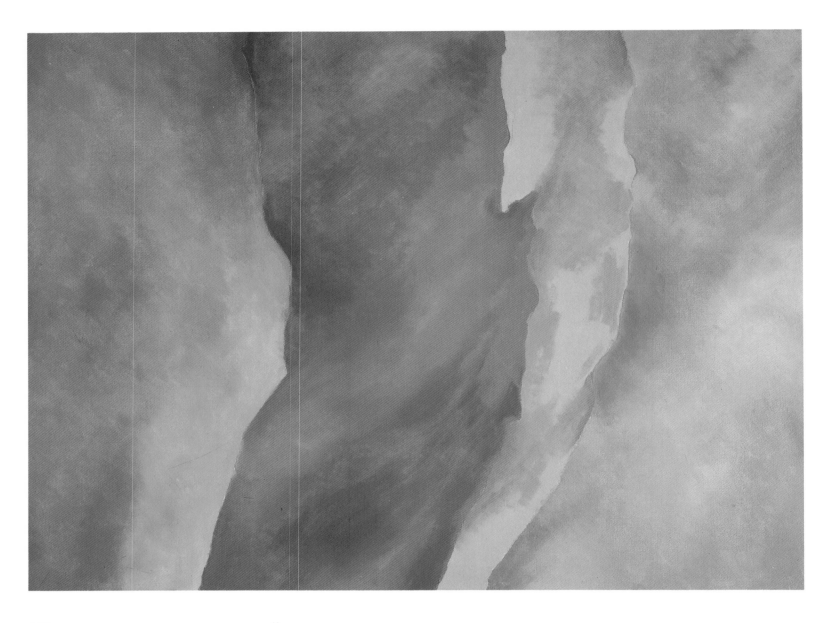

116 IT WAS RED AND PINK, 1959, oil on canvas, 30 × 40,
Milwaukee Art Museum Collection, Gift of Mrs. Harry Lynde Bradley

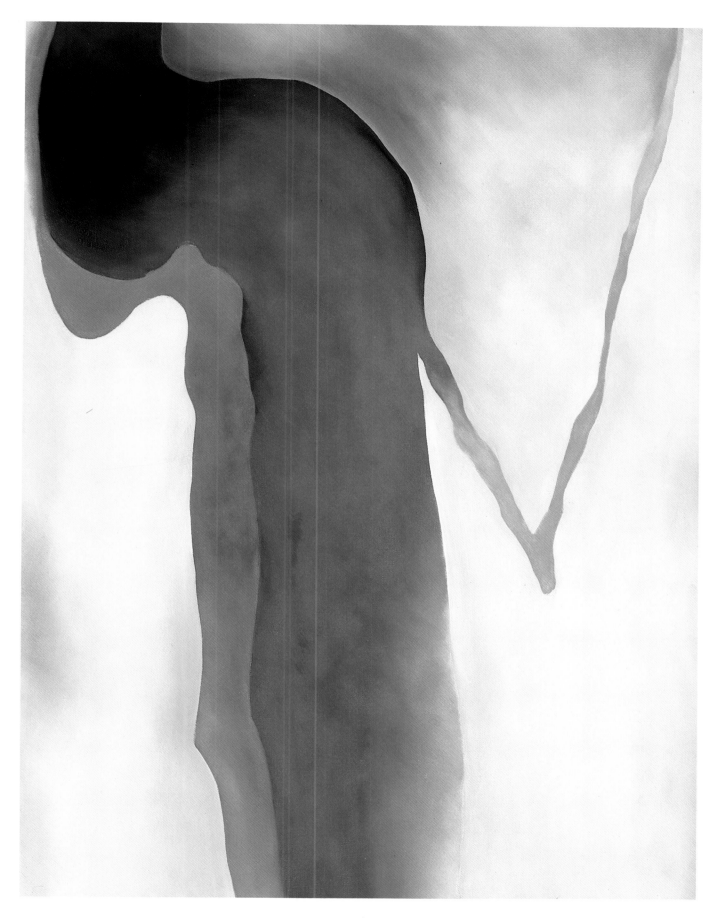

117 BLUE, BLACK AND GREY, 1960, oil on canvas, 40 × 30,
Mr. and Mrs. Gilbert H. Kinney

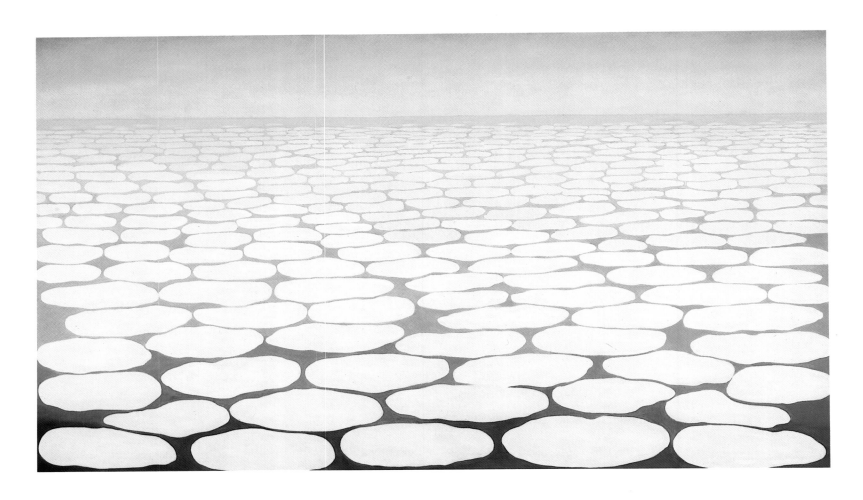

118 SKY ABOVE CLOUDS III, 1963, oil on canvas, 48 × 84, Private Collection

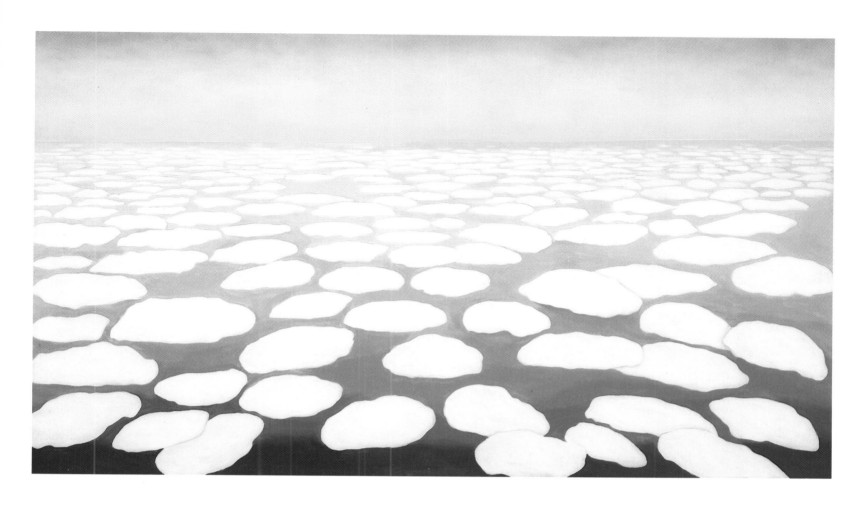

119 SKY ABOVE CLOUDS II, 1963, oil on canvas, 48×84,
Private Collection

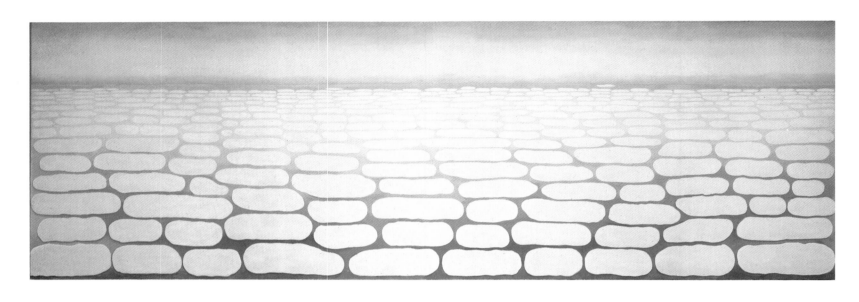

120 SKY ABOVE CLOUDS IV, 1965, oil on canvas, 96 × 288,
The Art Institute of Chicago, Paul and Gabriella Rosenbaum Foundation, Restricted Gift and
Gift of Georgia O'Keeffe (exhibited in Washington and Chicago only)

LETTERS

From the Faraway

SARAH GREENOUGH

Throughout her long career, Georgia O'Keeffe repeatedly expressed her dislike, even distrust, of words: "Words and I—are not good friends at all except with some people," she wrote in 1916. "The painter using the word often seems to me like a child trying to walk," she stated many years later, "I think I'd rather let the painting work for itself than help it with the word."[1] She made few public statements, publishing less than a dozen short exhibition introductions, two articles, and two books consisting mainly of illustrations of her work. Yet despite her professed difficulty with the written word, O'Keeffe's letters show that she wrote often, well, with consistency and great conviction. Although much of her life was spent in remote areas of the United States—"the Faraway" as she called it—she had numerous friends and colleagues with whom she regularly corresponded from the early 1910s through the late 1950s. Spontaneous, unmeditated, and witty, her letters are exuberant expressions of her life, art, and relationships.[2]

The Georgia O'Keeffe who emerges from these letters is significantly different from the person we have come to know through the many portraits, both written and visual, made of her. Successive generations from Alfred Stieglitz to Andy Warhol were entranced with her image. She was drawn, painted, sculpted, filmed, written about, and most especially photographed, perhaps more than any other twentieth-century American artist. In fact, this fascination with O'Keeffe has contributed to our difficulty in separating her art and life from her image. The selected letters published here make it clear that the traditional descriptions of O'Keeffe's personality—as aloof, enigmatic, ascetic, reserved, controlled, even haughty—apply far more to the legend created by the photographers and others than to the person. O'Keeffe's letters not only dispel our misconceptions, allowing us a fuller understanding of her personality, but also help to explain why legend developed in the first place.

Alfred Stieglitz was first introduced to O'Keeffe in January 1916 when he saw some of her charcoal drawings. He immediately responded to them, remarking that they were among the most impressive new works he had seen in a long time.[3] But it was in their ensuing correspondence that he came to know her personality. In O'Keeffe's letters Stieglitz found an unreserved individual, whose energy and enthusiasm could hardly be contained on paper: "The sound of the wind is great," O'Keeffe wrote to him in September 1916, "but the pink roses on my rugs! And the little squares with three pink roses in each one—dark lined squares—I have half a notion to count them so you will know how many are hitting me—give me flies and mosquitoes and ticks—even fleas—every time in preference to pink roses in a square with another rose on top of it."[4] O'Keeffe filled her letters with a child-like wonder and appreciation of nature, and unlike most of Stieglitz's associates in New York, seemed to have little concern for aesthetic theories or intellectual discussions: "The plains—the wonderful great big sky—makes me want to breathe so deep that I'll break—There is so much of it—I want to get outside of it all—I would if I could—even if it killed me—"[5] O'Keeffe's prose, like her drawings, appeared untutored: composed mainly of short phrases with no regard for sentence construction or traditional punctuation, it was spontaneous, unfiltered, almost stream-of-consciousness writing.[6] For Stieglitz, who rarely ventured west of the Hudson River, it must have seemed as if this young Midwestern woman was an intuitive, almost pure artist; that she was "modern by instinct," as Marsden Hartley later wrote.[7]

This understanding of O'Keeffe as an instinctive, almost naive modern artist prevailed throughout the 1920s. In the literature on her from this time there is no mention that she studied at the School of The Art Institute of Chicago in 1905–1906; went to 291 and saw exhibitions of Rodin and Matisse in 1908, Picasso, Braque, Marin, and Hartley between 1914 and 1916; read any of the recent books or periodicals on modern art; or that she was greatly influenced by Arthur Wesley Dow's writings and teachings at Columbia University Teachers College.[8] Critics dismissed as insignificant the year she spent studying with William Merritt Chase in 1907 and 1908 at The Art Students League, and insisted that she never adopted "New York's borrowed art theories."[9] Her work did not "derive from European influences," they wrote, but was "entirely and locally American."[10] It is true that O'Keeffe always preferred direct action to theoretical speculation, but her letters clearly indicate that she had not led an intellectually sheltered or culturally deprived life. While living in New York in 1914 and 1915 she knew Randolph Bourne and others associated with him in the political science department at Columbia University. She read extensively on political science, contemporary drama, literature, and history; she also attended plays, concerts, and lectures on suffrage.[11] She kept up with the latest art publications, reading such periodicals as *Camera Work*, *291*, or *The Seven Arts*, or such books as Arthur Jerome Eddy's *Cubism and Post-Impressionism*, Clive Bell's *Art*, Willard Huntington Wright's *Creative Will* and *Modern Painting: Its Tendency and Meaning*, or Marius DeZayas' *African Negro Art: Its Influences on Modern Art*. By the fall of 1915, before she met Stieglitz, she was reading Kandinsky's *On the Spiritual in Art* for the second time.

After O'Keeffe met Stieglitz her life changed dramatically. Within a very short time, and at a young age, she was catapulted into the public eye, both through the attention Stieglitz gave to her art and through the photographs he took of her. Between 1917 and 1937 Stieglitz made over 300 portraits of O'Keeffe that affected not just the critical and public perception of her personality but also that of the nature of her art. (They continue even now to influence our understanding of her.) As a group the portraits defy generalization, but most were made in their first years together, between 1918 and 1922, when they were most deeply and passionately in love. Like a lover exploring the person and personality of his beloved, Stieglitz photographed every inch of O'Keeffe's body. He photographed her sleeping, waking, dressing, and painting. Occasionally he photographed her with waiflike expressions of wonder, innocence, and purity, but in many of the early images she appeared as carefully controlled and sensuous, or serious and independent. At times she seemed to be a somewhat softer version of the late nineteenth-century *femme fatale*, not only emanating a sense of womanhood but also embodying a powerful sexuality. Through the poses and expressions O'Keeffe assumed, or Stieglitz chose to emphasize, and through framing and camera angle, she became a symbol of the quintessential woman—serious, independent, and sensual.

This was the image of O'Keeffe that was first introduced to a large audience in the 1920s. Stieglitz had shown O'Keeffe's work at 291 in 1917, but did not exhibit it again until 1923. In 1921, however, he devoted almost half of an exhibition of his own photographs to studies of O'Keeffe. More than the rest of his work, these portraits, and particularly several nudes, elicited a great deal of critical attention and caused O'Keeffe to become known as a model, a "newspaper personality," to use the words of Henry McBride.[12] But the person seen in these portraits, and the understanding of her personality that they represent, contrasts sharply with the forthright, playful, witty, spontaneous, and at times vulnerable woman we come to know in the letters. There she revealed a different character and a sexuality that was, in fact, open, robust, frank, and earthy.

The notoriety that O'Keeffe acquired in the 1920s, as a result of the large number of portraits Stieglitz made of her, significantly affected the critical reaction to her work. During this time, a large

and very vocal majority of critics repeatedly discussed her painting in relation to her sex; they saw her first as a woman and only second, if at all, as an artist. Even in the early 1920s when much of her work was quite abstract and devoid of sexual references, she was hailed as the "priestess of Eternal Woman."[13] Readers were told that "the essence of very womanhood permeates her pictures."[14] Lewis Mumford wrote, "she has beautified the sense of what it is to be a woman; she has revealed the intimacies of love's juncture with the purity and the absence of shame that lovers feel in their meeting."[15] Freud's theories were extremely popular in the 1920s and undoubtedly encouraged sexual allusions to O'Keeffe's "swelling hills and reclining valleys . . . pregnant with beauty."[16] But the critics also had a difficult time separating Stieglitz's photographs of O'Keeffe from her art: Oscar Bluemner's discussion of her surfaces as "throbbing with pulse lines," or Hartley's description of her abstract compositions as "shameless private documents . . . of unqualified nakedness of statement," could just as easily—and perhaps even more appropriately—have been applied to Stieglitz's portraits of O'Keeffe as to her own paintings.[17] Rosenfeld even went so far as to write that O'Keeffe referred all natural forms back to the "grand white surfaces" of a woman's body.[18]

As is evident in her letters, O'Keeffe was greatly disturbed by these reviews. "I wanted to lose the one for the Hartley book when I had the only copy of it," she wrote Mitchell Kennerley, "The things they write sound so strange and far removed from what I feel of myself. They make me seem like some strange sort of creature floating in the air—breathing in clouds for nourishment—when the truth is that I like beef steak—and like it rare at that."[19] Criticism made her "shiver," she wrote, and gave her "a queer feeling of being invaded."[20] Since 1915 O'Keeffe had been ambivalent about showing her work, fearing that it would be misunderstood and misinterpreted. When that fear was realized in the early 1920s she purposefully changed her style, making it less abstract, more representational. Her choice of apples, pears, plums, and especially flowers, however, only encouraged comment on the sexual qualities of her work. O'Keeffe's letters confirm that she believed that men and women saw and responded to the world in fundamentally different ways, but she did not think that women's art was any more or less sexual than men's. Because she was so distressed by much of the critical writing on her, which was primarily by men, and because she hoped that another woman might see her art more clearly, she solicited reviews from several women.[21] These reviews were not always satisfactory, however.

O'Keeffe tried to inure herself to critical opinion, maintaining that she had, as she wrote to the critic Henry McBride, "a strange oily skin" that protected her.[22] In 1922 when she was upset by one of Rosenfeld's articles, Hutchins Hapgood cheered her when he said that critics were writing not about her art, but "their own autobiography." She explained to Mitchell Kennerley, "it really wasn't about me at all."[23] Throughout her life she never bothered to correct misstated facts or outrageous interpretations, but instead told her friends that she delighted in feeling entirely different from much of what was written about her. She pretended to be unconcerned, but she was not. Her letters show that throughout the 1920s and 1930s she was often not well after the opening of her annual exhibitions, and in late 1932 she was sick for more than a year after she "experimented so publicly" and failed so publicly to complete a mural for Radio City.[24]

O'Keeffe's apparent physical and emotional collapse in 1932 and 1933 forced her to come to a clearer understanding of herself and her limitations. In order to reconcile critical opinion with her own appreciation of herself, she began to develop a distinct and separate public persona. In the same way that Stieglitz's earlier photographic portraits had made her a symbol of the sensuous, "quintessential" woman, his photographs from the 1930s established yet another—that of a sober, aloof, introspective individual with little sense of humor. These depictions of O'Keeffe as a serious, confident,

but stern artist were the portraits she released to the press in the 1930s and 1940s. It was this public image that O'Keeffe projected and cultivated thereafter. In later years when other photographers, such as Yousuf Karsh or Arnold Newman, took her portrait, she continued to adopt the same attitude, even occasionally the same poses, as she had in the portraits made by Stieglitz in the 1930s. Rather than struggle to define publicly her true self, she projected a hard, almost impenetrable facade. In the course of a very long life she allowed herself to be understood first as an intuitive, unintellectual artist and later as a recluse. O'Keeffe's public image was of far less concern to her than her art; as her friend Jean Toomer noted, she liked to pretend "she hasn't a mind."[25] And O'Keeffe herself said that she realized she might "seem very free—a cross between a petted baby and a well fed cow—— but I know a few things."[26]

The letters published here show that O'Keeffe did know "a few things" and that she was a far more complex person than the public image she projected. The letters poignantly reveal her great love for Stieglitz and the landscape of New Mexico, and they speak of her struggle to construct a way of life that would accommodate both. Beginning in the 1930s she devoted half of the year to Stieglitz, living with him in New York or Lake George, and helping him run his last gallery, An American Place; the other half of the year she painted in New Mexico, living in the adobe house she bought at Ghost Ranch. During these later years she became protective of her time to paint, but she was not divorced from the world. She had many friends, both in New York and New Mexico, with whom she spoke her mind, whether to give her opinion of a painting or to express her deep love for a person or place, and she demanded the same honesty in return. Once committed, O'Keeffe was a warm and open person who graced her friends with direct, yet hauntingly beautiful letters. Like her paintings, her letters are deceptively simple; at first glance, she appears to be quite literally describing the world around her. Yet her phrasing, her choice of words, her descriptions of color and form, are so unusual and evocative that when she has finished she has described a world unlike any ever seen before.

Notes

1. O'Keeffe to Alfred Stieglitz, 1 February 1916, letter 8; O'Keeffe to Fiske Kimball, 26 May 1945, Philadelphia Museum of Art Archives; *Contemporary American Painting and Sculpture* (Urbana, 1955), 226.

2. The 125 letters published here were chosen from a total of more than 350.

3. Anita Pollitzer wrote to O'Keeffe on 1 January 1916, Collection of American Literature, Beinecke Rare Book and Manuscript Library, Yale University (hereafter cited as YCAL), telling her that she had shown Stieglitz several of O'Keeffe's drawings, and recounted his response: " 'Why they're genuinely fine things—You say a woman did these —She's an unusual woman—She's broad minded, she's bigger than most women, but she's got the sensitive emotion—I'd know she was a woman—Look at that line . . . tell her . . . they're the purest, finest, sincerest things that have entered 291 in a long while' "; letter quoted in full in Jan Garden Castro, *The Art and Life of Georgia O'Keeffe* (New York, 1985), 30–31. The famous line that Stieglitz is supposed to have uttered on seeing these drawings—

"Finally a woman on paper"—has been added in another hand, not that of Pollitzer, Stieglitz, or O'Keeffe. Whether he said it or not, however, is immaterial because he allowed it to be repeated so often that it became true for him.

4. O'Keeffe to Alfred Stieglitz, letter 13.

5. O'Keeffe to Alfred Stieglitz, letter 13.

6. The similarity between O'Keeffe's prose and that of Gertrude Stein is strong. By late December 1915, early January 1916, O'Keeffe had read Stein's portraits of "Henri Matisse" and "Pablo Picasso" in *Camera Work*, special number (August 1912), 23–25, 29–30, but it is unclear whether or not Stein influenced O'Keeffe's style of writing. Early O'Keeffe letters from 1910 and 1911 are conventional in their use of traditional sentence construction and punctuation; words that she frequently misspelled later in life, particularly "too," are spelled correctly and contractions include apostrophes. By 1915, however, in her letters to Pollitzer, O'Keeffe began to shed some of these conventions; she started using short phrases

instead of full sentences and dashes instead of commas and periods. By late 1915, early 1916, her calligraphy began to grow much looser and freer; phrases were shorter, more impressionistic; and apostrophes, commas, and periods became very rare. This was just when she was reading Stein, but at the same time her art was becoming much looser, more expansive and expressive. Her writing style after 1916 was frequently reminiscent of Stein, particularly her use of the present tense, her almost stream-of-consciousness approach, and her habit of repeating the same idea over and over again until she had clarified it in her mind.

7. Marsden Hartley, *Adventures in the Arts* (New York, 1921, reprinted, New York, 1972), 118.

8. In "Georgia O'Keeffe, American," *Manuscripts* 5 (March 1923), 10, Herbert Seligmann did acknowledge that O'Keeffe was introduced "to modern European expression through the medium of '291,'" but he dismissed this influence and stated that her "very American" art was "unique." It is true that much of the critical writing on O'Keeffe in the 1920s is impressionistic, not historical, but when "facts" are presented they are often misleading and incorrect.

9. Frances O'Brien, "Georgia O'Keeffe," *The Nation* 125 (12 October 1927), 361.

10. Paul Strand [Letter], *The World*, 11 February 1923, Metropolitan section, 11; Seligmann, "Georgia O'Keeffe," 10.

11. O'Keeffe's letters to Anita Pollitzer from the summer and fall of 1915 (YCAL) indicate that she had read such diverse books as Floyd Dell's *Women as World Builders*, Randolph Bourne's *Life and Youth*, Hudson Maxim's *Defenseless America*, H.G. Wells' *Tono Bungay*, a translation of *The Trojan Women*, books by Huxley and Thomas Hardy, as well as studies on *Contemporary Dramatists*, and feminism.

12. Henry McBride, "O'Keeffe at the Museum," *The Sun*, 18 May 1946, 9.

13. Oscar Bluemner, "A Painter's Comments," in *Georgia O'Keeffe Paintings, 1926* [exh. cat. Anderson Galleries] (New York, 1927), unpaginated. For further discussion of the critical reaction to O'Keeffe's work in the 1920s, see Marilyn Hall Mitchell, "Sexist Art Criticism: Georgia O'Keeffe—A Case Study," *Signs* 3 (1978), 681–687, and Katharine Hoffman, "Georgia O'Keeffe and the Femi-

nine Experience," *Helicon Nine, The Journal of Women's Art and Letters* 6 (Spring 1982), 7–15.

14. Paul Rosenfeld, "The Paintings of Georgia O'Keeffe," *Vanity Fair* 19 (October 1922), 112.

15. Lewis Mumford, "O'Keeffe and Matisse," *The New Republic*, 2 March 1927. Stieglitz reprinted this in the exhibition catalogue for the *O'Keeffe Exhibition*, Intimate Galleries (New York, 1928), unpaginated.

16. Louis Kalonyme, "Georgia O'Keeffe: A Woman in Painting," *Creative Art* 2 (January 1928), 35–40.

17. Bluemner, "A Painter's Comments," unpaginated; Hartley, *Adventures in the Arts*, 116.

18. Paul Rosenfeld, *Port of New York* (New York, 1924), 205.

19. O'Keeffe to Mitchell Kennerley, Fall 1922, letter 26. Despite the fact that O'Keeffe disliked this piece by Hartley, Stieglitz reprinted it in the 1923 exhibition catalogue for her show at the Anderson Galleries, New York. In 1924 the art critic of the *Brooklyn Daily Eagle* wrote that as a direct result of this introduction by Hartley the public viewed her exhibition "with suspicion"; 9 March 1924, 2B.

20. Letter 26.

21. O'Keeffe was pleased with Blanche Matthias' review of her work in "Georgia O'Keeffe and the Intimate Gallery: Stieglitz Showing Seven Americans," *The Chicago Evening Post, Magazine of the Art World*, 2 March 1926, 1, 14. In 1925 she had asked Mabel Dodge Luhan to write about her work (see letter 34); however, it was not the kind of article O'Keeffe had envisioned. In "The Art of Georgia O'Keeffe," unpublished manuscript, YCAL, Luhan wrote that the art of O'Keeffe is "unconscious." She "externalises [sic] the frustration of her true being out on to canvases" which receives "her out-pouring sexual juices" and permits her "to walk this earth with the cleansed, purgated look of fulfilled life!"

22. O'Keeffe to Henry McBride, 22 July 1939, letter 78.

23. O'Keeffe to Mitchell Kennerley, letter 26.

24. See O'Keeffe to Dorothy Brett, September? 1932, letter 62.

25. Toomer to Alfred Stieglitz, 21 December 1933, YCAL. He continued, "I don't think she thinks she fools me."

26. O'Keeffe to Dorothy Brett, 12? October 1930, letter 54.

Note to the Reader

All the letters published here are printed in their entirety. Some spelling mistakes have been corrected, but O'Keeffe's idiosyncratic punctuation and erratic use of apostrophes have been retained to preserve the character of the original handwritten letters. Information central to an understanding of the letters has been footnoted; identification of the recipients or other people, places, or events mentioned can be found in the endnotes beginning on page 274.

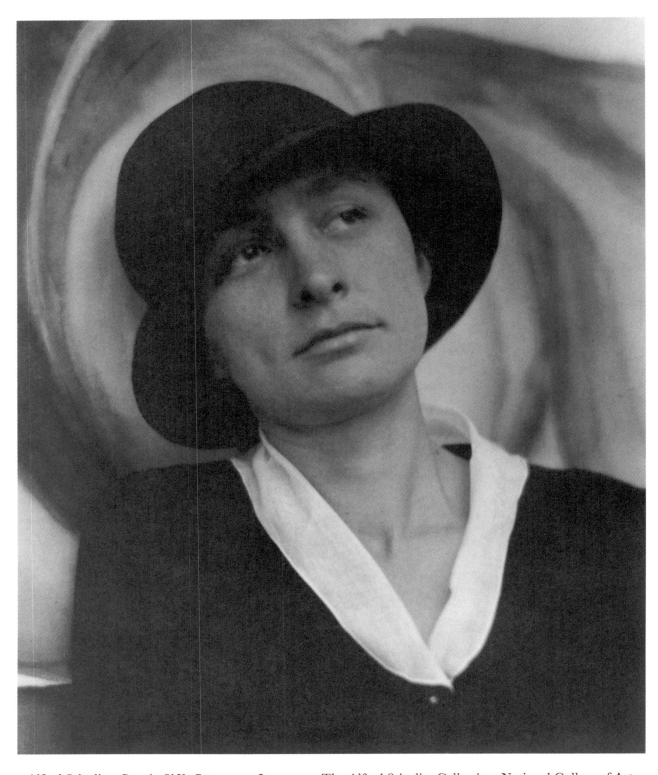

Alfred Stieglitz, *Georgia O'Keeffe at 291*, 1 June 1917, The Alfred Stieglitz Collection, National Gallery of Art

1915-1918

In June 1915, after studying for nine months at Teachers College, Columbia University, Georgia O'Keeffe left New York City. As she had done for the past two years, she returned to Charlottesville to teach in the summer school of the University of Virginia. Later that fall she accepted a position at Columbia College in Columbia, South Carolina, and the following fall she moved to Canyon, Texas, to teach at the West Texas State Normal College. Although she made new friends in these communities, few people understood or appreciated her art, and she was very much alone; but she was not isolated. Her enthusiasm for and commitment to her art, and her curiosity to see and know what others were doing, did not allow her to remain out of touch. Through her correspondence with fellow students from Teachers College, particularly Anita Pollitzer, and later with photographers Alfred Stieglitz and Paul Strand, she was kept fully informed on the latest events in the New York art world. Pollitzer, Stieglitz, and Strand, in their frequent letters to O'Keeffe, described current exhibitions, new paintings, photographs, plays, and operas, as well as music and conversations they had heard. They also sent her the newest publications. O'Keeffe filled her own letters with vivid anecdotes of her life and evocative descriptions of her surroundings, but she also used them to clarify new ideas she was exploring in her art. In 1915 and 1916 she was particularly concerned with incorporating the emotive quality of music into her art. From Arthur Dow, who taught at Teachers College, and from her reading of Camera Work, *Arthur Jerome Eddy's* Cubism and Post-Impressionism, *and Wassily Kandinsky's* On the Spiritual in Art, *she had come to think that because music was non-representational, it was the purest, most direct form of expression. Like so many other artists of her generation, O'Keeffe believed that just as musicians used pure sound and rhythm to evoke emotional states, so too should artists use pure form and color to create what Dow called "visual music." In her letters from Virginia and South Carolina she frequently wrote of her attempts to play the violin so that it would "speak" of her feelings, and just as often she expressed her desire to record the "music" of her surroundings through color and form. By the spring of 1916, however, she worried that her visual music might be misunderstood, that her work was becoming too personal, even hermetic. Her move to Canyon, Texas, in the fall of 1916, eliminated this concern. The west Texas landscape, with its extreme contrasts of color, form, and scale, became the inspiration for much of her art. The solitude of Virginia and South Carolina had given O'Keeffe time to consolidate much that she had learned in the last few years, but Texas gave her an appreciation of nature that would invigorate her art for the rest of her career.*

1. *To Anita Pollitzer*

[Charlottesville, late June 1915]

Dear litttle Pollitzer —— Dont you like little spelled with three ts —— but you are little you know and I like you little but I also like you a lot.

I cant begin to tell you how much I enjoyed your letter —— write me another — wont you? Im sure the Camera Work was great —— why dont you lend me yours for a few days. I'll be very good to it.

I sent you the things I have done that would roll —— I have painted three portraits —— I hate to use that word — I should have said people — or heads or something — but I dont have much time to work — All the things I sent you are only about half done —— Im ashamed of them — guess I didn't spend more than an hour on any of them ——

Tell me — do you like my music — I didnt make it to music — it is just my own tune — it is something I wanted very much to tell someone — and what I wanted to express was a feeling like wonderful music gives me — Mr. Bement liked it very much. I am going to try those hollyhocks again — and not have it so realistic — they are almost gone now so I will have to make them up. —— Of course I don't know about next winter —— it is impossible as you understand

The last time I went up to 291 there was nothing on the walls —— chairs just knocked around — tracks on the floor and —— talk behind the curtain. I even liked it when there was nothing.

Isnt it nice to be a fool ——

Sincerely —

Georgia O'Keeffe

Dorothys address is
Mechanics Falls — Maine — now.

2. *To Anita Pollitzer*

[Charlottesville, 25 August 1915]

Dear Anita:

Thank you for calling me Pat. I like it — It always seemed funny that we called one another Miss.

Your letters are certainly like drinks of fine cold spring water on a hot day — They have a spark of the kind of fire in them that makes life worthwhile —— That nervous energy that makes people like you and I want and go after everything in the world — bump our heads on all the hard walls and scratch our hands on all the briars —— but it makes living great — doesn't it? —— I'm glad I want everything in the world — good and bad — bitter and sweet —— I want it all and a lot of it too — Your letter makes me think that life is almost as good to you as it is to me. I was pretty grumpy when College was over — was tired — got as thin as a rail at summer school but I gained eleven pounds and a half the first two weeks after it was over and expect to keep on gaining five a week for at least two more weeks —— Anyway — I'm feeling like a human being — and thinking all the world is fine again ——

I've been thinking about you and Dorothy (she is not working) going to the League. I would stay with the College if I were you. Alon is a funny little fellow but I like the way he teaches. I just wouldn't take anything for having stumbled around in his class. You have to stumble sometime. You might just as well do it now as anytime. I think you have a better chance of keeping your own way of doing things with him.

Yes he was nice to work with here — I always like him you know — Dorothy would be suspicious at my saying that but I guess you will not. — I am really very fond of him

in a curious sort of way —— I always nearly kill myself swallowing lumps in my throat when I tell him good by —— and he is always so nice and funny. He has been *very very* nice to me — and I just like him. I wouldn't be "arting" now if it wasn't for him — and as it is the most interesting thing in life to me I ought to thank him He told me this summer that I didnt have a bit of respect for him then nearly killed himself laughing. But it isn't so — I really think a lot of him.

Then 291 came and I was so crazy about it that I sent for Number 2 and 3 — and I think they are great — They just take my breath away —— it is almost as good as going to 291. I subscribed to it — it was too good to let it go by —— Had to have The Masses too. I got Jerome Eddy a long time ago — and sent to the Masses for Kandinsky but haven't been able to get it. They said they couldn't find out who published it. Wish you would tell me. — Tell me when you get hold of anything interesting. I got Floyd Dell's "Women as World Builders" a few days ago and got quite excited over it. The professor was very much interested in Feminism —— that was why I read it — and I've been slaving on war books trying to catch up with some of the things he started me on. I've been reading yarns too —— some that he liked that I hadn't read — am on Thomas Hardy's "Jude the Obscure" now and it is very interesting. We had a great time — I have almost a mania for walking and he did too so we just tramped — and tramped and tramped. He gave me so many new things to think about and we never fussed and never got slushy so I had a beautiful time and guess he did too — He stayed over four days after School was over just for some extra walks —— I told him all about you —— He was just interested in everything.

Anita —— talking of 291 — and New York — I am afraid I'll not be there. Maybe you can help me decide. I have a position in Columbia College — South Carolina —— I don't want it — I want to go back to N.Y. I have a notion that I want to go back to the college but I'm not sure —— what do you think? I want to show Mr. Martin what I've been doing and see what he says about it. I think I would have time to work down there by myself but nobody will be interested — It will just be like it is here now. Last week I spent out at Anna Barringers and we worked like dogs. I only have two peculiar pastel landscapes to show for it — one of them I worked three whole mornings on — I don't know what sort of a spell had me — I rather like it — and I also have a fine portrait of her little brother and a lot of other trash —— She doesn't excite or inspire me at all. I like her but miss the artist in her — If she would let loose and really be herself — minus affectation — I believe Id like it better — I believe an artist is the last person in the world who can afford to be affected.

I like the idea of your picture — I wish you would get it down —— no I don't think it silly —— it seems quite the opposite —— Isn't it curious the way we are always afraid someone will think the most serious — earnest ideas we have — are silly —— I am always afraid to show the things that mean most to me — specially the first time.

I am just doing what I want to. Painting on a mass of trees against the mountains

and sky from 4:30 to 6 evenings and in between am just doing what I feel like — Walk for about two hours before breakfast — read for two after that —— then have the rest of the day —— I don't always work — except about an hour — guess I've done something every day —— Have been sewing too — making undergarments — it is lots of fun when you haven't had time to sew for so long.

I was trying to get fat and make a nice realistic landscape —— I was getting such twists in my head from doing as I pleased that it is almost impossible to come down to earth.

I wish I could see you little girl — you are one of the things I hate most to miss in New York. I just don't see how I can stay away — It would probably be good for me to sit down and slave by myself for a year —— I haven't decided yet ——.

 Lovingly —
 Georgia —

I am writing only to you — you know — anything I say about anyone is the same as if it wasn't said isn't it.

3. *To Anita Pollitzer*

[Columbia, SC, 11 October 1915]

Anita

 —— arent you funny to wonder if I like your letters. I was walking up from the little bandbox post office with the mail under my arm — reading your letter this afternoon — and when I came to the part telling what Stieglitz said about "its worth going to Hell to get there" — I laughed aloud — and dropped all the things under my arm

I had gone for the mail because I had worked till — what I thought didnt count — so it wasn't any use to keep on — I read your letter twice then went for a walk with about eight of the girls — it was supposed to be a run — and they were all very much astonished that none of them could keep up with me —— I can run at a jog trot almost as easily as I can walk — and most girls cant you know.

We explored much woods and country and found the quaintest little deserted house imaginable with wonderful big pink and white and yellow roses climbing on it — and funny little garden effects —— all surrounded by great tall pines

It would have been too cold to go without a coat if we hadn't run most of the way —— whenever they had breath —— so you know how great it felt

I came back and read your letter again

Anita — do you know — I believe I would rather have Stieglitz like something —— anything I had done — than anyone else I know of —— I have always thought that —— If I ever make anything that satisfies me even ever so little — I am going to show it to him to find out if its any good — Don't you often wish you could make something he might like?

Still Anita — I dont see why we ever think of what others think of what we do — no matter who they are — isn't it enough just to express yourself —— If it were to a particular person as music often is — of course we would like them to understand — at least a little —— but why should we care about the rest of the crowd — If I make a picture to you why should I care if anyone else likes it or is interested in it or not I am getting a lot of fun out of slaving by myself — The disgusting part is that I so often find myself saying —— what would you — or Dorothy — or Mr. Martin or Mr. Dow — or Mr. Bement — or somebody — most anybody —— say if they saw it — It is curious — how one works for flattery ——

Rather it is curious how hard it seems to be for me right now not to cater to someone when I work —— rather than just to express myself

During the summer — I didn't work for anyone — I just sort of went mad usually — I wanted to say "Let them all be damned — I'll do as I please" —— It was vacation after the winter — but — now —— remember Ive only been working a week —— I find myself catering to opinion again — and I think I'll just stop it.

Anita — I just want to tell you lots of things — we all stood still and listened to the wind way up in the tops of the pines this afternoon —— and I wished you could hear it — I just imagined how your eyes would shine and how you would love it — I haven't found anyone yet who likes to live like we do —

Pat.

Saturday night.

4. *To Anita Pollitzer*

[Columbia, SC, 20? October 1915]

Anita — it has been wonderful weather down here — it would hardly be possible to tell you how much I've enjoyed it — All the little undergrowth in the woods has turned bright — and above — way up high —— the pines — singing — It makes me love everybody I love at all —— almost a hundred times more —— It is wonderful — Thanks for all your trouble about the picture — I sent it — but am having it sent back to me — because after it was framed there was something —— two things to be exact — that I wanted to change — It makes little difference to me whether it gets in or not —— it is not particularly satisfying to me —— I only sent it because I had made up my mind to when Dorothy sent it back to me.

Anita? What is Art — anyway?

When I think of how hopelessly unable I am to answer that question I cannot help feeling like a farce — pretending to teach anybody anything about it — I won't be able to keep at it long Anita — or I'll lose what little self respect I have —— unless I can in some way solve the problem a little — give myself some little answer to it —— What are we trying to do — what is the excuse for it all — If you could sit down and do just exactly

what you wanted to right now for a year — what in the dickens would you do — The things Ive done that satisfy me most are charcoal landscapes -- and ——— things ——— the colors I seem to want to use absolutely nauseate me —

I don't mean to complain — I am really quite enjoying the muddle ——— and am wondering if I'll get anything out of it and if I do what it will be — I decided I wasn't going to cater to what anyone else might like ——— why should I — and when you leave that element out of your work there is nothing much left

Im floundering as usual

Tell me what you think Art is — if you can ——— ask a lot of people — and see if anybody knows ——— What do you suppose Mr. Dow would say —

You asked me about music — I like it better than anything in the world ——— Color gives me the same thrill once in a long long time — I can almost remember and count the times — it is usually just the outdoors or the flowers — or a person ——— sometimes a story — or something that will call a picture to my mind — will affect me like music —

Do you think we can ever get much of it in Art ——— I don't know — anything about anything ——— and Anita Im afraid I never will.

I went to see Forbes Robertson last night ——— Anita — again why don't most of us grow worthwhile personalities instead of the pitiful little things we are

Is it our theory of life that stunts us ——— Most of us are not even respectable warts on the face on the earth —

Anita Im feeling fine and feel as if Im just having time to get my breath and stand still and look at the world ——— It is great sport I am really enjoying it hugely —

Only I would like something human to talk to — like you and Dorothy ——— Of course she is great — she is surprisingly fine — and improves with time —

You can't imagine how much I enjoy your letters — Wont it be great when we meet again ———

The sky is just dripping today and it seems I have never seen or felt anything more perfectly quiet.

Lots of love to you Anita
— Georgia O'Keeffe

5. *To Anita Pollitzer*

[Columbia, SC] December 13—1915

Dear Anita ——— Did you ever have something to say and feel as if the whole side of the wall wouldn't be big enough to say it on and then sit down on the floor and try to get it on to a sheet of charcoal paper — and when you had put it down look at it and try to put into words what you have been trying to say with just marks ——— and then ——— wonder what it all is anyway ——— Ive been crawling around on the floor till I have

cramps in my feet — one creation looks too much like T.C.* the other too much like soft soap —— Maybe the fault is with what Im trying to say — I dont seem to be able to find words for it —

I always have a hard time finding words for anything —

Anita — I wonder if I am a raving lunatic for trying to make these things —— You know — I don't care if I am — but I do wonder sometimes.

I wish I could see you — I cant tell you how much I wish it. Im going to try some more — I turned them to the wall while I wrote this —— One I made this afternoon — the other tonight —— they always seem different when you have been away a little while. I hope you love me a little tonight — I seem to want everybody in the world to —— Anita.

 Georgia

Monday night.

6. *To Anita Pollitzer*

[Columbia, SC, 4 January 1916]

Dear Anita:

There seems to be nothing for me to say except Thank you —— very calmly and quietly.† I could hardly believe my eyes when I read your letter this afternoon — I haven't been working —— except one night — all during the holidays — that night I worked till nearly morning — The thing seems to express in a way what I want it to but — it also seems rather effeminate — it is essentially a womans feeling —— satisfies me in a way — I dont know whether the fault is with the execution or with what I tried to say —— Ive doubted over it — and wondered over it till I had just about decided it wasnt any use to keep on amusing myself ruining perfectly good paper trying to express myself — I wasn't even sure that I had anything worth expressing —— There are things we want to say — but saying them is pretty nervy —— What reason have I for getting the notion that I want to say something and must say it —— Of course marks on paper are free — free speech — press — pictures — all go together I suppose — but I was just feeling rather downcast about it — and it is so nice to feel that I said something to you — and to Stieglitz

I wonder what I said — I wonder if any of you got what I tried to say — Isn't it damnable that I cant talk to you If Stieglitz says any more about them — ask him why he liked them ——

*Teachers College at Columbia University, which O'Keeffe attended in 1914–1915 and in the spring of 1916.

†On 1 January 1916 Pollitzer showed Stieglitz several of the charcoal drawings O'Keeffe had made in 1915 including: *Special No. 1, Special No. 2,* cat. 1, *Special No. 3, Special No. 4,* cat. 2, *Special No. 5,* cat. 3, *Special No. 7, Special No. 8, Untitled,* all in the Estate of Georgia O'Keeffe; *Special No. 9,* cat. 5.

Anyway, Anita — it makes me want to keep on — and I had almost decided that it was a fool's game — Of course I would rather have something hang in 291 than anyplace in New York — but wanting things hung is simply wanting your vanity satisfied —— of course it sounds good but what sounds best to me is that he liked them —— I dont care so much about the rest of it — only I would be interested in knowing what people get out of them —— if they get anything — Wouldn't it be a great experiment —— I'll just not even imagine such luck — but I'll keep working — anyway —

You say I am *living* in Columbia — Anita —— how could I help it — balancing on the edge of loving like I imagine we never love but once ——. Columbia is a nightmare to me —— everything out here is deliciously stupid —— and Anita — I — am simply walking along through it while — something — that I dont want to hurry seems to be growing in my brain —— heart —— all of me — whatever it is that makes me — I dont know Anita — I can't explain it even to myself but Im terribly afraid the bubble will break —— and all the time I feel so ridiculously secure that it makes me laugh

Anita, I cant begin to tell you how much I have enjoyed that Camera Work — It surprised me so much —— and you know how much I love what is inside of it — That Picasso Drawing is wonderful music isn't it — Anita — I like it so much that I am almost jealous of other people even looking at it —— and I love the Gertrude Stein portrait —— the stuff simply fascinates me — I like it all — you know how much without my trying to tell you — The word — food — seems to express what it gives me more than anything else.

We have been having wonderful warm weather —— I have thrown the whole holiday away and am not sorry — Spent most of it outdoors — I don't regret the laziness of it either —

Im feeling fine — never felt better in my life and am weighing the most I ever do —— It's disgusting to be feeling so fine —— so much like reaching to all creation —— and to be sitting around spending so much time on nothing —

Im disgusted with myself —

I was made to work hard — and Im not working half hard enough — Nobody else here has energy like I have — no one else can keep up

I hate it

Still —— its wonderful and I like it too

At any rate — as you said in the fall — it is an experience.

I am glad you showed the things to Stieglitz —— but how on earth am I ever going to thank you or get even with you — I love these Nadelman things too Anita — I just have too many things to thank you for tonight — I'll just have to stop and not try

Goodnight.

Georgia.

7. *To Anita Pollitzer*

[Columbia, SC, 14 January 1916]

Dear Anita:

Thanks for the little cards — I recognize the pups and love the mountains. What am I doing down here —— Why Anita — at times I'm glad and at times I have a Hell of a time —— Thats what I've been having the lately days —— I owe everybody I like to hear from a letter or two or three and haven't been able to write — just couldn't —— so you can be sure I was darned glad to see your letter this morning —— Everything I do looks like dough —— or the devil — I dont know which —— and I dont seem to be able to collect my wits enough to get anything done —— so I started to sew — have almost made a waist —— just have to stitch the cuffs on to finish it and I dont seem to care if they never get stitched — My brain feels like an old scrapbag — all sorts of pieces of all sorts of things ——

Yes — tell Dorothy about the drawings if you want to —— when you want to —— Do just as you please — I dont care a bit —— about anything now — I just seem to be asleep and cant wake up — I'll not tell her — you see I couldn't very well —— you have all the facts —— so do as you please —— I know they look like nonsense to her —— but opinions are always interesting —— Im not sure that it isnt all a fool game —— I'd like to get it either knocked in harder or knocked out. She always tried to knock it out —— Nobody ever tried to knock it in but you —— I had almost decided never to try any more when you showed them to 291 — Yesterday just by accident I found those music things I did with Bement last year and they are certainly different ——

Anita — I'd pack my trunk and leave for half a cent —— I never was so disgusted with such a lot of people and their ways of doing —— I halfway have a new job out in Texas —— hope I get — I'll have a cat and a dog and a horse to ride if I want it —— and the wind blows like mad —— and there is nothing after the last house of town as far as you can see —— there is something wonderful about the bigness and the loneliness and the windiness of it all —— mirages people it with all sorts of things at times —— sometimes Ive seen the most wonderful sunsets over what seemed to be ocean —— It is great —— I would like to go today —— Next to New York its the finest thing I know — here I feel like Im in a shoe that doesn't fit. — So far I've forgotten it by dreaming I guess —— and Im disgusted with dreams now —— I want real things —— live people to take hold of — to see — and to talk to —— Music that makes holes in the sky —— and Anita — I want to love as hard as I can and I cant let myself — When he is far away I cant feel *sure* that he wants me to — even though I know it —— so Im only feeling lukewarm when I want to be hot and cant let myself — It's damnable — but it doesn't matter — so long as its just me ——

Pat.

8. *To Alfred Stieglitz*

Mr. Stieglitz ——

I like what you write me — Maybe I dont get exactly your meaning — but I like mine — like you liked your interpretation of my drawings . . .* It was such a surprise to me that you saw them — and I am so glad they surprised you — that they gave you joy. I am glad I could give you once what 291 has given me many times . . You cant imagine how it all astonishes me.

I have been just trying to express myself — . . . I just have to say things you know —— Words and I are not good friends at all except with some people — when Im close to them and can feel as well as hear their response — I have to say it someway — Last year I went color mad — but Ive almost hated to think of color since the fall went — Ive been slaving on the violin — trying to make that talk — I wish I could tell you some of the things Ive wanted to say as I felt them . . . The drawings dont count — its the life — that really counts — To say things that way may be a relief —. . . . It may be interesting to see how different people react to them. . . . — I am glad they said something to you. — I think so much alone — work alone — am so much alone — but for letters — that I am not always sure that Im thinking straight — Its great — I like it — The outdoors is wonderful — and Im just now having time to think things I should have thought long ago —— the uncertain feeling that some of my ideas may be near insanity — adds to the fun of it —— and the prospect of really talking to live human beings again — sometime in the future is great. . . . — Hibernating in South Carolina is an experience that I would not advise anyone to miss — The place is of so little consequence —— except for the outdoors —— that one has a chance to give one's mind, time, and attention to anything one wishes.

I cant tell you how sorry I am that I cant talk to you — what Ive been thinking surprises me so — has been such fun — at times has hurt too . . . that it would be great to tell you . . . Some of the fields are green — very very green — almost unbelievably green against the dark of the pine woods — and its warm — the air feels warm and soft — and lovely . . .

I wonder if Marin's Woolworth has spring fever again this year . . . I hope it has
Sincerely
Georgia O'Keeffe

I put this in the envelope — stretched and laughed.

Its so funny that I should write you because I want to. I wonder if many people do . . You see — I would go in and talk to you if I could — and I hate to be completely outdone by a little thing like distance.

*The ellipses are O'Keeffe's.

9. *To Anita Pollitzer*

Dear Anita

For the lord's sake — tie a rope around my neck and then get everybody you know — and everyone you dont know to swing onto the other end of it —— because Im going crazy if you dont hold me down and keep me from it. I seem to want to tell you all the world again tonight.

Ive been working like mad all day —— had a great time —— Anita it seems I never had such a good time —— I was just trying to say what I wanted to say —— and it is so much fun to say what you want to — I worked till my head all felt tight in the top —— then I stopped and looked Anita — and do you know — I really doubt the soundness of the mentality of a person who can work so hard and laugh like I did and get such genuine fun out of that sort of thing —— who can make anything like that as seriously as I did

Anita — do you suppose Im crazy? Send me that number of 291 you said you got for me —— if you have a roll for it —— and I'll send you some drawings in the roll —— If I can think to get a roll myself I'll send them before —— because I want you to tell me if I'm completely mad — I look at the stuff and want to feel my own skull — Anita — I get such a lot of fun out of it — I just went down the hall and asked Professor Ariail if he had a paper roll and he said "For goodness sake — whats up now — what have you got in your head — I never saw such excitement in anyones eyes" — just to see what he would say — I took the drawing down and showed it to him — He liked it — and he laughed —— "Why it's as mad as a March hare" — he said — I've been trying to educate him to Modern Art — but had never showed him anything of mine before He didnt have a paper roll — Maybe I can get one tomorrow from someone. I have a notion its the best one I ever made — but Anita — I believe I'll have to stop —— or risk going crazy —

I made one of spring that makes everyone laugh — two people happened to see it — so everyone means two people

Anita — it was great of you to send me that Bakst book — I never enjoyed anything any more and lots of other people have enjoyed it too — I looked at it all the spare time I had the day I got it — I had read a good deal about them — and never was so curious to see anything in my life — Were the costumes as great in reality as they are on paper?

Again I must say — it was great of you to send it to me. Dorothy and I just pored over the Bakst book last year — and I never imagined myself having any one of them in color.

I had a fine letter from Dorothy today too —

The world just seems to be on wheels —— going so fast I cant see the spokes — and I like it.

Goodnight — be happy —

Pat.

10. *To Anita Pollitzer*

[Columbia, SC, 21 February 1916] 11 A.M.–Thursday

Dear Anita

It seems that one ought to be doing something besides writing letters this time in the morning — but it also seems that one isn't.

Your letters and the picture just came in the morning mail —— that was before breakfast.

Last night I was in bed and asleep by 10:30 because I didn't want to say what I wanted to say —— do you get that? I had —— fiddled! all the evening till my fingers were sore — then went to bed in self defense — You see — I just cant help looking at the fool things I make sometimes and wondering if there is any sense to it all. What good is it going to do anyone but me —— to 99 out of a 100 — it would seem wasted time and energy — Maybe the 99 are right —

I got out that Marin number of 291 and put it where I could see it.

This morning — I have been darning stockings —— one pair — There is just one girl working in the other studio so I have had practically nothing to do but darn. I darned all the holes and all the spots that looked as if they might ever wear out and then darned some more —— all on the same pair of stockings — because I wanted to think —— It has been like a scale evenly balanced all the morning. I simply couldn't pull either end of it down — I felt like some sort of a lost soul wandering around in space — unable to find anything to settle on —— something intangible — that I couldn't get a grip on.

The Masses came yesterday — that always makes me feel like a tree pulled up by the roots and left to die in the sun — the old food is gone and the tree hasn't much power to make any.

It's funny —— I like it —— but learning to live is so queer. They start us out in life with such ridiculous notions. —

Finally I finished darning every possible spot of those stockings and went down to my room to get them out of my sight — for fear I'd darn some more on them (I might add that I only darn about three times a year) As I opened the door — I saw the Marin cover — it was on the brown wood of the bureau —— the long needles of a bunch of pine branches I had in a jar hung over it a little —— Anita — it is just like a fine personality in the room — a fine expression of a fine personality —— or Im a damned fool. I believe it is the only kind of stuff there is any sense in — I wasn't thinking about it as I went in the door —— it just jumped up and slapped me in the face. I would like to see Marin — Id like to know him. Do you remember how fine that little blue drawing that hung on the door in the far room last year was — ? — and I was crazy about the Woolworth flying around — falling down —

I wish you had been here Tuesday — I nearly went insane — working ——

Yesterday didn't have time to work — had classes and was busy — The reaction of

the day before was —— wonder and questions —— I rather like not having anyone to talk to —— it has both advantages and disadvantages —— It always takes me three or four days to get normal after I get so excited — . . —

But it's nice to talk to you this way.

I wish I could give you the bunch of little yellow jonquils and feathery green stuff that a girl brought me this morning. They are spring. Things are turning green —— the wheat fields are wonderful —— so very — very green.

Those jonquils are little —— about half the usual size — they seem so fine that one ought not touch them ——

The dinner bell rang ——

People came in to talk afterward ——

Then girls —

And my mood is all gone —— guess I have nothing else to say. Mrs. Robinson — the woman senator from Colorado was in Columbia — talked on suffrage last week —— she was certainly great — funny too.

Pat.

11. *To Anita Pollitzer*

[Columbia, SC, 25 February 1916]

Dear Anita:

Kick your heels in the air! Ive elected to go to Texas and will probably be up next week. I am two hundred dollars short of what I need to finance me through the time I want to spend in N.Y. but if I can't scratch around and chase it up from somewhere I'll go without it —— because I'm going. I'm chasing it — hunting for it at a great rate —

I just had a telegram from the man this morning telling me my election is certain but he wants me to go to T.C. for this term as I understand it —— He says letter will follow —— I'll probably get it Saturday —— Then things will be more definite — The place is certain —— on condition as I understand it —— and I like the condition better than the place — I am not going to tell Dorothy because I want to surprise her — If she has moved write me by return mail —

My head is about to pop open so guess I'll not write any more —— Isn't it exciting! I cant believe it will come true can you?

Pat.

12. *To Alfred Stieglitz*

[Charlottesville, 27 July 1916]

It's nice to think that the walls of 291 are empty ——

I went in a year ago after you had stripped them — and I just thought things on them —— it is one of the nicest memories I have of 291.

That is absurd to say —— I often wondered what it is you put into the place that makes it so nice even when it's empty — just tracks in the dust on the floor and a chair at a queer angle — still it was great and I was glad that I had gone —— glad that I saw no one . . .

No — nothing you do with my drawings is "nervy"*

I seem to feel that they are as much yours as mine —

They were only mine alone till the first person saw them —

I wonder which one it is you want to keep — Some things I cannot say yes or no to right now — I wouldn't mind if you wrote me that you had torn them all up — I don't want them — I don't want even to see them — but I'm not always the same — sometime I may have to tear them all up myself — You understand — they are all as much yours as mine.

I don't care what you do with them so long as I don't have to see them.

It is nice of you to frame what you wanted to — You are a much better keeper than I am

I wonder if you would like to see the cast of the thing I modeled just before I left N.Y.

It's like everything else — I want to show it to you — but — at the same time — hate to show it to anyone — The base is very bad — he didn't fix it as I told him and a lot of it seems lost but still I'm liking it ——.

I'm feeling all right again — Went up to Mt. Elliott Springs above Staunton over the weekend and climbed Mt. Elliott.

I got to the top alone in the moonlight — just as day was beginning to come — it was great — the wind — and the stars and the clouds below — and all the time I was terribly afraid of snakes —

The others slept about a mile below by the campfire —— and I was glad.

Lots of outdoors made me very hilarious —

When I came home and thought about it I was surprised at my foolishness.

I wish I could go in and talk to you this afternoon —

It's great to feel fine again — it seems almost impossible that I'm not apt to go in and talk to you for a long long time — because I want to now.

I've been working some — last week — water colors — and am going to make the weekend if I can get at it before it's gone . . .

It is getting ready to rain — and it's almost time for supper — and I'm going over to my farmer friends afterward —— You remember — the little man from Georgia —— I like his wife

So there seem to be several good reasons why I should not ramble any more —

*O'Keeffe's first public exhibition was at 291 from 23 May through 5 July 1916. Stieglitz exhibited ten of the charcoal drawings that Pollitzer had brought to him in January, along with work by Charles Duncan and Réné Lafferty. Fearing that the unfixed drawings might be damaged, he framed several without first consulting O'Keeffe. She, however, did not think that was "nervy."

Goodnight — I wish I could someway tell you how nice your letters have been — how nice it is that you are.

I wrote the other part of this last night — Today the photographs were here when I came in at noon —— and I am speechless.

What can I say — ? You must just say it yourself.

Wednesday night.

13. *To Alfred Stieglitz*

[Canyon, Texas, 4 September 1916]

Your letter this morning is the biggest letter I ever got —— Some way or other it seems as if it is the biggest thing anyone ever said to me — and that it should come this morning when I am wondering — no I'm not exactly wondering but what I have been thinking in words — is — *I'll be damned* and I want to damn every other person in this little spot — like a nasty petty little sore of some kind — on the wonderful plains. The plains — the wonderful great big sky — makes me want to breathe so deep that I'll break — There is so much of it — I want to get outside of it all — I would if I could — even if it killed me —

I have been here less than 12 hours — slept eight of them — have talked to possibly 10 people — mostly educators — *think* quick for me — of a bad word to apply to them — the *little* things they forced on me —— they are so just like folks get the depraved notion they ought to be —— that I feel its a pity to disfigure such wonderful country with people of any kind — I wonder if I am going to allow myself to be paid 1800 dollars a year to get like that — I never felt so much like kicking holes in the world in my life — still there is something great about wading into this particular kind of slime that I've never tried before — alone — wondering — if I can keep my head up above these little houses and know more of the plains and the big country than the little people

Previous contacts make some of them not like my coming here

So — you see it was nice to get a big letter this morning — I needed it —

I walked and heard the wind — the trees are mostly locust bushes 20 feet high or less — mostly less — and a prairie wind in the locust has a sound all its own —— like your pines have a sound all their own — I opened my eyes and simply saw the wallpaper It was so hideously ugly — I remembered where I was and shut my eyes right tight so I couldn't see it — with my eyes shut I remembered the wind sounding just like this before —

I didn't want to see the room — it's so ugly — it's awful and I didn't want to look out the window for fear of seeing ugly little frame houses — so I felt for my watch — looked at it — decided I needn't open my eyes again for 15 minutes — The sound of the wind is great —— but the pink roses on my rugs! And the little squares with three pink

roses in each one — dark lined squares — I have half a notion to count them so you will know how many are hitting me — give me flies and mosquitoes and ticks —— even fleas —— every time in preference to three pink roses in a square with another rose on top of it

Then you mentioned me in purple — I'd be about as apt to be naked —— don't worry ——! don't you hate pink roses!

As I read the first part of your letter — saying you hadn't looked at the stuff I left for my sister to send you — I immediately thought — I'd like to run right down and telegraph you not to open them — then — that would be such a foolish thing to do

Not foolish to me — or for me — but the other queer folks who think I'm queer

There is dinner — and how I hate it — You know — I ——

I waited till later to finish the above sentence thinking that maybe I must stop somewhere with the things I want to say —— but I want to say it and I'll trust to luck that you'll understand

Your letter makes me feel like Lafferty's paintings —— they made me want to go right to him quick — your letter makes me want to just shake all this place off — and go to you and the lake — but — there is really more exhilaration in the fight here than there could possibly be in leaving it before it's begun — like I want to —

After mailing my last letter to you I wanted to grab it out of the box and tell you more — I wanted to tell you of the way the outdoors just gets me —

Some way I felt as if I hadn't told you at all — how big and fine and wonderful it all was —

It seems so funny that a week ago it was the mountains I thought the most wonderful — and today it's the plains — I guess it's the feeling of bigness in both that just carries me away — and Katherine — I wish I could tell you how beautiful she is

Living? Maybe so — When one lives one doesn't think about it, I guess — I don't know. The plains send you greetings —— Big as what comes after living — if there is anything it must be big —— and these plains are the biggest thing I know.

My putting you with Lafferty is really wrong — his things made me feel that *he* needed.

Your letter coming this morning made me think how great it would be to be near you and talk to you —— you are more the size of the plains than most folks — and if I could go with my letter to you and the lake — I could tell you better — how fine they are — and more about all the things I've been liking so much but I seem to feel that you know without as much telling as other folks need.

14. *To Anita Pollitzer*

[Canyon, Texas, 11 September 1916]

Tonight I walked into the sunset — to mail some letters — the whole sky — and there is so much of it out here — was just blazing — and grey blue clouds were rioting all through

the hotness of it — and the ugly little buildings and windmills looked great against it.

But some way or other I didn't seem to like the redness much so after I mailed the letters I walked home — and kept on walking —

The Eastern sky was all grey blue — bunches of clouds — different kinds of clouds — sticking around everywhere and the whole thing — lit up — first in one place — then in another with flashes of lightning —— sometimes just sheet lightning —— and sometimes sheet lightning with a sharp bright zigzag flashing across it ——.

I walked out past the last house — past the last locust tree —— and sat on the fence for a long time — looking —— just looking at the lightning —— you see there was nothing but sky and flat prairie land — land that seems more like the ocean than anything else I know — There was a wonderful moon ——

Well I just sat there and had a great time all by myself — Not even many night noises — just the wind ——

I wondered what you are doing ——

It is absurd the way I love this country — Then when I came back — it was funny —— roads just shoot across blocks anywhere — all the houses looked alike — and I almost got lost — I had to laugh at myself — I couldnt tell which house was home ——

I am loving the plains more than ever it seems —— and the SKY — Anita you have never seen SKY — it is wonderful —

Pat.

15. *To Anita Pollitzer*

[Canyon, Texas, 18 September 1916]

Anita — I wonder what the El Greco does to you —

My eyes just keep going over it — from one part to another —— all over it —— and then over it again — and I want to see it really — it keeps me moving

I'm reading Willard again.

Last night I couldn't sleep till after four in the morning —— I had been out to the canyon all afternoon — till late at night — wonderful color —— I wish I could tell you how big —— and with the night the colors deeper and darker — cattle on the pastures in the bottom looked like little pin heads — I can understand Pa Dow painting his pretty colored canyons —— it must have been a great temptation — no wonder he fell

Then the moon rose right up out of the ground after we got on the plains again — battered a little where he bumped his head but enormous —— —— There was no wind — it was just big and still —— so very big and still — long legged jack rabbits hopping across in front of the light as we passed —— A great place to see the nighttime because there is nothing else ——

Then I came home — not sleepy so I made a pattern of some flowers I had picked — They were like water lilies — white ones — with the quality of smoothness gone

Sunday afternoon

My sister writes that she still has the photographs —— I hadn't addressed them and she forgot whom to send them to but she sent the paintings — I hope you get them —— I've made some of the rottenest things you ever saw since I've been out here. I keep them in my trunk and just take them out and wonder about them once in a while —— I want to show them to you —— This thinking alone is great but it is puzzling. When I looked at them today it seemed almost as if someone else had made them and I wondered why.

Anita —— Im so glad Im out here — I can't tell you how much I like it. I like the plains —— and I like the work — everything is so ridiculously new — and there is something about it that just makes you glad youre living here —— You understand —— there is nothing here — so maybe there is something wrong with me that I am liking it so much.

Yes —— I moved from the pink roses — I only spent two nights with them.

Anita — while you are in New York — if you have time will you go up to the Metropolitan and spend this ten dollars for the West Texas State Normal? The whole place here burned down three years ago —— they just moved into this building in April and have practically no library — and nothing for my department but Dows Composi- tion — Apollo — Caffins — "How to Study Pictures" — and not more than three or four other books besides the International Studios for the past three years — Craftsman and some other fool thing — School Arts Magazine or something of the sort.

If you know of any books on rugs or furniture — worth getting — tell me — They will get most anything within reason I think — I don't want to ask for too much this year but one of the best on both rugs and furniture will get by I think. I've decided on some other stuff but don't know about those —

What I want you to do with this ten is to get some photographs of textiles — Greek pottery and Persian plates —— or if you come across anything you think would be better for teaching —— get it instead — those came into my mind first. I have two beginners classes in design — at least that is what I am aiming to teach them —— and one in costume design —— in six weeks I am going to have one in Interior Decoration —— Dont know exactly how Im going at it — but Im on the way. They will have planned a house when they come to me to furnish it —— At any rate I think that is the way it goes. — 12 hours work a week now —— 16 hours when I begin the next class. My cos- tume people all seem to be pretty smart — they are mostly seniors — Isn't it funny Anita. I have to laugh at myself —— but I like it.

If you haven't time don't bother about the photographs but if you have time I would like so much to have you get them — Haven't heard from Dorothy for a long time but I'll ask her if she goes back and you haven't time — Wonder if she is going —

Pat.

16. *To Anita Pollitzer*

Dear Anita:

Guess I havent written you for a long time but you know —— sometimes the Devil just gets me by the ears and this time he pulled them out of joint and I've been so surprised and amused that I've just been looking on laughing — so of course didn't do anything else.

I had to give a talk at the Faculty Circle last Monday night —— a week ago yesterday — so I had been laboring on Aesthetics — Wright — Bell — DeZayas — Eddy — All I could find — everywhere — have been slaving on it since in November —— even read a lot of Caffin —— lots of stupid stuff — and other stuff too —— Having to get my material into shape —— Modern Art —— to give it in an interesting 3/4 of an hour to folks who know nothing about any kind of Art —— Well — I worked like the devil — and it was a great success —— You see — I hadn't talked to the faculty at all and I was determined to get them going —— They kept me going all through the time allotted to the man who was to come after me and an hour after it was time to go home — and some of them wanted me to talk again next time —— It was funny — I planned to say things that would make them ask questions — Really —— I had a circus It was so funny to see them get so excited over something they had doubts about the value of ——

But that isn't all — You know that kind of reading and thinking takes one very much off the earth

—— So imagine my astonishment to have a mere — ordinary — everyday man pull me out of the clouds with two or three good yanks and knock me down on the earth so hard that I waked up. I met him at a party Xmas time —— next time I went to town he followed me around till I was alone then asked if he could come up — I said — No —— thinking we had absolutely no interests in common —— but he looked so queer — I changed my mind right quick and said he could —— then held up my hands in holy horror wondering what I'd do — So — The first time he came because I didn't want to hurt his feelings — and the next time because I wanted to explain something I had said the first time —— And then my landlady informed me that she objected to my having anyone come to see me at all —— and I nearly died laughing because — I had begun to enjoy the problem of trying to talk to him — It was so impossible that it was funny — He is prosecuting attorney in the court here —— Yale — etc — but you see I am almost hopelessly specialized — and had been thinking and reading and working so specially hard on a specialized line that there wasnt much else in my brain —— so I practiced on him — he was a fair sample of the mind Id have to tackle in Faculty Circle —— and he seemed interested — but I couldn't imagine why —

The night the old lady said she didn't want anyone to come any more — he was

coming —— and Anita —— I had written Arthur such a funny letter the day before — and Stieglitz that morning

When he came — I had to tell him right away about the old lady and that he couldn't come anymore — it was so funny —— And you know I cant move Anita because there isnt any place to move to — I have had rooms engaged for over a month in a house that's being built

Well —— he said —— lets not stay here lets ride so I got my coat and hat —— and off we went —

We rode a long time —— it was a wonderful lavender sort of moonlight night — — Went out to some hills in a canyon draw that I wanted to see at night and stopped facing the hills

It was really wonderful — only someway he isn't the kind you enjoy outdoors with —— he spoils it —— I was in a wildly hilarious humor —— We got out and walked a long way — It was warm —— almost like summer — When we got back in the car we sat there talking a long time —— I was leaning forward — looking over toward the hills telling some yarn — and bless you —— when I sat back straight — his arm was around me —— Jingles — it was funny — we argued — we talked — we all but fought —— and he couldn't understand because it amused me so —— I almost died laughing — Of all the people in the world to find themselves out at the end of the earth —— The barest hills you ever saw in front — nothing but plains behind —— beautiful lavender moonlight — and that well fed piece of human meat wanting to put his arms round me —— I wonder that the car didn't scream with laughter —— and still I wouldn't get mad because he was so darned human and it was so funny ——

— Anyway — it tumbled me out of the clouds — sort of stupefied me — it was two weeks ago tonight — I have been thinking more than I've been doing —— Then too there has been the problem of Summer School to decide — 9 weeks work $340 or $450 looks very good —— so does 3½ months doing as I please — Va wrote and asked me back and I answered but know they won't give me what I want —— I don't want to go back anyway.

—— Many things to make me think —— or try to think —— and very little doing —

Tonight I'm doing up all my work —— am going to send it off in the morning —— You or Stieglitz will get it —— I dont know which — wont know till I address it

Im going to start all new ——

It has snowed for almost three days — is great out ——

I looked at the moon many times the night of the eclipse — it was wonderful here too. Goodnight

I read this over —— Have been walking in the snow —— its wonderful out —— cold dark.

—— When I had read it over I said to myself —— hardly worth sending its so stupid

It doesn't sound funny when I write it —— but in reality was so funny when it happened —— I had almost forgotten about it till I thought of writing you —— curious the way things that happen start you thinking of other things —— made me restless —— want people — I've talked more than usual with the girls and boys —— Have been teaching in the first and second grades — training school — just because I want to — . . . cracked I guess

17. To Paul Strand

[On train from New York to Texas, 3 June 1917]
Sunday — nearly noon

Very green out the window — grass almost unbelievably green — trees darker — indifferent — mostly quite aways off — the near grass so very green — Ive been reading your book — just finished Childhood — The last hour or so is the first that I haven't simply stared stupidly into space — I doubt even if Ive been thinking — dont know what Ive been doing — I looked at it many times — wondered why I didn't read — In Kansas City I wanted to so began.

I've been liking it — liking it very much —— several times the wish that you were by me — reading it with me — came —— Then I shut it and saw the green and thought I must tell you of it

And Ive been wanting to tell you again and again how much I liked your work — I believe Ive been looking at things and seeing them as I thought you might photograph them — Isn't that funny — making Strand photographs for myself in my head

So — I am thanking you for much — I think you people have made me see — or should I say feel new colors — I cannot say them to you but I think Im going to make them

I saw my brother in Chicago — He has enlisted in the officers camp of engineers at Ft. Sheridan — is hoping to be one of the first from there to go to France — and doesn't expect to return if he goes —

A sober — serious — willingness appalling — he has changed much — it makes me stand still and wonder — a sort of awe — He was the sort that used to seem like a large wind when he came into the house

I understand how it has happened — I understand your feeling about it You are both right — I say I understand you both —— is it true though

Do I understand anything, I do not know

Greetings

18. *To Anita Pollitzer*

[Canyon, Texas, 20 June 1917]

It is the end of your first day at Virginia I wonder how you have liked it —

Im sure it has seemed funny to you.

My summer work here is great It seems that Im liking it even better than the winter work.

Maybe — I dont know

You see —— being in N.Y. again for a few days was great —— I guess I did as much in the ten days as I usually do in a year —

Dorothy is looking better than last year — Her work different in color —— warmer —— really wonderful —— only she hasnt worked hard enough —— always off spots. She has improved herself —— grown

Great as usual ——

Bement is married —— An actress quite pretty —— about 35 I imagine —— Sells his pictures so he says

He likes the combination of wife and agent

Martin same as ever —— A bit discouraged over his work because he doesn't get much encouragement from the college Of course that is natural

Aline — I only saw one night —— we walked in the rain in the park for a couple of hours —— till after twelve.

I just couldnt get to see her again — She is great too Its nice to know that she is in the world —— if there were only more like her —

Every one at the College is giving an emergency course of some kind.

Arthur? Oh —— Things happened —— really fine ——

He is on some Advisory board in Washington now He improves and he doesnt — Queer — I sort of feel that I have gone past I dont know. I doubt if I would have let him know I was there if Dorothy hadn't insisted ——

He is really pretty fine — I had a great letter a few days ago —— The greatest he ever wrote me —— I cant exactly explain It would take such a long time and Im in a hurry.

Stieglitz —— Well —— it was him I went up to see —— Just had to go Anita — There wasnt any way out of it —— and Im so glad I went. 291 is closing —— A picture library to be there —— Pictures to rent out —— He is going to have just one little room 8 × 11 to the right as you get out of the elevator —— Just a place to sit he says —— I dont know Its all queer —— But Anita Everything is queer ——

He has a new Wright and I saw another one —— both Synchromist things that are wonderful —— Theory plus feeling —— They are really great I met him too He is a little over medium size but looks glum diseased — physically and mentally

— Id like to give him an airing in the country —— green grass — blue sky and water — clean flowers — and clean simple folks.

Walkowitz new work is much better —— I like it much better anyway —— change in the work —— in me too probably

Marins is like bunches of flowers ——

—— Why Anita I had a wonderful time.

Did you ever meet Paul Strand —— Dorothy and I both fell for him

He showed me lots and lots of prints — photographs —— and I almost lost my mind over them — photographs that are as queer in shapes as Picasso drawings — He is to be the subject of the next Camera Work ——

I hope you have met him —— he is great

Met another man I liked Gaisman —— inventor of the Auto-Strop Razor and Auto-graph Camera —— whatever that is — He took Stieglitz and Strand and me to Sea Gate then to Coney Island Decoration Day —— It was a great party and a great day —— Dorothy wouldnt go —.

19. *To Paul Strand*

[Canyon, Texas, 25 June 1917]

Sunday morning — a little breeze — cool feeling air — very hot sun — such a nice quiet feeling morning — strips of green — blue green — pale hazy — almost unbelievably beautiful — out of my window — it startled me when I first saw it — it isnt often hazy here — Ive been to breakfast — brought it to my sister — went for the mail — had a ride —— got your package — the little prints — its eleven oclock —— I wish you could see the nice color out of my window — The little prints — I looked at them a long time — moved around — did other things and came back to them — picked them up again and again — and found myself unconsciously looking off into space every time before I put them down — I see — its almost as though you are sitting by me — silent — yet telling me so many things — I want — just to reach my hand out to you and let you hold it — Can you understand that — its different from telling you in words what they say to me — in a way it is much more real — maybe thats why I want to touch people so often — its only another way of talking

You see — when I saw the large prints — they made me see you better — what was in the prints must be in you —— then it was a marvelous discovery — that that could be in anyone now —— feeling more definitely what is in you — what you are — your songs — that I see here — are sad — very wonderful music — quieting music of the man I found — a real living human being — and the man I found in the big prints — You would not be what you are to me at all if I had not seen the part of you that is in the big prints — These little ones are merely songs that the man I have come to know is singing

I feel that you are going to do much more wonderful things than any of us have seen yet —— that you are only just beginning.

The little prints make me conscious of your physical strength —— my weakness — relatively but that in spite of it — in spite of my weakness I give you something that makes it possible for you to use your strength — or should I say express it

Is that why I wanted to put my hand in yours as I looked at them — I don't know

Do you understand a little

The look in your eyes that startled me so was the day you and Walkowitz showed me his things —— I had just run from eyes — I had run like mad only to find a glimmer of the same thing in new eyes — so I looked away — wondering wasn't there any place to get away from that look — from folks that feel that way about me

My fault — yes — maybe

However — it doesnt matter now

Nothing matters much — Its nice to have your songs

I almost went to sleep here — was sitting on my bed and lay down to think

20. *To Paul Strand*

[Canyon, Texas, 23 July 1917]

Its Sunday — almost supper time — I read all morning and slept all afternoon — Funny — I waked up every little while — looked at the time to see if it was time to stop sleeping — if the afternoon was over yet — So hot to go any where — and I had hardly slept at all for two nights — This morning I was up at daylight — Watching the sun rise — When that seemed rather stupid I began darning stockings and I very seldom sew at all — its so much trouble — however sometimes when I want to think — sewing helps — I always have to laugh at myself when I sew — it seems so funny — I almost continued sewing this afternoon instead of sleeping — it seems such a waste of energy that I seldom feel that I can afford it — I hated your letter early in the week — hate was my mood I guess for I just read it again and it is really beautiful

That morning I hated any one who simply stood and felt — I wanted them to *do* I dont know what — I guess I despised you for sitting somewhere — a long way off and simply telling me that you felt instead of acting — It wasnt just you either — It was other folks telling me the same thing — Some writing it to me — some telling it to me — till I hated them all — not that I would have you not write me — How can I tell it to you — how explain

Your letter yesterday was tremendous I started to read it on the street — caught my breath and stopped — put it in the envelope — then in a few minutes took it out again and read it all — Its night — a new moon — I've been riding for a long time — a wonderful evening — but I didn't enjoy it — I wonder why Im writing to you — would I

like to see you — it doesn't seem that I'd care much about it tonight — Things other folks have made me feel — make one sick feel sick —— things they do because they like me — People so often treat the thing they like so queerly — isn't it funny —. Ive been looking at your Camera Work — read your article again — and I like it — think its fine — Then I went for a drink — on my way downstairs thinking of your work — I love the little snow scene

Why you know I love it all The prints you sent me — the bowls — the shadows
Why say I like one or two

I like them all — some more than others — some I hate while I like your letter — your work — the same to me — I wonder if you would be the same if I saw you sometimes and I hoped you would have patience with my grouchy mood

Goodnight.

21. *To Paul Strand*

[Canyon, Texas, 24 October 1917]

Paul —

The best way I can tell you how your letter this morning and the article on 291 made me feel is to tell you that I love you like I did the day you showed me your work ——

Love you both armsful — Or is it what you say that I love ——

Anyway its great — and I hope it goes into print quick.

291 having come into a persons life makes one wonder how on earth the folks who havent known it have been able to grow up —— and how they worry **along.**

Right here I looked up and Greens History of England — open at its description of Queen Elizabeth caught my eye — and I picked it up and read a long time — then sat — just thinking

? Black — yes its black — and Paul — I think I love that too . . . — Your poem I mean — Ive just read that too — and I seem to remember the one you wrote me last summer too —— I'll hunt that and read it again.

You are great too — Isnt our little mutual admiration tendency amusing.

22. *To Paul Strand*

[Canyon, Texas, 15 November 1917]

At home again

Three letters from you waiting in the post office — Ted at the station — going to war — aviation.

I send these other sheets because they are written — were real when written

There is no hesitancy in what I feel for him — We meet equally — on equal ground — frankly freely giving — both — You pull me in spite of myself —

Ive talked in Faculty Meeting — a rearing snorting time — it was amazing to me
— I just knocked everybodys head against the wall and made hash —— and told them
what I thought of school teachers and their darned courses of study and raised a time
generally —

It was an event — Rather surprising too — to have the whole bunch each old chap
and each old girl — most all of them anyway — come up and squeeze my hand or my
arm and pat my back — when I had half way expected they might not speak to me after
the things I said — I half way expected to be run out of the room — I talked for conser-
vation of thought — in the child and student — education for the livingness of life rather
than to get a certificate —— That teachers are not living — they are primarily teachers

War is killing the individual in it unless he has learned livingness — if he had it he
wouldn't be a good soldier

Art never seemed so worth while to me before

I have a million things to do

Must paint too

Must write too

Im on the War path at such mad speed — against their hate and narrowness — it
makes me laugh. And they seem to be with me — its funny.

Havent time to write more but I certainly gave the old boys and girls a good jolt —

They laughed and they clapped and they looked at one another in amazed wonder
It was great to just Knock things right and left and not give a DAMN.

Goodnight.

23. *To Elizabeth Stieglitz [Davidson]*

[Canyon, Texas, January 1918]

Your letters are nice

—— No nice isnt the word They are wonderful — it would be great if you were
here to talk to would you get up and leave the stupid maddening sort of folks —

— There is really no place to go to or would you stay and fight it out — Really
nothing to do but stay — nothing really makes me move yet You will laugh if I tell you
what the last piece of excitement is over —— it seems to be growing as the days go by
— and its really so funny Some Xmas cards at the Drug Store that I asked the man
not to sell —

Its so funny — I have to laugh every time I think of it but it seems this whole town
is talking about me —— Not patriotic.

One had a statue of liberty on it and a verse that ended with something to the effect
that we wanted to wipe Germany off the map — I said it was utterly incongruous and
proGerman propaganda

The others — some statue of liberty — and a verse with something about hating the Kaiser — Both entirely against what they all profess to believe as the principles of Christianity —— and certainly not in keeping with any kind of Xmas spirit I ever heard of

The good Christians are up in arms

— It happened about three weeks ago and the gossip is beginning to have a great flavor — so fine that its coming back to me — I was perfectly unconscious for a long time — it was just that I didn't want the students to buy cards like that — I never dreamed of folks talking

I dont care about what they say about me — but its amazing to see what is in their heads — thats what riles me so —

Ive sat here a long time — a dog barking — The night very still —— a train way off rumbling and humming Ive heard it a long time —— I dont know whether it is coming or going

I guess its coming

I dont seem to have anything else to say — except the only thing I had to say even in the beginning and havent said yet

It is simply — that it looks as though the War is going to last a long time and I dont see how Im going to be able to stand folks It shows them up so queerly so rottenly — so pitifully — and so disgustingly

Sunday night — no Monday morning

When I turned out the light and lay down last night — I saw a star out the window Laughed and slept

I wonder if the star was there before and I couldn't see it

24. *To Elizabeth Stieglitz [Davidson]*

[Lake George, 15 August 1918]

Morning — the big porch toward the Lake Quiet — We walked to the village and back —— No — I forgot —— we went in the car and walked home — Rested on the lawn He is developing out in the barn

I [am] here to write some letters Ive wanted to write Ive thought to write you often — When I think of you it is always with a feeling of — Thank you very Much — We are very happy here —— I was never so happy in my life*

*In June 1918 O'Keeffe moved from Texas to New York at the urging of Stieglitz, his niece Elizabeth Stieglitz [Davidson], and Paul Strand. Soon thereafter she and Stieglitz began living together. This letter was written during O'Keeffe's first visit to the Stieglitz family's summer house in Lake George, New York.

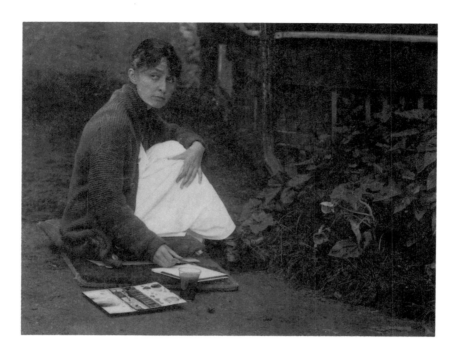

Alfred Stieglitz, *Georgia O'Keeffe*, 1918, The Alfred Stieglitz Collection, National Gallery of Art

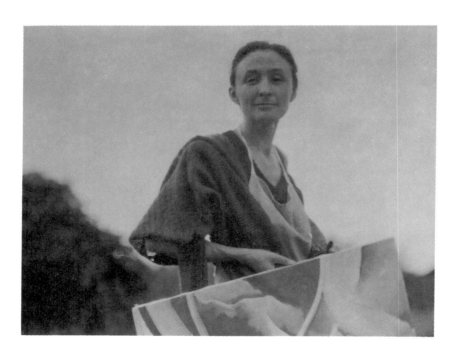

Alfred Stieglitz, *Georgia O'Keeffe*, 1921, The Alfred Stieglitz Collection, National Gallery of Art

1919–1929

Between 1919 and 1929, while O'Keeffe was living in New York with Stieglitz, the number of letters she wrote diminished significantly. Her circle of friends, on the whole, was Stieglitz's: Arthur Dove and his wife, Helen Torr, Paul and Rebecca Strand, John Marin, Charles Demuth, Waldo Frank, Herbert Seligmann, and Paul Rosenfeld. Living in and around New York, they saw each other frequently during most of the year. When O'Keeffe and Stieglitz were at his family's summer house in Lake George, New York, O'Keeffe let Stieglitz keep in touch with their friends, occasionally including her greetings in his letters. (The two notable exceptions were her brief but intense correspondence between 1923 and 1925 with the writer Sherwood Anderson, and a sustained exchange of letters with Ettie Stettheimer, which lasted to the late 1940s.) Although most of O'Keeffe's letters from this time were in response to exhibition reviews, to acknowledge letters or gifts, or to ask favors, several themes emerge. After each of her exhibitions during the 1920s, O'Keeffe was subjected to a great deal of public scrutiny, much of which she found wrong, misleading, and disturbing: "the things they write sound so strange and far removed from what I feel of myself," she wrote in 1922. In response, she became concerned with defining herself, not to answer her critics or correct misstated facts, but to clarify for herself such basic questions as who she was and how she responded to the world, who she was in relation to Stieglitz and the other artists associated with him, and how her art was similar to or different from theirs. She increasingly wrote of herself as an intuitive or subjective person who responded quickly, without premeditation, to people, events, and places. Stieglitz, on the other hand, she saw as someone who thoroughly analyzed every situation from every point of view before he acted; he did consciously things that she did subconsciously. The dichotomy that she saw between herself and Stieglitz—between the intuitive-subjective and the rational-intellectual—became for her symptomatic of a larger, more fundamental difference between men and women, and by extension, between men's art and women's art. Stieglitz had for many years affirmed a similar belief and undoubtedly influenced her thinking, but for O'Keeffe the issue took on a sharper edge, more of a sense of urgency. She came to believe that many male critics overlooked and overemphasized certain aspects of her art, and this led her to solicit critical writing from women.

25. *To Doris McMurdo*

Lake George, July 1st – 1922 –

Your letter this noon was certainly a surprise — And you are right — I seldom write letters — It isnt that I haven't time as much as the fact that I haven't the inclination — Today however — I have been writing reams — My left hand has a bee sting that swells up the back of it and a sprain that swells up the wrist — I stuck a rusty nail in my knee — so altogether Im quite mutilated — and thought to complete the misery of swelling and a rainy day with letter writing long delayed —

Im afraid that if I dont answer you immediately it may be a very long time — so its lucky the letter came today.

Every time I think of that page in Vanity Fair I just want to snort — its only redeeming feature is the line at the bottom of it — I mean at the bottom of the page —

There was something about me in the Dial for December 1921 and a reproduction

of one of my things — later this year — I imagine in the autumn — Vanity Fair is going to have an article on me with five illustrations I think — At any rate they say they are — but I never believe anything till it happens —.

I am sorry to hear that you are not well — have not been well —. You were such a husky looking youngster —.

Anita is married — lives in New York and has a very nice little girl of five —

— Ida — finished her training at Mt. Sinai — New York — Last year — spent the winter in Virginia — teaching — but is nursing now — She is too husky and healthy looking for any good use — but makes a specialty of taking care of herself — she rides horseback every morning — and is kind to herself in general — a wonderfully nice person —

I simply go along — I had two exhibitions in New York — at 291 Fifth Ave — one in 1915 — and one in 1917 if I remember rightly — Since then I have shown a few things occasionally at different mixed exhibitions — I may have a big one next winter — but I cant get very much excited over it because its lots of work about frames and hanging and publicity — and I dont like publicity — it embarrasses me — but as most people buy pictures more through their ears than their eyes — one must be written about and talked about or the people who buy through their ears think your work is no good — and wont buy and one must sell to live — so one must be written about and talked about whether one likes it or not — It always seems they say such stupid things —.

— July 4th —

People came unexpectedly and interfered —— My hand and knee are better

I am here for the summer probably — It is very beautiful — too perfect really —

I was in Maine early in the spring —— in May — and that was wonderful — right on the ocean before any summer people were there — It was cold — but really wonderful — If I hadn't things that I want to finish here from other years I would much prefer Maine — but there are friends here too and it works out this way — I hope you are much better very soon — Sincerely

 Georgia O'Keeffe

26. *To Mitchell Kennerley*

[New York, Fall 1922]

Dear Mitchell Kennerley:

When I untied the package yesterday and saw the little blue book I was the most surprised person you can imagine —— and so pleased — that it embarrassed me —*

You see Rosenfeld's articles have embarrassed me — I wanted to lose the one for the Hartley book when I had the only copy of it to read —— so it couldnt be in the book. The things they write sound so strange and far removed from what I feel of myself

*Kennerley sent O'Keeffe a blue scrapbook with two articles by Paul Rosenfeld, from 1921 and 1922, pasted into it.

They make me seem like some strange unearthly sort of a creature floating in the air — breathing in clouds for nourishment —— when the truth is that I like beef steak — and like it rare at that.

Hapgood came in when I was reading Rosenfelds article in the Dial — I was in a fury — and he laughed — He thought it very funny that I should mind — telling me they were only writing their own autobiography — that it really wasnt about me at all —

So — what could I do about it ——

The little book looks so clean and fine — I'll paste things in it but Im sure — every time I do it — it will shiver and have a queer feeling of being invaded the way I do when I read things about myself —

Stieglitz sends you greetings —— he was quite as pleased as I was — maybe more so —— He has had great pleasure in the feeling that he has for you — that you have given him — and that is much to me — I have often wanted to tell you — but didn't know how without disturbing you —

Sincerely —

Georgia O'Keeffe —

27. *To Henry McBride*

[New York, February 1923]

My dear Henry McBride:

After a week of my exhibition I took myself to bed with the grippe — it was the day before your advice about the nunnery came out in the Sunday paper — or I might have chosen the nunnery instead

— However — six days in bed with the grippe is a fair substitution for a nunnery — and I had plenty of time to think about my sins —.

Your notice pleased me immensely — and made me laugh —. I thought it very funny —. I was particularly pleased — that with three women to write about you put me first —— My particular kind of vanity — doesn't mind not being noticed at all . . . and I dont even mind being called names —— but I dont like to be second or third or fourth — I like being first — if Im noticed at all — thats why I get on with Stieglitz — with him I feel first — and when he is around — and there are others —— he is the center and I dont count at all

Now these are secrets — and dont you tell all New York about it or everyone will know how to hurt my feelings — and I'll have to get a new set —

— One more thing I must tell you — Marin brought his new work over last week — and the first day I was out of bed Stieglitz brought it to me to look at (first) I spent the whole day with it —

I think it by far the best he has ever done — Several wonderful sail boats — I feel

like going out and robbing someone for him — So he wont have to worry about money —.
I wanted to spend all that I got from my show on them — Stieglitz laughs at me — but
he is quite as excited himself ——

You must see them soon — I'd like to send one of the sail boats to get you — but
you will probably have to come up some other way —

There are wonderful houses too — and a great sea — You must see them soon

Sincerely — and thanks again for the notice

　　　Georgia O'Keeffe

I must add that I dont mind if Marin comes first — because he is a man — its a different
class —

28. *To Sherwood Anderson*

[Lake George, 1 August 1923?]

Dear Sherwood Anderson:

This morning I saw an envelope on the table Stieglitz addressed to you — Ive
wanted so often to write you — two things in particular to tell you — but I do not write
— I do not write to anyone — maybe I do not like telling myself to people — and writing
means that.

First I wanted to tell you — way back in the winter that I liked your "Many Mar-
riages" — and that what others have said about it has amused me much — I realize
when I hear others speak of it that I do not seem to read the way they do — I seem to
— like — or discard — for no particular reason excepting that it is inevitable at the mo-
ment. — At the time I read it I saw no particular reason why I should write you that
I liked it — because I do not consider my liking — or disliking of any particular conse-
quence to anyone but myself — And knowing you were trying to work I felt that opinions
on what was past for you would probably be like just so much rubbish — in your way
for the clear thing ahead — And when I think of you — I think of you rather often —
it is always with the wish — a real wish — that the work is going well — that nothing
interferes —

I think of you often because the few times you came to us were fine — like fine days
in the mountains — fine to remember — clear sparkling and lots of air — fine air

And the letters you have written Stieglitz the last few months have helped much over
difficult days — The spring has been terrible and when we got here he was just a little
heap of misery — sleepless — with eyes — ears — nose — arm — feet — ankles — intes-
tines — all taking their turn at deviling him — one after the other —— and it is only
the last few days that he is beginning to be himself again — I had almost given up hope
— It was rather difficult — in a way he is amazingly tough but at the same time is the
most sensitive thing I have ever seen — The winter had been very hard on him — The

nerves seemed tied up so tight that they wouldnt unwind — So you can see why I appreciated your letters — maybe more than he did — because of what they gave him — I dont remember now what you wrote — I only remember that they made me feel that you feel something of what I know he is — that it means much to you in your life — adds much to your life — and a real love for him seemed to have grown from it

And in his misery he was very sad — and I guess I had grown pretty sad and forlorn feeling too — so your voice was very kind to hear out of faraway and I want to tell you that it meant much — Thanks —

Sincerely

Georgia O'Keeffe

I can only write you this now because things are better.

29. *To Sherwood Anderson*

[Lake George, September 1923 ?]

Its a wonderful morning — The leaves are turning — crickets singing — most summer people gone home —— there is no sun but its warm and fine — We have been having perfect days of perfect quiet sunshine — working lots — and I feel like singing —

My sister is here —— she is a nurse — and is like nothing else that ever grew — She keeps the house very gay with wild flowers — and amuses Stieglitz much — You have never seen anything funnier — An old woman Katherine who was Stieglitz mothers maid is here too —. She does many things — and likes to do them — We all spend most of our time alone — each tending to his own particular job — and get on wonderfully — it is a very amusing household —

— Stieglitz is in great form — working like a beaver — taking great strides ahead as usual — and in quite a happy frame of mind — His work is always a surprise to me —. One feels there can be nothing more for him to do — and then away he goes — shooting way ahead just like the last time.

— A great boy —

I wish you could see the place here — there is something so perfect about the mountains and the lake and the trees — Sometimes I want to tear it all to pieces — it seems so perfect — but it is really lovely — And when the household is in good running order —— and I feel free to work it is very nice. — You must sometime come.

Yesterday Stieglitz and I walked for the mail — there was a letter from Huebsch saying he was mailing proof sheets or something of your book — we waited a long time for the package window to open — and it wasn't there yet — He has been speaking of it every day — wondering when it will come —— We very much enjoyed the parts that came out in Phantasmus — I was particularly amused — you see — I grew up to the

age of 13 in Wisconsin — then lived in the South after that — and a lot of the things you write about seem very familiar to me — and the way you have mixed what is today with the middle west of your childhood — amuses me much —— The way you make parts that I feel sure are yarns — seem a reality even to yourself — and the picture of your father —— then your feeling that you are your fathers son — then the seriousness of your story after telling how you are your fathers son —

It all amused me much and I wondered how much you yourself took it all seriously — or was it partially unconscious —

I wonder do I make myself clear — It isn't important that you answer me —— I do not mean to ask it as a question that you should answer — Probably my pleasure was in the wondering — and I can only answer it for me — Probably the artist never knows himself about such things.

After the noon meal —

I want to say that what I wrote this morning has probably more to do with me than with you — It is something Ive been thinking of the past week — I havent read your new book — Stieglitz has been busy with it — enjoying it — reading me a little in spots —

I guess Im full of furies today — I wonder if man has ever been written down the way he has written woman down — I rather feel that he hasn't been — that some woman still has the job to perform — and I wonder if she will ever get at it — I hope so —.

Again greetings from both of us.

— Next morning —

Ive been thinking of what you say about form —. And either I dont agree with you — or I use a different way of thinking about it to myself — Maybe we mean somewhat the same thing and have different ways of saying it —

I feel that a real living form is the natural result of the individuals effort to create the living thing out of the adventure of his spirit into the unknown — where it has experienced something — felt something — it has not understood — and from that experience comes the desire to make the unknown — known — By unknown — I mean the thing that means so much to the person that he wants to put it down — clarify something he feels but does not clearly understand — sometimes he partially knows why — sometimes he doesn't — sometimes it is all working in the dark —— but a working that must be done —— Making the unknown — known — in terms of ones medium is all absorbing — if you stop to think of form — as form you are lost — The artists form must be inevitable — You mustn't even think you wont succeed —

I feel a sort of fury when you say that you wont succeed — I want to shake you to your senses — shake such an idea out of you for always — Whether you succeed or not is irrelevant — There is no such thing — Making your unknown known is the important thing — and keeping the unknown always beyond you — catching crystalizing your simpler clearer vision of life — only to see it turn stale compared to what you vaguely feel

ahead — that you must always keep working to grasp — The form *must* take care of its self if you can keep your vision clear —— I some way feel that everyone is born with it clear but that with most of humanity it becomes blasted — one way or another

You and I dont know whether our vision is clear in relation to our time or not — No matter what failure or success we may have — we will not know — But we can keep our own integrity — according to our own sense of balance with the world and that creates our form —

What others have called form has nothing to do with our form — I want to create my own I cant do anything else — if I stop to think of what others —— authorities or the public — or anyone — would say of my form I'd not be able to do anything

I can never show what I am working on without being stopped — Whether it is liked or disliked I am affected in the same way — sort of paralyzed —.

I seem to be ranting on here at a great pace I seem to feel incensed that you dont treat the thing that is yourself as the simple fact of yourself — there it is — just you — no great excitement about it if you take a good look at it — a very simple fact — the only thing you have — keep it as clear as you can — moving — there are several million of us — have we all a *form*?

Im getting twisted

Greetings

Georgia O'Keeffe

30. *To Sherwood Anderson*

[New York, 11 February 1924]

Dear Sherwood Anderson:

Last night I sent you a night letter — and I am wondering if you have it this morning — I have intended writing you for a long time but there is something about New York that makes me feel more and more dumb as the days go by. — I had some enthusiasms when I came from the country but now they seem to be just memories and if I am to use them at all it seems that it must be done with an effort of the will — mind — rather than all of me moving naturally from the inside out — all of me working to- gether —. I seem to feel lucky if I can get any one part of me to work in any one time in any direction —

So — when I came from the country I wanted to have an exhibition — a small one —— And wanting it I started for it — I wanted it to confirm what started last year.

Well — when you really start after anything — you usually get — not what you start after but something similar to it — if you get anything at all And in this case — instead of a small exhibition of my own it has developed into two small exhibitions — Stieglitz and I are both showing our work of this year in the rooms I had last year. They are to be two separate exhibitions — He in the two smaller rooms — I in the larger one. There are to be

two separate catalogues — His prints of this year are all 4 by five inches all of the sky. They are very wonderful — way off the earth all but four or five that are of barns and snow. — He has been writing on the statement for his catalogue for two days — it is like his others — very direct — with a real kick to it —

I have had a cold — and have been shut up in my room since I knew the event was to take place — and nothing goes on in my head — His is the continuation of a long fight —— Mine — My work this year is very much on the ground — There will be only two abstract things — or three at the most — all the rest is objective — as objective as I can make it — He has done with the sky something similar to what I had done with color before — as he says — proving my case — He has done consciously something that I did mostly unconsciously —— and it is amazing to see how he has done it out of the sky with the camera —.

I suppose the reason I got down to an effort to be objective is that I didn't like the interpretations of my other things —— so here I am with an array of alligator pears —— about ten of them — calla lilies — four or six — leaves — summer green ones — ranging through yellow to the dark somber blackish purplish red — eight or ten — horrid yellow sunflowers — two new red cannas — some white birches with yellow leaves —— only two that I have no name for and I dont know where they come from — Altogether about forty things — and — When I realize that I have asked you to write something for my catalogue — I must laugh of course — I dont want you to write anything about this exhibition — I am only telling you about it because I think it will interest you — I only want you to write anything you want to about anything that is — You see — you are read — this part of the world is conscious of you — a book has a much better chance than a picture because of its wide circulation — so the picture has to send out the printed word to get people to come and look at it —

———————

Since sitting here writing this to you I have an idea that I may be able to get into shape to use myself —— in case I do not hear from you or possibly to use with yours — it bothers me a bit to think that I may have turned your mind off the track of your own work

I may be able to get something down — I dont know —

Yes. I do know I will because Im going to start on it to clarify it for myself when I finish this — but I probably wouldn't have found a starting point so readily if I hadn't written this to you. Stieglitz had a cold a while back and was very down but is over it and with excitement ahead is very chipper — Its great to see the way ideas fly around once he gets started. — I dont think the show will be as hard on him this year as it was last year.

At any rate I am hoping so.

Be glad you are in Nevada and not in New York — Greetings from the two of us —

Sincerely

Georgia O'Keeffe

31. *To Sherwood Anderson*

[Lake George, 11 June 1924]

My Dear Sherwood Anderson:

Its Wednesday — June 11th — And Stieglitz and I are alone again on the hill at the lake — We are more alone than before because old Fred who has been here on the place for 38 years — died this winter — For the first time we are really masters of the house and so far we have managed wonderfully — Stieglitz of course was much worried that we couldn't get along — I didn't worry at all because I knew we would get along — As a matter of fact — I couldn't for the life of me see why we shouldn't get along and if we couldn't manage one way we could another. Of course I haven't always had Fred — and Stieglitz has — that is probably why he worried and I didn't — We have been here six days — The house is clean enough to live in — I got a man and got a lot of odd jobs done in about three hours that would have taken Fred at least two months — a garden is planted — the ground had to be plowed too — it is all planted — excepting potatoes — they go in tomorrow — and now Im painting and praying for rain. I like to dig — and I got a man who comes after his regular eight hour a day job is over — He works as hard and as fast as I would like to work myself — and that is a pretty good pace — Altogether I am not missing Fred — He never did anything that he could possibly avoid doing and then he didn't do it until he had to — He wouldn't like it if he could see how well we get along without him —

I dont think I was ever so glad to get to the country before — and I was never so glad to have a house to come to and feel that I can sleep and eat and have a bath — a hot one every night — and know that I dont have to move for at least a few months — I hope five or six.

It seems we have been moving all winter — Stieglitz has to do everything in his mind so many times before he does it in reality that it keeps the process of anything like moving going on for a long time — It really isn't the moving with him. It is many things within himself that he focuses on the idea of moving — He has to go over and over them again and again — trying to understand what it is that he is and why — in relation to the world — and what the world is and where is it all going to and what it is all about — and the poor little thing is looking for a place in it — and doesn't see any place where he thinks he fits

— Well — I dont know whether I fit or not but I do know that if I dont cook the dinner we wont have any and when it is eaten if I dont wash the dishes — Well Stieglitz always tries but he is so absent minded he throws the left over scraps of bread and cheese — crusts he wouldn't eat — back into the bread box and wipes the dishes and puts them back into the draining rack as though they were still wet — I almost think that left to himself he would absent mindedly throw away the dishes because they are dirty — I have to laugh — He tries to help because he has a theory about doing things for your-

self — But it isn't really worth putting his mind on it — He just doesnt know how — His material for working hasn't come yet and he walks around like a forlorn lost creature — I am very busy — because I know things have to be done — just the ordinary drudgery that goes with living — Ive never had any theories about liking to do it — or wanting to do it — or that I ought to do it — but when its here to be done and no one else to do it — I can do it — and I dont mind — As a matter of fact I rather like it after that nightmare of New York.

Here at least the lilacs are in full bloom — and the grass is tall and soft and wavy everywhere — the mountains are a fine green — it almost seems finer than the autumn — and best of all — we are alone —

Stieglitz misses people — but I don't think he even cares much about that — He is amused that I am liking it all so much — I think he will get to work earlier this year than usual — He is certainly in much better condition than he was when we came up last year — but he is a forlorn little soul — I do what I can — but I have to keep some of myself or I wouldn't have anything left to give

Living is so difficult — almost too difficult

Do not think from what I write that I am blue — I am having my few great days of the year when there is no one around and I can really breathe — I dont know why people disturb me so much — They make me feel like a hobbled horse — Being alone is good for Stieglitz too — He doesnt get excited — he reads a little — writes letters — and pokes around, a funny little soft grey creature

Greetings to you — from us both

I wanted to write you in the city often but couldn't —— It wasnt nice — it was cracked and torn and bent and a little moldy

Here there is a whippoorwill — and the air is sweet with lilacs — the grass all tall and soft — it looks a bit deserted but I even like that — It is the first time I have come here that I have really liked it —
Good night

I go so hard all day that I ache all over by night — and I like it — It makes me sleep — and in the city I dont sleep well — You dont appreciate sleeping till you haven't slept well for a long time —

 Georgia O'Keeffe

32. *To Sherwood Anderson*

[Lake George, 11 ? November 1924]

The thermometer touches zero — the pipes all freeze. And when you have run around to them all with a tea kettle of boiling water and thawed them out — and the sun shines and the wind blows a gale —

The boxes are all gone — boxes of work and material in general — Trunks are packed — Why you feel great — Two days ahead to make you feel you are living before you leave for the city —

The lake is like metal — its steaming too The mountains are bare — Stieglitz hasn't been feeling well

He is better this morning — Today better than yesterday — yesterday better than the day before — so I feel quite on the top of the world —

What you say about what other people will paint because of what I paint doesn't bother me at all — If it wasn't something that is very much in the world — nobody would be trying to put it down — No one would be interested in it —

I am much excited over my work this year — Up here it looks great to me — I have no idea of what I will see when I see it in town — I dont mean that I think it great — —— I mean it has given me a great time and some of it I enjoy very much — and I really dont often enjoy my own things —

Its great here this morning. I wish you could see it —

 — Georgia OKeeffe

33. *To Henry McBride*

[New York, March 1925?]

My dear Henry McBride:

— You are good! and I laughed at what you did to me — We are going to send it to Hartley —— so that he sees what you say about those who live abroad —

— As for myself —— My optimism betting against Stieglitz pessimism seems to be winning again — and I enjoy winning — tho I think I am always prepared to lose —

— The show goes well — if being jammed and selling enough to pay my bills and then some more is an indication — and the "events" move along with the rest of it —

—— All this I only know by hearsay — Stieglitz telling me — I have been in bed with the grippe and a nurse for five days —— Today am up for the first —

Such time would seem wasted to me if it wasn't that things like those big calla lilies — and others much larger are apt to get a footing at such times —— And that New York business goes round in my head — I am sure I wouldn't have such a hard time to get hold of it if I had always lived up here looking out at it

If I could just get down all Im thinking about while Im sick those calla lilies would look like a mere speck — and my NewYorks would turn the world over — but — fortunately — or unfortunately — I lose a lot of it before I can do anything about it — so it is usually only remnants that finally appear ——

— I hope you are well

My mind is quite foggy — and writing makes me very hot —

— But I wanted to tell you how much we enjoyed your page — and how much I laughed at myself —

Sincerely

Georgia O'Keeffe

34. *To Mabel Dodge Luhan*

[New York, 1925?]

Mabel Luhan:

About the only thing I know about you — from meeting you — is that I know I dont know anything. — That I like — because everybody else knows — So when they say — "Dont you think so?" I dont think so — I dont think at all because I cant. — No clue to think from — except that I have never felt a more feminine person —— and what that is I do not know — so I let it go at that till something else crystalizes

Last summer when I read what you wrote about Katherine Cornell I told Stieglitz I wished you had seen my work — that I thought you could write something about me that the men cant —

What I want written — I do not know — I have no definite idea of what it should be — but a woman who has lived many things and who sees lines and colors as an expression of living — might say something that a man cant — I feel there is something unexplored about woman that only a woman can explore — Men have done all they can do about it. — Does that mean anything to you — or doesn't it?

Do you think maybe that is just a notion I have picked up — or made up — or just like to imagine? Greetings from us both — And kiss the sky for me —

You laugh — But I loved the sky out there

Georgia O'Keeffe —

35. *To Ettie Stettheimer*

Lake George, Aug. 6–25

That I haven't written you isn't because I havent thought of you — As a matter of fact I think I have thought of you every day. There was a very funny dream about you and Florine the first week or so we were here —

You came to visit us and Florine brought six single burner oil cook stoves which she insisted upon having placed in a solid block on the floor in the middle of her bedroom — she was so afraid of being cold — The room was the room I slept in when I was a child — so small that my brother and I slept together — I have forgotten most of the rest of it —

The reason I didn't write you before is that I have been lame since we came up till about a week ago — I was vaccinated a few days before coming up and it affected the glands in my hip so that I couldnt walk — It was most annoying — so I just went dumb and dont think I had much of a thought or feeling of any kind — I just sat around — and wanted to throw anything handy at anyone who said I looked better — because I always felt the same — felt fine — but I couldn't walk

—— So — the ground hog ate the transplanted sunflowers — the potato bugs ate the potato vines — the hail storm ruined the tomatoes, the beans and the corn — They used my circular saw to trim a tree — They cut the whole top off the only early apple tree to improve the view for the other house —— and now wonder why we dont have applesauce like last year — I caught Stieglitz cutting — or trying to cut wire with my pruning shears — The first person we got to cook went to visit her uncle on Sunday and sprained her ankle — Rosenfeld tried to cook and he fell down in the lake and sprained his so Stieglitz had to stew the peaches and bake the potatoes for a day or two — Then we got another woman — her husband didn't want her to come so she had to be driven home every afternoon to get his supper before she got ours. She put onions in the salad and no Stieglitz could risk that — The next one we got weighs near 200 and after the first day I found her sobbing into the potatoes and scrambled eggs because she had no one to talk to when she was through working —

Since then we have had enough people to keep her busy all the time and she is all right — She is very clean so I could say my daily prayers of thanksgiving to her and not mind a bit —

We had two yowling brats here for six weeks who carefully kept anyone from tasting their food or having anything resembling peace or conversation at table — Except for breakfast — Stieglitz, Rosenfeld and I ate that alone with great pleasure and appreciation — till the toaster short circuited — shortly after that Kreymborg and his wife came to live in a room that we are not using usually — It opens on a sleeping porch so I guess they live with relative peace away from the rest of us — They only eat breakfast with us and it is still pleasant — Stieglitz sister — Mrs. Schubart arrived yesterday — and I thank my stars that she eats her breakfast in her bed —

The closets are cleaned — the attic is cleaned — the wood room is cleaned, there is a new oil hotwater heater — The garbage is finally being buried where you dont have to walk past it if you walk most anywhere — The much needed shelf is put up in the back bathroom — that iron bed in the attic is painted — also the back porch of that little house across the way and the benches — The benches are not all the same color green because when we went to get a second can of it they didn't have a second can of that color —

Just like this paper

You see why I didn't write — Someone had to attend to all these things — Stieglitz passed a kidney stone and is feeling better — When he wasn't busy with that he was busy

with that other hot water heater we had in the cellar before we got the new one — And once in a while he ran after a cloud — and sometimes he caught it —

My present worry is that the road has been almost washed away by the heavy rains — and our young man — named Irving Young — who does our chores and odd jobs and hopes to go to China or South America as a missionary next year — wont work in the rain and when ever he gets ready to work on that road it rains — He has a new six week old wife and I guess she wont let him out in the rain — He is huge — but Im grateful to him too like I am to the fat cook — because in spite of there being four men on the place every one looks terribly worried and distressed and helpless at the idea of heaving a block of ice into the ice box — and he doesnt mind lifting ice — He only seems to cringe at the idea of tons of crushed rock —

The dock is wobbly on the end — and the water washes over it when ever it wants to — There are no steps going down into the water so it must be rather uncomfortable to go bathing — I dont know — I haven't tried it yet — Lame women dont swim — It will hold the boat — and that is all that interests me at present — When I get ready to go bathing I'll have to create some steps for the dock —— or else get my stomach wet sooner than I want to ——

I have decided that next summer I am going to tent on that 366th island that they talk about here — The one that only comes up for leap year — with the hope that there wont be anything on it to attend to —

Where there wont have to be a new barrel for oil and I wont have to hunt for the keys to the reservoirs that someone misplaced while I wasnt around — and the carving knife isn't as apt to be in the barn as in the dining room

— And the worst of it all is that I am feeling so dumb that I dont seem to mind having such stupid things to do —

Dont ever let yourself be vaccinated unless you really want to disintegrate both physically and mentally —. I am very well — I have one painting and have yards of failures dropped around me in bunches — They are so stupid I dont even destroy them

Why bother about paintings — No one but myself gets a grouch over them

It isn't at all comparable to having to try to remember to order the meat for dinner in time to get it cooked — and also to try to remember to tell both men who bring eggs that we got five *very very* bad ones the other day and we dont know which one of them brought them to us — All the things I write of are things that upset someone else ——

So it goes — This may seem a bit foolish and scratchy — Most of it was written on a truck at the station yesterday while I waited for the train — Stieglitz had gone to the city to have his eyes treated —

He wishes me to send greetings to you and your sisters — and after reading this you will know that if I am fond of you I am hoping that the mechanics of living through the summer are easy and pleasant — for you all —

Georgia O'Keeffe

36. *To Blanche Matthias*

My dear Blanche Matthias:

Thanks for the paper and the article — A strange woman brought it in to Stieglitz one morning before we knew it was out — She was so excited she had to come to see what you were writing about.

I think it one of the best things that have been done on me — and want very much to thank you —. It was nice of you to think of doing it at all — and the spirit of it is really fine —

I wish you could see the things on the walls — Since the 291 exhibitions I havent had anything as sympathetically cared for — Being Stieglitz own place the things seem to feel at home —

———————————

The page before this was written days ago — and I am sorry it did not go to you. Your letter to us both this morning — sends this to you tonight —

A pile of the papers with your article on the front page are in the room. People often pick it up and read it and sometimes ask to carry it away — When they ask for it he always says yes — that is what they are there for.

Really very fine things are happening in the room — if you could see it I am sure you would like being a part of it — Stieglitz always seems more remarkable — and he brings remarkable things out of the people he comes in contact with —

I feel like a little plant that he has watered and weeded and dug around — and he seems to have been able to grow himself — without anyone watering or weeding or digging around him —

I dont quite understand it all We will talk sometimes — I have two new paintings of New York that I think are probably my best paintings. They seem to surprise everyone —

We have seen Bragdon — just a little —— We are very busy — and — I guess I am particularly busy with myself — It must be so just now —

I hope you are caring for yourself — giving yourself a chance — Something in you must quiet down so that you can get well — I wish I could help you

I am learning something myself — I dont know exactly what it is — but if I did — if I could put it clearly into form it would cure you ——

— That is worthy of a laugh — but I am sure it is true —

— Georgia O'Keeffe —

37. *To Waldo Frank*

[Lake George, Summer 1926]

I have just read the article on the Jew in the Menorah that you sent Stieglitz

I was much interested — Maybe not as much in the article as in something I feel you trying to do with yourself —

As I sat here — many things going through my mind about you and what I had just read — One thing — thought — growing out of another too fast to write them down — I want to tell them to you but they go too fast. I am one of the intuitives — or subjectives — or whatever you call the type of person who comes to quick and positive decisions — and then sometimes — when it interests me — have to work for days or weeks or months to find out why I came to those decisions — Mostly I dont bother about it because I dont seem to have time — So my opinions I always count as of no value — real value — for anyone but myself — And it amuses me that I even have the desire to offer them to anyone —

Dont think that I really underrate my way of thinking — or moving into the world — or whatever you want to call it — It is just my way of being — and I have just wits enough to know that if you really sift to the bottom any more reasonable approach to life or any particular problem — it really isnt any more rational than mine is

So — in spite of all this — or maybe because of it I want to tell you that of all the workers I know — excluding Stieglitz who isnt in our class at all — and Marin — who isnt of our world at all — He is creating his own world without very much contact — almost none at all —

You are mixing with that vile hash of so called thinkers and workers — working with it — playing with it — being of it — and consciously trying to come out whole — Sometimes you seem to get out almost all of you but your feet I dont see anyone else getting so far out —— I rather am inclined to think you will make it some day — and get out and walk around in the sun — unsmeared — You may not know it when it happens — I may not see it You see — you will not know it because you will be thinking of other things — It will happen *to* you — not *for* you — and will happen *for* others if you can keep your direction clear

—— Remember me to Tom — I am glad things are going well

Georgia —

38. *To Waldo Frank*

[New York, 10 January 1927]

The light on the river is very bright this morning

— and I am wondering if you are leaving tonight —. As I told you I havent forgotten that I was intending to write you —— I do not seem to be crystalizing anything

this winter — Much is happening — but it doesn't take shape —— The only sign of shape that I can see is that after I have talked with anyone — I have felt more like the lash of a stinging whip on life — than anything else — and I dont think I like it.

My exhibition goes up today or tomorrow — It is too beautiful —

I hope the next one will not be beautiful

I would like the next one to be so magnificently vulgar that all the people who have liked what I have been doing would stop speaking to me — My feeling today is that if I could do that I would be a great success to myself — I had halfway hoped to have a talk with you before you go — if it had happened naturally it could have happened — I haven't felt like making even half a step toward anyone —. — Maybe — partially because I am not clear —— am not steady on my feet

I have come to the end of something — and until I am clear there is no reason why I should talk to anyone —

You have touched very critical happenings in my life several times without knowing it — Your book was one of them —

I dont seem to be able to think or feel of it in terms of liking or disliking — It is there — and that is all there is to it — And I feel that your intention toward me was more kindly than toward anyone else in the book — that is — there seemed to be more of a warm kindly feeling — and less of the knife for me than for most of the others —

I do not want particularly to thank you for the book — that seems relatively unimportant — I am simply glad that you *are* something sharp — and alert — working. Where you are makes no difference — so long as you have the peace — and the urge for work —

Sincerely —

Georgia OKeeffe —

I will be thinking of you and wishing you well —.

39. *To Henry McBride*

[New York] Sunday – Jan. 16 – 27 –

Thanks for the notice in the Sun — I like what you print about me — and am amused and as usual dont understand what it is all about even if you do say I am intellectual

I am particularly amused and pleased to have the emotional faucet turned off — no matter what other one you turn on.

It is grand —

And all the ladies who like my things will think they are becoming intellectual — Its wonderful And the men will think them much safer if my method is French

I will phone you to spend an evening with us sometime soon — if you would like to
Sincerely
 Georgia OKeeffe —

It is a grand page — I really feel much relieved because I am terribly afraid of you

40. *To Ettie Stettheimer*

<div align="right">Lake George – Sept. 21 – 28</div>

Dear Ettie:

Last night I wrote Florine and I think I haven't had time to address and send it to her — Stieglitz wanted me to write you that he would have written if he had not been sick — particularly concerning the Lawrence book —— that he understands how you feel about it but that he disagrees with you — That in time you will disagree with yourself and Lawrence will be the same old hero —

 —— Well — I enjoyed it —

He told me to write you other things — I dont remember what they are — I dont remember much — It is night and the crickets are singing — the wind blows — I suppose it is even lonely here — I like it when I know there is no one near by — and that it is all dark and uninviting outside — Stieglitz seems a little better today — just a little — he will not own up to it — it is hard to tell —

I have thought often to write you during the summer — we both enjoy your letters — and here I sit — scribbling along with not a thought in my head — unless strained spinach, peas, beans, squash — ground lamb and beef — strained this — five drops of that — a teaspoon in a third of a glass of water — or is it half a glass — pulse this — heart that — grind the meat four times — two ounces — 1 oz. — ½ zweibach — will all those dabs of water make up 2 qts — is this too hot — that white stuff must be dissolved in cooler water — the liquid mixed with hot — castor oil every 15 minutes and so on — divide those 25 — or is it 21 ounces into 5 meals — until the girl who helped me grind and measure and rub the stuff through the 2 sieves actually got hysterical laughing about it

I almost feel as though I'm not doing all these wonderful things myself — but just looking on — If I really am doing all these things that I see happening — Im quite efficient — I recommend myself to anyone who is ill —

Good night —

Dont be sorry for me — I'm very busy — and learning a great deal —

Stieglitz complains about various things today so Im quite sure he is better —

 —— G —

Stieglitz asked me what I wrote you — I told him — and he asked — "did you tell her that I am disgusted with myself — much disgusted?" — I said no — And he said well you add that

41. *To Mitchell Kennerley*

Dear Mitchell:

Alfred tells me you are going away tomorrow — Thursday —

I want to tell you that my good — my best wish for you goes with you —. I want to tell you about the paintings too —. First the yellow one —— I always look forward to the Autumn — to working at that time — When Stieglitz was so sick last fall it was difficult to put that aside — and continue what I had been trying to put down of the Autumn for years — But as I walked far up into the hills — through the woods — one morning — it occurred to me that the thing I enjoy of the autumn is there no matter what is happening to me — no matter how gloomy I may be feeling —— so I came back with my hickory leaf and daisy — to paint something that I know is — no matter what people do to me or anyone else —— I also enjoyed making it reach up by the way I made it reach out —.* To me it is a particular triumph because everybody and everything about me seemed to be particularly in the way of my doing anything

— The barn is a very healthy part of me — there should be more of it — It is something that I know too — it is my childhood — I seem to be one of the few people I know of to have no complaints against my first twelve years —— The pink dish with the city is frankly my foolishness —— but I thought to myself — I am that way so here it goes — if I am that way I might as well put it down — The Lily — ? Why — it just has to be painted with red in time†

—— I see my little world — as something that I am in — something that I play in — it is inevitable to me —

But I never get over being surprised that it means anything to anyone else —

— I like it that you like it —

With Love

 Georgia.

42. *To Henry McBride*

I would like to write something on this to you — but to save my life I dont know what it could be —

So I will make it as simple and encouraging as possible —— first — I hope your cold is better —— Secondly — I wanted to send you grapes or oranges or something

Yellow Hickory Leaves with Daisy, 1928, oil on canvas, The Art Institute of Chicago.

†Three paintings are mentioned in this paragraph: *Red Barn, Wisconsin*, 1928, oil on board, private collection;
East River from the Shelton, 1928, cat. 61; and *Single Lily with Red*, 1929, oil on panel, Whitney Museum of American Art.

when I heard that you had a cold — but I didn't dare — it was so near my exhibition that I was just plain afraid of your suspicions.

The encouraging note that I want to add is that I hope not to have an exhibition again for a long — long —— long time.

Even if you have a cold — maybe that will make you feel a little better

Georgia OKeeffe —

43. *To Blanche Matthias*

[New York, April 1929]

Dear Blanche Matthias:

Your letter of March 13th. came just a few days after I had called your hotel to ask you to go to a Hofmann concert with me. I was sorry — still am sorry — that I did not get you because it was one of the two beautiful — *really* beautiful — concerts that I heard during the winter. Your letter is very dear — very nice to have — It makes me happy to know that you are.

I am sending — by this mail — your address to a girl friend in Chicago. She is one of the rare girls that I know. Ethel Tyrrell — She suddenly seems to have the idea that I might be able to do murals for the Chicago Fair and offers to try to find out about it. I am writing her that you might help her. I know you will enjoy her whether anything comes of the Murals or not. From what we hear of the Fair it seems doubtful whether it will really come off or not — but I have such a desire to paint something for a particular place — and paint it *Big* that I move toward this even though I feel dubious about its really happening.

— If I can keep up my courage and leave Stieglitz I plan to go West the beginning of next week for two months. It is always such a struggle for me to leave him.

I plan to return and be with him in the country from the first of July on.

If you are in Chicago and would give me your telephone number I may see you when I go through if you like. If there is no chance to paint anything there I will probably not stop except between trains.

My love to you Blanche — and my greetings to your husband.

Demuth is on the wall at the Room now — a retrospective show — very fine — Only maybe I begin to feel that I want to know that the center of the earth is burning — melting hot.

Georgia —

1929–1946

In the spring of 1929 O'Keeffe, then forty-two, went to New Mexico for four months. She had been away from Stieglitz before in the 1920s, when she spent time in Maine, Washington, and Wisconsin, but never had she been gone for so long or made such a conscious and radical break from his way of life. For the past several summers at Lake George she had felt smothered by the soft green landscape and by Stieglitz and his family. But she also felt that she had exhausted a certain phase in her art and needed a change. New Mexico invigorated her; she made new friends, including the New Mexican artists Russell Vernon Hunter and Cady Wells, and discovered new subjects in the landscape, bones, and rocks of the Southwest. But her euphoria was tempered by the recognition that it could tear her away from Stieglitz. As she wrote to Hunter, "I am divided between my man and a life with him—and something of the outdoors . . . that is in my blood. . . . I will have to get along with my divided self the best way I can." She was able to reconcile her divided life until the fall of 1932 when she failed to complete a mural at Radio City. This public defeat precipitated a breakdown from which O'Keeffe did not recover until the spring of 1934. As a result, however, she came to a much clearer understanding of herself. Expressing little anguish or concern with exhibition reviews or articles about her work, she was much less interested in her public image. She recognized that although she might seem even to her friends to be "a cross between a petted baby and a well fed cow," she "knew a few things." By the mid-1930s she recognized that except for the six or seven months she devoted each year to Stieglitz, she preferred to be alone. In New Mexico, in the house she bought at Ghost Ranch in 1940, and even in New York with Stieglitz, she carved out an independent life, seeing friends in her environment and on her own terms. It became a way of life that she loved almost as much as the New Mexico landscape.

44. *To Henry McBride*

[Taos, Summer 1929]

My best greetings to you Henry McBride — and I hope this finds you very fine and fit. Stieglitz wrote me yesterday that he had a letter from you yesterday — and I — wanting one too — decided the only way to get it would be to write for it.

I am having a wonderful time — such a wonderful time that I dont care if Europe falls off the map or out of the world — or where it goes to

You know I never feel at home in the East like I do out here — and finally feeling in the right place again — I feel like myself — and I like it — and I like what Mabel has dug up out of the Earth here with her Indian Tony crown* — No one who hasn't seen it and who hasn't seen her at it can know much about this Taos Myth — It is just unbelievable —— One perfect day after another — everyone going like mad after something — even if it is only sitting in the sun

I have the most beautiful adobe studio — never had such a nice place all to myself — Out the very large window to a rich green alfalfa field — then the sage brush and

*In 1923 Mabel Dodge married Antonio Lujan, a Taos Pueblo Indian.

beyond — a most perfect mountain — it makes me feel like flying — and I don't care what becomes of Art —

We wired Marin to come out — and he came — He is having a great time too. Stieglitz says we are being ruined for home — and I feel like saying I am glad of it —.

When you say you like Mabel — I must tell you — you really dont even imagine half of what you are liking — Just the life she keeps going around her would be a great deal — but that along with this country is almost too much for anyone to have in this life — However I am standing it well — never felt better — I often think how much it would all entertain you — Do write me that you are having a good summer — and if you are not — just get up and leave it — and go where you will have a good time — or like something or other — Have I painted? I dont know — I hope to — but I really dont care

There are four nice careful paintings — and two — Others —

No — there are five careful ones So thats that.

Write to me — I'll have lots to tell you next winter — Yours till the Mountain out yonder sinks ——

Georgia O'Keeffe —

45. *To Paul Strand*

[Taos, May 1929]

It is a long time since I have written you — a long time —

I just want to tell you that I am surviving the Ford — I wish you could have seen Mabel and Beck working me out on the back road this afternoon —— Passing and turning and twisting — parking and chasing prairie dogs —

I have driven into the garage twice — and backed out once — the bridges here are only wide enough for angels to fly over so they give me great difficulty — but Im getting on — I broke one window so far — door swung open as I went through a gate

The garage man tells me that my next accident will probably be to wreck a fender —

— It is lively I assure you — But everything is lively except Tony sleeping in his big chair after supper at night

We all seem to go like Mad all day — Beck and I thrive on it — it really couldn't be more perfect — everything seems to go just right for us — She is looking fine — and I never felt better in my life —

It is quite as grand as that San Antonio time — It seems queer to me now that I did not have to come sooner — but that is the way it is

You would certainly be pleased if you could see what seems to be happening for Beck — in every way —

Thanks for the pencil — and goodnight

— Georgia —

46. *To Mabel Dodge Luhan*

Dear Mabel:

I have thought to you every day — I hope you know it without my telling you —
I have not written because — What could I say?

I feel so suspended between one crystalizing and another — one that has finished
and one that is beginning — that it is very difficult to say anything —

Each day is perfect in its way — we miss you — and we miss Tony — the life takes
on different shapes and colors as the different ones come and go — but always you are
present — I went to the house top porch for sunset last night — Well — you know what
it's like — but I wonder if you can imagine my seeing it for the first time — and always
I say to myself — Well — Mabel is a great girl — to do this — I have told you all this
—— Maybe it bores you to have me repeat it — but it comes to me so often — always
I am finding something new here that you have thought of — Of all the people who speak
of you no one gave me any idea anything like what I see —— and it all gives me some
thing I must do something with or you can shoot me ——

I dont know whether you know how important these days are for me or not —
And I am not sure that I am *really* clear about it — but I feel it is so — They seem to be
like the loud ring of a hammer striking something hard — All this is why I have not
written — the surface doings of the days are only important in so far as they do some
thing for an undercurrent that seems to be running very strong in me — As I cant tell
where it is going — all I can say is that I am enjoying the way — and many things it
brings me to —

And I would like very very much knowing what you have done here — even if I
had no part in it — It isn't even just the place — it is the life you let happen — I hope
not to repeat all this now that I have written it to you

With affection

Georgia —

47. *To Mabel Dodge Luhan*

Dear Mabel —

It is 5 A.M. — I have been up for about an hour — watching the moon grow pale
— and the dawn come — I walked around in the wet grass by the Pink House — one
bright — bright star — so bright that it seems like a tear in its eye — The flowers are so
lovely — I came over here to the Studio — so I could see the mountain line — so clear
cut where the sun will come —

I wish I could see you this morning — more than that I wish I could tell you how important these months have been to me — Maybe you know — I am ready to go now — in every way — If you were here I could tell you quite definitely how it came about — it is some thing so perfect — so perfect for ending this and beginning a new thing —

It seems so perfect that I wonder —— is it just a dream I make up —.

It will keep — I can tell you when I see you

I knew that if I stayed long enough the day would come when I would feel right about going — as I feel this morning — I knew I would have to go back to my Stieglitz —— but I didn't want to go till I was ready and today I am ready — and want to go —

May I kiss you goodby — very tenderly — for I am thanking you for much — much more than hours in your house — and will you give Tony my kindest Greetings

If I can do anything for you as far away as Lake George — I would like to —

I had wanted to talk with you about lots of things.

I am giving Spud your Memoirs to keep for you — I couldn't think what else to do with it —

— One can not thank for days like these but I think you can imagine how I feel about them —

I only wish that I had been able to tell you more about what happened for me while you were away

I am anxious to get to work for the fall — it is always my best time I had one particular painting —— that tree in Lawrences front yard as you see it when you lie under it on the table — with stars* — it looks as tho it is standing on its head — I wanted you to see it — Will send you photographs of paintings if I get any of them worth sending

— Goodby Mabel —

Write to me if you feel like it — I will be wanting to know how you are — and hoping all is going well with you — Much love

 Georgia —

48. *To Rebecca Strand [James]*

[On train from New Mexico to New York, 24 August 1929]

Dear Beck:

I am hot and greasy and drippy as the train tears through Kansas — so fast that the birds seem to fly backward — I think of you because I wish I could give you a feeling of completeness that I have about Taos — the days you were with me and what followed —

* *The Lawrence Tree*, 1929, cat. 76.

It ended for me in as perfect a way as anything I can imagine — I can't write you about it — I will try to tell you when I see you — I will simply summarize what I did after you left — I drove down and up the canyon that day — The day after rode horseback — starting in a wild thunderstorm — up to Bretts with the Hapgoods and Charles Collier — We stayed four days — the night we got back it was late but Charles Collier and I got up early next morning and went back in the Ford for me to paint two days — a porcupine visited us at night among other things — I got three quills — I also got a painting of the big pine tree as you see it lying on that table under it at night* — it looks as tho it is standing on its head with all the stars around — Pretty good — for me —

When Charles and I went down we took the circle drive on the way — about a hundred miles instead of 17 — it was lovely — Next morning we were off with Miriam for Santo Domingo — by far the largest and finest dance I saw — very large chorus — must have been over fifty in it — right at our feet — we had a roof — shaded with boughs — our feet hanging over — it is a beautiful place — beautiful church — dance about 3 times the size of any we saw — less poverty among the indians it seemed to me — Miriam went home with Brett from Santa Fe and Charles and I arrived at Alcalde at about 11 that night — we stayed three or four days — I dont remember — I painted that mesa and failed — We had one of the finest drives I had from Alcalde west — up toward Abiquiu — very beautiful — When we started home Marie went with us to meet Henwar who had driven up in the morning with Spud and a desk he had made. It began to rain — all the arroyos were flooded — we got over with much excitement and applause for Charles and the Ford by going up the bank and driving downstream —— We finally had to get out — barefooted — He built a road over a place where it had entirely disap-peared — we got stuck in the sand — everything possible happened — I guess it took us about five hours — cars and cars lined up all along the way — We finally got to Taos about three hours before any other car got through — certainly had a great time —

Henwar and Spud had supper with us at the Hotel and Marie decided we must take a real trip — go to the Grand Canyon and Navajo Country — Well — a day later we started — in the Rolls Royce and Packard — Marie — Henwar — Charles — Spud and I — I wont go into it now —— We went to both rims of the Canyon — crossed the new Lees Ferry bridge — through as much Navajo country as heavy rains would permit — up to Bryce Canyon — almost to Salt Lake City — across the Great Mesa — or maybe it is called Grand Mesa — I dont remember — over Independence Pass to Colorado Springs and down to Taos by Raton — We were ten days — terrible roads — heat that made you feel your eyes were frying — We crossed Painted Desert too — incredible color —— and what shapes! even had such a bad hail storm that the ground was almost white — There seemed little left to do when it was all over — all sorts of hotels and sandwiches — We drove with tops of the cars down most of the time — greased faces and peeling noses and everybody loved it —

* The Lawrence Tree, 1929, cat. 76.

Well — when we began to near home I had just about decided I could go East with peace of mind and be satisfied. When I got to Taos — got my mail — I felt more so — next morning when I discovered the upset condition of the household — I was sure of it — Mabel and Tony gone to Sanitorium at Albuquerque — her heart — she and Ida parted — the tales Ida told me — Mrs. Hapgood gone — insulted — Mrs. Miller ready to leave at a moments notice — everyone aquiver — the whole place dug up for pipes — knocking down walls for doors and what not — you never saw such wreckage — I began to pack — some very beautiful things happened the last days — beautiful like the untouchable beauty of a flower I will try to tell you later — Petes flowers were gay and lovely everywhere

— Everyone missed you — I was ready to go — in every way — I wish it could have been complete for you in that way — instead of your feeling torn away — Monday afternoon Marie and Henwar and a friend drove up to see my paintings and bring some of my things — It was beautiful moonlight — and Spud and I were persuaded to drive down with them — Henwar brought us back early in the morning — I have deserted the Cadillac for the Rolls Royce — it isn't a car Beck — it is a dream — Henwar let us drive it — and it is even a dream to drive it —

Stieglitz thought me dead on that trip — and seems to think Im ruined — Im *not* Im *fine* — Ive had enough — and Im ready to go on — very anxious to get back to him and feel much like working — If I hadnt been cooked through on the desert I would probably think it pretty hot on the train today — as it is I just sit here and drink Vichy and sweat I feel so quiet about everything that it is only with an effort that I realize that tomorrow morning I meet my brother in Chicago and the next day Stieglitz in Albany — I don't even have the sensation of going anywhere — I didn't tell anyone but Pete and Charles goodby — wrote notes to everyone else — I ran across that alfalfa field for telephone and telegram the past week till I told Mrs. Miller that if I stayed only a bleached skeleton would be making those trips — I weigh 118 —

Well it is a great time we had — It seems ages and years since you left —

I realize I must be different than when I came out but it seems so long ago that I cant remember what I was like — so I can't lapse back to it — I can only be as I am — and I feel terribly alive — Even Lake George doesn't seem to exist —— I want to get to Stieglitz and to work

Let me know how you are and your plans — My greetings to Paul —

Tell him not to think about me till he sees me. I havent had time to answer his letter — My being has been so much that letters just couldn't squeeze into the corners — The waking hours didn't seem to have an empty crack —

Someone stole the sweet herbs from Tonys car

Love ——

Georgia —

49. *To Ettie Stettheimer*

[On train from New Mexico to New York, 24 August 1929]

Dear Ettie:

A week ago today I took this paper at this funny little hotel to write you because it seemed amusing. I have carried it so long that it isn't amusing any more — However — the paper having lost its flavor isn't going to stop me.

I am on the train going back to Stieglitz — and in a hurry to get there — I have had four months west and it seems to be all that I needed — It has been like the wind and the sun — there doesnt seem to have been a crack of the waking day or night that wasnt full —— I haven't gained an ounce in weight but I feel so alive that I am apt to crack at any moment —

I have frozen in the mountains in rain and hail — and slept out under the stars — and cooked and burned on the desert so that riding through Kansas on the train when everyone is wilting about me seems nothing at all for heat — my nose has peeled and all my bones have been sore from riding — I drove with friends through Arizona — Utah — Colorado — New Mexico till the thought of a wheel under me makes me want to hold my head

— I got a new Ford and learned to drive it — I even painted — and I laughed a great deal — I went every place that I had time to go — and Im ready to go back East as long as I have to go sometime — If it were not for the Stieglitz call I would probably never go — but that is strong — so I am on the way He has had a bad summer but the summers at Lake George are always bad — that is why I had to spend one away — I had to have one more good one before I got too old and decrepit — Well — I have had it — and I feel like the top of the World about it — I hope a little of it stays with me till I see you —

It is my old way of life — you wouldn't like it — it would seem impossible to you as it does to Stieglitz probably — but it is mine — and I like it — I would just go dead if I couldn't have it — When I saw my exhibition last year I knew I must get back to some of my own ways or quit — it was mostly all dead for me — Maybe painting will not come out of this — I dont know —— but at any rate I feel alive — and that is something I enjoy.

Tell me what the summer has been for you — I hope it has been good for all of you —

I will be in Lake George by the time you get this

My greetings to Carrie and Florine

With Love

Georgia —

50. *To Mabel Dodge Luhan*

Dear Mabel:

Here I am at Lake George — bag and baggage — me and my trunk and my four packages that I sent — everything but my Ford — and that will get here in time I guess if Everett and Charles have luck and dont break their heads with it —

It is wonderful to be here and be with my funny little Stieglitz — He is grand — so grand that I dont seem to see family about or anything else — I just seem to think — to know — that he is the grandest thing in the world — and wonder how I ever was able to stay away from him so long.

— It all seems so perfect — I feel I must wake up and find it a dream — It just doesn't seem humanly possible that things can be this way — He is so nice — and I am so glad to be back with him again — I was at your house for four months Mabel — when I wasn't away from it —— I never stayed at anyones house so long before — didn't realize that till just this minute — the length of time I stayed is one of the things that prove how perfect it was — It was really perfect for what I was needing this summer — as this is perfect for me now — I dont know why things should happen for me in that way — The summer had brought me to a state of mind where I felt as grateful for my largest hurts as I did for my largest happiness — in spite of all my tearing about many things that had been accumulating inside of me for years were arranging themselves — and rearranging themselves — The same thing had been happening to Stieglitz — and as we meet — it is quite difficult to tell how — it seems the most perfect thing that has ever happened to me — Maybe you understand it without understanding it — as I do —.

Well — I felt I must write it to you — also — I want to tell you that I didn't at all like coming away without seeing you — It wasn't the difficulty of going to Albuquerque that kept me from seeing you — it was that I felt that considering the state you were in I probably would do more harm than good by disturbing you —— and I felt that half an hour would be nothing — I would want to talk with you many times — with times to think — in between — to say the things I had to say to you —— half an hour would be worse than nothing —

— I am not going to say to you — what I hope for you — or wish for you — in the usual polite friendly way — you must know it — what I might put into words about it would sound just too stupid and stale —— everyone can say similar things and it means nothing — but I do want to tell you that I will be thinking much of you — and for you —— and that — if you sometimes — again — feel that there is only Alba — just dont forget — there is Georgia too —— maybe she understands a little —

— Stieglitz just handed me this proof of himself — I am sending it to you — because — well — I have him — and as I looked at it I thought you would like to see it — He seems to me the most beautiful thing I ever knew —

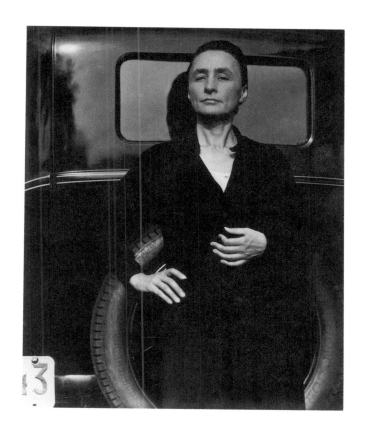

Alfred Stieglitz, *Georgia O'Keeffe—After Return from New Mexico*, 1929, The Alfred Stieglitz Collection, National Gallery of Art

Maybe you laugh and think me funny —— Well — that's the way I am — I think Tony felt all the time that I should be here by him — it *is* where I belong — Will you give Tony my greetings —— and tell him I appreciate all the things he did for me — and he did many that he knew nothing about — He could not understand my funny ways — and yet he did —— you understand what I mean ——

— The family will be gone from here in two weeks — I have a great desire to get to work — will begin getting my things together today — The sun is shining — everything is green — My Stieglitz is wonderful to me — and I want to work — I know it could not all be so wonderful for me today if you had not given me the summer as it was —

Thank you Mabel

— with love

Georgia —

51. *To Mabel Dodge Luhan*

[Lake George, September 1929]

Dear Mabel:

This is my eleventh day with Stieglitz They have been very wonderful days —— the most perfect thing I can imagine having come after the months at your house — The days have been warm and still — real summer days — the green so near — close all about one — the lake and mountains hazy out there most of the time — and Stieglitz is wonderful — I must just rave on and say he is beautiful — Imagine my astonishment to find him learning to drive a car — However since flying to New York he doesnt think much of cars or trains or speed boats — no form of transportation seems to mean anything to him except flying — Well — thats that — We were all just plain slow out there in Taos — and he almost flew out there too

He is a great one — I went with him to the doctor today to see about a little spot on his eye — the doctor is crazy about flying too — I had to laugh as I sat there listening to the two in a perfect fever over flying — He seems better physically than in four or five years — and within himself — that thing that we all have to keep functioning to keep in shape at all — he is grand — I just look at him and wonder if I can believe my eyes — He said today — and I had to laugh — "I have thrown overboard all my ideas — and all my ideals — and everything else — till there is nothing left but myself" — well — he is sweet — we have been having a grand time together — I have started to work — that is good too — it feels very good — I feel as tho I am just beginning everything — Maybe you think me a lunatic — maybe I am one —— the sort of state I find myself in is so pleasant that it doesnt seem quite normally human — I have even gained two pounds and a half — please tell Tony —.

— I often think of you and speak of you — Taos seems miles and miles and years away — and still it all seems very close — so close I can almost touch it — and I am always wondering how you are — and I often wish I could talk with you

You see — I am always feeling that I owe you very wonderful days — and I havent really told you much of anything about it — Others will be telling you things about me — but you know how that is — I suppose the moments one most enjoys are moments — alone — when one unexpectedly stretches something inside you that needs stretching —.

— You make me laugh when you say I experiment with people — I disagree with you most emphatically — I am not smart enough for that — I just dont function that way at all — but we will not argue that — I am even willing to let you think I am that way if you want to —

I just feel Im bound to seem all wrong most of the time — so there is nothing to do but walk ahead and make the best of it —

—— The talks with you were good and alive —— I hope we have some more ——
with love — and my greetings to Tony

Georgia —.

52. *To Rebecca Strand [James]*

[Lake George, 5 November 1929]

To Mrs. Rebecca Salsbury Strand Esq:

Enclosed please find your own checks which I told you not to send me — as I think you paid two months rent on the Pink House I would still be owing you twenty five ——
We will see when I get to town

— We are feeling pretty fine for packing days Almost packed — three days ahead — Stieglitz feels like a hero — and I just feel relieved that he isn't in a stew — It seems to me that we never went to town in better condition

— Good idea that going West! And when I spread out my work last night before packing it — I patted myself on the back and said to myself — not so bad — guess you've won again — It looked so good I called him in to look at it — it was the only time I had seen it all together —— it is just what I have done here — He curled over in a chair — and looked as pleased and surprised as I felt

So thats what Ive done as I see it myself — Of course I can pick holes in it —— but what of that — one can pick holes in anything —

— I have no thoughts — and there is no new —— s.

G.

53. *To Dorothy Brett*

[New York, early April 1930]

Dear Brett:

I have your letter — it is a bit distressing — I am glad you are at work — it is the only thing — We never doubted the manuscript being yours.

I wish you could get yourself into a state that is past regrets. I some way feel that you did what you could and what you had to with each day as it passed and that is the most one can do —

My period of indecision is over — I a[m] going West — will be seeing you around the 1[5th] [o]f June . . . little [a]fter* — I couldn't decide until Stieglitz decided — it came quietly — naturally — like the flow of all the winter has been — It is what I want to do for my work — and I have been so very well after the summer out there. — He feels it the thing to do — and I feel it most certainly my first choice — I am sure it will be quite a different summer — I feel so much like working It is almost as tho Stieglitz makes me a present of myself in the way he feels about it — Well — we will see —

Ida Rauh has been here since I started this. From what she tells us I see nothing to write you. As a matter of fact from what I gather from her and Jo Davidson if I were you I would not go into their [d]etails — Your own clear — vivid impression of [him] is what is important for you — is his gift to [you] — . . . see that any good can come from letting them harrow you by telling you such tales — if you had been there you would undoubtedly have seen it all differently — I cant tell you how much I feel it was all beyond anything you could do about it —— and I dont a bit like to think of you letting people upset you with their gossip about a thing like this that is very dear to you — They will just make gossip of it. Try to keep what is beautiful to you and what you can use for today and now — You must not let the things you can not help destroy you —

I know it is easy for me to talk — but I am so sure that Work is the thing in life — and we mustn't let the human problems kill us — I think it doesn't if we really see it —

When Ida is here [and] [tal]ks about M[abel] I [feel] it is all so sick I [may] not go to Taos [an]d let the chance of mixing with it come — but the Mountain calls one and the desert — and the sagebrush —— the country seems to call one in a way that one has to answer it —

I want to see you too — Well — I'll be out — unless something unforeseen happens — I am going to Lake George on May 7th — Stieglitz will go up later for a few days — he plans to go for the summer sometime in June —.

The fruit trees are blooming here now — it is about two weeks later up there so it should be lovely.

Good night Brett

* Many of O'Keeffe's letters to Brett, including this one and numbers 54 and 62, are damaged; holes along the creases have made some passages illegible. These are indicated with ellipses.

Do save your strength and energy for creating — dont spend it on problems and situations you cant help —

Charles is going to drive my Ford ou[t] . . .

I know Stieglitz thinks much of you and your difficulties — he said at supper that that was one reason why he was satisfied for me to go out there again —

Love from us both —

 Georgia

54. *To Dorothy Brett*

Dear Brett:

Your letter yesterday makes me a bit sad —— and another way not — You suffer and are alone — but you have gone a long way —— and the good . . . —— You do not have to travel it again — the vision ahead may seem a bit bleak but my feeling about life is a curious kind of triumphant feeling about — seeing it black — knowing it is so and walking into it fearlessly because one has no choice — enjoying ones consciousness — I may seem very free — a cross between a petted baby and a well fed cow — but I know a few things —

One thing that gets me about where you are —— the Taos country — it is so beautiful — and so poisonous — the only way to live in it is to strictly mind your own business — your own . . . your own pleasures — and use your ears as little as possible — and keep the proportion of what one sees as it is in nature — much country — desert and mountain — and relatively keep the human being as about the size of a pin point — That was my feeling —— is my feeling about my summer —— most of the human side of it isn't worth thinking about — and as one chooses between the country and the human being the country becomes much more wonderful — You remember I told you last winter that you should write — I feel it so much more definitely now for reasons that I will not go into — You say you cannot do it there alone —— and I feel like . . . saying that you can —.

An impersonal picture of what you went through — colored as it would be by love rather than —— other things — could be at this time a very unusual document — not that it need be printed now — but it should be written now

My love to you — and my wish is with you daily that the work — as I have said before — both painting and writing — are going well —

 G

55. *To William M. Milliken*

The Shelton Hotel — New York, November 1 — 1930

Mr. Milliken
Director — Cleveland Art Museum
Cleveland — Ohio

Dear Mr. Milliken:

I have been hoping that you would forget that you asked me to write you of the White Flower* but I see that you do not.

It is easier for me to paint it than to write about it and I would so much rather people would look at it than read about it. I see no reason for painting anything that can be put into any other form as well —.

At the time I made this painting — outside my door that opened on a wide stretch of desert these flowers bloomed all summer in the daytime —.

The large White Flower with the golden heart is something I have to say about White — quite different from what White has been meaning to me. Whether the flower or the color is the focus I do not know. I do know that the flower is painted large to convey to you my experience of the flower —— and what is my experience of the flower if it is not color.

I know I can not paint a flower. I can not paint the sun on the desert on a bright summer morning but maybe in terms of paint color I can convey to you my experience of the flower or the experience that makes the flower of significance to me at that particular time.

Color is one of the great things in the world that makes life worth living to me and as I have come to think of painting it is my effort to create an equivalent with paint color for the world — life as I see it

Yours very truly
Georgia O'Keeffe —.

56. *To Henry McBride*

[Alcalde, July 1931] 2:45 – AM

A night when I can not sleep — I think the first one since I am out here —— bright moonlight on my door — everything so still but for a very persistent mocking bird — somewhere out there in the night. — I thought to myself — What can I read? — There isn't a printed word in the place as far as I know except that Creative Art with Mabels article on me — I hadn't at all been able to face the idea of reading it before — but now I got up and read it —

Well — I doubt if it reads to anyone else as it reads to me tonight — rather beautiful — a bit disjointed — something of a lie — because she doesnt say something poisonous she wants to say — and that wouldn't be true either — And one picture losing all the point

* *White Flower, New Mexico*, 1929, oil on canvas, Cleveland Museum of Art.

there is to it by standing on its left ear — the Lawrence tree.* The bottom of it as it is printed should be the left hand side That tree should stand on its head —— And the Ranchos Church† seems to be cut up all round — that I really think quite inexcusable —— specially when there is no note about the reproduction being only a part of the picture —

— I dont know what it is all about. I look through the rest of the book and decide that frankly — I dont know what Art is all about —

It all puzzles me very much. Ten weeks away from New York — most of it spent by the roadside — in that famous Ford that I now drive very well — attempting to paint landscape — I must think it important or I wouldnt work so hard at it — Then I see that the end of my studio is a large pile of bones — a horses head — a cows head — a calfs head — long bones — short bones — all sorts of funny little bones and big ones too —— A beautiful rams head has the center of the table — with a stone with a cross on it and an extra curly horn

And then I wonder what painting is all about What will I do with those bones and sticks and stones — and the big pink sea shell that I got from an indian — it looks like a rose — and the small katchina — indian doll — with the funny flat feather on its head and its eyes popping out — it has a curious kind of live stillness

— There is also a beautiful eagle feather

When I leave the landscape it seems I am going to work with these funny things that I now think feel so much like it

— but maybe I will not.

— The days here are very good. They are mostly days alone — out of doors all day — I hate being under a roof — it galls me that I haven't the courage to sleep out there in the hills alone — but I haven't —

I will be going East soon. I dont seem to remember what its like there but I'll be finding out. Cant leave that man alone too long — The things I like here seem so far away from what I vaguely remember of New York.

I wonder if you would like it here — We are thirty five miles from town — Santa Fe — without even a telephone —

I hope your summer is going well —— I heard you went to Europe —

I hope you are home digging postholes by now — I some way seem to feel it would be a healthier thing for an Art Critic to be doing

The daylight is coming Henry McBride — I am going up on the roof and watch it come —— we do such things here without being thought crazy — it is nice — isn't it.

fondly

Georgia

* *The Lawrence Tree*, 1929, cat. 76.
† *Ranchos Church*, 1929, cat. 72.

57. *To Russell Vernon Hunter*

[Lake George, late August 1931]

My dear Vernon Hunter:

I had your very good letter months ago —. Was at Alcalde — 35 miles north of Santa Fe at the time and heard soon after from Robert Walker that you had been in Santa Fe — I am sorry not to have seen you out there —.

I thought of driving your way but my time out there is so short — only about ten weeks this year — I spent it all but two weeks driving almost daily out from Alcalde toward a place called Abiquiu — painting and painting. I think I never had a better time painting — and never worked more steadily and never loved the country more.

Here I feel smothered with green — I drove over to the ocean last week for a smell of the salt air and a week on the beach —— It is the only thing aside from the desert — but it is 240 miles away so I cant go every day — I am glad you think you will settle down out there — I envy you — To me it seems to be a painters country but God knows nothing worth speaking of has come out of it yet —

I am feeling a bit disgruntled that I thought I had to come East and came the middle of July. Everything is so soft here — I do not work — When the sun shines I want to be out in it and when it is grey I think it too dark to work

I walk much and endure the green and that is about all there is to it —

Give my love to the wind and the big spaces — and tell me about it

Sincerely

Georgia OKeeffe —

58. *To Russell Vernon Hunter*

[New York, January 1932]

My dear Vernon Hunter

Your letter gives me great pleasure — it is so much a picture of what I know out there. When you say that you enjoy mine I must hasten to tell you that often after the last time I wrote you — it was from Lake George — I have intended to write again because I thought I had written so stupidly.

I will send you sometime soon photographs of the paintings I have had photographed this year. The show is very different this year — it makes me wonder — wonder so many things — when I hear the things people say.

— Makes me wish for the night and the wind and the piece of tin blowing off the roof —

You speak of Rivera — I think his show very uneven but he himself is a person. He came to my show — stood in front of every painting — looking and carefully considering it — a fullsized — deliberating person — and I thought to myself — "If one person like that

came every year and looked that way I would paint much better — and if I thought a dozen or even five or six would come and look like that I would have to work like blazes every waking hour."

I think I haven't much respect for my audience —

You speak of the indians too — I met and got to know one in Taos who is one of the most remarkable people I have ever known — He is wonderful to me like a mountain is wonderful — or the sky is wonderful — but such an uncanny sense of life and human ways — such a child and such a man at the same time —— a very grand sort of a human being —

— Then I must smile as I write of it — one can not speak of a human being like that — one only knows of it Maybe one should even forget it so that it doesn't become unreal with embroidering it —

There is no news of the city except that it is mad — and everyone feels poor — My greetings to the sky and the wind —

Sincerely

Georgia O'Keeffe

59. *To Russell Vernon Hunter*

[New York, January 1932]

The Family Album is very amusing. Thank you —

— As you see — I am on the wall again —— You may be amused — and I hope will feel a bit disgusted as I do — when I tell you that I seem to be getting publicity on my subject matter in a new way this year —— I brought home a lot of bones — cows head — a horses head — and what not — and painted them with artificial flowers — a new way of trying to define my feeling about that country — and they seem to think that painting bones is news — News quite apart from Art News —

It makes me feel like crawling far far into a dark — dark hole and staying there a long long time —

I hope you are working

My very good greetings to you for the New Year

— Georgia O'Keeffe —

60. *To Dorothy Brett*

[New York, mid-February 1932]

Dear Brett:

I came to stay at the room while Stieglitz is at Tristan this afternoon — He gave me your letter when I came in —— As I am here alone — only a few people coming and going during the noon hour I must say a word to you about your letter

— Dont be alarmed about the Beck business —— Showing or not showing any ones work doesn't make it any better or worse — so let it go at that — dont fill your mind with it —

The place is the most beautiful now that it has been at all* — The rooms as a whole are more severe —— more clear in feeling — and each print as you walk down the length of each wall and look closely at each print — it is as though a breath is caught — I wish you could see it — I think not many will see it as I do — It takes very good eyesight and it takes time — time not only to look but to think and let yourself feel it —— and all of us here hate to take time to let anything happen — I am glad he is showing them but there is something about it all that makes me very sad —

My show looked well but the two most important phases of it — the landscapes and the bones were both in a very objective stage of development — I hadn't worked on the landscapes at all after I brought them in from outdoors — so that memory or dream thing I do that for me comes nearer reality than my objective kind of work — was quite lacking — I hadn't worked at either the landscapes or bones long enough objectively to be able to carry them on in the other way as I wanted to — I have my living for another year so count myself very lucky this year as no one seems to be buying or selling anything — To sell a painting seems a miracle —

I didn't work while my things were up — Have just got started again this week — No painting yet — only drawing — I have hoped to do something of New York

Seeing myself as I do when I see my year on the wall makes starting at it all again rather difficult — I try to make out a direction for myself for at least a year and as that involves my personal living as well as my working it becomes a bit difficult

I think of your house up on the side of the mountain — of Friedas house at the ranch — the walk along the ditch — and wish I could be walking along the ditch without my clothes on — or sitting up among the trees in a sunny spot — alone — just me and the sun and the trees and the pine needles on the ground —

I am uncertain about going out again for the summer — Maybe if my NewYorks move along a bit the next thing will move after them —.† From your letter this morning I take it that you will not be coming East — it is too bad as you seemed to want to come — and I know you would really enjoy this show — but the town isn't much —.

Give my greetings to the sky and the mountains and the sun and the wind

My thoughts to you —

Georgia —

*From 15 February to 5 March 1932 Stieglitz exhibited 127 photographs made between 1892 and 1932 at An American Place.

†In 1932 O'Keeffe worked on a mural titled *Skyscrapers*, which she later partially destroyed. It was reproduced in the *Springfield Sunday Union and Republican*, 1 May 1932, p. 6E.

61. *To Russell Vernon Hunter*

[New York, Spring 1932]

My dear Vernon Hunter

Your letter gives me such a vivid picture of some thing I love in space — love almost as passionately as I can love a person — that I am almost tempted to pack my little bag and go —— but I will not go to it right this morning — No matter how much I love it — There is some thing in me that must finish jobs once started — when I can —.

So I am here — and what you write me of is there

The cockscomb is here too — I put it in much cold water and it all came to life from a kind of flatness it had in the box when I opened it —— tho it was very beautiful as it lay in the box a bit wilted when I opened it —. I love it — Thank you.

I must confess to you — that I even have the desire to go into old Mexico — that I would have gone — undoubtedly — if it were only myself that I considered — You are wise — so wise — in staying in your own country that you know and love — I am divided between my man and a life with him — and some thing of the outdoors — of your world — that is in my blood — and that I know I will never get rid of — I have to get along with my divided self the best way I can —.

So give my greetings to the sun and the sky — and the wind — and the dry never ending land

— Sincerely

Georgia OKeeffe

62. *To Dorothy Brett*

On the train from New York to Lake George [September? 1932]

Dear Brett:

For a long time I have intended writing you but I have written no one because my doings have been so uncertain from day to day. I have had a job for Radio City for about two months but one difficulty or another has kept me from starting and at the present moment I am just as apt to give it all up and not do it at all as I am to go ahead with it — It is really no ones fault except that we have wild strange ways in building our mad buildings in N.Y. and my kind of work is maybe a bit tender for what it has to stand in that sort of a world — I want to do [it] but if both time and my kind of material for pa[inting] are lacking it is a bit difficult — I cant paint a room that isnt built and if the time between the building and the opening isn't long enough I cant do it either — so it all hangs in mid air — If the opening is put off another month I still want to do it — and that I will not know till next week — No one in my world wants me to do it but I want to do it because I have wanted to do a room for so long — I want to try it — I must

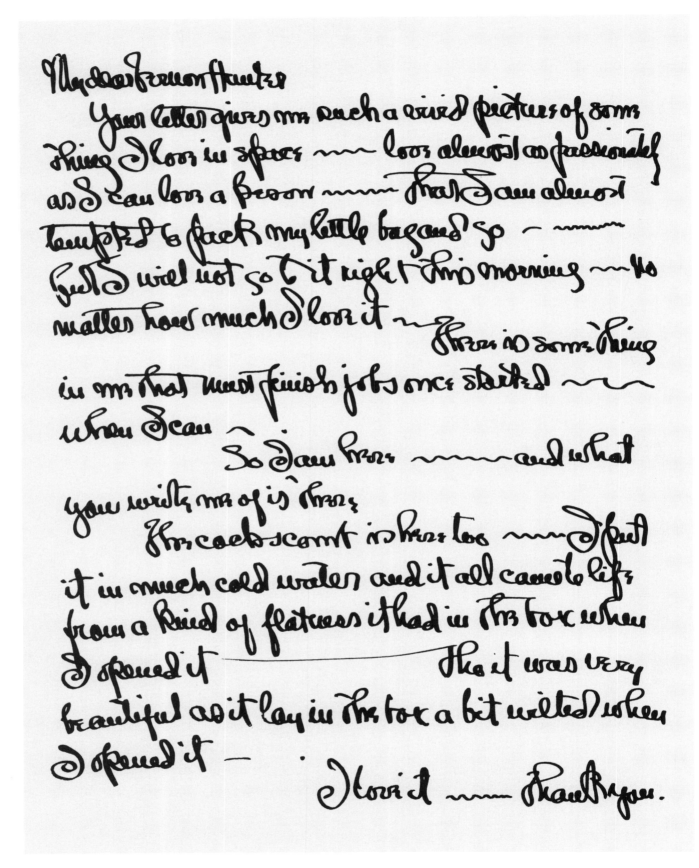

Georgia O'Keeffe to Russell Vernon Hunter, spring 1932, Estate of Georgia O'Keeffe

I must confess to you — that I even have the desire to go into old Mexico — that I would have gone - undoubtedly — if it were only myself that I considered

You are wise — so wise — in staying in your own country that you know and love

I am divided between the man and a life with him — and something of the outdoors — of your world — that is in my blood — and that I know I will never get rid of

I have to get along with my divided self the best way I can —

So give my greetings to the sun and the sky — and the wind — and the big never ending land

Sincerely

Georgia O'Keeffe

admit that experimenting so publicly is a bit precarious in every way. Everyone dislikes the Idea of Radio City — but I feel that has nothing to do with my wanting to paint a room — So there we are all in a squabble — everyone getting on everyone elses nerves —

I have been to Canada three times — very good country for painting — quite as good as New Mexico — but I miss the sun — it is better in that one never meets anyone one knows and I can't talk with anyone I meet because they all speak French — Had a very grand time [l]ast time up on the Gaspé Peninsula — a ve[ry] rocky coast — very high cliffs rising out of the sea and wild forest coming right down to the sea — it is very good — quite perfect if it had New Mexico sun —— I have a few paintings — one four feet by seven feet of a cross that I saw in the Laurentian Hills in the spring* — A bit mad but rather nice —

About your Lawrence book — I feel so surely that if it is to be of any value to anyone — it must be your truth as nearly as you are able to put it down. It seems to me the only truth of him that you can create — You must write it truly to the end for yourself — Then if you do not wish to print it to the end stop where you wish — My personal feeling about it is that there is no point in doing it if it is not a truth — Ones truth must always necessarily have a certain amount of fantasy in it — I think the human being functions that way — but the fantasy must be ones truth to keep ones whole consistent — It must be your real experience — you cant make up anything as good as what happened if the whole thing was as wonderful [for] you as you have made me feel it was Why [bring it] into the world less than the most beautiful thing you ca[n] — I hope I am clear to you

When I think of you I often wish I could simply put my hand lightly on your shoulder when you are alone — that you might not feel too alone — My very warm feeling for what you are trying to do — goes to you along with my greeting to the sky and the mountains and the sun

 — fondly

 Georgia —

63. *To Russell Vernon Hunter*

[New York, October 1932]

Dear Vernon Hunter —

Your letter about the difficulties of the Art World of the South West sounds a bit complicated — and strange — The depression makes most "Art" being done at the moment seem like so many dry leaves — left over from the year before when the spring comes — I find myself rubbing my head and saying to myself — wondering vaguely —— what has it got to do with my life anyway — what does it add to the days for me — and it seldom seems to add much —

Cross with Red Heart, 1932, oil on canvas, The Regis Collection.

So I say to myself — what is it all about anyway — I am in town for a few days — it all seems so bewildering — I was going to paint a room in Radio City — but the plaster will not be dry in time so I will not have time to paint the room before the place opens — That is I dont want to try if I am not sure that I have time to do it fairly well — The place over there is a mad house — I have never made daily visits to anything like that before to see how it moves — I get much excitement out of it —

However I think I'll go back to the country tomorrow and let someone else paint the room on the wet plaster —

It is a great town — a bit mad — even though everyone seems to be drooping this fall —

No — I didn't get West this year —— I went to Canada for a while — it is first rate for painting — only I miss the sun — that sun that burns through to your bones. I was up on the Gaspé Peninsula — up beyond Quebec — very grand — and no one to talk with as I do not speak French

I have your article from Jerry Bywaters and have returned it to him — I like it — You have seen me from a different angle and I like it so much better than what I usually get — Thank you —

I asked him to send me a dozen copies when it is printed

It has been interesting to me that within the past two weeks that article came from you on me and one came from another boy from the South West on Marin — The best one I have ever read on him. It hasn't been printed or I would send it to you

My work this summer has been queer — at present I am not thinking much of it —

However — we will see — I think I'll go back to the country and paint the kitchen wall as I am not to be busy in Radio City — I have a fever to do a room — Our kitchen has the best plaster so I thought I'd start on that — at any rate it will be dry —.

I hope your work is going well — I always think of October as a great month out there —. My greetings to the sky

Sincerely

Georgia O'Keeffe

64. *To Russell Vernon Hunter*

[New York, early February 1933]

My dear Vernon Hunter

It is a long time since I had your article and your last long letter — I have thought of you but have been ill — in my bed for two months and the month before — that is the month of November I spent done up in a blanket on a couch by the window in the country reading most of the time — so for three months I have been — well — just of no use at all — It is an irregular heart that seems to be quieting down a bit now — is pretty

good while in bed — by inches and minutes I begin to try to get up — I am always pokey recovering from anything — but I'll keep moving a little at a time till Im up I suppose — It all gives one such an absurdly tired feeling that one is content to just lie still — However — when I stood at the window this morning for a moment — a sense of life that one gets from seeing it out there makes one wish to be out in it — My exhibition has been on for three weeks I think — I haven't seen it — I haven't even been seeing anyone but yesterday the doctor said — try seeing someone every day for ten minutes — it seems so funny — being ill is funny anyway — I never quite believe it — it always seems it wasn't intended for me

About the picture for Amarillo — you know prices are funny like being sick — not much sense in the whole idea — There must be plenty of money in Amarillo in spite of depression — but one can't always get the people who have it to spend it — I could send you something for a thousand dollars on up —. I can send something very good for two thousand five hundred or three thousand — As a matter of fact I don't feel much interested unless I *can* send a very good one — My best things are higher but I am willing to stand by the things at the price I quote you — When I get better I will send you some photographs of the things of this year — just for yourself —— because I think you so smart to stay out there with the space and the wind instead of coming to this mad place

— Of course it is quiet even here this winter when I spend it in bed seeing no one —

Most all my work is from Canada this year — I like the country up there very much From Montreal we went up the coast of the Gaspé Peninsula to the end of it — Wonderful for painting but cold even in August — I haven't much new work — the fall is my best working time — October I spent in town over that Radio City thing then after that I was ill — In Canada I missed that hot sun of the south west — Wish I could be in it now — look out over the flatness for a few moments — preferably at dawn —

I liked your article only I dont understand you speaking of "time" in relation to a painting — I rather think that time and painting havent much in common and will have to get along without one another — except that it takes time to create the painting — and time to look at it — and like it — I am not saying that it takes time to understand a painting because at present I am inclined to think that rather unimportant — maybe impossible — as it seems quite impossible for two people to really understand one another —

Ive been writing on this for three days —— The nothings that they keep me doing trying to get me out of bed seem to take up all of both day and night —

My greetings to your horizon

Sincerely

— Georgia OKeeffe

65. *To Russell Vernon Hunter*

[Lake George] October 21 – 33 –

It is so long since I had your nice long letter in the spring — I thought often to answer it and did not — Yes — I did start to immediately — and a couple sheets written you blew about my room for weeks — It seemed I could not go on so I gave it up.

I have done nothing all summer but wait for myself to be myself again — I got a new Ford and drove myself about a bit with nothing over my head — I am still driving that way with paper in my cap to keep from getting too cold — I cant drive far but I like being out in the sun and can walk so little that the drive is a help to get off the front porch — We have a little farmhouse on a hill with a very beautiful view on all sides — The lake so long and narrow out in front it seems like a river — the mountains beyond it — and out in the back too — Not mountains like in your part of the world — but here these are called mountains —

I have not worked at all — Yes — I have one drawing that I think very good — Otherwise nothing. Nothing seems worth being put down — I seem to have nothing to say It appalls me but that is the way it is — so I dont work —

I read and sew and fuss about at much of nothing — walk a little — drive a little and the day is gone — sleep only a very little — eat a great deal — Not much of a life — everything seems reversed. And still it has been rather pleasant — that is its worst feature — to be so tired that I cant get up the energy for anything else — I seem to get better very steadily but it is so long — so far to go — And all such a bore —

I wish it were spring now — warmer —— and I think I'd go West — but the places I know out there are all too cold

Here I am in the country alone — just a maid who does things for me — a person I like very much — it is good being alone — no one to talk to — I know no one living about near by — if I liked the country it would be quite perfect but I dont like this kind of country —— so I am quite aggravated. I am well enough to work if I wanted to but I cant get myself to want to.

So this lovely landscape is all wasted on me — autumn leaves and all — I do not feel well enough to go to town — can not stand the excitement — will probably stay here at least another month.

And so it goes —

Stieglitz went down to the city October first. Is having a retrospective Marin show — after that intends to show his work of this year. He has been painting some with oils the past two years.

You know I havent been in town but two days on my return from Bermuda in the spring and those two days were spent in bed so I havent been able to get at photographs of my work of last year to send you some as I had intended

I think I remember that in your letter you spoke of a museum or something of the sort being given to Canyon by Mary Hudspath —— if I remember rightly I knew her quite well — She taught Spanish and was quite deaf — a very nice person —

I hope you are glad that you have settled down in your own country — it is nice to feel that someone has had the sense to instead of chasing NewYork —

Write me of your doings — It is always pleasant to hear — I just now remember the photographs of your paintings too —

You have caught something of your own country but I would wish that you could look at it only with your own eye — quite forgetting that you ever saw a painting —— as you write of it you seem to see it — then as you paint it I seem to think I see others ideas of painting in your way — Try to paint your world as tho you are the first man looking at it — the wind and the heat — and the cold — the dust —— and the vast starlit night. I too was fascinated with the windmills — When the spring comes I think I must go back to it — I sometimes wish I had never seen it — The pull is so strong —

So give my greetings to the sky

Sincerely

Georgia O'Keeffe

66. *To Paul Strand*

[Lake George, 26 December 1933]

Dear Paul:

Your question came on Xmas eve — I am so trifling — but you know I always have been and probably always will be. The mail is more prompt than I am but I am sure its intentions are no better.

The material came a few days before I went to town — It is lovely — I'll probably keep it for years before I sew it up — you know I am that way too — a funny love for just material — I thought to write you as soon as I returned here from the town and tell you of any news I might find there — but I came back and got right into bed with a cold — and only feel right again the past few days —. Now the city seems so far away again that it is difficult to recall —

Toomer being here with me has made the days so vivid that back through that and the fever of the cold seems a long time ago. Alfred came for Xmas. He came Saturday night and left this morning Tuesday — the 26th — a few hours ago.

It all seems very perfect. Alfred looked bad when he came — the quiet — and the snow — And my strangely kept house that isnt kept at all but works quite perfectly — Toomer — an unusually beautiful — clear person — with a very amusing streak in him — lots of real fun — My lovely white cat — and two funny kittens — There was very little talk — I have finally arrived at that — the not talking seems to give a real quiet that seems to make the whole house feel good.

It was all sort of still — but so alive — He went back to town looking like a different person — It was very nice. I wish you could have been here too. You would have liked it.

Toomer has written something about him that he had ready to read — I think it very good — that is — when Toomer finished reading it last night — I said nothing till he asked me — Then all I had to say was — "I am satisfied" — and you know that for me to feel that way really means something.

I really wish you could have been here for everything.

This morning the typewriter clicks at a great pace upstairs. He works all day. We only talk at night and even then often just sit and read. The snow falls very thick and fast — real winter snow.

As far as the city is concerned — Many asked about you and Beck — where you both were —— no one made any remarks about your personal affairs — so I made none. The principal things about it all for me were that I could again walk the street a little without fear of losing my mind — even sat through dinner in a room with music one night. — Went with Paul to half a concert — stayed long enough to hear Milhauds "La Création du Monde" — I made a visit to Florine — saw her latest paintings — went to see the Brancusis — that was lovely — so lovely — Duchamp was there — and of course talking with him is nice.

Demuth just happened to come to town — He hadn't been in town since I saw him last on my last days about last October a year ago. He has the illusion he is losing his memory — seems all right when he forgets about that and talks of other things — Seeing him was one of the nicest things We had not had any definite word from him in over a year when we saw him last. I was glad to see him even if he did seem somewhat shattered.

I did not see Marin but his retrospective show was very beautiful — The new work is up now. I'll be going down later and see it

I seem to have little desire to go to the town to stay. Had to spend too much time resting after every move I made but it is nice to know that I can go if I want to — Not to feel uncertain as I did.

The world here is very lovely white it is all white — It seems so quiet and nice — makes me feel it is even preferable to a warm place —— but that is probably just my inertia My love to you Paul — I hope you are feeling nice and sweet in your mind and heart.

G.

Toomer sends you greetings

67. To Jean Toomer

I must tell you what happened to me today. I mailed a telegram and two written pages to you —— then took your greeting to your background from the mailbox — read it — and laughed —

The road is smooth beautiful ice from rain and thaw New Years Day — good for skating — one slides sideways very often — when I intended to turn up the road to our house — I was much surprised to feel the car slowly and surely slide completely around and face toward the village — It was very funny to me. I just sat there and laughed and thought of what Alfred would say. I had shifted into first and was going so slowly that it seemed impossible — but there it was — I was turned around — and didn't feel I had been careless — but I was surprised — Your Chicago letter makes me feel very good all the way through — So good that I went out and drove till lunch time — it was warm — warm enough to have the windows of the car open tho the snow is still all here — and everything seemed such a lovely color — really startlingly beautiful — I enjoyed it almost as much as that cold blue day with snow blowing when you were here — and I liked being alone with it — and the feeling you give me —

You seem to have given me a strangely beautiful feeling of balance that makes the days seem very precious to me — I seem to have come to life in such a quiet surprising fashion — as tho I am not sick any more — Everything in me begins to move and I feel like a really positive thing again — seems to have very little to do with you or me — Something you give me that has very little to do with anything you said or did —

[7 January 1934]

I started to paint on Wednesday — it will undoubtedly take quite a period of fumbling before I start on a new path — but Im started — and seem to settle down to it every day as tho it is the only thing I do

— I miss you —— We had duck for dinner today —— Sunday — even the duck missed you. It seems ages and ages — and it is just a week — so many things seem to have turned over in me that it seems a very long time — and even tho I miss you I am glad to be alone. I like the feeling that you are very busy with your own affairs — and that you wear the red scarf — I like doing that to everyone who sees you — While I am busy putting myself together piece by piece — I need time —

— Everything here is the same

The two little Kitten Cats are the same My Kitten Cat is lovelier than ever — Maybe I love her too much Maybe it is something in me that I *have* to spend on something alive that is beautiful to me I am quite amused with my love for her — and I like her being so sure that I like her — her certainty is one of the nicest things about her —

I still put off going to town — I had to — Margaret is very good natured — everything is very nice — only I miss you — It also seems that I never felt more ready and willing to be alone.

68. *To Jean Toomer*

[Lake George, 10 January 1934]

I waked this morning with a dream about you just disappearing — As I seemed to be waking you were leaning over me as you sat on the side of my bed the way you did the night I went to sleep and slept all evening in the dining room — I was warm and just rousing myself with the feeling of you bending over me — when someone came for you — I wasnt quite awake yet — seemed to be in my room upstairs — doors opening and closing in the hall and to the bathroom — whispers — a womans slight laugh — a space of time — then I seemed to wake and realize that you had gone out and that the noises I had heard in my half sleep undoubtedly meant that you had been in bed with her — and in my half sleep it seemed that she had come for you as tho it was her right — I was neither surprised no[r] hurt that you were gone or that I heard you with her

And you will laugh when I tell you who the woman was — It is so funny — it was Dorothy Kreymborg

And I waked to my room here — down stairs with a sharp consciousness of the difference between us

The center of you seems to me to be built with your mind — clear — beautiful — relentless — with a deep warm humanness that I think I can see and understand but *have not* — so maybe I neither see nor understand even tho I think I do — I understand enough to feel I do not wish to touch it unless I can accept it completely because it is so humanly beautiful and beyond me at the moment I dread touching it in any way but with complete acceptance My center does not come from my mind — it feels in me like a plot of warm moist well tilled earth with the sun shining hot on it — nothing with a spark of possibility of growth seems seeded in it at the moment —

It seems I would rather feel it starkly empty than let anything be planted that can not be tended to the fullest possibility of its growth and what that means I do not know

but I do know that the demands of my plot of earth are relentless if anything is to grow in it — worthy of its quality

Maybe the quality that we have in common is relentlessness — maybe the thing that attracts me to you separates me from you — a kind of beauty that circumstance has developed in you — and that I have not felt the need of till now. I can not reach it in a minute

If the past year or two or three has taught me anything it is that my plot of earth must be tended with absurd care — By myself first — and if second by someone else it must be with absolute trust — their thinking carefully and knowing what they do — It seems it would be very difficult for me to live if it were wrecked again just now —

The morning you left I only told you half of my difficulties of the night before. We can not really meet without a real battle with one another and each one within the self if I see at all.

You have other things to think of now — this asks nothing of you.

I[t] is simply as I see — I write it — though I think I have said most of it —

My beautiful white Kitten Cat is in a bad way for three days — she seems to have a distressing need for a grown real male — and these two little Kitten Cats seem quite puzzled and frequently quite excited — and they are all running me wild — I feel like digging a hole in the back yard and burying the whole outfit

I never saw such a performance before — and right at this moment I dont need it — troubles enough with myself —

I do have to laugh when I think of your possible remarks if it had happened when you were here

I like you much.

I like knowing the feel of your maleness
 and your laugh —

69. *To Jean Toomer*

[Lake George, 8 February 1934]

I am back from the Town tonight — and what a relief!

I feel like someone else here — just in the two or three hours I am here — It seems that I can barely remember the day I went — as tho I was smashed to bits so many times in the 12 days that I dont remember by whom or what or when or where — only what sits here and writes does not seem to have much connection with that terrible time I had in town — Already I feel very quiet and pleasant — and how I love seeing my cat — and she seems so pleased to see me —

I can not give you any news except that I can tell you a little of my show — Every thing else seemed to batter me so that I dont want to think of it. Even my show I do not particularly enjoy thinking of — There are paintings of so many things that may be unpaintable — and still that can not be so —— The feeling that a person gives me that I can not say in words comes in colors and shapes — I never told you — or anyone else — but there is a painting I made from something of you the first time you were here — I hunted for it and hung it — it amused me to put it there —— It is rather disturbing to take the best of the work you have done from the people you have loved and hang it that way and go away and leave it — Makes one feel strangely raw and torn — I think I would like to forget I have been in town — though I really stand it very much better each time

There were talks that seemed almost to kill me — and surprisingly strong sweet beautiful things seemed to come from them — so that I have a strange feeling of being disconnected from my body — Sounds crazy

Anyway I am much relieved to be back here — everything is as usual except that Margaret is cross with me because I didn't tell her I was going to stay so long — she has cut her hair — it looks very sweet and there was no Pickwick Ale for supper —

I hope that your not writing means that the work is going very well I could not write — I was too tired and too torn to pieces in town It feels wonderful to be back here tonight —

Next morning —

It is 20 below — I got the car started after about 15 minutes of struggling — returned from the village by 9:30 — I cant begin to tell you how glad I am to be back — And my cat seems really to love me — she sits right here with her nose about three inches from the paper — Is much more attentive than when I went away — The whole place here sends you a greeting I think.

70. *To Jean Toomer*

[On boat from New York to Bermuda, 5 March 1934]
Just a little I must write you from the boat before I start into another way of living.

It has been a warm — soft — smooth — sparkling day — Sun that I seemed to have forgotten could be warm — I felt petted all over — lying out there on the deck — alone — looking at the water — It seems another world — I am glad to be moving into it — away and away from everyone and everything that seems connected with my life — everything except myself of course — it is something of a trial to take that along —

The days in the city were very good for me I think — tho I did not enjoy them particularly. I had to go shopping as I had very little to wear and the struggles with garments of various kinds — shopgirls — taxis and what not was good I think — It got me back very much into my old way of going about and doing things so that each day it seemed to tire me less

As for my connections with people — I feel more or less like a reed blown about by the winds of my habits — my affections — the things that I am — moving it seems — more and more toward a kind of aloneness — not because I wish it so but because there seems no other way. The days with A. were very dear to me in a way — It was very difficult to leave him but I knew I could not stay —

The city was cold and windy — snow as I never saw it there — the harbor all floating ice

My old sense of reality seems displaced and I cannot quite anchor a new one — What you write me of your eye and your cold bothers me — particularly since I have

not heard again — I imagine you got a cold and got sick just because things seemed too difficult for you — or am I wrong.

Anyway it bothers me — particularly as I seem to be treating myself very well —— taking myself to the sun

It all makes everything seem so awry and fantastic

Someone skidded into my parked car before I left Lake George and did $35.00 worth of damage to the side of it — Luckily I was insured

I hope you are better

You must know that my coming out here to these toy like islands on the glassy green blue sea is only an evasion — I do not look forward to it — do not like it that I come for any such reason but that is the way it is

I will write you of the life when I get to it — The circumstances are a bit odd to say the least

In the meantime I hope you are better and busy at something —

71. *To Rebecca Strand [James]*

[Bermuda, 26 April 1934]

Dear Rebecca —

It is probably a long time since I wrote you —

I have been out here in Bermuda sitting in the sun again — for two months — Yes — in two months one improves — maybe sitting up at Lake George in a snow drift I might have improved too — but sun and a summer feeling are good for a change — I have liked it —— Young foolish things that laugh a lot and talk about nothing have amused me — flowers and birds — all the pretty things — light and lovely and nothing — till one must write something — I am going back next Saturday — if I can get passage — the 28th ——

It has rained for two days — rather a relief after many sunny days — When it rains there seems to be no particular reason why one should even get out of bed to walk around — of course one does get up for a meal once in a while — but looking out at the rain one thinks a little more carefully —

I begin to order my life as if I intend to really do something about it. — I order my passage for Saturday — they tell me they haven't any — I say I must go any way — long pause on the telephone — and then the voice says — I will see — and I say to myself — Of course I will get it. — So — the first of May I expect to be in New York — I also say to myself that I will only stay in New York a couple of days — three at the most — Then to Lake George where I must attend to some things and see the doctor —

After that — ?

I begin to think of New Mexico with a vague kind of interest — And I also think I want to keep house — what an idea! — maybe it is the rain — I think I'll probably not

go to Taos — and let me whisper it to you softly — I do not want to go to Maries either —— and dont tell that I said it. I do not want to mix up with people as much as that.

I will not be able to stay away from home as much as I did before working — so I must be someplace where the people do not run me crazy — and I dont see anything to do about that but to have a house of my own.

I have heard from various sources that I was going West but it was news to me as I had not really thought definitely about it till the past two days —— Getting past New York and Lake George will be something of a battle probably — but if the doctor says I can go — I think I'll make it —. I havent a very positive desire to go — I really have to move myself mostly with my head

And I say to myself — it would be the easiest way for me to get to work —— and that I must do —

I have no other reason — I have been drawing some here — very dull drawings — I get so interested in them it quite amuses me.

What I'll do about my car I dont know — sell it I guess if no one will drive it —

All this comes of a rainy day — Maybe the sun will change me but I think not. — I hope all is well with you.

— Mabel offered me the Pink House the Studio back of it or a house she was trying to buy from a Mexican out back of Tonys house and Studio — I wrote her at the time that I had no plans which was true and that was all there was to that —

I am really feeling much better — even bicycle four or five miles — It is hard work but I can do it ——

I ask you nothing about how you think I might work out a way of living or any thing like that because I am a bit too vague about my doings. But I know that I do not wish to try to live among many people — They tire me more than anything —

And maybe all this will go out of my head when the rain goes —

If you write address me at Lake George — As soon as I am in NewYork I will write to Lake George to hold mail for me.

Fondly —

G.

72. *To David H. McAlpin*

[New York, 24 December 1936]

Xmas Eve —

I wanted to write you before and I didn't. I make no excuse

— I wanted to thank you for choosing the purse so carefully that I laugh every time I see it — it is so like me that it seems funny you should have found it for me

Well — that's the way it is — a very careful thought you gave me and I like it Elizabeth Arden sent me a little black velvet treasure with a rich pale pink satin lining —

a row of shiny stones across the opening — a gold lipstick case with a little green stone on it — perfume — a gold powder box — you would laugh — it is so like I am not — even though it is in my bureau drawer it isn't mine — never could be — that makes me laugh too — it is so sweetly her way

I sent you a Marin Book yesterday. I do not really expect you to like Marin very much but you seem to be inclined to look into things rather carefully when they have your attention at all so I thought it might interest you —

This takes you my very good wish for Xmas and the New Year —

Sincerely —

Georgia O'Keeffe

73. *To Helen Torr and Arthur Dove*

[New York, January 1938]

Dear Dove and Reds:

Thanks for your very good letter —— Yes I read and write a little — only a very little — I am quite illiterate — We had to print those letters because so many thought as you do that I couldnt read or write at all —* and it is just as well in these times to be able to do a little of both on account of the newspapers — I am hoping in a few years to be able to give it up with the aid of Radio — Dictaphone — Telephone — etc — I dont like to patronize the printed word — There is too much of it —

I received those two handsome dishes with much embarrassment — even tho I like them —

Maybe in time I can stop admiring aloud — Anyway I think they are lovely — Pins on the black dish are easy to see — Ive been under the covers for two weeks with grippe — am just creeping about the past three days so havent had a chance to use the white one but I love it.

A[t] present I creep about with a very stiff neck and shoulder — grovel for heat to the Landlord office downstairs and read a little — and pace the floor just because I cant sit still —— knowing all the time that one gets past all these things after a while — My show is beautiful — almost gaudy with copper and brass frames — They seem to help the heat of the red earth of out there rather than cool it as the silver does — The frames are lacy and embroidery like — stock metal mouldings. I like them

No one has bought one so maybe I like them alone —

Love To You both

Georgia

Wish you could see my show — lots of venetian red earth —

*Accompanying her annual exhibition at An American Place, O'Keeffe published eight letters she had written to Stieglitz in the summer of 1937: *Georgia O'Keeffe—Catalogue of the 14th Annual Exhibition of Paintings* (New York, 27 December 1937–11 February 1938), 3–11.

74. *To Cady Wells*

Dear Cady:

I should have written you before — and I haven't.

Ambition to do anything is rather lacking as one is getting over the grippe and it is particularly lacking when anything seems difficult.

Stieglitz said he would write you himself. He always has a particularly mad time when my show is on so I haven't even asked him if he wrote because he is always so tired at night.

I showed him the things on a bright sunny morning right after breakfast — all but the oils which I did not think so good — I had thought you would use paint — paint just as it comes out of the tube and you made it into washes — and to me washes not as pleasant as your water color washes — Why dont you paint —.

Maybe you dont want to use just paint — but it might be an exercise worth trying — maybe not — I do not want to say to you what you should do —

When Stieglitz looked at the water colors he remarked almost what I had said — they will be liked — they will sell — they are good — very good — but they would not make a show at the Place.

You see Walker was not a good painter — he seldom had anything that one felt was complete but he was a searcher. He moved toward something very big and simple. I always felt he would not live long enough to work through to anything of importance — but I liked his direction — his intelligence and a kind of truth that he had — His self was always in the painting — and may I say to you without offending — that I do not find your self in your paintings — there is beautiful taste

With your mind you can organize a well balanced picture — and the color is always good — very good (Mabel telephoned at this moment — now isn't that a treat to be able to write you that) — but some way the thing that makes a painting live and breathe isn't there for me and I don't know why —

Well — I don't like paintings anyway so maybe I dont know

I hope the winter is being pleasant for you

Stieglitz liked best the painting with the bushy tree on the right and the bare trunk and branch on the left

I think of you — and often wonder what the days are for you —

Sincerely

Georgia —

75. *To Cady Wells*

Dear Cady:

No — Im not annoyed with you — and I dont care anything about your manners one way or the other —— Your letter seems very normal and I like it that you are angry tho making you angry or whatever I did to you was not my wish or intention — I knew when I wrote that I was hurting the artist in you and I like it that you kick back and spit at me. It isnt that I have any particular liking for being treated that way but I like the artist standing up for himself — believing in his own word no matter what any-one may say about it. Believing in what one does ones self is really more important than having other people pat you on the back There really isn't any reason for you to be so annoyed with me that you want to choke me for saying that your things are very good and will sell — I dont see anything so awful about that remark — It simply means that I think you are keyed in a way with your time so that people will like what you do. The same thing could be said of me —— I don't consider it a remark either for or against me. It just happens to be a fact. — And as long as you make perfectly clear without actually saying it that you dont care what I think anyway — I cant imagine why you want to choke me — why bother — I very much doubt its being worthwhile. I am glad you have had such a good winter.

Maybe it will please you while you are thinking unpleasant things about me to think to yourself that my winter has not been so good —

You can say to yourself gleefully — serves her right!

However — it is pleasant enough now — a week of lovely spring sun — my hedge is all turning green and I am feeling fine again —

Wonder what we can fuss about next — probably everything.

G.

76. *To William Einstein*

From my bed in Lake George
– the first morning here – July 19 – [1938]

I arrived yesterday afternoon — everything quiet — damp and misty.

Alfred came up last Thursday — six days ago He is nicely settled — sleeping in the dining room — The nurse came with him but hurt her leg some way getting off the train so has been laid up ever since she was here — She left a couple of hours after I arrived — It is really lovely here — but my aim is to rest myself as much as I can during the time I feel I must stay and to leave as soon as I can —

It was hot in the town but I didn't mind — Every time I waked last night enough to know anything I was surprised that it was cool enough to have a blanket over me

Ansel Adams, *Georgia O'Keeffe in Her Car, Ghost Ranch, New Mexico*, 1937. Courtesy of the Trustees of the Ansel Adams Publishing Rights Trust.

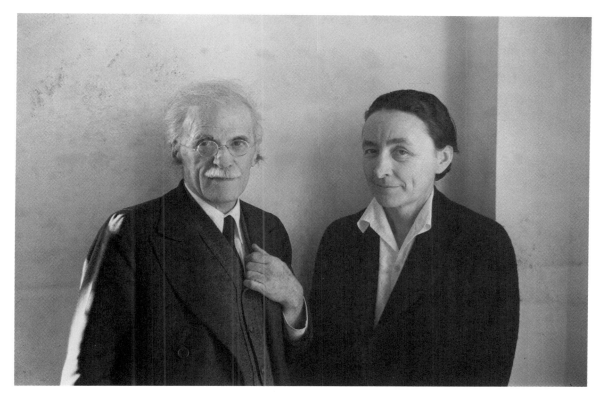

Ansel Adams, *Stieglitz and O'Keeffe, New York*, c. 1939, courtesy of the Trustees of the Ansel Adams Publishing Rights Trust.

I have a lame arm — a bad nose — mostly need a dry open space all by myself — Alfred remarked — "None of your particular friends will be out there this year — what will you do?" — my answer — "Be by myself which I like — or make some new friends" — Alfreds answer in a very sad voice "Yes I know." Dave and Godfrey invite me on a trip into the high Sierras in California for September — Adams going too. I am going if everything is alright here and I am alright and get in some riding before then — Adams knows the places to go and can get the best equipment together —— all I need is to be fit to go. This morning I dont feel much like it — sitting here in this damp place — comfortable — But Oh My God!

Im too tired to even write straight.

I showed your drawings to Hoffman. He was much surprised and amused. I let him take them to show to someone he thought might use them. I explained that you were doing more and I thought they would even be better — He asked if he might take them — was very enthusiastic. — It was just a few days before I got away — He will write me here. I will send you the letter — I told him to keep the drawings for me — or you can write him for them if you want them and nothing comes of his effort to market them.

Ive been asked to do some work for a pineapple co. out in Hawaii — by an advertising co.* — We telephone and telegraph and talk — and now a man has gone out to Hawaii on the china clipper to see the people — etc. I dont know whether anything will come of it or not.

— At this moment I dont much care — but about ten days ago after I had looked over all the maps and folders and pictures I was much interested

I did the Steuben glass drawing† — was promptly paid for the use of the drawing — on condition that they be permitted to buy the drawing later if they want it — price not asked — and they gave me that glass dish they sent me to think the drawing on —

I believe there is nothing else in my head at the moment

My greetings to Eli

I am glad your figure is improving — Your state of mind is undoubtedly much more shapely too —

Ross is coming August 15 I think

G.

*The advertising agency N. W. Ayer arranged for O'Keeffe to visit Hawaii from February to April 1939 under the auspices of the Dole Pineapple Company. She painted two works that Dole bought: *Pineapple Bud*, 1939, oil on canvas, now in a private collection, and *Heliconia*, 1939, oil on canvas, still owned by Dole.

†O'Keeffe made a drawing of a flower that was then engraved onto a fourteen-inch glass Steuben bowl in an edition of six. Reproduced in *Designs in Glass by Twenty Seven Contemporary Artists* (New York, 1940), 23.

77. To Cady Wells

Dear Cady:

Your check slid under my door one day last week. I will try to collect my wits and cash the check tomorrow and give the painting to the packing man.* I feel you dont really like the painting so it is difficult for me to get myself to do anything about it.

— Maybe I will try to make you another painting. If I do — and you like it better I guess you will be willing to exchange it — I guess we will have to let it go at that. I would really have liked to have you take the deers head† — it is for me very perfect in a delicate kind of detail that I think you would have liked very much to live with — subtle and to me lightly sad and gay at the same time —— It is of our country there without any of the feeling imposed by peoples who have lived there — You might not see it that way at all — It is also one of my paintings that I least wish to give up — however — I feel it would satisfy your exacting demands more than any of the four you thought about — and I oddly wish to please you — However — for the present lets call it settled — I merely wanted to say what I have honestly thought about it myself — as I thought of it since I saw you —

— Easter has come and gone — it is warm like real spring today — I had intended to write you yesterday morning — Sunday — but I had a terrible quarrel Saturday night — really an awful quarrel — with an old friend — He said horrid things about an older friend who was here and left early — He left very angry with others who had been here for supper and I got into bed — then someone else telephoned and four more people came — I staying in bed — after they left I read till after three — reading some old letters that I wrote in my twenties that had been in a drawer waiting to be read since they were brought to me about a month ago. Letters written when I was first beginning to see and work in my own way — I waked yesterday morning at 7:30 and read on with the letters till about eleven — It was a queer experience — my excitement over the out doors and just being alive — my working and working and always seeming to think that maybe it was foolish — but I kept at it a bit madly because it was the only thing I wanted to do — it was like an urge to speak — and the drawing and painting made me feel much more truly articulate than the word. I must laugh at the things I read at that time and do not remember at all —

There are many boats going up and down the river — many rusty looking freighters — there seems to be one every few minutes of the day and night — Many horns and whistles —— many English boats.

— It seems so terrible to have such a quarrel with anyone you have spent hours and hours and hours with for some seventeen years — it is two days now and wrath still seems

*Wells bought two paintings from O'Keeffe's 1939 show: *Katchina Doll*, 1938, oil on canvas, San Francisco Museum of Modern Art, and *Seaweed and Sea Bean*, 1928, oil (location unknown).

†*Deer Horns*, 1938, oil on canvas, private collection.

to knock around the room hitting the walls like I've seen billiard balls hitting the cushions again — and again and again — or maybe that is too gentle

— I hope things are going well with you Cady — or shall I say better.

I will write your sister when the box goes off to her ——

Fondly

Georgia —.

Monday night —.

78. *To Henry McBride*

405 E. 54 – New York July 22–39

Dear Henry McBride:

Yes Im still in town — I've been going to the doctor three times a week — following his printed page of when and what and how much to do of everything I do till I feel all doctors should hang and we might just as well die when it is such a dull life trying to get healthy — I feel better than Ive felt in years but I do nothing but work on it — havent done anything else since the last time I saw you — As far as I can make out there isn't much the matter with me except that I was tired and had been too tired too long and that seems to get lots of little things going wrong — Ive stayed in bed six weeks and tried to follow orders till I begin to hate the sight of the doctor — The only thing I enjoy is that I'm to be out of my bed walking on the street or the roof at six in the morning — Ive tried the Park and all the streets around from 10th to 86th. I take buses — then walk in a new place — It is funny the way people look at you at that hour — In the evening after supper I walk again and two days ago I turned my ankle and skinned my knee so now I sit in bed and get the girl to clean the closets and catch up with things generally that my daily program leaves no time for — This big idea to write you is inspired by some clippings of what you wrote about me at different times — I laughed and laughed and wished I had them all here — They are very funny — When I read things like that I wonder that Ive been able to walk down the street so unaware of the printed word about me — It is as if I have a strange oily skin of some sort that words dont get through at the time they might disturb me — they dont seem to get through till I think them funny —

Anyway I enjoyed what I read and it starts me wondering what you are doing. I wanted to see you before you went away but I just couldn't make it —

Alfred is going through his prints — apparently having a very good time — I've tried my best to get him to go to the country and leave me here alone and he doesn't move at all — He looks well and very alive and alert — Seems interested — and I dont see much use in expecting more from living —

I think about you — wonder about you — Hope your country life is pleasant —

And look forward to seeing you. I even looked up Westchester on the map

I hardly see anyone so I haven't any news Of course I see the doctor but Im not going to be able to look at him much longer

Write to me if you feel like it and if you dont feel like it dont write

I haven't been to the Modern Museum since that opening night — I have heard rumors of changes there — sort of whispers — Art to be run like Standard Oil or some thing like that

Well even that will pass —

My best wish to you

Sincerely

 Georgia O'Keeffe

79. *To Russell Vernon Hunter*

[New York, October – November 1939]

My dear Vernon Hunter —

So good to hear from you and I like having the letters written at different times all coming together — I had it when I came back from four days out on Long Island at the ocean — days and nights of indian summer to spend with the ocean — the only thing here at all completely comparable with your country

— No — I think I'll not get out this fall. Stieglitz has not been well — he had a heart attack — not as bad as last year but bad enough — He steadily improves but is definitely weaker — and I think I can not get away. He goes to the place mornings — stays at home afternoons so far — The war upset him very much

— I had a wonderful time out on the islands and loved it — Yes I worked — it is beautiful for painting as they have everything — almost tropics — fourteen or fifteen thousand foot mountains — bare lava land more wicked than the desert — lovely flowers — and the sea — and it is all in a fairly small space — many high thin waterfalls pouring down the mountains —

I flew from one island to another — several beautiful trips — Yes I liked it — If it were not for the war and all the uncertainties it brings I think I'd make an effort to go again soon.

There was nothing the matter with me this summer except that I was tired and have had a hard time getting a bit rested. I would probably have gone west if I hadn't had a dull doctor who told me not to go to the high altitude — I am convinced now that doctors are no good — I would undoubtedly be feeling much better if I had spent the summer up near Abiquiu —

————————————

I am a couple of weeks or more behind with this now — It lay among papers and I just now came across it —

I have been getting out in the country around N.Y. quite often — There are new Parkways that make getting out of town much easier than it was a few years ago. I dont think much of this kind of country but it is pleasant to get away from the city for a few days or even a few hours —

I have done very little painting — feel like a rather useless member of society —

Since starting this we have hung a very beautiful Marin show — all old things — but he is really good you know

I saw the San Francisco Fair — thought that room with my painting in it most unattractive — they wanted the horses head with the pink rose in the eye* — and when I saw the whole set up I was very glad I hadn't sent it — I only went to see the old paintings at the fair here —

— It seemed that I walked miles through rooms of paintings in San Francisco — so much good painting and no good paintings — Im not caring a great deal for rooms and rooms of American paintings when I am pretty sure that the best ones are not there —

— Im not even in any humor to talk about Art They have such a sorry show at the Metropolitan — so dull —

And I am feeling dull tonight too —

I'll send this along to you — hoping you will think better of me than this deserves — My greetings to your very pretty wife

Sincerely

Georgia O'Keeffe —

80. *To Ettie Stettheimer*

[Abiquiu, 15 August 1940]

Dear Ettie:

How are you — how are all three of you?

My friend Felix writes me that you had a birthday party — invited him — and that he had a very pleasant evening

Carl writes me that you have morning glories on your terrace

That is all I know about you since I saw you last.

I drove out here — that is — an extra piece of humanity known as Narcissa Swift drove out with me and did the driving — it was a very good trip and when I look back on it now I guess it was a pretty fast one — we drove 830 miles one day — the others I dont remember.

I have bought a house out here — the one I have lived in the past three years here — It is for me a nice house and I like being here. I am about 100 miles from the railroad — 68 from Santa Fe — 95 from Taos — 40 miles from town — 18 miles from a post office and it is good

* *Horse's Skull with Pink Rose*, 1931, oil on canvas, Estate of Georgia O'Keeffe.

I went to Taos Saturday — came back Sunday — saw Beck — spent the night at her house — went up the mountain to see Brett and Frieda — saw Spud Johnson — various other folks and was delighted to get back up here — so far away that no one ever comes — I suppose I am odd but I do like the far away — You would hate it probably — I have a lovely Siamese kitten that a friend who lives far away like I do only way over and up in the Sangre de Christo mountains to the east — gave me — It is an odd little kitten — talks to you all the time — goes to walk with me like a dog — and is beautiful

I've had one rattlesnake in the house — Sitting in the fireplace as I went through the room. The door to the garage had been left open and he came in — The girl who works for me was riding this evening and she came in with two rattles from two snakes she killed tonight — one has ten rattles and a button on it — a 11 year old snake — the other has six rattles and a button —

— Colored earth — rattlesnakes and a Siamese Kitten for news is all I have — With all the earth being rearranged as it is these days I sometimes wonder if I am crazy to walk off and leave it and sit down in the far away country as I have — at least it is quiet here — I have no radio — and no newspaper — only *Time* that the girl gets when she goes to town — for food — I get vegetables and fruit from the ranch house two miles away — I've only been to town twice since I'm here — I'm having a lovely time — and I hope yours is passable — Too bad you dont like nothing the way I do.

My love to the three of you

Fondly

Georgia —

Ghost Ranch — Abiquiu — N.M.

81. *To Maria Chabot*

In the Air — November 1941

It is breathtaking as one rises up over the world one has been living in — looking out at — and looks down at it stretching away and away. The Rio Grande — the mountains — then the pattern of rivers — ridges — washes — roads — fields — water holes — wet and dry — Then little lakes — a brown pattern — then after a while as we go over the Amarillo country, a fascinating restrained pattern of different greens and cooler browns — on the square and on the bias with a few curved shapes and many lakes. It is very handsome way off into the level distance, fantastically handsome — like marvelous rug patterns of maybe "Abstract Paintings".

The world all simplified and beautiful and clear-cut in patterns like time and history will simplify and straighten out these times of ours — What one sees from the air is so simple and so beautiful I cannot help feeling that it would do something wonderful for the human race — rid it of much smallness and pettishness if more people flew — How-

ever, I am probably wrong because I will probably not really be very different when I get my feet on the earth than I was when they left it.

We circle to land and as we circle I see that it is a cloudless sky — a soft opalescent edge to the horizon that becomes clear and sharp as we land —

I walked out — the sun was just going — the air fresh and cool smelled of the sea — maybe it was the flatness of the earth made me think of the sea so I thought I smelled it. As we circle into the sky again it is dusk and there is our beautiful star over the green and grey and brown pattern of the land all dotted with lakes — a pinkish hazy sky — all a little like a black opal — and I tell your beautiful Western world goodbye again — a sort of final goodbye like my last sunset alone at the ranch.

I'll watch it into the night but I've told it goodbye — the evening star — the many lakes under the long hot sunset line — soft and hazy tonight.

Ahead looks very hazy and grey as we go toward the low country. As I look back and see the high beautiful star over the little lakes and long hot sunset line, I can almost see the star at the ranch too — in the high clear country where it rains sometimes.

When the dusk was almost gone we ate — chicken with dressing — roasted — and all the things that go with such a meal. I ate everything but the soft white bread and butter — Then when I looked out the window — the bright sky full of stars — the dark earth scattered with lights — earth stars they seem tonight — sometimes big patterns of them blinking — sometimes small patterns — always the scattered ones — sometimes I think the Pleiades of the earth — always the green light on the end of the wing of the plane — out there between sky and earth.

We went down at Wichita — it was warmer, more moist feeling. Oh — yes — I have left your country even though I am only some five hundred miles from Denver.

And as it is gone and I tell you goodnight, I want to thank you for the many, many things you thought of for me — your real kindness — and freshness — you made so many things so easy for me.

It is no use to write about any more of the trip. I have left the good country — I must get myself in order for the other kind of life with the dawn —

I hope that you find being alone very pleasant.

 G.

82. *To Frank Lloyd Wright*

[On the train from Chicago to New York, May 1942]
Thursday afternoon

Dear Frank Lloyd Wright,

I wish that I could tell you how much the hours with you mean to me — I've thought of you most of my waking hours since I left your house and I assure you that I left with a keen feeling of regret

Last night in the hotel in Chicago — my sister gone on to Cleveland to meet her husband — I got out your book. I read the part marked with the red line at the end — then started at the beginning and read to the end of the first evening — stopping often to think about it — always relating what you give me to painting — to what I want to do — and you may smile when I say to you that I thought seriously of taking the train back to Madison to visit you again — I thought too —— if I had offered you one of my best paintings years ago — maybe you would have taken it — I remember that even then — so long ago — that was what I wanted to do even tho I did not know you as I do now — I felt that I should offer you my best but I knew Alfred would make a great stir if I started doing things like that —

I have always said to him that I think I should give things away — that it would be alright — and he always says — "Yes — it would be if you were alone — but it wouldn't be while I'm around"

Since I visited you I know that my feeling was right for *me*. Two together aren't the same as one alone —

As I think over this whole trip — the hours with you are the only part of it that I feel really add to my life —

I salute you and go on to the second evening of your book with very real thanks
Will you give a very quiet greeting and thanks to the beautiful wife
Sincerely
 Georgia O'Keeffe.

83. *To Arthur Dove*

[Abiquiu, September 1942]

Dear Dove:

It is long ago that I had your letter and the little book — Thanks so much. The odd thing was that when I received it I had been thinking of you and intending to write you for days —

I go East next week — leaving here Sunday — It seems all so far away that it is difficult for me to imagine that I'll be having city life again so soon — I get so much into the way of living here that a change seems very odd

I wish you could see what I see out the window — the earth pink and yellow cliffs to the north — the full pale moon about to go down in an early morning lavender sky behind a very long beautiful tree covered mesa to the west — pink and purple hills in front and the scrubby fine dull green cedars — and a feeling of much space —

It is a very beautiful world — I wish you could see it

My love to both you and Reds —

I've moved to within a block of 509.* Was afraid taxi service would be curtailed —

*An American Place, 509 Madison Avenue, New York.

also I wanted a room for Alfred small enough to heat with an electric stove if necessary —
maybe you can come to see me there if you get to town

You are one of my best thoughts

Sincerely

Georgia

Abiquiu — N.M.

84. *To Ettie Stettheimer*

[Abiquiu, August? 1943]

Dear Ettie:

You sound hot and like the city — I intended to write —— Oh yes — I intended to write — long before I had your letter but I dont seem to get to it — I am having a very good summer. Am feeling very well and my working seems to go better than in a long time — Living has to be adjusted with the rationing but I manage very well. I can get butter eggs and milk within 20 miles — There are three different kinds of weeds — not counting dandelion that we had in May — that can be eaten for greens — one called verdolaga — is as delicate as any leaf vegetable Ive ever eaten — It has a slight sour taste as if a little vinegar had been put on it —

Well — we manage very well — canning and drying and preserving what we can get as it is quite impossible to have fresh fruit except right after trips to town and they are few — and it is the only way we can manage — If you want to give me the canning sugar points — 15 and 16 from your sugar ration book I would use them — but maybe you just use it for extra sugar — I cant imagine you canning — dont deprive yourself in any way but dont throw the sugar points away either —

The same girl who has been with me for two years is here again — she is WAC age so has planted 15 acres of beans in the valley to feel she is putting in her war effort — Well — those beans mean steady contact with the Spanish people of the valley and what we learn is most interesting I assure you — She speaks Spanish — it is such a different civilization that it always seems astonishing to me to discover the things that go on — their manners and customs — and beliefs — The little town 20 miles from me on the way toward Santa Fe is a big Penetentes center —— a very small town really — only one white man and he is married to a native — I am going to the Morada — their church — this afternoon

Next day — I went to the morada — a small long building on a hill well above the town — inside the walls a pale sweet pink and an altar full of gory christs and saints — a startling death figure in black with a bow and arrow — 7 crosses — big heavy ones — large enough to crucify a man on — a great iron chain — a wall all splattered with

blood — The mixture of pain and love — pain in the implements of religion and love in the care of the place — It is like their chillie that they eat — painfully hot — and quite sweet in some of their favorite dishes —

I am glad Florine is doing so well — Ive intended to write her but I hardly write to anyone but Alfred

My greetings to both Florine and Carrie

Fondly —

 Georgia

85. *To Eleanor Roosevelt*

<div align="right">

59 E 54 – NY Feb. 10 – 44

</div>

Mrs. Franklin Roosevelt

29 Wash. Sq. W.

N.Y.

Having noticed in the N.Y. Times of Feb. 1st that you are against the Equal Rights Amendment may I say to you that it is the women who have studied the idea of Equal Rights and worked for Equal Rights that make it possible for you, today, to be the power that you are in our country, to work as you work and to have the kind of public life that you have.

The Equal Rights Amendment would write into the highest law of our country, legal equality for all. At present women do not have it and I believe we are considered — half the people.

Equal Rights and Responsibilities is a basic idea that would have very important psychological effects on women and men from the time they are born. It could very much change the girl child's idea of her place in the world. I would like each child to feel responsible for the country and that no door for any activity they may choose is closed on account of sex.

It seems to me very important to the idea of true democracy — to my country — and to the world eventually — that all men and women stand equal under the sky —

I wish that you could be with us in this fight — You could be a real help to this change that must come.

Sincerely

 Georgia O'Keeffe

86. *To Carl Zigrosser*

[Abiquiu, April 1944]

Dear Carl Zigrosser:

Your catalogue pleases me* — I have not read all of it — on many points my opinion would be of no importance

However

If in your second paragraph you can put a sentence to the effect that the collection does not represent the things he would choose to buy — the things he has liked best — It is hard for me to say but I remember the Riveras were bought at auction for between 15 and 50 dollars — not because they were really wanted but because he was ashamed to see them go for so little —

He has growled no end about America but at his root is a deep feeling for America — that I think became the key — the center that he worked from and for —— it often made him buy things that no one else would buy I also think he showed the works of the French to find out for himself what the New Movement was about — By living with the things when he showed them he was learning — He didn't do it because he knew

I would say to you and smile as I say it that he doesnt really know anything now — He is just one of Gods good accidents — fitting the niche of his times particularly well

I think he is not fair to Strand. He gave Strand two shows toward the end of 291 I think —— and I have always thought that in those things like "Dishes" — No. 41 — that Strand was the first to consciously use in photography the abstract idea that came to us through cubism — Stieglitz is mad at Strand now so not very fair to him

————

His reason for taking Hartley on I think very amusing — he says it was because Hartley only asked for $2.50 a week to live — and an American with such an idea he thought should be supported in anything he wanted to do.

————

I was the last person shown at 291 — you might for my benefit put in a sentence to the effect that he did not know me personally when he gave me the 2 shows at 291 —

It often sounds as if I was born and taught to walk by him — and never thought of painting till he worked on me — I dont really care but I know Ive had to be both strong and tough to survive — on second thought — I suppose whether he knew me or not at that time has nothing to do with this thing you are doing — so if you leave it out I dont care — such things matter so little in the long run —

Your catalogue to me seems very good — and as an interested person I say it is very interesting — I am very grateful to you for being what you are in doing this because it

*In the summer and fall of 1944 the Philadelphia Museum of Art mounted an exhibition of Stieglitz's collection of paintings, drawings, prints, and photographs. The catalogue accompanying the show, *History of an American—Alfred Stieglitz: "291" and After* (Philadelphia, 1944), was written by Henry Clifford and Carl Zigrosser.

is something I felt I had to get done and that I could feel that I trust you with it completely means much to me. It is better too that it is being done while he is still about I am glad it is on the way.

I will not return East till fall. I know you men will arrange things very well — but I want to get there before you take it down in the fall — I hope you make it as late as you can

I think what you have done when considered as a whole covers the point I mention on my first page — but I expect no one to have brains so ideas must be nailed very hard to be understood

If you make no changes I think it will be alright —— so suit yourself —

I think you have done very well —

And my real thanks to you —

This is scattered and scrappy because I am all packed to go camping at what I call The Black Place — and I've stopped to try to consider this when my head was really somewhere else

　　　　— Sincerely

　　　　　Georgia OKeeffe —

— About Strand — Stieglitz was as much his father as his own father — He started going to 291 when he was 16 — It takes nothing from Stieglitz to let him have full credit — as a matter of fact it adds to Stieglitz

This that I write next has nothing to do with your catalogue — If it had not been for Strand 1710* would not have opened as it did. When I saw that Stieglitz wanted a place again I started pushing Strand — and Strand helped me then as you help me now —

Oh — it is such an odd world isn't it —

Mine here is so very beautiful Tonight I will sleep in some of our barest country — The mud and the cold and rain and dust and wind drove me home on Friday — This morning I start again — full of hope — for good weather and good painting

87. *To Ettie and Carrie Stettheimer*

[Abiquiu, April – May 1944]

Dear Ettie and Carrie:

I have Etties letter today — Monday and I am so glad to have word of you — from you. I have wondered — and thought about you — wondered how Florine is — how both of you are — so it is good to hear — even if it tells me very little — and nothing to be cheerful about. It makes me wish to be there so that I might see you — sit with you a little — That you write me makes me know that you know I am thinking of you — Thinking of you and wondering — as I have for several years — how I could give you a

*1710 was the room number of An American Place at 509 Madison Avenue.

little of the up feeling I have about life — and always knowing that it is something I can do nothing about —

As I sit here in my bed writing I put my hand to my face and it smells so sweet I must tell you what I did this evening — thinking of you as I did it because I had just received your letter — the sun was low and I walked with Maria — the tall handsome young woman who lives with me — out into the Red Hills toward the East — looking for an herb that an old Mexican woman told us about — We had a little basket — We found the herb — it is called — chimaja — It is very green — grows in small bunches — but all the bunches not protected by rocks or sticks or some other little growing thing — had been eaten closely by the antelope — The tracks were all about — However we got maybe a quart of the herb by hunting and hunting — picking and cutting — and tho Ive washed my hands several times since I came in they still smell sweet — a kind of sweetness like the taste of a fine mango — Well — maybe it doesn't make sense to you but I loved walking in the low sun – evening light through the red and purple earth — bending or kneeling often to pick the small fragrant leaves — you cook it fresh with eggs — or put it, dried, in soup — And it amused me to be hunting something the Antelope likes so well — Im going to try it in salad — It entertains me too — to find something to eat — growing wild out in that bare place. I guess it is because I can like doing things like that — that I find living in a place like this so good — I do find it very good — It has been cold — really cold till about the past three days — I still wear a woolen suit but it is warm enough not to need a fire to get up in the morning the past three days

Ive had a Spanish woman for a couple of days working on a couple of fireplaces that were not finished last fall — I enjoy the way she can handle mud — and I like the smell of the mud —

Yes I've been painting too — I like my life here — even tho it is far away from most of the people I care about

I write you these things because I feel that anything I might say about Florine — or even your selves could only be very inadequate at this time —

My love to both of you — and to Florine too if you can convey such a message to her —

Very fondly

Georgia —

88. *To Ettie and Carrie Stettheimer*

[Abiquiu, 10 June 1944]

Dear Ettie and Carrie:

I was really shocked and startled to have your letter saying Florine is gone. I had not heard till you wrote me tho I feared when I came away from what you told me.

I have not written you sooner because I had your letter just as I was starting off to

camp at a place I go to paint — I certainly take a beating from the country and the weather — It was cold and it was hot. It poured rain and there was a hard hail storm — then a couple of hours after rain and hail — while the ground — very wet — is like soft butter under a thin layer of dry sand — the dust is blowing — a fine white sand — Difficult — very — but so beautiful too — and so often thinking of Florine — I always feel so startled when someone I have known — is gone from this — As I looked at my beautiful Black Hills I kept thinking that she would love them too if she could see them without the physical difficulties —

About her paintings — at the moment I would not know what to say —— I believe I would wait a little and see what comes. — If I can do anything when I return I will be very glad to. I will be back earlier this year I think — probably October —

I believe the Museum situation is changing very rapidly like everything else and I dont know where it is going or what it is about. It is difficult to think of her work outside her own place — I hope you leave it there for a while — Maybe I say that because her world there was so complete, so much her own — that taking the paintings and putting them some other place is like destroying the painting — the big painting that was her way of life and her painting all together

It is difficult — must be extremely difficult for you both

When I stay away like this for so long I feel completely out of touch with so many things — I feel very small — and far away — and unimportant — I sit in my bed at night writing you this —— not knowing of any comfort I can give you — I get out of bed — see the moon shining — go out and climb the ladder to the roof — Looking at the wideness and stillness of my world in the moon light — wondering —

All I can say to you is that I am very fond of both of you — I'll be thinking of you both — very often — very warmly

— Georgia —

89. *To Maude and Frederick Mortimer Clapp*

Abiquiu, NM Monday – June 9 – [1945]

It is San Antonio day — The Spanish people do not work and say it always rains. There has been no rain since I came out but today a little came — enough to wet the sage and moisten the top of the dry soil — and make the world smell very fresh and fine — I drove up the canyon four or five miles when the sun was low and I wish I could send you a mariposa lily — and the smell of the damp sage — the odd dark and bright look that comes over my world in the low light after a little rain — it is still as can be — as far as wind is concerned — every little dry plant and cedar bush so still — it makes the birds seem very noisy — We have had hard winds almost every afternoon — So the stillness today seems very still —

Maude — I am pleased that you went in to see Stieglitz and the Doves — I suppose Stieglitz was sad — particularly sad with his cold but I could do very little for him if I were there — So I am here — He told me that you asked to see the Black Iris and the Black Abstraction* — James Sweeney calls them "The Untouchables" — Maybe you didn't ask to see them — Maybe Stieglitz just showed them to you because he likes them — Anyway he wrote me and I was pleased that one day you walked down the street and were interested and went in —

I should have thanked you for the candy you sent me when I was coming away — it gave me a feeling of a good wish on the way — the candy and the very fine apron.

I wonder if you ate chillie when you were out here — It is hot — but its first taste is sweet — then comes the hotness — Many do not care for it. Mary Wheelwright fairly snorts at the idea of anyone eating it — We eat it always twice a day and often three times — I mention it only to remind you of it if you ate it and liked it. It is a very special article of food if you like it. I always think that I can not remember how good it is from one meal to the next

My world is beautiful and impossible and I am so pleased to be here — My household runs very well at the moment — At first I painted outdoors — Now we have a very small gnat that is very annoying so I have been indoors —— We have that gnat for three or four weeks at this time — then after that have nothing that bites — very seldom a mosquito — of course we always have the rattlers but I never see them — only one so far this year —

I hope that you both keep well and get out of the city — I believe you spoke of where you intended going but I do not remember where it was — Anyway all my good wishes and affection go with you where ever you are

Sincerely

Georgia O'Keeffe

90. To James Johnson Sweeney

Abiquiu – NM June – 11 – 45

Dear James Sweeney:

I have thought letters to you often but they were not written. I could make excuses but they would be only excuses and at best of not much interest.

I knew that in time writing you would be the only thing for me to do at that moment as it seems to be this morning.

First I want to speak about the remarks made by someone on your acquisition board about the price of Marins water colors. I think that as far back as 1928 or 29 a Winslow Homer was sold at auction for between ten and fifteen thousand dollars — probably at the American Art Association or whatever that Auction house at the corner of Madison

* *Black Iris III*, 1926, cat. 49; *Black Abstraction*, 1927, cat. 54.

Ave. and 57th Street was called at that time. I also think it was an early one and not very important. I think Mr. Brixey bought it instead of buying a Marin at that time — I may be mistaken but think I am not — Through the time when we had the Intimate Gallery in the Anderson Gallery building I heard a good deal about auction prices. Since then I have not followed them at all — really know nothing about them —

I have no patience with the acquisition board for laughing at the Marin prices on obviously important paintings — prices really have no meaning — except that someone is controlling something and that they have something to control. You will forgive me I hope — after all these weeks for bringing this up but at the time we were talking of it I was rather sidetracked from it with the idea of my own showing —

I must say to you again that I am very pleased and flattered that you wish to do the show for me. It makes me feel rather inadequate and wish that I were better. Stieglitz efforts for me have often made me feel that way too — The annoying thing about it is that I can not honestly say to myself that I could not have been better.

However — we need not go into that. But I do wish to say that if for any reason you wish to change your mind feel assured that it will be alright with me — For myself I feel no need of the showing. As I sit out here in my dry lonely country I feel even less need for all those things that go with the city. And while I am in the city I am always waiting to come back here.

Since I left New York and since seeing you I have had a girl who did some secretarial work for me last winter — collect clippings and put them together for you. I dont know how well she will have done it but she will have done something — It will be odd reading for you I am afraid —

When I say that for myself I do not need what showing at the Museum shows means — I should add that I think that what I have done is something rather unique in my time and that I am one of the few who gives our country any voice of its own — I claim no credit — it is only that I have seen with my own eye and that I couldnt help seeing with my own eye —. It may not be painting but it is something — and even if it is not something I do not feel bothered — I do not know why I am so indifferent —

I wonder if by any chance the Museum sent me a check for that painting of the window. I received the returned Red Hills* but I received no check for the exchange. The Red Hills were sold again last week and I thought I had better be sure of what the Museum was doing about it. If the check was sent me it has gone astray in the mail as I have not received it —

Will you let me know because I haven't said anything to Stieglitz about not receiving the check and he has sold the painting —

Oh — isn't it a nuisance — all these things we have to bother about — I'd rather just look at the sage out my window and I rather imagine you would too.

* *Lake George Window*, 1929, oil on canvas, Museum of Modern Art; *Red Hills and the Sun, Lake George*, 1927, oil on canvas, The Phillips Collection.

The spring here has been cold and windy and dry — usually the mornings are lovely — I like my life here — no matter what the weather —

91. *To James Johnson Sweeney*

Abiquiu — July 28–45

Dear James:

Andrew writes me that Alice Holtman got the keys from him so I suppose that you have heard from her by now —

Dont take those clippings very seriously —— I've never denied anything they wrote so it isn't always true — I always thought it didn't matter much — maybe I even really enjoyed usually feeling quite different about myself — than people often seemed to see me.

I have decided that I will return to the city earlier than November 1st if it will make what we have to do for the show work out any better. Will you tell me? I can even go to town October 1st. Write me what you think about it — I would rather return earlier and have plenty of time for everything.

I love my world here — but I always know I have to go so a few weeks earlier doesnt matter much — I wrote Rich about the letters. His secretary wrote me he is on vacation — Maybe he will receive your letter — I am writing to the secretary.

I am so surprised that you choose to do this thing because I never had any idea whether you were interested in what I have been doing or not — It pleases me very much.

Sincerely

Georgia —.

92. *To Caroline Fesler*

[New York, 24 December 1945]

My dear Caroline Fesler:

The days go by and suddenly it is time to greet you again for Xmas.

As I went on with my framing I kept thinking of you. Tomorrow we try the frames for the last time. I am not intending to put them on till after my show but I like to have them ready.

I so much enjoyed the hours with you when you were here. Wasn't it odd that I didn't encourage you to take a painting. I was interested in the framing — and in what you feel about the paintings — They looked so different to me here than in the country I was a little bewildered at seeing them here —. It didn't occur to me that you might want one. I hadn't shown them to anyone but Stieglitz — I have only shown them to two or three people since.

I liked it that you liked the blue and the red of the bone series It is a kind of thing

that I do that makes me feel I am going off into space — in a way that I like — and that frightens me a little because it is so unlike what anyone else is doing —. I always feel that sometime I may fall off the edge — It is something I like so much to do that I dont care if I do fall off the edge — No sense in it but it is my way — I have sent my check to buy the Abiquiu house.

The gift I'll send later — So that is on the way. Fantastic like my painting but I some way oddly feel its right —

I hope this finds you well — And I imagine you very busy with Xmas — Dont do too much —

When do you come to town again — I look forward to you
Sincerely
 Georgia O'Keeffe

My best wish for the New Year —

93. *To Cady Wells*

[Abiquiu, early 1940s]

Cady — it is Monday night — and I must write you as you did not come because I have thought so much about you — to you. I really did not think you would come but I hoped you would — I wanted to walk through my world here with you — up to the cliffs — and through the red hills — Last evening Maria and I walked up to the cliff through the bare — open space — then back down another area where the water drains and there are trees and big bushes — tonight — at sunset I walked alone out through the red hills — I thought of you — wished you were with me but I get a keen sort of exhilaration from being alone — it was cold enough to wear a woolen jacket — I walked some distance — then climbed quite high — a place swept clean where the wind blows between two hills too high to climb unless you want to work very hard — I didn't want to climb so high — it was too late — but from where I stood it seemed I could see all over this world — When the sun is just gone the color is so fine — and I like the feel of wind against me when I get up high — My world here is a world almost untouched by man — I feel that your world out there has been colored by the soul of the Mexican

— I really dont know why I should so much wish you to walk with me through what is just outside my door — unless it is that I think it almost the best thing to do that I know of out here — it is so bare — with a sort of ages old feeling of death on it — still it is warm and soft and I love it with my skin —— and I never meet anyone out there —— it is almost always alone — I wanted you to walk through it with me like I wanted you to go to hear Marian Anderson sing — it is one of the best things I know of — Well — you did things you really wanted to do I am sure — the days must have gone very

fast. I did not realize till this afternoon when I counted up the days on my fingers that you must be leaving either today or tomorrow — It was very good to see you —— I have really become very fond of you —

94. *To Henry McBride*

[New York, early 1940s]

Dear Henry McBride:

I must write a word to you tonight — Friday — With my way of being busy over nothing — out of breath with being busy — I leave many things undone that I really think I wish to do

I just want to say this to you — You see — I see Alfred as an old man that I am very fond of — growing older — so that it sometimes shocks and startles me when he looks particularly pale and tired — Aside from my fondness for him personally I feel that he has been very important to something that has made my world for me — I like it that I can make him feel that I have hold of his hand to steady him as he goes on —— and as I see you it is a somewhat similar feeling — only I am not so close — I like you to know that I appreciate you — You give to me if you let me do such a little thing for you — You give to me much more than I can possibly give to you — just by being what you have been

Believe me

Sincerely

Georgia —

1947–1981

After Stieglitz's death in July 1946, O'Keeffe spent the next three years settling his estate. With the assistance of Doris Bry and the advice of several friends, notably Daniel Catton Rich, James Johnson Sweeney, and Duncan Phillips, she divided among several major American museums his huge collection of paintings, prints, drawings, and photographs by some of the foremost American and European modern artists. Thereafter, her life was much more private. Without Stieglitz's encouragement she felt little need to exhibit; after a final show at An American Place in October and November of 1950, she had only ten one-person exhibitions in the next thirty-five years. In the spring of 1949, no longer drawn back to New York each winter by Stieglitz, she settled permanently in Abiquiu. She continued to correspond with her old friends—Peggie Kiskadden, Henry McBride, Anita Pollitzer, Russell Vernon Hunter, Todd Webb, and others—telling them of her travels to Mexico, South America, Europe, Asia, and India. These final letters speak of her contentment in her way of life, her continued concern with current events, her quiet confidence in her art, and her deep love for the New Mexico landscape. After a telephone was installed in her Abiquiu house in the late 1950s, her correspondence dwindled, but did not stop. She died in Santa Fe on 6 March 1986 at the age of ninety-eight.

95. *To Albert Barnes*

59 E. 54 – NY Sunday – 6/22 – 47

Dear Dr. Barnes:

It was fine to see you on Thursday — good to hear what you seemed to feel about the Stieglitz show at the Museum. I think your interest would have pleased him very much.

I want to thank you for certain things you said that help me clarify what I must do with the collection eventually.

I go to the country on Wednesday for six months at my own affairs then will return and finish the Stieglitz business. I find that many things settle into place with time.

About my Barn* — I wish you had asked about it last year. I think I must leave it with the Stieglitz collection through the Chicago showing early in 1948. If I sell it the price will not be low and I am not at all sure that you would be interested.

There are certain pictures of mine and of Marins that Stieglitz has asked high prices for and because so many people have said he was crazy to have such ideas. I have wanted to remove those things from the market so that no one would get them for less than he has asked. Maybe I am crazy too. My Barn is one of those things.

Going over to Merion to see your paintings has always been a real pleasure to me. My last day there is particularly vivid. —— Naturally I would like to have something of mine among them.

* *White Canadian Barn No. II,* 1932, oil on canvas, The Metropolitan Museum of Art.

You seemed to turn from all my paintings except the Barn as if they did not exist. I wanted to ask you what you were thinking but hearing what you wished to say interested me more than what you did not seem to intend to say —— so I let it go at that.

I was most interested in your reactions to the Stieglitz material in general. It was important to me at this time when I haven't much to say about the Museum that is good.

May I see you when I return in the winter. James Sweeney and I both enjoyed your visit very much.

Sincerely

Georgia O'Keeffe —

96. *To Margaret Kiskadden*

[On train from New Mexico to New York, Fall 1947]

Dear Peggie:

It is a long time since I have spoken to you — I have not even greeted your new child — which I really wish to do before she leaves you for college — or is it a boy — I do not remember — Forgive me that — but my year has been very difficult — Last winter I made up my mind that I must either work very hard for a year or be two or three years getting Stieglitz affairs in order — So I worked hard — hard as no one should work unless it is on something of their own —— then it does not matter.

You can not imagine the number of things he had put away at the Place. I must do something with all of them — either sell or give them away — Jim Sweeney helped me — and in the spring we opened at the Museum of Modern Art for the summer — a show that was two shows — one was the collection of other peoples things — the other his own photographs.

Aside from that we have made an effort to get a small photograph made of everything he has photographed — It was an appalling chore. As I write it to you I wonder if I am in my right mind. I can not go into the strange and difficult things that happened. None of those "sitters" at the Place did anything but make trouble — Oh it seemed there was trouble everywhere — Dont be sorry for it — It was all very interesting — taking inventory of my period in most difficult fashion — and it is good if one really can weather it — one has to make so many decisions — there is no way to be right — so many things and people cease to have any meaning

I am on my way back to the city to finish as I can — settle my affairs so I can stay in New Mexico.

The Stieglitz will is not yet settled so that I can finish that but I think it will be very soon —

All summer I was so bothered about many things in connection with it that I seemed to do none of the things I intended to do — I didnt seem to be quite present anywhere —

The Abiquiu house has a roof on it and is all newly plastered — the garden leveled — it is all amazing and I must add — a bit crazy — Maria has done it — and in an odd way the utter foolishness of doing that seemed to keep me alive on that other impossible chore —

All this is why I have not written tho I think of you often with affection — and hope that your life is good

I seem to have had no time for myself and my own affairs. — I even had the girl secretary who helps me out at the ranch for her months vacation and then to work a month during the summer —

———

Now I am back in town and there are so many things to do and attend to I probably will not write again — Last night I went to "Medea" — then for a couple of hours with Judith Anderson afterward — It seems to me much better than what we usually have in theatre — It even seemed to me one of the good things I have ever seen on the stage

My love to all of you Peggie — and think of me with kindness even if I do not write — As always

 Georgia

59 E. 54 — New York —

97. *To Henry McBride*

Abiquiu, NM 7/19/48

Dear Henry McBride:

Ettie writes me today that you fell down and bumped your head or something so that you had to go to the Hospital — that you enjoyed the Hospital and being taken care of — but that you have recovered and are at home.

Well — now that is a fine thing to be doing this time of the year. Why dont you do it in the winter then all the artists would visit you and send you flowers —

I am afraid to write you that I am sorry because you would probably just sniff and think I intended having a show — That was pretty mean of you when I was so glad to see you at Etties dinner and you suspiciously remarked that I must be intending to have a show. I could shake you every time I think of it — and I must also say that after the last specimen of a notice I had from you I cant imagine why you would think I'd be wanting another.

I only read two reviews of my Museum Show — yours — and Sobys — Yours I read because I like you — Soby I read because Stieglitz particularly asked me to —

This summer I have one big painting — four feet high — seven wide* — It looks very well to me where it is so I think it will stay there. It is too large to take to town —

* *Spring*, 1948, oil on canvas, private collection.

No one would buy it — the conversation I dont miss. If Alfred were here I would take it for him. He would enjoy it — for the others I don't seem to care — it can stay here.

My life is very pleasant this year — one of the events was a particularly brilliant star when I first came. It was so bright that it made a pattern of star light in my room like pale moonlight — I wonder if you had it in the East. It was so very bright in the evening.

Ive been sleeping on the roof this week. I have an army sleeping bag and it is the best outfit I've ever seen for sleeping out. I like to see the sky when I wake and I like the air — and I like seeing all over my world with the rising sun.

I have a garden this year. The vegetables are really surprising — There are lots of startling poppies along beside the lettuce — all different every morning — so delicate — and gay — My onion patch is round and about 15 feet across — a rose in the middle of it — Oh — my garden would surprise you and I think you would like it very much — it has an adobe wall all round it —

On Sunday morning — early — the water comes in to irrigate — creeping over it all till it is all a lake — divided into many sections with raised paths to walk on to control the water — I dont know how I ever got anything so good — I might add that the good people of the town have water for their needs on week days — I can have it on Sunday because I am an outsider and a heathen anyway.

I live alone up here and seldom see anyone — I have that sour swede that I had for so long in N.Y. but she doesnt like it — says she is going to leave. That was two weeks ago and she is still here. — I told her I would take her to the train any day she wants to go.

Two men came out of the sky in a big shining plane — landing at my door one day this week — going to look at the baby dinosaur bed — one the park commissioner of the West — the other a man who makes plastics — After visiting the dinosaur they had lunch with me — and went off into the sky — it was odd and amusing — unreal like the poppies —

Now I've told you a little about my world because I think its good — and to say something of the summer to you. —— Maybe because you fell down and hurt your head.

I see that I've written you pages. Usually I dont bother to tell much about what is here — Take care of yourself and dont fall down again

Fondly

Georgia

98. *To Russell Vernon Hunter*

Abiquiu, NM Oct. 30–48

Dear Vernon Hunter:

It is always good to hear from you tho sad to hear of your fathers being gone — Of course he will never be gone —

It is odd — Stieglitz was never out here but there are certain places that he always seems with me here. I wrote him so often from here and thought to him so often —

I wish you could come and sit with me here. It has been raining off and on for two days. Tonight is raining hard — Ive done over an old house in Abiquiu — Have a huge studio — white — with a dirt floor — It is so large it is like being outdoors — I have two tables ten feet long and four feet wide and two big saw horses and a large desk — and the room seems empty.

Ive been living here about three weeks — My first painting — a dead tree surrounded by the autumn is very gentle and pleasant and high in key but it holds its place on the wall alone more than forty feet away.*

This house is just another of the odd things I have done in my life — it even has a lovely garden all walled in — and it has surprised me to feel what a warming difference a garden can make in ones life. I am sorry that I must leave it for the city. I still have at least a winters work settling Stieglitz affairs — After that I will stay here. I would like to stay away from the city for a long time —

You must come and sit with me next summer and we can talk a long time —

I wonder — it just occurs to me — do you do anything about photography in the Dallas museum. I have a few very fine sets of Camera Work that I want to place well — Would the museum be interested — ? I wonder if you have seen it —

Well I wish that you were here and we could talk —

Are you painting any? Is your work at the museum interesting

I look forward to seeing you next summer

Sincerely

Georgia OKeeffe

My greetings to Virginia and Kim —

99. *To Daniel Catton Rich*

Abiquiu, NM 11/13/49

Dear Dan Rich:

I have been to Fisk and am back in Abiquiu — It was an experience that now seems like a strange dream

Doris and I drove. Crossing the Panhandle of Texas is always a very special event for me — cattle lowing at night — driving in the early morning toward the dawn and the rising sun — The plains are not like anything else and I always wonder why I go other places. — Why people live in Tennessee for instance —— or Arkansas — or Oklahoma —

Well — we arrived at Fisk to find a most fantastic place arranged to hang pictures — An old gymnasium done over — by a N.Y. architect. The ceiling had been lowered and

* *Grey Tree, Fall,* 1948, oil on canvas, private collection.

painted black and was so full of those new bell shaped lights hanging on 36 inch stems that it looked as if they wanted to sell lighting fixtures — Oh I cant go into the details of it — It is just too much — but with great effort we got the lights changed — took off many boards of unnecessary moulding — painted walls — changed the color of wood-work — cabinets etc. in the new Art library room — made them a big table like my big tables in the studio here —

It seems fantastic when I think of it — even the first inside doorway was crooked and had to be straightened

It was a fine space for pictures but everything they had changed according to Mr. Platt of N.Y. — was wrong —

The inertia of the South seems like a mountain as I think of it now — They had spent so much and had nothing for it — I was really distressed about that — Mr. Platt had written them that I wanted all the things he ordered.

— Well — the man who had charge of the buildings was good — His hours of work changed — he got there between 7 and 8 mornings instead of 9 — Doris and I always got there at 7 to think and plan a little and to be sure they didn't start doing anything wrong — All the workmen were sour when we started — also I began feeling that all the dark skins hated us because we were white. We made some very good friends among the students but everything seemed a sort of battle — However I felt we won — and I think we won because we worked harder than anyone and we left a good job when it was finished.

The day before their opening Kelly who lighted the Lachaise show at Knoedlers — phoned me from N.Y. and asked about the lighting when he received the invitation to the opening — He had been at the meeting when I saw the architect — Then they had not consulted him further — When I told him how desperate I felt about the lights — he said well I'll fly down in the morning — I was most bothered about the lights on the photographs — He is an odd young man but he saved the lighting part of the show. He got things we needed sent by plane to Nashville faster than we could get them from the airfield to the University — And only an odd young man would do what he did just because he was interested in lighting — It was really very sweet

There was a lame colored man — head of the group of men who worked on buildings — who was quite special. It was interesting — He was the sweetest of them all — I had a hard time to move them with their union ideas — and was surprised to find that the lame one was head of the union — He wanted to know if I would go to a meeting of his union and speak to them

There was a very black girl — who asked me the startling question — Why do you associate the idea of purity with white and not with black — She was very quick with her intuitions — and clear with her thinking — so right down on the earth like a truth — I find myself constantly wondering what she would think and say about what goes on around me — as if it is a test

It was almost impossible for her to accept the idea that she was black — She wanted only to be a person — She was just as funny as she could be —— but very rare besides —

I had no idea before of the many things color of the skin can mean and do — it is sad — That black girl had something that made me discount the color of her skin as I never have with any other colored person—

Yes — Fisk was an experience in snootiness — inertia and what you will — a kind of eagerness that made one want to cry

So — when the show was up I was too tired to go to Chicago. I had painted a blue — light bright blue wall that one saw through a doorway in a white wall — facing the entrance — It all felt fresh and alive —

When I thought of going to Chicago I had no idea that Fisk would be so difficult and so tiring — When I had finished I was pleased with what I had done but I only wanted to come home —

It is warmer here than when we left — a lovely still Sunday today — It is good to be here — with the feeling of one more thing finished

From your letter I believe that what belongs to me are pages of Leica shots marked

 Show — Large Prints Page I Page II

 Show — Small Prints

 Prints with Passe-Partout, Not in Show

If your other Leica pages correspond with the prints you received these above mentioned should be returned to me.

I will ask Doris to see you about the two photogravures of "Old and New N.Y." (Leica No. 132) when she goes east.

I am sorry this has been so difficult. So far it seems to be the only mistake of the kind. I wonder if you made the picture exchange with Marin.

Also what are the Arensburg and Brancusi dates. I would like to see both — tho at the moment can not imagine wanting to leave home —

Thank you for asking me to stay with you if I had gone to Chicago —

And give my best greetings to the family

Sincerely —

 Georgia O'Keeffe —

100. *To William Howard Schubart*

<div align="right">Abiquiu, NM 4/6/50</div>

Dear Howard:

Enclosed find signed papers —

I have never experienced anything like this week — the church overpowers the little group of houses — and there is so much praying — so much parading — with sad doleful singing — tunes that seem to come from a long long old experience — every day feels

like Sunday — I've just been up on the roof listening — The old fellows who were important handed down the word that they should sing so that the hills would ring back the song to them — the songs are short and get their strength from being repeated again and again as the procession comes down from the hills and goes to the church — then after a time leaves the church and goes back up the hills — It is oddly moving with the faintest touch of green just coming —— and the long dark mesa back of it all —

Sad — a remnant of an old faith —

— G

101. *To William Howard Schubart*

[Abiquiu, April – July 1950]

Howard

Do you drink tea — Tea can be a real experience you know — Yes —— you probably know —

Do you drink mint tea?

It is a full moon tonight — I think a bit hazy for here — The back patio from the kitchen to the studio is a big dark shadow —

Also — it is snake time — driving to town yesterday — and again today I saw three or four dead snakes on the road — some pressed flat — some just dead — run over by cars — fine big strong looking snakes — I hate to see them dead — In the spring and in the fall they crawl out on the pavement because it is smooth and warm — then the cars kill them

— Now it is snake time again — anytime I might step on one walking across that big dark shadow — I might even find one in the house one day if a screen door is left open — No — I dont mind — in some odd way they seem to be my friends — at least I always feel they are — It is a special kind of awareness I always feel about them — always so hard to see — day or night — so I carried my pot of mint tea very carefully — thinking — Yes — someday a snake will startle me and I'll just jump and throw or spill the tea pot — So I walked out of the shadow at the patio gate to look at the moon — And as I stood looking at the long dark mesa line — the moon above it — the curve of the low wall going down at the left — the mountain out beyond the wide valley as if across water — I thought to myself — Well — it would be good to sit on the wall and drink my tea — but one doesnt do that alone — I'll go in and ask Howard if he drinks tea — and mint tea

I have a patch of mint just outside the door that goes into the garden because I like mint tea

Yes —— mint tea and snakes — the mesa and the moon

How are you?

G.

[Abiquiu] 7/28/50 –

Dear Howard:

I have your letter telling me of your fears about my having a show — that it may not be good etc.

Dont think I havent thought that over — and that I think I have material for a very good show — it may be even rather startling.

However — as you know — I have 2 houses and there are paintings in both of them — within a few days I will get the paintings all in one room in one house and see how I look — I was willing to have a show just on what I have here in Abiquiu — so I feel pretty secure about that — I have always been willing to bet on myself you know — and been willing to stand on what I am and can do even when the world isnt much with me — Alfred was always a little timid about my changes in my work — I always had to be willing to stand alone — I dont even mind if I dont win — but for some unaccountable reason I expect to win —

It is as if I feel that my world is a rock — When a very prominent catholic priest — he was head of the chemistry at Fordham — tried to convert me to the catholic church — I was amazed that he could only make the catholic church seem like a mound of jelly compared to my rock —

— I dont even care much about the approbation of the Art world — its politics stink

I dont see that it matters too much — I'll be living out here in the sticks anyway — What is the difference whether I win or lose — I am a very small moment in time

I am enclosing a letter from Doris that I had today — I will look at all my work together —— I could have a show in October and be out of the Place by Dec. 15th — and risk leasing the Place after that —— also risk selling enough to carry it —— My financial estimate is nearer correct than hers.

I dont have to save money for anyone — I dont suppose it matters if I am that much behind if it works out that way — Why dont you go in and call on Doris at the Place and see the kind of slave I have — I think she is pretty good. Dont tell her I sent you her letter. You had better phone first to be sure she is there.

She knows about all my affairs but a few personal — very personal things — and my finances — and it is just as well that way —

The phone is still in Alfreds name — Plaza 5-7258 — I think

I am sorry to be so changeable about this lease business but I seem to be — so kindly accept me that way — as I at the moment accept the idea that I have shingles on my right hand and arm

 — G

103. *To William Howard Schubart*

[Abiquiu] 8/4/50

Dear Howard:

It seems odd to think of you at Lake George tonight — I can smell the outdoors — and hear it —— and see the stars — So often before I went to bed at night I would walk out toward the barn and look at the sky in the open space.

There was no light little house —— there were no people — there was only the night — I will never go back there — unless — maybe to stand just for a moment where I put the little bit that was left of Alfred after he was cremated — but I think not even for that.

I put him where he would hear the Lake —

That is finished.

About my work Howard — I always have two opinions — one is my way of seeing it for myself —— and for myself I am never satisfied — never really — I almost always fail — always I think — now next time I can do it — Maybe that is part of what keeps one working —— I can also look at myself — by that I mean my work from the point of view of the looking public — and that is the way I look at it when I think of showing. I have always first had a show for myself —— and made up my mind — then after that it doesnt matter to me very much what anyone else says —— good or bad

What I put down as the most ordinary things I see and know is different than what others see and know — I cant help it — it just is that way.

Good night to you at Lake George —

G.

I am glad I am not there.

104. *To Margaret Kiskadden*

At the Ranch — Sunday afternoon 9/3/50

Peggie Dear:

Since you left I have wanted to write you and tell you what a very real pleasure your visit was to me. It made me feel that I had been at home again — at home with many things that have meant home in my life but are not quite a part of what is my life as I live it now — A tear drops as I write it to you — as I know tears were coming when you left and I could say nothing — The long time we spent over Alfreds work the day before you went made it seem that he had been here too — He always seems oddly present here

at the ranch — I was always so aware of him here for so many years — I wrote to him from this table so many many times — so he is always here — and when you were in Abiquiu he seemed vaguely present — as you drove out the gate — it was as if that thing he had been in my life for so long was going again — driving off into the dawn

Having you come after all the years was very sweet to me — You were the same as always — the new little boy so full of life and growing — very sweet too — a new thing I will always be thinking of it

You must plan to come again next year. I will be thinking it that way —

The Monday after you left Frieda and Angelino came and stayed till Tuesday afternoon — I asked the Mortons from across the river and the young couple who live at the end of the road up Burns Canyon — to show her what lives up the Chama River — different from Taos — I had a very good time — and I think they did too — Frieda is so astonishing —

At present Helmut DeTerra is asleep in the dining room — He was at one time married to one of Alfreds "inlaws" — a few years ago discovered some astonishing prehistoric man in Mexico City — much interested in the possible diggings here and in Abiquiu but is hampered at the moment with a lame foot — Pleasant to have him for a couple of days — and so my life goes —

Your two fine cheeses came yesterday as we sat at breakfast planning a picnic — The red one went along — it was very good indeed — also the soft one with the salad at night — You think too much of such things for me — but I liked the thought —— that is — I ate it with great pleasure — I was worried about you as you left — you had so little sleep to start on such a long drive — and the difficult time that was ahead of you with your friends and their loss —

You should not tax yourself that way — it is too much — We all need you to be more careful — I hope it was not too much for you and that you are quite alright

Could you send me Tissies name and address — so that I can write them to come for Xmas — My greetings to your Bill and Bull — and my love to you as always

G —

105. *To William Howard Schubart*

Abiquiu, NM 10/26/50

Dear Howard:

I can not tell you how pleased I am to be back in this world again — what a feeling of relief it is to me. The brightest yellow is gone from the long line of cottonwood trees along the river valley — With the dawn my first morning here I had to laugh to myself

— it seemed as if all the trees and wide flat stretch in front of them — all warm with the autumn grass — and the unchanging mountain behind the valley — all moved right into my room to me — I was very amused —

It is a very beautiful world here —— and dark little Emelia had everything so neat and fine for me — She had worked so hard that I felt sorry for her — Oh — it is very good to be back — And I feel about my friends that I leave in N.Y. that I have left them all shut up in an odd pen that they cant get out of —

As I sit here writing — seated on a large cushion at the foot of the bed — using a stool for a table I see the large almost full pale gold moon rise up out of the horizon at the end of the mountain — Needless to say that is why I am writing here instead of at a desk. The moon came up with such a soft feeling —— then as the sky darkens the moon becomes brighter — more brilliant.

Howard — I know I havent done my show as anyone else would do it — but let me say to you — and believe me — it is alright —— no matter what comes of it — I have no expectations so I can not be disappointed — I feel oddly secure in just letting it work for its self. If it doesn't make any headway — well — then it just doesn't — but I some way feel that it can get along alone — with Doris — I dont expect anything of her either — except that I think she understands my feeling and will try to follow it.

I am sorry that you worry about it —— but maybe you enjoy worrying a little. I do not know.

Certainly talk with Doris about anything you want to — ask her anything you want to — only dont let her worm anything about my finances out of you —

You speak of "authorities" I was to sign — I signed a great many and returned them to you. I assume that you received them long ago as I mailed them the day after I received them — You undoubtedly have them by now ——.

Howard — I too was looking at you — It seemed that you looked better than when I had seen you last — I was surprised that your eyes were so blue — You looked very fresh and alive — You ask me if I am always intending to stay here — all I can say is that I do not know — but I doubt if I can do better. It might be fine to look at the Irish sea with you — but left to myself it seems a lot of trouble —

I wanted to go to Hawaii again — this is the first winter I could go but it doesn't seem a very sensible thing to do with times as they are — So I think of Old Mexico — Maybe — I really dont care — I like it here —— I spent maybe a foolish amount on books in N.Y. — that take me off to a kind of thinking that is exciting to me — pictures — and poetry — and some very dull things that make me think I understand something of the ways and means others have used for creating —

Often as I read I wonder would it interest you

Or — a painting — would you like it as I do —

I stopped in Kansas City and spent the day in the Oriental section with the man who has collected it. He unrolled many Chinese scrolls for me — There are four that are vivid

and very beautiful to me — Two others I saw in Chicago that I will not forget — one of a Chinese woman orchestra that was very lively — and alive

I dont think it matters much where one is if one is interested —

So why shouldn't I be here if I'm interested

— G.

106. *To William Howard Schubart*

[Abiquiu] 12/23/50

Oh Howard —

I wish you were here tonight — The night is so fine — the moon so bright — the patio walls so warm and alive in the cool bright moonlight — one very bright star over the southwest corner of the patio — that patio is an enclosed space with the bright sky overhead — the walls are the walls of rooms with few openings into the patio — and they are the soft warm adobe that one always wants to touch — or one sometimes feels it is too fine to touch — one should just leave it there alone — remote —— untouched.

There is a Xmas tree standing on the round well top in the patio — another one here at my door — It is so amusing to see trees where there usually aren't any. Particularly in the clearness of a night like this. Emelia and Jo and I got them from the mountains yesterday.

A friend came today from N.Y. for Xmas — tired and has gone to bed tho it is only eight

It interests me to feel how very pleasant a warm real person makes the house feel — She is quite crippled and creaking in all her joints which astonishes me — and makes me feel how alive I am without any creaks —

I havent written in a long time I know — I've been doing odd things — You know there are men and women out here who dance and sing to make the corn grow — to bless the home —— to cure the sick —— Indians of course — Ive gone to two all night dances — one in a village about 250 miles away — the Shallico — at Zuni — the blessing of the home — The other about the same distance, in another direction — up a very rough mountain road newly built — or cut for the occasion — a Navajo ceremony that has to do with curing the sick and also something to do with a kind of adoration of fire that I dont understand — but I would say that some 1200 people gathered out there in the night — built big fires — particularly a big central fire — surrounded by some 15 or more smaller fires within an enclosure of pine boughs — teams of 20 and 30 came in and danced and sang all night — they all bring food and eat around the fires — evening and morning — the singing and dancing amid the green — the smoke — the fires and the stars — It is quite wonderful —

107. *To William Howard Schubart*

Abiquiu, NM 1/19/51

Oh Howard —

My past is catching up with me — That truck came today with crates and crates of things — and I dont mind it so much in Abiquiu because —— after all — being here is rather new — but up at the ranch it seems like an invasion. The truck was so big he had a hard time to get in my gate because the road going past isn't very wide here in Abiquiu — and I didn't have him go to the ranch because the mile and a half after you leave the highway is something he just couldn't get over at all —

However — everything is neatly stacked away and now that is done. When I will open the crates I do not know — My interest is very mild — so the door is locked on that —

———

Yes — I understand the "A" and "B" account idea. What had me puzzled before was that you deposited picture money in both accounts. However it seems to be settled and clear now — Halpert was very amused that I had my show at the Place so maybe she will not work to sell anything for me — however — give her time and she will recover — and if she doesn't — well — then she doesn't and I'll do something else.

I have several times been so annoyed with her that I thought Id rather sell nothing than stay with her — so there we are —

I am not in the least bothered about it —

With this mail I am returning, signed the letters you sent me to sign for the two accounts indebtedness to you. Thank you very much for the inventory — so very detailed and neat. Only one thing I find hard to believe and that is that my income tax is only $910.00 — or is that because of the Pittston loss — When I look at a statement like this and see the capital appreciation it astonishes me —— and I wonder if that is what the war is for — or am I fortunate in the people that I know —— or am I just fortunate — I am really most fortunate that I love the sky — and the "Faraway" — and being so rich in those things — tonight I'll send you the moon — I just went out to look at it — the town so very silent — the moon more than half full — the air cold and dry smells so good of the piñon wood we all burn

The studio looks like an attic — it always does when I work — it would undoubtedly distress you — one ten foot table is full of canvas and stretchers and hammers and tacks — then there is a small table full of little pieces of canvas covered cards painted tones of all the colors I have — every day — or I should say night — I stretch a little canvas. It hurts my hand so I do it a little at a time — My palette is very clean — my brushes too — The palette is on a table I can wheel about — another one is on the window sill — the easel is over there by the window — another easel is on the window sill — This table — ten feet long and four feet wide has many little piles of papers — I always think they

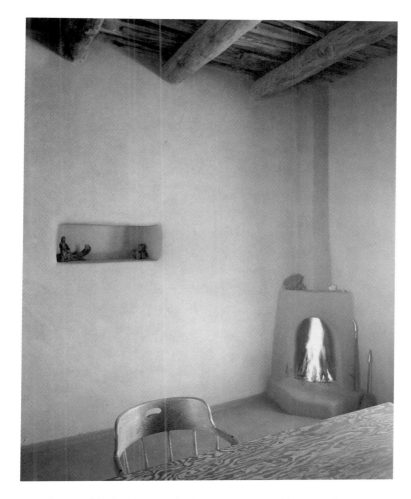

Laura Gilpin, *Georgia O'Keeffe Residence, Abiquiu,* 1960
© 1987, Laura Gilpin Collection, Amon Carter Museum

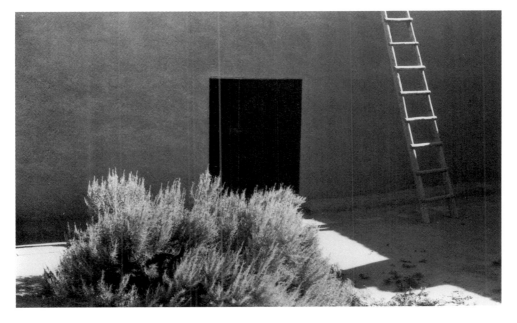

Georgia O'Keeffe, *Patio Door, Abiquiu,* 1961 ?, Collection of American Literature,
Beinecke Rare Book and Manuscript Library, Yale University

are not going to be there one day — that I will have attended to all of them — but it never is that way —

I see this is pages long

Good night to you — pin up the moon — not as fine as it will be the next time I give it to you — pin it up along with that star — The star is smaller but such a fine glitter — I always think of all the desert people who have looked at it and figured out things with it —— or about it

— G.

My love to you

108. *To William Howard Schubart*

Dear Howard:

I am back in Abiquiu since Friday night the 23rd. and very glad to be here.

First I must ask you — did you receive my tax papers —— and did you receive a check I sent you for $1650? I received my Manhattan Bank statements alright. If you did anything about having them held up they could be sent to me here now this month end

The trip was good — but also hard. I did so many things — I wanted to see their murals the boys have been doing for the past 25 years or so — Rivera is writing the History of Mexico on the long handsome colonnades of the fine old Colonial buildings on such a big painting scale — you can not discount it whether you like it or not — He tells a story — with people and their products — and their landscape — I liked best his earlier things — The color gets brighter as he goes on but I thought the quality becomes rather spectacular than fine — But Mexico is often that way. Most of the Riveras are in Mexico City or near by.

Orozco is from Guadalajara — the second city of the country — over toward the west and his best murals are there or near there. His color is startlingly effective — It hits you first as color — then you begin to disentangle the shapes — You get the big effect from the color and the shapes — then as an after thought you begin to wonder what it is about — what is his story — It always has a feeling of violence and revolution — They are all that way — that is what they were born into and grew up with — You feel it as part of their lives —

Siqueiros I did not care for — tho I only saw one — Orozco seems to me their great painter — Rivera seems to be painting the Story of Mexico on a grand scale — It is too bad the two men couldn't have been one — It could have been astonishing

My friend Miguel Covarrubias is painting a mural in a native arts Museum that will open soon and at the same time is managing a big ballet performance — that is financed by the state — He is also doing all the costumes — It will open on the 30th — and I thought that if I stayed another day I would die of the excitement — the feuds and

general goings on — I wanted to see the ballet but I just couldnt take any more of the excitements of its doings — The trip to Yucatan was a very special week all by itself — sea level — white earth and rock — dry jungle — and those astonishing Mayan things — fantastic to look at —— more fantastic to climb. Rose Covarrubias went with me and always climbed a couple of steps below me so I couldnt look down — The sheer drop of 90 steps — each almost a foot high and six or eight inches wide — (I didn't actually measure them) — was appalling — Of course there are Mayan things in Mexico — that I saw first — Some of the finest near Mexico City and Oaxaca — As I look back on it — the good things were really high points —— a pier that we drove a mile or more — straight out into the ocean — then an hour at sunset running up a beach with a hard wind blowing the palms around in fine fashion — so many beautiful shells — the sun went down very red into a pale green sea — I liked it all — but now that I'm home and look back on it — it was very hard work — 5600 miles driving

The few lines you sent me sounded tired — But I hope you are alright

My love to you

— G

109. *To Edith Halpert*

[Abiquiu, 10? September 1951]

Your letter this AM dated Sept. 7 makes me look for your last one and I am embarrassed to find it dated August 1st.

My house has been like a mad house with friends I had thought would be spread over June July and August all coming at once and some of them not liking others too well — and such

But the place is clear now — and I come out of the food — dust — call it what you want — with my usual idea — that I prefer to live alone — even if I get very queer with it —

Now to your suggestion of a "Theme Show" —— I have always thought that a good idea — I could never get Stieglitz interested in doing it. What would you think of a pastel show —— It could cover all the years as it is something I have always returned to and could be very handsome — or even pretty — I do not mind the word as most artists do — I accept it as something pleasant that really adds to everyones life unless their aesthetic ruts are too deep.

And couldnt you just print at end of the catalogue that other work by G.OK. may be seen at the D.T. Gallery*

I dont know what kind of theme you had in mind. — Maybe your idea is better ——
Let me hear.

*"D.T." is an abbreviation for the Downtown Gallery directed by Edith Halpert.

110. *To Donald Gallup*

Abiquiu, NM 3/31/52

Dear Donald Gallup:

Thanks for your letter. I am sending copy of it to Doris — also to Einstein. Doris Bry will be seeing you about these things we write of. Come to what you can with her about it — This is where I am not there any more.

It is nice you got the Rönnebeck material. Have you ever thought to ask Spud Johnson of Taos for any papers he may have. He has been a friend of Bynner, Mabel — Lawrence — etc and might have something of interest. He also printed "The Laughing Horse" as you may know.

I have had much of Hartley in my life as you know and I have chosen one of those German ones to keep. All Hartleys are of interest when you first look at them — For me after the second or third day I take them off the wall — I repeat this again and again — put them up — take them down.

Dove I can leave on the wall day after day — month after month —

Marin I can keep on the wall longer than Hartley — but not as long as Dove — Dove stays.

Doris Bry has wanted to work up a fund for Yale to buy those paintings I have of the Stieglitz group. I would rather see her go on with her work on the catalogues etc.

We have gone so far with what has been done that it seems it should be carried further. For myself — I wish to go on to my own things. This paper work is not my life

 Sincerely

 Georgia O'Keeffe

If you ever come this way come to my world for a day or two or three — It is quite special —.

111. *To William Howard Schubart*

Abiquiu, NM 7/25/52

Dear Howard:

I assume that your remarks on my mid year statement are a gentle reminder that for what I have to spend I spend a good deal — Yes I do — and the odd thing is that I have the idea that I would be satisfied with so much less. The $2062.50 I sent in May I had intended to go into my Principal account and it went into the Checking account — however it makes no difference — I'll probably catch up

 — Money is so oddly like a liquid

 — Thank you

 — G.

— I might also add that as I looked over a few papers I notice that in spite of my bad ways capital has increased almost 100000 — since 1950 — so you are not so bad as a "Moon gilder"

By the way a very hot colored thin moon went down in the West last night — and I always think of the thin moon as a pale moon.

Ive had a priest — Catholic — visiting me for a week — it was very pleasant but when he is gone I realize how uncatholic — in his sense — my soul is — as I read a little book he left me — "The Cloud of Unknowing" by an unknown monk of the 14th century — I am startled to realize my lack for the need of the comfort of the Church —

When I stand alone with the earth and sky a feeling of something in me going off in every direction into the unknown of infinity means more to me than any thing any organized religion gives me.

The church, to me, seems to assume a fear of death — and after — and I think I have no fear

My love to you —
 G.

112. *To William Howard Schubart*

Paris – 4/2/53

Oh Howard

Your letter made me laugh — I knew I shouldn't send you that gloomy one from the boat — but I hated the boat — and also I have an odd idea about traveling — I believe that most of what I see traveling are people unsatisfied — hunting the unknown that they will never find — Maybe I am queer that I am so singularly pleased with the life I have in N.M. I never even seem to see a dog that looks as fine as mine — and I hope they live till I get home —

I keep wondering how this world would seem to me if I had seen it 40 years ago. I do not regret that I did not see it before — but so far I do not long to stay in it as so many seem to — I will look at it — and I think I will be pleased to go home. I had planned to stay through May — I see you return on June first. I asked you before if you mind if I take the same plane — I am going to try to — you may change yours — so may I.

We were met at Le Havre by a new little car and spent a week driving through Brittany — to Paris by way of Le Mans — parts of 2 days at Chartres — the gardens of Versailles — Chartres was the first startling moment for me — It makes me sort the things of Paris very carefully — the next most startling and unexpected was St. Chapelle today — I was astonished in the lower chapel — but when I walked into the upper one after that narrow staircase — I was really astonished — I never imagined anything like it — From that I went to the Conciergerie today and that is a real gloom — Next to Sainte Chapelle

— Ive enjoyed some of the statues and Chinese bronzes at the Guimet — I must go back to see exactly where the statues are from — but both the statues and early Chinese bronze vessels are really wonderful — Ive walked miles through the Museum of Man — very interesting — I seem to remember particularly a very beautiful large Fra Angelico at the Louvre — and an astonishing portrait of some French king — I will look for him again too I am staying at Hotel Regina but address me same as I gave you —

Ive walked miles through their Museum of Modern Art — a duty — but interesting. There is a very fine Turkish exhibition just across the street — I spent this morning there — This hotel is next door to the Louvre buildings as you may know — The cathedral of Paris I went to first thing because Chartres was so exciting — but it seemed not so good tho the windows are lovely —

We have driven all over the city both day and night — Eaten in all sorts of places — most extraordinary things — Spring green and flowers are here — Yes it is a beautiful city — will soon seem a dream to me I suppose. We vaguely plan to be here about 10 days more

— G —

113. *To Anita Pollitzer*

The Ranch – Abiquiu, NM 10/24/55

Dear Anita:

It is a week or more and I do not write you. Now you must realize that I am old enough so that people I have called friends have died — but my dogs are here. Bo sleeps at my door every night and Chia at present sleeps on the bed because she has a cold —

When I go out to work as I do this time of year Bo goes along and sleeps in the shade of the car after looking about to see if there are any rabbits, antelope — or anything alive of interest —

If I go out to walk they go along — if I drive they go — except that I do not take them to town. Friends — maybe the best — and very beautiful too — I am old enough so that my friends children bring their new husbands and wives — and then their children.

Is the man who brings me a load of wood my friend — I pay him — and then because the wood is good I give him a loaf of bread I've made because I know the bread is good — I know he cooks for himself and he will know the bread is good and I want to give him something because the wood is good — Sounds funny doesnt it.

Are my Texas neighbors across the River friends. Is Jackie my friend? I call him my darling and tell him my idea of a darling is someone who is a nuisance — he has been the horror of the community — I hope he doesn't become a jail bird — at 20 he has been in jail 3 times — at present he is in the Marines

Is my framer my friend? He has been a great help to me for many years — Is the young man who sends me a tub of salt herring because he likes it — my friend — I've had

to learn to cook it and now can do very well with it — This year there was a box of codfish too. That was new —

Is the woman who gets me to go to Europe my friend — ?

I consider my doctor and her family my friends

I once had a cat that was my friend The people I visited often in N.J. when N.Y. broke me down were certainly friends

I have a new woman here to take care of me and tend to the many things that have to be done — I've had her 2 weeks and my life is so much easier that maybe such a one is a friend — I dont know — she may not stay — The term "friend" is an odd word —

Names of interest are what would interest most people I suppose — It is another sort of human quality of human nearness and usefulness that has made what I call my friends

Good night Anita

I am sleepy and a little cold

 G

Maybe the man who gave me the dogs is my friend — He knew their parents and grand-parents — He knew they were good

114. *To Caroline Fesler*

Abiquiu, NM 2/5/56

Dear Caroline Fesler:

It is a long time and I have not spoken to you. Probably I have thought of you more often because I have not written than I would have if I had written — but I want to say to you that I have thought of you very very often.

Tonight it seems I must write.

The first thing is that Dr. Rolf has been here this week. She came Tuesday night and left Friday. It was so surprising to have her here — to look out the window at the world all white with snow — then look back and see her sitting there.

I always feel indebted to you for her work on me and I must say that after her working on me three hours a day for two days I feel quite made over. I have missed her the last two times I had to go to the city — by city I mean N.Y. — and I really missed her strong hands.

It is Sunday tonight. Last night the Budapest Quartet played at Las Alamos — I live so out of touch with the world I wouldn't have known it if Maria Chabot hadn't told me. She got the passes one has to have to go up there and we went. It was a lovely concert and a pleasure to hear real music after having only the mechanical variety that comes out of a High Fidelity setup for a long time. It was really a pleasure.

Then after the concert I went back stage and asked the Schneiders to come for lunch today. They came with Mrs. Hoestine. Maria came too and we had a very fine time — Best of all it was Sashas birthday.

When they came in they just stopped and looked in an odd way that made me feel they were very surprised. I am living in the house that was being built when I saw you last — and inch by inch it is becoming — my house — something that feels like my shell to live in so I guess it isn't like other houses they go to. I had to take them around and show them the different rooms. We spoke of a mutual friend through whom I had met them and of other mutual friends — including yourself. This seems to be the week you have come to my house tho you were only present in thought —— Maybe that is as real as anything. It was a very lively few hours — Alexander showed us his violin — It is so beautiful as you know. He played some Bach — then I had to show some paintings which is something I never do

— Oh — for me it was a very fine afternoon — The touch with the artist is such a live thing — And the slight touch with my other life that was very different than my life is now.

— They are all gone — and I am left with my tiger alley cat — and my two blue black Chows — asleep on the couch.

My life here is very good. I would rather be here than any place I know so I assume that as lives go it is pretty good — In the springs of 53 and 54 I went to Europe — France and particularly Spain — glimpses of North Africa and Germany —

The spring here has terrible winds with dust — It is a good time to go away if one is going —

I hear of you quite definitely from Rolf —— and I suppose she reports to you about me —

Alan Priest spent a month with me on his way back from Japan when he went about the large Japanese Show that was sent here —— But you had probably heard that — This takes to you all my good thoughts and best wishes — always
 Fondly
 Georgia O'Keeffe

115. *To John I. H. Baur*

Abiquiu, NM 4/22/57

Dear Mr. Baur:

I am sometimes long in getting at the mail —— then sometimes it is too late to answer part of it — When I read your letter again I find that you did not send me the questions you speak of. If you will send them to me I will see what I can do and I will not wait so long again.

I think I would say that I have worked differently at different times — "From the Plains" was painted from something I heard very often — a very special rhythm that would go on for hours and hours — that was why I painted it again a couple of years ago* —

From experiences of one kind or another shapes and colors come to me very clearly — Sometimes I start in very realistic fashion and as I go on from one painting after another of the same thing it becomes simplified till it can be nothing but abstract — but for me it is my reason for painting it I suppose.

At the moment I am very annoyed. — I have the shapes — on yellow scratch paper —— in my mind for over a year —— and I cannot see the color for them — Ive drawn them again — and again — it is from something I have heard again and again till I hear it in the wind — but I can not get the color for it — only shapes — None of this makes sense — but no matter

 Sincerely

 Georgia O'Keeffe

John I. H. Baur
The Whitney Museum of American Art
22 West 54 — N. Y.

116. *To John I. H. Baur*

<div align="right">Abiquiu, NM 5/8/57</div>

Dear John Baur:

 As I look at your questionnaire I must laugh and say to you what the man who works in my garden said a few days ago "Words are like the wind"

 — He only speaks Spanish — I only speak English — if it is anything particular I must say to him someone must usually say it for me — Probably reading and writing are difficult for him — I dont know — I have had him for several years so we must get along well enough — "Words are like the wind" — Circumstances make us not have many

 Sincerely

 — Georgia O'Keeffe —

117. *To Frederick Mortimer Clapp*

<div align="right">Abiquiu, NM 1/27/61</div>

Dear Tim:

 Your letter distresses me that the world is so dreary to you — Doesn't even the new president make you a bit interested in the year ahead — It makes me very interested

* *From the Plains I*, 1919, oil on canvas, private collection; *From the Plains II*, 1954, oil on canvas, Collection Thyssen Bornemisza.

And of course I like my life — Today it snowed off and on all day — I was painting — and the dog lay here asleep almost all day. He doesn't like to get wet

This fall I went to Cambodia via Japan — Hong Kong — and Bangkok — then returned through Fiji and Tahiti — I was also on Moorea and I imagine it must be the most beautiful place in the world — That was very exciting to me.

When I went round the world I missed Cambodia because of the revolution and it was one of the places I wanted most to go — so I went this fall

I am always busy — very busy — Almost every afternoon I walk a mile or two with this dog — getting me out that way is one of his real uses.

I have had a number of visitors the past two weeks but usually I am alone and I even like that.

In March or April I think I will be going to the city for a few days. I hope to see you Sincerely —

Georgia —

118. *To Todd and Lucille Webb*

[Abiquiu, 22 December 1963]

Anyone living in this modest looking house should not have a parasol like you sent me so I return it to you. I only need a sun shade in the very hot places where a palm leaf fan does very well

Had a wonderful walk in new snow at the Ranch today with the dogs — it was very good indeed — Thanks for that fine map — Best to you both ——

G.

119. *To Adelyn Dohme Breeskin*

Abiquiu, NM 11/26/65

Adelyn Dohme Breeskin
Smithsonian Inst.
Collection of Fine Arts
Washington, D.C.

Dear Adelyn Breeskin:

I am sorry that I have not answered your letters of Sept. 27 and Nov. 16 — I do not pretend to think that excuses excuse — but I worked very hard this summer and wrote to no one — saw almost no one — It was a bit funny — I painted a painting 8 ft. high

and 24 feet wide* — It kept me working every minute from 6 A.M. till 8–9 at night as I had to be finished before it was cold — I worked in the garage and it has no heat — Such a size is of course ridiculous but I had it in my head as something I wanted to do for a couple of years so I finally got at it and had a fine time — and there it is — Not my best and not my worst — If you get out to Fort Worth for my showing there in March it will be there if I dont ruin it unstretching and restretching it again to ship it —

I would like to go to the opening of your show on Dec. 1st but can not. I had to go to N.Y. on Nov. 4th and on the way back stopped at Fort Worth to see the Museum which I had not seen then went on to Houston to see the show Jim Sweeney has there now of work being done in Paris at the time of our Armory Show. It is a very beautiful show.

I was away almost three weeks and must be home now and catch up with myself. Thank you for asking me. If you come this way again be sure to stop
Sincerely,

 Georgia O'Keeffe

I will be interested to see your catalogue to see what you have of mine for your show —

120. *To Aaron Copland*

Abiquiu, NM 7/19/68

Dear Aaron Copland:

Your records came to me and I am very pleased to have them — It has always annoyed me that your music does not speak to me — I always enjoy seeing you — You dont seem to get old like most of those people at the Academy so it is always a particular pleasure to see you — Maybe I can get to the music one day — It is to me as if our worlds are so different that I dont seem able to get through the door into yours — I say it as it is — thinking you will understand — and probably laugh as you lay down this sheet of paper
 Sincerely

 Georgia O'Keeffe

121. *To Joseph H. Hirshhorn*

Abiquiu, New Mexico November 29, 1972

Dear Joe

It was very fine to have the surprise of your coming for my birthday and I appreciate the effort it must have taken. It was very good to see you.

* *Sky Above Clouds IV*, 1965, cat. 120.

But Joe, I must say to you again — and I hope it is for the last time — that you should run Jim down and get him to present your show at your Museum in Washington. I have a notion that you think Jim is too old. But he will be the best you can have as long as he is around and he'd probably just as soon die hanging pictures as doing anything else. And I only keep dogging you about this because I am so afraid your opening will not come off well. If you don't come off well in the beginning, you will never be able to pick it up and we will have another failure in Washington which is no pleasure as an idea.

Too many people would like to see you fail. Getting Jim to work on it is the only thing that makes me feel you [are] reasonably secure. Even if he says he is going to Israel for six months, you might be able to keep him from staying six months if you made him an offer that he wouldn't refuse. I would say that getting him to do it would be worth a good deal. I just feel we can't afford not to have your Museum come off as a success. It would make such a difference to the Art situation of the whole country.

I know that you and the man who has been helping you can't possibly make it a success. It will take the best person you can find to make it a go and you haven't a minute to waste. There may be some young person that I have never heard of that I should be trying to push upon you. I know that Jim is not as young as he was — any more than any of us. He should be working on it now if he's going to do it — but I told you that three years ago. I have heard that Mr. Bunshaft would like Jim to do it and he certainly wants the Museum to come off well. It is going to be a difficult situation to choose from the quantity of pictures you have and get it on the wall so that it will be effective — to make the whole thing have a distinguished air. As you know, I have nothing to gain by keeping at you like this but I am so certain that I am right. And it's something for the country as well as for you. I don't know whether you think, as I do, that if anybody else had hung the first Guggenheim show it never would have been the success that Jim made of it. There you are, Joe. I've said it before, but I must say it again.

Give Olga my love and tell her I know she agrees with what I am saying to you. Hurry up. It is later than you think.

Sincerely,

Georgia

122. *To Derek Bok*

[Abiquiu, late June 1973]

It is difficult to write and acknowledge what I felt about the time with you. Words have been misused so that the usual words don't express my meaning and I can't make up new ones for it. Seeing you with the two girls and the boy — the house — the greenery around it — the procession at Harvard with the audience crowding so near — the view from the

stage, such a wide audience under the heavy green of the trees — the red of the Harvard gowns and hoods coloring it here and there. The violent gestures of that Chinese man speaking Latin. Margaret Mead leaned over to me and remarked, "They clap but not half of them understand what he is saying." I was so pleased that Serkin and music received the loudest ovation.

The Watergate conversations were lively over the luncheon table, Sissela beside me gesticulating with her little hands. The luncheon was really very pleasant.

The walk in the rain, finding the flowers like stars hanging over the wall — it was all very special for one living in Abiquiu and Ghost Ranch for 25 years, only venturing out once in a while for a look at the world. This look was special.

Thank you.

Georgia —

123. *To Juan Hamilton*

[On plane from New Mexico to California, 1976]

Good morning — Juan — from the clouds — all white — and dull out the window — yes I am on the plane Ida missed a road so we had to go back a bit — lost about 10 or 15 minutes — Then — at the airport she passed the TWA gate — but I got out and walked back because many cars were there At the TWA gate was a porter I have had many times — he said we must hurry — so we hurried — he wheeling my bags and I was seated about 5 minutes till the plane took off — He has helped me many times and I had to laugh as I have become Georgia to him — I left Ida at the curb and here I am on the way

It is raining since half way from Santa Fe but just this minute the sun comes out — I have a seat at the window — no one in the other two

A slice of blue grey sky has cut over the clouds. — Ive tasted the plastic scrambled eggs and ham and drank the coffee — All that is best I think to you
 — G.

I might add that I miss the feeling of security you give me but I seem to manage to get along in my own casual fashion —

The plane is very smooth —

Sat. afternoon

I slept longer last night than I have in months — then again this morning
 G.

124. *To Todd Webb*

Dear Todd:

It was good to see you and have coffee with you early in the morning — a little after six — even though it wasn't orderly.

I have wanted to remind you of what you did for me years ago and thank you. For the first time I really saw you and noticed you specially. It was the day I was to get my show together for the Museum of Modern Art — wrapped — ready to be sent over. Andrew who always packed and unpacked things didn't come. None of the men came — not even Zoler who always appeared regularly at the noon hour for lunch. I had the world to myself to pack up thirty or forty paintings to go. It looked like quite a formidable task. It looked like too much to get done — pictures 30 x 36 — 3 x 4 — and a few 30 x 48. I was at it when you came in to see Stieglitz and after a while, came over to see what I was doing. When you saw the problem, you started right in to help me. I may have seen you before, talking with Stieglitz, but I never spoke with you. However, I will never forget your helping me for hours — a person, almost a stranger — till we had everything packed and ready to go. I probably thanked you, but it is one of those things one doesn't forget and when I think of you, I always thank you again.

There was another time that I often remember when you were very kind to me. As you may know, Richard thought I ought to have a dog so from a new litter of his puppies he gave me one. It was lavender like a Maltese cat with tail and back hair almost white. I had quite a time to get that dog to be mine and didn't really accept that. I took him to the ranch — fed him myself and walked him out toward the cliffs — morning and evenings. It got so that I reached home first and blew my whistle — it was one of those whistles that you can hear for a mile. He would come running like a bullet to me. He was big with a strong smooth coat and when he was in Abiquiu he was the town boss. At that time my dogs were free to run around the town from 6 A.M. to 6 P.M. He had some bad scars from the fights that made him the town boss. He would run through a flock of chickens as if they were not there.

One morning he came in the back way — dragging his legs behind him. There was much excitement and you came out. We called the vet who came immediately. When he saw that the dog could not move those legs, he said, "We will see before we do anything else. Keep him for two weeks, and see if he can move his legs." I was really completely upset, so every morning at the first sight of dawn, I got up and went out to look at the dog and talk to him.

When the two weeks were up, there was a very very slight movement in the tail — almost nothing. So again I called the vet. As he looked the dog over, he said that it would be hard for the dog to drag those legs always. — You were there — We talked a little and decided to put him to sleep and call it his end. He had had a good life. He looked so beau-

tiful as he sat there with us. When I think of it now I even get an odd feeling in my stomach. He was given a shot and lay quietly down. He was put in the back of the car. It was all that a man could do to lift him in.

We drove out into the White Hills — dug a hole under a small sized cedar bush and put my beautiful dog into it and covered him with earth and many rocks. I like to think that probably he goes running and leaping through the White Hills alone in the night.

The photographs came — for which thanks. I am sending you some writing, I hope it is what you want.

Sincerely,
Georgia O'Keeffe

When you were first photographing in New York in 1945 and 1946, Stieglitz often told me, on a bad day, that you had been in to see him. You were young and maybe to him, your working at that time on the city was somewhat like he remembered himself in New York working even when the weather was bad. And he was interested to know what you were doing. As you know, 1946 was his last year.

125. *To Cady Wells*

[On train from New York to New Mexico, undated]
Saturday morning

Cady!

I am in the beautiful country — *our* beautiful country — It is quite green — cloudy — and very cool — And Oh Cady — how I love it — it is really absurd in a way to just love country as I love this — I think of you and I wish for you to return to this *soon*

I'll always be having that in my head and in my heart for you *hard*
G.

Notes to the Letters

The abbreviations listed below have been used to indicate the archival sources for O'Keeffe's letters. Unless noted, all of the original letters are handwritten.

AAA	Archives of American Art, Smithsonian Institution, Washington, D.C.
AIC	Ryerson Library, The Art Institute of Chicago
CCP	Center for Creative Photography, University of Arizona, Tucson
GOK	Estate of Georgia O'Keeffe, Abiquiu, New Mexico
HRC-UT	Harry Ransom Humanities Research Center, University of Texas at Austin
Newberry	Sherwood Anderson Papers, The Newberry Library, Chicago
NYPL	Mitchell Kennerley Papers, Rare Books and Manuscript Division, The New York Public Library, Astor, Lenox, and Tilden Foundations
UPA	The Waldo Frank Collection and The Carl Zigrosser Collection, Special Collections, Van Pelt Library, University of Pennsylvania, Philadelphia
YCAL	Collection of American Literature, Beinecke Rare Book and Manuscript Library, Yale University, New Haven

1. *Anita Pollitzer*, late June 1915, YCAL

Anita Pollitzer (1894–1975) studied art with O'Keeffe at Columbia University Teachers College in 1914–1915. Later she was an organizer and officer of the National Woman's Party and vigorously campaigned for passage of the Equal Rights Amendment. At her instigation, O'Keeffe addressed a meeting of the National Woman's Party in February 1926 in Washington, D.C.

Pollitzer wrote to O'Keeffe on 10 June 1915 (YCAL) telling her of a recent visit to Stieglitz's gallery. At her request Stieglitz sold her for $3.00 what he termed "the most wonderful" issue of *Camera Work*, numbers 34/35 (April–July 1911), with reproductions of Rodin's and Edward Steichen's work. It was this issue that O'Keeffe asked to borrow.

Alon Bement (1876–1954) studied at the Boston Museum of Fine Arts School, the Ecole des Beaux-Arts, and the Académie Julian, was a professor of fine arts at Columbia University, and taught at the University of Virginia summer school, where O'Keeffe met him in the summer of 1912. He encouraged her to start painting again after a two-year hiatus and introduced her to the writings and teachings of Arthur Wesley Dow.

In *Georgia O'Keeffe* (New York, 1976), unpaginated, O'Keeffe recalled that after she moved to New York in 1918 she destroyed many paintings, drawings, and watercolors, including one of hollyhocks.

291 was the abbreviated name of Stieglitz's gallery, The Little Galleries of the Photo-Secession at 291 Fifth Avenue, New York. He directed the gallery from 1905 to 1917 and exhibited the work of some of the finest European and American modern artists and photographers, including Paul Cézanne, Pablo Picasso, Georges Braque, Henri Matisse, John Marin, Arthur Dove, Marsden Hartley, Edward Steichen, Alvin Langdon Coburn, and Paul Strand.

Dorothy True was an art student from Portland, Maine, who studied with O'Keeffe and Pollitzer at Columbia University Teachers College in 1914–1915. She later studied at the Art Students League in New York from 1915 to 1918 with George Bridgman and Kenneth Hays Miller.

2. *Anita Pollitzer*, 25 August 1915, YCAL

Pat or Patsy was the nickname given to O'Keeffe by her fellow students at the Art Students League in New York in 1907–1908. She rarely used it after 1915.

College is Columbia University Teachers College, which O'Keeffe attended in 1914–1915.

In the summer of 1915 Pollitzer wrote to O'Keeffe (YCAL), wondering whether she should attend the Art Students League or stay at Columbia University Teachers College. She felt that although Alon Bement was a stimulating teacher, the League gave one "a good solid grinding."

In a letter of 26 July 1915 (YCAL) Pollitzer told O'Keeffe that she had asked Stieglitz to send her *291*, the periodical published by Stieglitz and edited by Paul Haviland, Marius DeZayas, and Agnes Ernst Meyer. Number One, the issue that O'Keeffe was "so crazy about," contained caricatures by DeZayas, "ideogrammes" by Guillaume Apollinaire, stories by Stieglitz, and drawings by Picasso and Steichen. Number Two had "psychotypes" by DeZayas and Meyer and drawings by Katharine N. Rhoades. Number Three had a drawing by Abraham Walkowitz, "psychotypes" by DeZayas and Meyer, and poetry by Rhoades.

The Masses, a monthly magazine devoted to the interests of the working people, was published in New York between 1911 and 1917.

Arthur Jerome Eddy (1859–1920), a Chicago lawyer, art critic, and collector, wrote one of the most influential and widely read studies of modern European art, *Cubism and Post-Impressionism* (Chicago, 1914).

Wassily Kandinsky's *On the Spiritual in Art* was translated into English, with an introduction by M.T.H. Sadler, in 1914.

Floyd Dell, *Women as World Builders: Studies in Modern Feminism* (Chicago, 1913).

The "professor" was Arthur Whittier Macmahon (1890–1980), a professor of political science and later Eaton Professor of Public Administration at Columbia University. O'Keeffe met him in 1915 when both were teaching summer school at the University of Virginia. Macmahon had been a roommate of Randolph Bourne and traveled with him in Europe in 1913–1914.

Columbia College was a two-year Methodist teachers college for women in Columbia, South Carolina. O'Keeffe taught there from the fall of 1915 until late February 1916 when she returned to New York.

Charles Martin (1886–1955) was an artist and professor at Columbia University Teachers College. In the last few years of his life he taught fine arts at the Museum of Modern Art.

Anna Barringer (1885–1977), daughter of a University of Virginia medical school professor, taught with O'Keeffe at the University of Virginia summer school.

When O'Keeffe wrote that did she not think Pollitzer's idea for her new painting was "silly," she was responding to a letter Pollitzer had written in the summer of 1915 (YCAL) in which she said that she had "digested" Kandinsky's *On the Spiritual in Art* and was now working on something quite "symbolic" where colors "have meanings."

3. *Anita Pollitzer*, 11 October 1915, YCAL

In a letter to O'Keeffe of 8 October 1915 (YCAL) Pollitzer wrote that she had told Stieglitz that O'Keeffe had gone to South Carolina to teach. Pollitzer quoted Stieglitz as saying, " 'When she gets her money—she'll do Art with it—and if she'll get anywhere—its worth going to Hell to get there' "; reprinted in Jan Garden Castro, *The Art and Life of Georgia O'Keeffe* (New York, 1985), 22.

In the original of this letter, O'Keeffe misspelled Stieglitz's name as "Steiglitz."

Arthur Wesley Dow (1857–1922), professor and head of the department of fine arts at Columbia University Teachers College, was very influential in the early development of O'Keeffe's art. O'Keeffe was first introduced to his ideas in the summer of 1912 when she studied with his colleague Alon Bement at the summer school of the University of Virginia. In 1914–1915 she studied with Dow at Teachers College. Dow was influenced by Japanese art specifically and Oriental art in general, and believed that it was far more important to fill a space beautifully than to be true to nature. Through a series of exercises outlined in his books, *Composition*, 1899, and *Theory and Practice of Teaching Art*, 1912, Dow encouraged students to think in terms of tonal contrasts and surface patterns rather than naturalistic illusion. It was undoubtedly Dow, and through him perhaps also his mentor Ernest Fenollosa, who stimulated O'Keeffe's lifelong interest in Oriental art; see Barbara Rose, "O'Keeffe's Trail," *New York Review of Books* 24 (31 March 1977), 29–33.

4. *Anita Pollitzer*, 20? October 1915, YCAL

Pollitzer wrote to O'Keeffe on 14 October 1915 (YCAL), telling her that she had filled out entry cards for two of O'Keeffe's works (a hollyhock drawing and a monotype portrait) for an exhibition at the "Pennsylvania Art Academy." Pollitzer encouraged O'Keeffe to submit her pastel of "big simple trees," but O'Keeffe did not exhibit anything at the 1915 Pennsylvania Academy of the Fine Arts watercolor show.

On 26 October 1915 Pollitzer wrote to O'Keeffe (YCAL), "I shook absolutely when I came to the serious part of your letter asking me what Art is—Do you think I know what art is? Now if you ask me what we're trying to do that's a different thing—We're trying to live (& perhaps help other people to live) by saying or feeling—things or people—on canvas or paper —in lines, spaces & color"; quoted in Castro, *O'Keeffe*, 24.

Forbes Robertson was an English Shakespearean actor whom George B. Shaw described as possessing "a continuous charm, interest and variety"; *The Saturday Review* 84 (2 October 1897), 365.

5. *Anita Pollitzer*, 13 December 1915, YCAL

6. *Anita Pollitzer*, 4 January 1916, YCAL

Pollitzer wrote to O'Keeffe on 1 January 1916 (YCAL), describing her visit to Stieglitz's gallery, and quoted Stieglitz as saying, " 'Why they're genuinely fine things—you say a woman did these—She's an unusual woman—She's broad minded, she's bigger than most women, but she's got the sensitive emotion— I'd know she was a woman. . . . Tell her . . . they're the purest, finest, sincerest things that have entered 291 in a long while . . . I wouldn't mind showing them in one of these rooms one bit— perhaps I shall.' " (The entire letter is printed in Castro, *O'Keeffe*, 30–31.)

Camera Work, special number, August 1912, reproduced Pablo Picasso's drawing on page 39 (The Alfred Stieglitz Collection, The Metropolitan Museum of Art); two "portraits" by Gertrude Stein on "Henri Matisse" and "Pablo Picasso" appear on pages 23–25, and 29–30.

Elie Nadelman (1882–1946), the Polish-born American sculptor, showed fourteen drawings and sculpture at 291 from 8 December 1915 to 19 January 1916. Although articles by and about him were published in *Camera Work*, his work was not reproduced there until October 1916, number 48, page 68. Possibly Pollitzer sent O'Keeffe one of the illustrated reviews of his exhibition at 291.

7. *Anita Pollitzer*, 14 January 1916, YCAL

In *Some Memories of Drawings* (Northampton, Massachusetts, 1974), unpaginated, O'Keeffe identified *Drawing No. 14*, charcoal, Estate of Georgia O'Keeffe, as one of "those music things I did with Bement last year." However, in that publication and in her notebooks (which are not always accurate) she dated it 1916. The "music things" were made between the fall of 1914 and the spring of 1915 when she studied at Teachers College. It is possible that other "music" works include *Special No. 32*, 1914, pastel, Estate of Georgia O'Keeffe, and *Special No. 33*, 1914, pastel, private collection.

On 5 January 1916 O'Keeffe received a letter from R. B. Cousins, president of The West Texas State Normal College, in Canyon, Texas, stating that if she accepted a teaching position there her salary would be $150 per month (GOK).

8. *Alfred Stieglitz*, 1 February 1916, YCAL

Sometime in January 1916 O'Keeffe wrote Stieglitz asking him what he liked about her charcoal drawings that Anita Pollitzer had shown him on 1 January. Stieglitz responded (20 January 1916, YCAL) that although it was impossible for him to put into words what he saw and felt in her drawings, they gave him much joy.

John Marin (1870–1953) exhibited several studies of the Woolworth Building in his 1915 exhibition at 291, including two etchings from 1913 and one drawing from 1915, all of which were titled *Woolworth Building*, and one drawing from 1914 titled *Woolworth Building and Post Office*. Throughout her life O'Keeffe appreciated Marin's art and enjoyed his personality. In these early years she was particularly drawn to his watercolors of New York skyscrapers, admiring both his technique and the exuberant character of his work.

9. *Anita Pollitzer*, 9 February 1916, YCAL

Dr. James M. Ariail (1884–1976) was an English professor at Columbia College.

The Bakst book O'Keeffe refers to was, in all likelihood, *The Decorative Art of Léon Bakst* by Arsène Alexandre (London, 1913), with seventy-seven plates, many in color, and notes on the ballets by Jean Cocteau. In 1915 and 1916 Bakst achieved considerable recognition for his design of the costumes and scenes for Sergei Pavlovich Diaghilev's productions for the Ballet Russe.

10. *Anita Pollitzer*, 21 February 1916, YCAL

An untitled drawing by John Marin of a New York skyscraper was reproduced on the cover of *291*, number 4 (June 1915).

"The little blue drawing that hung on the door" in Marin's 1915 show at 291 may have been *Study in Blue*, a watercolor from 1914, catalogue number 21 in *Exhibition of Water-Colors, Oils, Etchings, Drawings, Recent and Old, John Marin*, 23 February– 15 March.

Helen Ring Robinson (d. 1923), a democratic member of the Colorado State Senate from 1913 to 1917, published a book in 1918 titled, *Preparing Women for Citizenship*.

11. *Anita Pollitzer*, 25 February 1916, YCAL

R.B. Cousins wrote to O'Keeffe on 15 February 1916 (GOK) stating that they would hire her if she took Dow's course in "Methods of Teaching Art" at the Teachers College "this sum-

mer," not "this term" as O'Keeffe wrote to Pollitzer. In a subsequent letter to Pollitzer of 28 February 1916 (YCAL), O'Keeffe recognized her mistake, admitting, "I seem to be hunting madly for an excuse to leave here." She resigned her position at Columbia College at the end of February and enrolled in Dow's methods class in early March 1916.

12. *Alfred Stieglitz*, 27 July 1916, YCAL

When O'Keeffe was in New York in the spring of 1916, she went to 291 several times; on one occasion Stieglitz loaned her a painting by Marsden Hartley that she had admired. When she left the city in the middle of June 1916, they began corresponding. That summer and early fall they wrote each other approximately four or five letters a month; by the winter of 1916–1917, however, they were writing each other almost every day and would continue to do so until May 1918, when O'Keeffe moved to New York. These letters are now at the Beinecke Rare Book and Manuscript Library, Yale University.

The "cast" to which O'Keeffe referred was a small, plaster sculpture made in 1916. Stieglitz included this sculpture in her 1917 show at 291; see Stieglitz photograph, accession number 1980.70.5, The Alfred Stieglitz Collection, National Gallery of Art. Stieglitz also later photographed it in front of one of her paintings; see Stieglitz photograph, accession number 1980.70. 127, The Alfred Stieglitz Collection, National Gallery of Art.

O'Keeffe's trip to Mt. Elliott Springs, Virginia, appears to have produced many watercolors, including: *Hill, Stream and Moon*, *Blue Hill No. I*, *Blue Hill No. III*, *Sunrise and Little Clouds II*, 1916, all in the Estate of Georgia O'Keeffe, and *Blue Hill No. II*, *Sunrise and Little Clouds I*, in private collections.

In late July 1916 Stieglitz sent O'Keeffe nine photographs he had taken of her 1916 show at 291.

13. *Alfred Stieglitz*, 4 September 1916, YCAL

When O'Keeffe wrote that Stieglitz's letter was "the biggest letter I ever got," she was referring not to its size (although he would occasionally write her sixty-page letters) but to its spirit, its expression of life and energy.

René Lafferty exhibited three oil paintings in the May–July 1916 show at 291 that also included work by O'Keeffe and Charles Duncan. Little is known about Lafferty except that he was a student of Robert Henri and was in a mental hospital for two years before his 291 exhibition.

Katherine Lumpkin (b. 1896?) from Columbia, South Carolina, was a friend of O'Keeffe's sister Claudia (1899–1984). She was YMCA secretary at the University of Virginia summer school in 1916.

14. *Anita Pollitzer*, 11 September 1916, YCAL

15. *Anita Pollitzer*, 18 September 1916, YCAL

In a letter of 15 September 1916 (YCAL) Pollitzer told O'Keeffe she was sending her a reproduction of an El Greco; however, the specific work is unknown.

Willard Huntington Wright (1888–1939), art critic and brother of synchromist painter Stanton Macdonald-Wright, wrote a widely read book, *Modern Painting: Its Tendency and Meaning* (New York, 1915). In addition to defending synchromism, Wright repeatedly argued that it was only through the development "of form by means of color" that modern art would succeed. In March 1916 Wright organized The Forum Exhibition of Modern American Painting to promote an appreciation of modern American art.

"I can understand Pa Dow painting his pretty colored canyons": In 1911 and 1912 Dow went to the Grand Canyon; he painted *Bright Angel Canyon* in 1912. O'Keeffe also succumbed

to the temptation to paint pretty colored canyons, making several studies of the Palo Duro Canyon, about twenty miles east of Canyon, Texas, including: *Painting No. 21 (Palo Duro Canyon)*, 1916, oil on board, and *Drawing No. 15*, 1916, charcoal, both in the Estate of Georgia O'Keeffe, and *Canyon with Crows*, 1917, watercolor, private collection.

Dow's *Composition: A Series of Exercises in Art Structure for the Use of Students and Teachers*, originally published in 1899 and republished several times thereafter, was his most influential and widely read book.

Charles H. Caffin (1854–1918), an English-born American art critic, art editor of *The Sun*, 1901–1905, critic for the *New York American*, 1905–1918, wrote several books on the history of American painting and sculpture. In 1905 he published *How to Study Pictures*. After the publication of his 1901 book *Photography as a Fine Art*, a collection of essays on pictorial photography, he was closely identified with the Stieglitz circle.

16. *Anita Pollitzer*, 17 January 1917, YCAL

Willard Huntington Wright, *The Creative Will; Studies in the Philosophy and the Syntax of Aesthetics* (New York, 1916).

Clive Bell, *Art* (London, 1914; New York, 1915). One of the most well-known and frequently reprinted works of this English art critic, *Art* was also the book in which Bell (1881–1964) advanced his concept of "significant form"; that is, "created form [which] moves us so profoundly because it expresses the emotion of the creator" (page 49). Arguing that the lines and colors alone convey the feelings of the artist, Bell stated that the subject of a picture was of no importance, it was only a vehicle for the artist to express an idea or emotion: "The emotion that the artist felt in his moment of inspiration he did not feel for objects seen as means, but for objects seen as pure form" (page 52).

Marius DeZayas, *African Negro Art: Its Influences on Modern Art* (New York, 1916). DeZayas (1880–1961) was a Mexican caricaturist and close associate of Stieglitz between 1910 and 1917, one of the editors of *291*, and director of the Modern Gallery and the DeZayas Gallery. As a result of his trips to Europe and his friendships with many European artists, DeZayas selected several 291 exhibitions, including the 1911 Picasso exhibition and the 1914 show of African art. In *African Negro Art* DeZayas wrote that because the African "represents only the form suggested by his mental condition," this art showed the possibility of finding new forms to express inner life (page 32).

Arthur Jerome Eddy, *Cubism and Post-Impressionism* (Chicago, 1914).

Charles H. Caffin wrote *Art for Life's Sake: An Application of the Principles of Art to the Ideals and Conduct of Individual and Collective Life* (New York, 1913); O'Keeffe was probably reading this book. Caffin argued that instinct and intuition were as important to man as reason, and he implored that the fine arts be accepted as "an integral part of Life" (page 18).

The landlady was Willena Shirley, wife of West Texas State physics professor Douglas Shirley.

Arthur Macmahon: see note 2.

"VA" is the University of Virginia summer school where O'Keeffe taught from 1913 through 1916.

17. *Paul Strand*, 3 June 1917, CCP

In 1916 Paul Strand (1890–1976), an American photographer who had studied with Lewis Hine, had a one-person show at 291. Six of his photographs were later reproduced in *Camera Work*, number 48 (October 1916), unpaginated, and eleven in *Camera Work*, numbers 49/50 (June 1917), unpaginated. O'Keeffe met Strand in late May 1917 when she went to New York to see her one-person show at 291. As is clear in her letters to Pollitzer and Strand, she was immediately attracted to him, both personally and professionally. Her comment that she was "making Strand

photographs for myself in my head" is telling, for it indicates the great impact photography would have on her work. (See Sarah Whitaker Peters, *Georgia O'Keeffe and Photography: Her Formative Years, 1915–1930*, Ph.D. dissertation, City University of New York, 1987.) In early 1916 many forces were leading her out of the symbolist- and art nouveau-inspired vocabulary that had dominated her earlier art; paintings by Hartley, Marin, and Picasso were influential, but so too was photography. It was particularly influential after the fall of 1916 when, stimulated by her desire to depict the Texas landscape, O'Keeffe attempted to apply the principles of abstraction to more representational scenes. Photography in general and Strand's photographs specifically showed her how she could abstractly present reality. Strand seems to have encouraged O'Keeffe to pursue certain formal properties she was already exploring. For example, the flattened and layered pictorial space that Strand used in such photographs as *From the Viaduct*, 1915, or *Abstraction—Bowls*, 1916, can also be seen in watercolors O'Keeffe made in the summer of 1917, for example, *Pink and Green Mountain, No. 1*, 1917, The Helen Foresman Spencer Museum of Art. O'Keeffe had employed this device before, and both she and Strand were influenced by Japanese art, but after she saw Strand's photographs, she used it with far more regularity. As she had paid homage to Stieglitz's photograph *The Hand of Man*, 1902, in her watercolor *Train at Night in the Desert*, 1916, Museum of Modern Art, so too did she echo Strand's *The White Fence*, 1916, in her 1918 watercolor *Trees and Picket Fence*, Milwaukee Art Museum.

"Very green out the window": It is possible that *Green Hill*, 1917, watercolor, private collection, was inspired by this trip through Kansas.

The reference to "Your book . . . Childhood" is vague but perhaps Strand gave O'Keeffe a copy of Leo Tolstoy's *Childhood, Boyhood, and Youth*.

O'Keeffe's brother in Chicago was Alexius O'Keeffe (1892–1930). In late 1918 he returned from the war in Europe in poor health, suffering from influenza and the effects of having been gassed.

18. *Anita Pollitzer*, 20 June 1917, YCAL

When O'Keeffe decided not to teach at the University of Virginia summer school in 1917, Pollitzer took over as "Teacher of Drawing."

Alon Bement married an actress named Emmet.

Aline Pollitzer (1897–?) was a cousin of Anita and the daughter of Dr. Sigmund Pollitzer with whom O'Keeffe lived when she was in New York in the spring of 1916.

"291 is closing": Early in the summer of 1917 Stieglitz decided to close 291 and stop publishing *Camera Work*. Several reasons account for this decision, but primarily Stieglitz was disillusioned, discouraged, and tired. In the wake of the Armory Show several other galleries had opened, including one directed by Stieglitz's close associate DeZayas, and these diverted attention from 291. For several years subscriptions to *Camera Work* had been dwindling, and by June 1917 only thirty-six subscribers remained. There was also increased talk of prohibition, which would severely limit the income his wife, Emmeline, received from her brother's breweries. But all this was overshadowed by the war; its mass hysteria, hatred, and materialism deeply upset Stieglitz who had spent many productive and enjoyable years as a student in Germany.

Stanton Macdonald-Wright (1890–1973) was an American painter and theoretician, and founder, with Morgan Russell, of synchromism, a style of painting based on the study of Cézanne and Picasso, and the color theories of Chevreul, Rood, and Helmholtz. Stieglitz showed his paintings, drawings, and watercolors at 291 from 20 March to 31 March 1917.

Abraham Walkowitz (1878–1965) was a Russian-born, American painter and a close associate of Stieglitz after 1912. He had three one-person shows at 291.

Henry J. Gaisman (1870–1974) was the inventor of the Auto-Strop Safety Razor and founder of the Auto-Strop Razor Company, which he sold to Gillette in 1930. He also invented the Autograph camera, which included a device that made it possible to write captions on film at the time a photograph was made. He sold the rights to this camera to Kodak in 1914 for $300,000, the highest price paid at that time for a single invention.

19. *Paul Strand*, 25 June 1917, CCP

"The little prints": Strand sent O'Keeffe several photographs, including *Snow, Backyard, New York*, 1915; *Porch Shadow*, 1916; and *Abstraction—Bowls*, 1916. Because Strand made enlargements from his negatives, it is impossible to know which ones O'Keeffe might have seen as small prints and which were large ones. What is clear, however, is her close identification of Strand's work with his personality; in her mind the two were inextricably linked. Also evident is her belief that art was or could be a non-verbal form of communication between two people.

20. *Paul Strand*, 23 July 1917, CCP

"I hated your letter early in the week": Strand's letters to O'Keeffe from 1917 and 1918 do not appear to have survived; however, O'Keeffe's letters to Strand from 1917 (CCP) indicate that Strand was uncertain whether or not he should enlist. Although O'Keeffe was not encouraging him to join, by late 1917 and early 1918 she became frustrated with his musings and his inability to make quick decisions. She preferred direct, spontaneous action rather than Strand's slow, deliberate ways.

Camera Work, numbers 49/50 (June 1918), included eleven reproductions of Strand's photographs and an article by him, "Photography," pages 3–4.

"The little snow scene . . . the bowls—the shadows": *Snow, Backyard, New York*, 1915; *Abstraction—Bowls*, 1916; and *Porch Shadows*, 1916.

21. *Paul Strand*, 24 October 1917, CCP

"The article on 291" is Strand's unpublished manuscript, "What was 291" (CCP). After the demise of 291 in June 1917 several people wrote articles lamenting its passing and defining its contribution. Strand's article also did this, but in addition he tried to suggest why Stieglitz had been forced to close 291.

John Richard Green, *History of the English People*, originally published in 1880, was an extremely popular book that had been issued in several English and American editions, including one in New York in 1917.

22. *Paul Strand*, 15 November 1917, CCP

Ted (James W.) Reid (1895–1983) was a student at West Texas State Normal College in 1917, and president of the drama club. O'Keeffe made his acquaintance when she helped the drama club make costumes and scenery. Despite O'Keeffe's advice to the contrary, Reid enlisted in the Air Service Signal Corps with the Air Force and received his wings in August 1918. After his tour in Europe, he was a teacher, school superintendent, and finally a public relations officer with a Fort Worth architectural firm.

23. *Elizabeth Stieglitz [Davidson]*, January 1918, YCAL

Elizabeth Stieglitz (1897–1956) was a niece of Stieglitz and one of his closest family members. In 1918 while she was a painter/proctor at the Art Students League she began to exchange letters with O'Keeffe, whom she had met the previous summer. When she learned that O'Keeffe was not only frustrated with teaching in Texas but suffering from influenza, she

urged her to move to New York. She even offered her the use of her studio. In May 1918 O'Keeffe accepted the offer; soon afterward, she and Stieglitz began living together in Elizabeth's studio. Throughout their lives, but particularly in the 1920s, Stieglitz and O'Keeffe were close to Elizabeth and her husband Donald Davidson (1878–1948).

24. *Elizabeth Stieglitz [Davidson]*, 15 August 1918, YCAL
'On the back of this letter is a note from Stieglitz in which he wrote, "there never was such Perfection between two of the 'Opposite Sex.'"

25. *Doris McMurdo*, 1 July 1922, Chatham Hall School, Chatham, VA
Doris McMurdo was a classmate of O'Keeffe's at the Chatham Episcopal Institute from 1903 to 1905.

"That page in Vanity Fair" was titled "The Female of the Species Achieves a New Deadliness," *Vanity Fair* 18 (July 1922), 50, and contained photographs and brief notes on six women painters, including Marguerite Zorach and Florence Cane. The statement on O'Keeffe, accompanying a photograph of her by Stieglitz, noted that she had to struggle out of the "mediocrity imposed by conventional art schools, to the new freedom of expression inspired by such men as Stieglitz." Stating that her work was undistinguished until she abandoned academic realism and "discovered her feminine self," the note concluded that her recent work seemed "to be a revelation of the very essence of woman as Life Giver." The line at the very bottom of the page that O'Keeffe liked was "Woman Painters of America Whose Work Exhibits Distinctiveness of Style and Marked Individuality."

The Dial 71 (December 1921), 649–670, contained an article by Paul Rosenfeld on "American Painting," with a reproduction of O'Keeffe's *Black Spot* on page 665.

Vanity Fair 19 (October 1922), included an article by Rosenfeld on "The Paintings of Georgia O'Keeffe," pages 56, 112, 114, with three reproductions of her work and a portrait of her by Stieglitz.

Anita Natalie O'Keeffe (1891–1985), Georgia's younger sister, married Robert Young in 1916 and had a daughter, Eleanor (1918–1941).

Ida Ten Eyck O'Keeffe (1889–1961), Georgia's next younger sister, was a nurse and frequent visitor to Lake George in the 1920s. Stieglitz made several photographs of Ida and Georgia clowning for the camera. Ida also painted and studied art at Teachers College.

O'Keeffe's two exhibitions at 291 were in 1916 (not 1915 as she wrote) and 1917.

In the winter of 1923 O'Keeffe had an exhibition at the Anderson Galleries. Titled "Alfred Stieglitz Presents One Hundred Pictures, Oils, Water-colors, Pastels, Drawings by Georgia O'Keeffe, American," it ran from 29 January to 10 February 1923.

When O'Keeffe went to York Beach, Maine, she stayed with Bennet and Marnie Schauffler. She frequently visited them in the 1920s.

26. *Mitchell Kennerley*, Fall 1922, NYPL
Mitchell Kennerley (1879–1950), a British-born American book publisher, editor, and art entrepreneur, was president of the Anderson Galleries. On several occasions during the early 1920s Kennerley gave Stieglitz exhibition space at the Anderson Galleries to show his and O'Keeffe's work. From December 1925 through May 1929 Stieglitz rented a small room in the Anderson Galleries (room number 303) and directed his second gallery, The Intimate Gallery.

Paul Rosenfeld wrote two articles on O'Keeffe in the early 1920s, "American Painting," *The Dial* 71 (December 1921), 649–670, and "The Paintings of Georgia O'Keeffe," *Vanity Fair* 19 (October 1922), 56, 112, 114, which effusively emphasized the feminine and sexual quality of her work: ". . . it is female, this art, only as is the person of a woman when dense, quivering, endless life is felt through her body."

Marsden Hartley devoted a section to O'Keeffe in his 1921 study *Adventures in the Arts* (New York, 1921; reprinted New York, 1972), 112–119. He too discussed the sexual aspects of her work, stating that she was "impaled with a white consciousness," and that her paintings were "shameless private documents" (pages 116, 117).

Hutchins Hapgood (1869–1944), a newspaper reporter, editor, and author of *A Victorian in the Modern World*, 1939, was an organizer of the Provincetown Theater and husband of the author Neith Boyce (1872–1951). His novels, including *The Spirit of the Ghetto*, 1902, and *Types from City Streets*, 1910, were among the first to focus on New York's lower east side. O'Keeffe often repeated Hapgood's remarks throughout her life whenever she was confronted with critical opinion she did not like.

27. *Henry McBride*, February 1923, YCAL
Henry McBride (1867–1962) was an American art critic for the *New York Herald*, *New York Sun*, and *The Dial*. A consistent and vocal supporter of O'Keeffe's work, McBride was one of the few critics in the 1920s who did not stress the feminine qualities of her work; "to overload them with Freudian implications is not particularly necessary," he wrote in *The New York Sun*, 14 January 1928, page 8. Because of this and because of his straightforward but witty writing, O'Keeffe enjoyed his reviews and the two were good friends.

O'Keeffe's 1923 exhibition at the Anderson Galleries—her first public showing after a hiatus of almost six years—was held from 29 January to 10 February. McBride reviewed the show in the *New York Herald*, 4 February 1923, page 7. Noting that she became "free without the aid of Freud . . . since all of her inhibitions seem to have been removed before the Freudian recommendations were preached upon this side of the Atlantic," McBride predicted that O'Keeffe would find herself "sort of a modern Margaret Fuller sneered at by Nathaniel Hawthorne for a too great tolerance of sin and finally prayed to by all the super-respectable women of the country for the receipts that would keep them from the madhouse." O'Keeffe would be "besieged by all her sisters for advice"; therefore McBride urged her "immediately after the show, to get herself to a nunnery."

"Three women": Following his review of O'Keeffe's show, McBride wrote on the exhibitions of Clare Sheridan's sculpture at Scott and Fowles, and Henrietta Shore's paintings at Ehrich's Gallery.

"Marin brought his new work. . . . several wonderful sail boats. . . . wonderful houses too—and a great sea": Sheldon Reich, in *John Marin: A Catalogue Raisonné* (Tucson, 1970), 494–515, lists several paintings and watercolors from 1922 that depict boats, seascapes, and houses.

When O'Keeffe wrote that she did not mind "if Marin comes first—because he is a man—its a different class," she did not mean to imply that men were superior to women. Nothing in her actions or writings indicates that she ever felt herself or women in general as inferior to men. She did believe, however, that men and women responded to and understood the world in fundamentally different ways. Therefore men were of a separate, "different class," but not a superior one.

28. *Sherwood Anderson*, 1 August 1923?, Newberry
Sherwood Anderson (1876–1941) was an American writer, author of *Winesburg, Ohio*, 1919; *Horses and Men*, 1923; *A Story Teller's Story*, 1924; and *Beyond Desire*, 1933, among others. An-

derson met Stieglitz and O'Keeffe in 1922. Anderson and Stieglitz, who were approximately the same age, were very similar in many respects: they had the same generational outlook, the same faith in American art, and a similar commitment to intuitive, rather than analytical, art. O'Keeffe also had much in common with Anderson. Both were from the Midwest, and unlike other writers and painters of the 1920s, they both celebrated that heritage. Both had the ability to combine fact and fantasy, dream and reality in such a believable manner and direct style that it was difficult to determine the boundary between the two. Anderson also greatly admired O'Keeffe's paintings—so much so, in fact, that he began to paint.

The dating of this letter and letter 29 is problematical. Anderson responded to this letter from O'Keeffe in one dated 4 August 1923, published in *Letters of Sherwood Anderson*, edited by Howard Mumford Jones in association with Walter B. Rideout (Boston, 1953), 104–105. He noted that he was pleased O'Keeffe liked *Many Marriages*, that perhaps he was beginning to get better control of the longer form. He continued that he hoped Stieglitz would like the stories "I'm a Fool" and "The Man Who Became a Woman," which were to be published in a book titled *Horses and Men* (New York, 1923). On 11 October 1923 Stieglitz wrote to Anderson, saying that he very much enjoyed "The Man Who Became a Woman." This indicates that letter 28 was written in August 1923. However, in letter 29, in which O'Keeffe responded to Anderson's comments about form, she also referred to a periodical, *Phantasmus*, which appears to have been published only in 1924. Although letter 29 is composed of several parts, the handwriting and paper are consistent throughout.

Many Marriages, a novel by Anderson, was published in New York by B.W. Huebsch in 1923.

During the winter and spring of 1923 the Stieglitz family considered selling their Lake George house, much to the distress of both Stieglitz and O'Keeffe; see S. Davidson Lowe, *Stieglitz: A Memoir/Biography* (New York, 1983), 263. In addition, Stieglitz's daughter, Kitty, suffered a postpartum collapse on 18 June 1923 from which she never recovered.

29. *Sherwood Anderson*, September 1923?, YCAL
 See note 28 for a discussion of the dating of this letter.
 "My sister is here" refers to Ida O'Keeffe; see note 25.
 Katherine [Herzig?] was Stieglitz's mother's companion.
 B.W. Huebsch (1875 or 1876–1964) was the editor and publisher of *The Freeman*, 1920–1924, and eventually merged his company with the Viking Press. After several other publishers had turned down Anderson's *Winesburg, Ohio*, Huebsch published it in 1919. He subsequently printed Anderson's *Poor White*, *The Triumph of the Egg*, *Many Marriages*, *Horses and Men*. The "proof sheets" he was sending Stieglitz and O'Keeffe may have been of *A Story Teller's Story*, which appeared in *Phantasmus* 1 (May and June 1924), 1–37, 109–164.
 "I've been thinking of what you say about form": Anderson wrote to O'Keeffe on 4 August 1923 (*The Letters of Sherwood Anderson*, page 105), saying that he was glad she liked *Many Marriages* and noting that "perhaps I'm getting a little better hold of the longer form. That is what I have wanted. To get the longer form well in hand and then pour the tale into it as wine in a vessel."

30. *Sherwood Anderson*, 11 February 1924, Newberry
 "Last night I sent you a night letter": On 10 February 1924 O'Keeffe sent Anderson a telegram asking him to write something for her upcoming show at the Anderson Galleries ("Alfred Stieglitz Presents Fifty-One Recent Pictures, Oils, Water-colors, Pastels, Drawings by Georgia O'Keeffe, American," 3 March–16 March, 1924). On the back of the telegram Anderson wrote

his reply: "Down with flu. Afraid it would be dull" (Newberry).
 "Stieglitz and I are both showing our work": At the same time as O'Keeffe's exhibition, Stieglitz showed sixty-one photographs. Titled "The Third Exhibition of Photography by Alfred Stieglitz," it was subtitled "Songs of the Sky—Secrets of the Skies as Revealed by My Camera and Other Prints." Forty-five of the images shown were four- by five-inch studies of clouds. Divorced from all references to the ground—"way off the earth" as O'Keeffe wrote—these small, abstract photographs were, as Stieglitz wrote in his catalogue introduction, "direct revelations of a man's world in the sky—documents of eternal relationship—perhaps even a philosophy" ("Chapter III," exhibition catalogue for "The Third Exhibition of Photography by Alfred Stieglitz," Anderson Galleries, unpaginated).
 When O'Keeffe wrote that Stieglitz "has done with the sky something similar to what I had done with color . . . he has done consciously something that I did mostly unconsciously," she meant that Stieglitz had purposefully set out to make abstract photographs, that he sought to use the tones and pure forms of the clouds as abstract forms to symbolize his feelings and ideas.
 "I suppose the reason I got down to an effort to be objective is that I didn't like the interpretations of my other things": In the early 1920s, and particularly after her 1923 exhibition, O'Keeffe's paintings were often analyzed in terms of their sexual or Freudian implications. See, for example, Paul Strand, "Georgia O'Keeffe," *Playboy*, July 1924, 16–20.
 In her 1924 exhibition O'Keeffe showed fifty-one paintings, mainly of fruits, vegetables, flowers, and trees, including *Pattern of Leaves*, 1923, cat. 39.
 For her 1924 exhibition O'Keeffe wrote a short, eight-line introduction, noting that she hoped her present show would "clarify some of the issues" raised in her 1923 show. The rest of the catalogue consists of reprints of 1923 reviews by McBride, Allan Burroughs, and Royal Cortissoz ("Alfred Stieglitz Presents Fifty-One Recent Pictures, Oils, Water-colors, Pastels, Drawings by Georgia O'Keeffe, American," unpaginated).

31. *Sherwood Anderson*, 11 June 1924, Newberry
 Fred Varnum (d. 1924) was the coachman and caretaker of the Stieglitz family's summer house in Lake George.

32. *Sherwood Anderson*, 11? November 1924, Newberry
 "My lake is like metal—its steaming too": O'Keeffe painted many pictures of the lake, at various times of the year and under different weather conditions; in *Lake George*, 1924, cat. 43, it is a cold gray-blue body of water. The curved blue line that sweeps up off the lake may be O'Keeffe's representation of steam or mist rising from the water.
 "What you say about what other people will paint": On 26 October 1924 Anderson wrote to her about a painting exhibition he had seen in New Orleans, and predicted "you are going to be imitated by some of the worst young lady painters God ever let loose" (Newberry).

33. *Henry McBride*, March 1925?, YCAL
 The dating of this letter is problematical. The only article in which McBride made any comment "about those who live abroad" was "The Stieglitz Group at Anderson's," *Evening Sun*, 14 March 1925. Reviewing the "Seven Americans" show at the Anderson Galleries, McBride described Hartley's paintings as "old world, old souled, and awfully fatigued." A date of 1925 is also consistent with O'Keeffe's reference to "those big calla lilies," as her first large flower paintings were shown in 1925. In the "Seven Americans" show O'Keeffe wanted to hang her first New York paintings, but Stieglitz refused; this explains her comment, "that New York business goes round in my head"; see *Georgia O'Keeffe*, New York, 1976, unpaginated. However,

why O'Keeffe wrote that she "laughed at what you did to me" is not clear, because McBride's only reference to her was that she, Stieglitz, and Dove emerged "above the heads of the other members of the group." Also, O'Keeffe's comment that she would not have had such a hard time painting New York "if I had always lived up here looking out at it" implied that she was living several stories above the ground. In March 1925 O'Keeffe and Stieglitz lived at 35 East 58th Street. Although they may have had a better view and lived higher up than they had in previous years, it was not until November 1925 that they lived in a skyscraper, the Shelton Hotel.

34. *Mabel Dodge Luhan*, 1925?, YCAL

Mabel Dodge Luhan (1879–1962), an author and patron of the arts, was best known for her sponsorship of artists and writers, first in New York before and during the First World War and later at her home in Taos, New Mexico. She gathered about her some of the most well-known figures of early twentieth-century America, including Max Eastman, Gertrude Stein, Lincoln Steffens, and Walter Lippmann. In addition to being married four times, to Carl Evans, Edwin Dodge, Maurice Sterne, and Tony Lujan (she Anglicized the spelling of his last name to Luhan), she also had widely publicized affairs with John Reed and D.H. Lawrence, which she described in her various books, including *Lorenzo in Taos*, 1932, and her four-volume memoir, *Intimate Memories, Volume One: Background*, 1933; *Volume Two: European Experiences*, 1935; *Volume Three: Movers and Shakers*, 1936; and *Volume Four: Edge of Taos Desert*, 1937.

It does not appear that Luhan actually published an article on the actress Katharine Cornell (1893–1974). She may have sent Stieglitz and O'Keeffe a manuscript of it.

Luhan did write an article on O'Keeffe, but it was never published. In "The Art of Georgia O'Keeffe" Luhan wrote that in O'Keeffe's work "is made manifest the classical dream of walking naked on Broadway." She "externalises the frustration of her true being out onto canvases which, receiving her outpouring of sexual juices, . . . permit her to walk this earth with the cleansed, purgated look of fulfilled life!" Reserving her strongest criticisms for Stieglitz, Luhan labeled him a "filthy, frustrated showman"; "this woman's sex, Stieglitz, it becomes yours upon these canvases. Sleeping, then, this woman is your thing. . . . you are the watchman standing with a club before the gate of her life, guarding and prolonging so long as you may endure, the unconsciousness within her." She implored him to "let live this somnolent woman by your side. But Camera-man, do you dare?" (manuscript, Mabel Dodge Luhan Archives, YCAL).

35. *Ettie Stettheimer*, 6 August 1925, GOK

The three sisters Ettie (Henrietta Walter, d. 1955), Carrie (Caroline Walter, d. 1944), and Florine (1871–1944) Stettheimer established a lively and well-known salon in New York in the 1920s, frequented by such people as Henry McBride, Marcel Duchamp, Alice B. Toklas, Gertrude Stein, Virgil Thomson, Marsden Hartley, Charles Demuth, Edward Steichen, Carl Van Vechten, and Stieglitz and O'Keeffe. Famous for serving great bowls of strawberries and champagne, the sisters graciously entertained their friends in a palatial apartment. Ettie wrote *Philosophy: An Autobiographical Fragment*, 1917, and *Love Days*, 1923, both under the pseudonym Henri Waste; and *Memorial Volume of and by Ettie Stettheimer*, 1951. Carrie created an elaborate dolls' house, filled with miniature furniture, books, cats, and dogs, and peopled with dolls representing their various friends—Duchamp, Thomson, McBride, Toklas, Stein. She even persuaded friends such as Duchamp to contribute miniature paintings and sculpture. (The dolls' house is now in The Museum of the City of New York.) Florine was a painter whose witty but eccentric style echoed the taste of her sisters. She designed sets for Stein's *Four Saints in Three Acts* and made many portraits of their friends, including Duchamp, Van Vechten, McBride, and Stieglitz. Despite the vast differences in their personal and artistic styles, O'Keeffe was a close friend to all of the Stettheimer sisters from the early 1920s until their deaths.

"The two yowling brats" were probably Elizabeth (Peggy) Davidson Murray (b. 1919) and Sue Davidson Lowe (b. 1922), daughters of Stieglitz's niece Elizabeth and her husband Donald Davidson. For Sue Lowe's recollection of this summer, and a reproduction of a 1925 Stieglitz photograph of the two sisters; see S. Davidson Lowe, *Stieglitz: A Memoir/Biography* (New York, 1983), 271–276.

Alfred (1883–1966) and Dorothy Kreymborg spent several weeks at Lake George in the summer of 1925. A poet, playwright, and critic, Alfred Kreymborg was also editor of *The American Caravan* and *Others, an Anthology of Verse*, and author of *Edna, the Girl of the Street*, 1915, and *Troubadour: An Autobiography*, 1925. Stieglitz photographed both Alfred and Dorothy Kreymborg in 1925; see Stieglitz's photographs, accession numbers 1949.3.663, and 1949.3.664, The Alfred Stieglitz Collection, National Gallery of Art.

Selma Schubart (1871–1957), Stieglitz's youngest sister, was often described as an intelligent but theatrical, self-centered, and difficult woman. She and O'Keeffe did not get along well.

36. *Blanche Matthias*, March 1926, YCAL

Blanche Matthias (b. 1887) was an art critic for the *Chicago Evening Post* when she met Stieglitz and O'Keeffe in 1921. She and O'Keeffe became good friends, and Matthias would often come from Chicago to see O'Keeffe's annual exhibitions. In later years, O'Keeffe visited Blanche and her husband Russell in San Francisco.

"Thanks for the paper and the article": Matthias published an article titled "Georgia O'Keeffe and the Intimate Gallery," *Chicago Evening Post Magazine of the Art World*, 2 March 1926, 1, 14, in which she reviewed O'Keeffe's current exhibition. Noting that much of the writing about O'Keeffe dramatized her and added to the mystery and aura surrounding her, Matthias stated that her work did not suggest "some morbid mood or some attitude toward sex." Matthias quoted O'Keeffe extensively, trying to show that her art was concerned with simplicity and order.

"I wish you could see the things on the walls": From December 1925 to May 1929 Stieglitz directed his second gallery, The Intimate Gallery, in room number 303 of the Anderson Galleries. It was his intention to exhibit the work of "Seven Americans" including himself, O'Keeffe, Marin, Dove, Hartley, Strand, and "X," whomever he deemed of significance.

"I feel like a little plant that he has watered and weeded and dug": Throughout her life, O'Keeffe frequently referred to the fact that Stieglitz had nurtured her; sometimes she resented this (see letter 86), but most often she gratefully acknowledged it. Her plant metaphor is particularly appropriate, for Stieglitz often used such comparisons during the 1920s. For example, in a letter to Sherwood Anderson he explained how he responded to a dealer who wanted him to move to Europe: "I told him the Soil was here—the planting was here—the growing where the planting—in the Soil right here" (10 December 1925, YCAL). For further discussion of the plant and soil metaphors used by the Stieglitz group in the 1920s, see Sarah Greenough, "From the American Earth: Alfred Stieglitz's Photographs of Apples," *The Art Journal* 41 (spring 1981), 46–54.

"I have painted two new paintings of New York": O'Keeffe painted several studies of New York in 1926, including *The Shelton with Sun Spots, New York*, cat. 57, and *Street, New York, No. 1*, cat. 56.

Claude Bragdon (1866–1946), an architect and designer of railroad stations throughout the United States and Canada, was also a theosophist and author of *Architecture and Democracy* and *Four-Dimensional Vistas.* He also helped translate Ouspensky's *Tertium Organum.* Bragdon lived at the Shelton Hotel and he, O'Keeffe, and Stieglitz often ate together in the cafeteria.

37. *Waldo Frank*, Summer 1926, UPA

Waldo Frank (1889–1967) was an American cultural critic, historian, and author of such books as *Our America*, 1919; *City Block*, 1922; *Time Exposures*, 1926; and *Rediscovery of America*, 1929. Stieglitz and Frank had a close but difficult relationship from 1918 to the late 1920s. Unlike many of Stieglitz's other friends, Frank spoke his mind and did not hesitate to oppose Stieglitz. From photographs of O'Keeffe and Frank together and from her letters to him, O'Keeffe appears to have enjoyed his company and admired his writings; see Stieglitz photograph, accession number 1980.70.186, The Alfred Stieglitz Collection, National Gallery of Art.

"The Jew in the Menorah": In *The Menorah Journal* 12 (June–July 1926), 225–234, Frank published an article titled, "Towards an Analysis of the Problem of the Jew." He defined the problem to be the ascertainment of what it is to be a Jew, if "the Jew *really* wills to survive in the modern world, *can* survive in the modern world, has a function in the modern world," and what that function is.

The meaning of the line "you are mixing with that vile hash of so called thinkers and workers" is unclear. Perhaps O'Keeffe was being ironic. But perhaps she also meant to set up a dichotomy between workers who, like herself, were intuitive, and "so called" thinkers who were analytical. Frank was neither a pure thinker nor a pure worker, but was trying to combine the two, and in so doing was concocting a vile mixture which was only partially successful. When she wrote that "sometimes you seem to get out almost all of you but your feet," she was echoing Stieglitz's opinion that although Frank was very intelligent he did not push his ideas to their logical conclusions.

Tom Frank (b. 1922) was Waldo Frank and Margaret Naumburg's son.

38. *Waldo Frank*, 10 January 1927, UPA

"The only signs of shape": In early January 1927 O'Keeffe was sick.

O'Keeffe's exhibition at The Intimate Gallery ran from 11 January to 27 February 1927 and included nine paintings of New York, including *Shelton with Sun Spots*, 1926, cat. 57; *Street, New York, No. I*, 1926, cat. 56; and sixteen flowers, including *Black Iris III*, 1926, cat. 49; and *The Dark Iris No. II*, 1926, cat. 48.

"Your book" was Waldo Frank's *Time Exposures*, written under the pseudonym "Search-Light" (New York, 1926). His essay "White Paint and Good Order" (pages 31–35) is one of the most even-handed accounts of O'Keeffe's work from the 1920s. Noting that O'Keeffe did not have "a chance" in New York in the 1920s, Frank wrote, "if this town were a bit simpler, a bit less impure, it might be at home with her simple purity. If it were less daft on polysyllables, it might hear her monosyllabic speech. If it were less noisy in its great affairs, it might hear her chuckle." Dismissing the "experts" who prated "mystic symbols . . . or Freudian symbols," he wrote, "how could you expect New York to admit that what it likes in O'Keeffe is precisely the fact that she is clear as water?" "Like a peasant . . . full of loamy hungers of the flesh," Frank concluded, O'Keeffe "is almost as quiet as a tree, and almost as instinctive. If a tree thinks, it is not with a brain but with every part of it. So O'Keeffe."

39. *Henry McBride*, 16 January 1927, YCAL

In "Georgia O'Keefe's [sic] Work Shown," *New York Sun*, 15 January 1927, p. 22B, Henry McBride wrote that her recent paintings were intellectual rather than emotional because "the processes are concealed. The tones melt smoothly into each other as though satin rather than rough canvas were the base. Emotion would not permit such plodding precision." Her method was "French," he concluded, because she planned everything out in her mind before starting to paint.

40. *Ettie Stettheimer*, 21 September 1928, GOK

The "Lawrence" book was D.H. Lawrence's *Lady Chatterley's Lover*, which was privately printed in Florence in 1928; several pirated editions also appeared in 1928 printed in New York, Paris, and Shanghai. Ettie had written to Stieglitz and O'Keeffe on 21 August 1928 that she was "furious about it—I think it's quite idiotic, naive, silly, undistinguished as writing but for one passage in the middle in which for the woman's physical ecstasy he found poetic equivalents. —The philosophic simplicity that satisfies him—if it does, because I think the book dishonest—is incredible. I am afraid to re-read his former books now, which meant so much to me. —Another illusion destroyed" (YCAL).

"Stieglitz seems a little better today": In early September 1928 Stieglitz had his first severe angina attack.

41. *Mitchell Kennerley*, 20 January 1929, NYPL

A note from Stieglitz to Kennerley in the Kennerley papers (NYPL) indicates that the price of *Yellow Hickory Leaves with Daisy* was $1,200; *Red Barn, Wisconsin*, $4,000; *East River from the Shelton*, $4,000; and *Green Corn No. 1* (not mentioned in this letter), $2,000. Kennerley did buy *Single Lily with Red* and in 1933 transferred it to the Whitney Museum. According to O'Keeffe's files (not compiled until several years later and not always correct), Kennerley did not buy any of the other paintings described in this letter, although he had bought works from previous shows including *Four Yellow Apples on Black Dish*, 1921, oil, private collection.

42. *Henry McBride*, February 1929, YCAL

This letter was written on the back of the announcement for O'Keeffe's 1929 show at The Intimate Gallery from 4 February to 17 March. In a review titled "Paintings by Georgia O'Keeffe," *The New York Sun*, 9 February 1929, 7, McBride stated that the large calla lilies were "the apotheosis of calla-lilies." He continued that "in an elusive but definite enough way for those who are at all psychic," these paintings were also symbolic of "the present grandeur of these United States."

43. *Blanche Matthias*, April 1929, YCAL

Josef Hofmann (1876–1957) was a Polish-born American classical pianist, who as a child prodigy was kept from touring the United States by the Society for the Prevention of Cruelty to Children. On 24 March 1929 he played Chopin and Liszt at Carnegie Hall, in a performance that the *New York Times* described as surpassing all other programs "and even the seductions of a glorious Spring day" (25 March 1929, 22).

Ethel Tyrrell was the daughter of Stieglitz's friend Henry Tyrrell, who wrote for the *New York World*. Stieglitz made several portraits of Ethel Tyrrell in the summer of 1925; see accession numbers 1949.3.654, 1949.3.655, 1949.3.656, 1949.3.657, and 1949.3.658, The Alfred Stieglitz Collection, National Gallery of Art.

The Chicago World's Fair did not open until 1933; O'Keeffe did not make a mural for it.

Charles Demuth (1883–1935) was an American modernist painter, member of the Stieglitz group, and frequent exhibitor at The Intimate Gallery. His exhibition, from 29 April to 18

May 1929, was the last one held at The Intimate Gallery. Stieglitz, O'Keeffe, and Demuth were close friends. O'Keeffe frequently reprinted lines from Demuth's writings in her exhibition catalogues, and Demuth bequeathed his paintings to her. They shared many subjects, including flowers and buildings, and O'Keeffe admired his delicacy and precision, but at times, as she notes in this letter, she felt his art lacked a sense of passion; she wanted to see in his work "that the center of the earth is burning—melting hot."

44. *Henry McBride*, summer 1929, YCAL

During the winter of 1928–1929 Mabel Dodge Luhan visited New York with Dorothy Brett, the English painter and friend of D.H. Lawrence. While there she saw Stieglitz and O'Keeffe and extended an invitation to them to visit her in Taos, New Mexico. As is clear in her earlier correspondence, O'Keeffe felt she needed a change. Even Stieglitz recognized this as early as 1925, writing to Waldo Frank, "she dreams of the plains—of real Spaces" (25 August 1925, YCAL). On 27 April 1929 O'Keeffe and Rebecca ("Beck") Strand set out for New Mexico. Because Beck and Paul Strand had previously visited Luhan in 1926 and found her to be a difficult hostess, O'Keeffe and Beck Strand did not plan to stay with her. Shortly after their arrival in Santa Fe, however, Luhan persuaded them to go to Taos and see an Indian dance; they spent the rest of the summer with her. Luhan gave them a separate house, called the "Pink House," which was across a field from her own, and O'Keeffe was given her own studio with a spectacular mountain view.

In "Georgia O'Keeffe in Taos," *Creative Art* 8 (June 1931), 407–410, Luhan recalled O'Keeffe's 1929 visit to New Mexico. "Things appeared to her visually enhanced," Luhan wrote, "people were revealed more fully to her and seemed brought further into being than those known. 'Wonderful' was a word that was always on her lips. 'Well! Well! Well!' she exclaimed. 'This is wonderful. No one told me it was like *this*.' "

O'Keeffe was enchanted not just with the landscape of New Mexico, but also with Luhan's husband, Tony Lujan (d. 1963). A Pueblo Indian, Lujan was a quiet, observant man. O'Keeffe respected his close contact with and deep reverence for the landscape of New Mexico, and she appreciated the introduction he gave her to its people, places, and ceremonies.

Marin went out to New Mexico in June 1929 and, like O'Keeffe, was immediately invigorated by the landscape and people, painting dozens of oils and watercolors.

45. *Paul Strand*, May 1929, CCP

In order to get around New Mexico, O'Keeffe bought a car—a Ford—in the summer of 1929. While learning how to drive, she had many exploits, which became legendary in the Taos community. For an amusing account of O'Keeffe as the "demon driver," see Luhan, *Creative Art*, 1931.

When O'Keeffe wrote "it is quite as grand as that San Antonio time," she was referring to a few months in the spring of 1918 that she spent in San Antonio, Texas. Suffering from influenza and stifled by the small community, O'Keeffe quit her teaching job at West Texas State Normal College in early February 1918, and went to San Antonio and Waring, Texas, with Leah Harris. Stieglitz became concerned about her health, but because he had jury duty and was unable to leave New York, he sent Strand to Texas to make sure she was well and persuade her to return to New York.

46. *Mabel Dodge Luhan*, June 1929, YCAL

In June 1929 Mabel Luhan returned to her home town of Buffalo, New York, for a hysterectomy. At about the same time, Tony Lujan returned to his home and common-law wife at the Taos Pueblo.

47. *Mabel Dodge Luhan*, August 1929, YCAL

Willard (Spud) Johnson (1897–1968) was a poet, author of *Horizontal Yellow*, 1935, and editor of *The Laughing Horse* and *Horse Fly*. He later wrote for the *Taos News* and *The New Mexican*.

O'Keeffe probably gave Johnson the first volume of Luhan's memoirs, *Intimate Memories: Background*, 1933. Subsequent volumes were *European Experiences*, 1935; *Movers and Shakers*, 1936; and *Edge of Taos Desert*, 1937.

48. *Rebecca Strand [James]*, 24 August 1929, YCAL

Rebecca (Beck) Salsbury Strand James (1891–1968), daughter of the manager of Buffalo Bill's Wild West Show, married Paul Strand in 1922. She quickly became a close friend of both Stieglitz and O'Keeffe. Possibly inspired by Marsden Hartley, and certainly encouraged by Stieglitz and her husband, Beck made paintings on glass, which were exhibited at An American Place in 1932. After divorcing Strand, she married William H. James, a New Mexico businessman, in 1937, and lived in New Mexico for the rest of her life.

The Honorable Dorothy Brett (1883–1977), daughter of Viscount Esher, was a painter who studied art at the Slade School in London from 1910 to 1916. While there she met Frieda and D.H. Lawrence. In 1924 she followed them to New Mexico, where she spent the rest of her life painting local scenes and Indians. When O'Keeffe saw her in 1929 she was living at Kiowa Ranch, Lawrence's home in New Mexico.

Charles Collier was the son of the director of the Bureau of Indian Affairs and later was associated with the College of Santa Fe, and founder of the International Institute of Iberian Colonial Art. He and O'Keeffe remained friends throughout their lives.

Miriam Hapgood, daughter of Hutchins Hapgood and Neith Boyce, became a close friend of Mabel Luhan. She was so enthralled by her first visit to New Mexico in 1929 that she soon returned and lived there for the next fourteen years.

Marie Tudor Garland (b. 1870) was a painter, poet, and author of *Hindu Mind Training*, 1917; *The Winged Spirit*, 1918; and *The Marriage Feast*, 1920. She owned the H & M Ranch in Alcalde, New Mexico, a town about forty miles south of Taos.

Henwar Rodakiewicz, who was married briefly to Marie Garland, was an independent filmmaker. In the early 1930s Stieglitz showed Rodakiewicz's film "Portrait of a Young Man" at An American Place.

After her operation in July 1929, Mabel Luhan returned to New Mexico with Ida O'Keeffe (Georgia's sister) as her private nurse.

Pete was a friend of Tony Lujan and an employee of Mabel Luhan. O'Keeffe rode with him in the evenings.

O'Keeffe met her brother Alexius in Chicago on her way home from New Mexico.

Beck Strand undoubtedly agreed with O'Keeffe when she wrote, "I realize I must be different than when I came out." On 14 May 1929, after they had been in New Mexico for only a few weeks, Beck Strand wrote to Stieglitz that O'Keeffe no longer seemed frail, but was "as tough as a hickory root, and it's not the false toughness of excitement and newness, but a strength that has come from finding what she knew she needed" (YCAL).

49. *Ettie Stettheimer*, 24 August 1929, GOK

This letter was written on stationery from the Hotel Jerome in Aspen, Colorado.

Stieglitz's summer at Lake George in 1929 was "bad" for many reasons. Nervous without O'Keeffe, he worried about her health, her travels in remote areas of New Mexico, and her involvements with other people. To vent some of his frustrations, he burned up many issues of *Camera Work* and *291*; to com-

pete with her, he tried to learn to drive; and to top her other exploits he flew, for the first time in his life, to New York. O'Keeffe dismissed all summers at Lake George as "bad" because the constant stream of visitors, both family and friends, left her little privacy or time to paint.

50. *Mabel Dodge Luhan*, September 1929, YCAL

Mabel Dodge Luhan was not well during much of the summer of 1929, but in addition she was convinced that O'Keeffe and her husband were having an affair. Because Tony could not read or write English, O'Keeffe had been acting as an intermediary, reading Mabel's letters to him and writing his to her. While Mabel was in Buffalo, she discovered that Tony had returned to his Indian wife, and threatened divorce. O'Keeffe interceded and implored her to recognize that "if Tony doesn't love you—according to my notion—then nobody ever will. . . . I have rarely seen something in two people . . . as I feel it between you and your Tony and I feel you have got to let him live and be his way." However, O'Keeffe raised Mabel Luhan's suspicions even more when she wrote to her, "if Tony happens to go out to women with his body it is the same thing when one goes out for a spiritual debauch" (Summer 1929, YCAL). Luhan later admitted that she was very jealous and she apologized for her "horrid" behavior, but thereafter O'Keeffe always kept her at a distance (Luhan to O'Keeffe, 22 January [1930?], GOK).

Alba was Luhan's Indian maid, Albidia Marcus.

51. *Mabel Dodge Luhan*, September 1929, YCAL

52. *Rebecca Strand [James]*, 5 November 1929, YCAL

"'Good idea that going West!'": O'Keeffe's trip to New Mexico in 1929 not only invigorated her art but boosted her self-confidence. For years she had operated under Stieglitz's shadow —as his protégée, his model, his wife. She later wrote, "it often sounds as if I was born and taught to walk by him" (letter 86). Living in his world, she had adopted his friends and even his subjects for her art. In New Mexico she chose her own way of life, her own friends, and her own, new subjects. Several major paintings resulted from this 1929 trip, including *Black Cross, Arizona*, 1929, cat. 73; *Ranchos Church*, 1929, cat. 72; and *The Lawrence Tree*, 1929, cat. 76. Her 1930 exhibition, which included many New Mexico paintings, was widely praised. One critic noted that it revealed "the real Taos and the real O'Keeffe"; see *The Art News* 28 (22 February 1930), 10.

53. *Dorothy Brett*, early April 1930, YCAL

On 29 March 1930 Brett wrote to Stieglitz, describing her feelings about D.H. Lawrence's recent death. She vowed never to tell her story of Lawrence, because it would be corrupted by jealousy and argument.

The manuscript to which O'Keeffe referred was an unpublished article on O'Keeffe by Brett, first written in April 1930 and revised in 1934 (YCAL). Titled "Remembered Life," it began with the line "Man thinks *about* Life—Life thinks in Woman."

Ida Rauh was a feminist and wife of Max Eastman, publisher of *The Masses*.

Jo Davidson (1883–1952) was an American sculptor who had recently been in New Mexico.

In this letter O'Keeffe tried to convince Brett to write her own account of Lawrence to counter Mabel Luhan's projected book *Lorenzo in Taos*, 1932, which both Brett and O'Keeffe thought would be inaccurate and self-serving. Brett did eventually write such a study, titled *Lawrence and Brett: A Friendship*, 1933.

54. *Dorothy Brett*, 12? October 1930, YCAL

In a letter postmarked 9 October 1930, Brett wrote to Stieg-

litz, telling him that O'Keeffe should not feel "sore or distressed about Taos." There were certain things O'Keeffe did not understand, she explained; Taos was a dream in comparison to Capri or Florence "or anyplace where a few members of a race are isolated together." O'Keeffe, she continued, "hasn't altogether realized herself in relation to the world. She has lived so much for her painting—lived so deeply with you—that she is like a tree walking among people, she looks for other trees, without seeing—most of them have but twigs" (YCAL).

55. *William M. Milliken*, 1 November 1930, Cleveland Museum of Art

William M. Milliken (1889–1978) was the director of the Cleveland Museum of Art from 1930 to 1958.

White Flower, New Mexico, oil on canvas, was bought directly out of O'Keeffe's 1930 show at An American Place, the gallery Stieglitz directed from 1929 until his death in 1946. Portions of this letter were later reprinted in Milliken's article, "White Flower by Georgia O'Keeffe," *The Bulletin of the Cleveland Museum of Art*, 4 (April 1937), 51–53.

56. *Henry McBride*, July 1931, YCAL

Mabel Dodge Luhan's article on "Georgia O'Keeffe in Taos," *Creative Art*, 1931, contained several amusing anecdotes of O'Keeffe's 1929 visit to New Mexico, but at times, it also was condescending. Describing her as a "dryad at the bottom of a tarn [who] seems outside people's codes, customs, and all folk ways," Luhan wrote that O'Keeffe "hardly understood, at first, what was happening in her. Perhaps she never quite understood it."

Although she complained to McBride that *The Lawrence Tree* was rotated, O'Keeffe herself reproduced it many different ways; see, for example, her 1976 book, *Georgia O'Keeffe*, unpaginated. When this painting was bought by The Wadsworth Atheneum, she wrote that it "was done so it could be hung with any end up" (Wadsworth Atheneum).

Over the next several years, O'Keeffe made many studies of bones; those from 1931 include *Cow's Skull with Calico Roses*, cat. 75, and *Horse's Skull with White Rose*, cat. 82.

O'Keeffe also painted several studies of katchina dolls; see, for example, *Katchina*, 1936, oil on canvas, San Francisco Museum of Modern Art.

57. *Russell Vernon Hunter*, late August 1931, GOK

Russell Vernon Hunter (1900–1955) was a New Mexican artist who had studied at the Denver Art Academy, the School of The Art Institute of Chicago, and with Stanton Macdonald-Wright in Los Angeles. From 1935 to 1942 he was State Director for the Federal Art Program of the W.P.A. in New Mexico; later he was administrative director of the Dallas Museum of Fine Arts and director of the Roswell Museum. In 1931 Hunter began to send O'Keeffe, whom he had met earlier that year, long letters filled with evocative descriptions of the life and landscape of the Southwest. They remained friends until his death in 1955.

Robert Walker (1894–1940) was an artist who moved to New Mexico in 1928.

In the summer of 1931 O'Keeffe rented a small cottage from Marie Garland in Alcalde, New Mexico.

When O'Keeffe returned from New Mexico in July 1931 she found that Stieglitz had accepted an invitation to visit Dorothy Norman in Woods Hole, Massachusetts. Perhaps in response, O'Keeffe went to York Beach, Maine, for three weeks in August 1931. By 1931 Norman had become a constant presence at An American Place, and had even helped to raise funds to pay the gallery's rent.

58. *Russell Vernon Hunter*, January 1932, GOK

On 29 December 1931 Hunter wrote to O'Keeffe that he had seen an announcement in the *New York Times* of O'Keeffe's show at An American Place (from 27 December 1931 to 11 February 1932) and Diego Rivera's show at the Museum of Modern Art (temporarily located in the Heckscher Building in New York).

O'Keeffe's 1931–1932 show was "different" because it included several paintings of bones, particularly skulls, which elicited a great deal of comment; see, for example, Henry McBride, "Skeletons on the Plain: Miss O'Keeffe Returns from the West With Grewsome Trophies," *New York Sun*, 2 January 1932, 8; or Elizabeth McCausland, "Georgia O'Keeffe Exhibits Skulls and Roses of 1931," *The Springfield Sunday Union and Republican*, 10 January 1932, 6E.

When O'Keeffe wrote, "you speak of Indians—I met and got to know one in Taos who is one of the most remarkable people I have ever known," she was referring either to Tony Lujan (see note 44) or to his friend John Marcos.

59. *Russell Vernon Hunter*, January 1932, GOK

This letter was written on the back of an announcement for O'Keeffe's 1931–1932 show at An American Place.

60. *Dorothy Brett*, mid-February 1932, HRC-UT

Brett wrote to Stieglitz on 10 February 1932, wondering why Beck Strand's paintings were being shown along with Paul Strand's photographs at An American Place in 1932. She did not understand "why Beck should be exalted over the heads of every other artist in the country as to be shown in the Room does exalt a painter, beyond other painters, and why she should be placed on a level with you and Georgia and Marin." She concluded that she felt Beck was not "a creative artist," but a good mimic (YCAL).

For the past two years, Stieglitz and the Strands had been drifting apart (as had Paul and Beck themselves). With the advent of the Great Depression, Paul Strand, unlike Stieglitz, felt compelled to make his photography more socially relevant. In addition, Paul and Beck both felt that Stieglitz had never acknowledged the work they had done to raise funds to support An American Place. Stieglitz, therefore, may have suggested this joint exhibition in order to mend their strained relationship, but it did not work. Although Beck Strand and Stieglitz remained friendly, Paul Strand had little to do with Stieglitz after 1932.

61. *Russell Vernon Hunter*, Spring 1932, GOK

Perhaps knowing that O'Keeffe had painted a cockscomb in 1931 (oil, private collection), Hunter included one in his letter to her.

62. *Dorothy Brett*, September? 1932, HRC-UT

For several years O'Keeffe had wanted to paint a mural (see letter 43); thus in the summer of 1932 when she was asked to do one for the women's powder room at Radio City in Rockefeller Center, she quickly accepted the commission. Stieglitz strongly objected. For him, Rockefeller Center represented crass American commercialism. O'Keeffe, however, was not swayed by his arguments, and over the summer and fall of 1932 she made several trips to New York to plan the mural. By the early fall she felt under increasing pressure: the construction was much slower than planned and she feared that there would not be enough time for her to paint the mural before the scheduled opening. When she arrived to inspect the room and begin painting, she was distressed to find that a section of the surface of the wall was peeling off. Forced to abandon the project, O'Keeffe had to admit that Stieglitz's fears of the insensitivity of big business were in this case correct.

In the late summer and early fall of 1932, O'Keeffe went to the Gaspé Peninsula with Stieglitz's niece Georgia Engelhard (1906–1986). A budding painter, "Little Georgia" was a favorite of both Stieglitz and O'Keeffe. Several paintings resulted from this trip, including *Nature Forms, Gaspé*, 1932, cat. 45.

In 1933 Brett published *Lawrence and Brett: A Friendship*.

63. *Russell Vernon Hunter*, October 1932, GOK

On 28 September 1932 Hunter wrote to O'Keeffe, telling her some of the Dallas art news, including the forthcoming publication of a new art periodical, *Contemporary Arts of the South and Southwest*, edited by the painter Jerry Bywaters.

It is not clear why O'Keeffe did not go to New Mexico in the summer of 1932. Perhaps in light of Stieglitz's increasing attention to Dorothy Norman, she did not want to leave him for such a long time.

Hunter published "A Note on Georgia O'Keeffe" in *Contemporary Arts of the South and Southwest* 1 (November and December 1932), 7.

The manuscript on Marin by "another boy from the South West" has not been identified.

O'Keeffe did not paint a mural on the Lake George kitchen wall.

64. *Russell Vernon Hunter*, early February 1933, GOK

In "A Note on Georgia O'Keeffe," *Contemporary Arts of the South and Southwest*, 1932, Hunter wrote that "in everything this woman is simple, direct and significant to the core. . . . Georgia O'Keeffe's regard for nature seems virtually pantheistic. She lays hold of things with an intensely passionate understanding."

The illness that O'Keeffe described in this letter was quite severe. Frustrated by her public failure to complete the mural for Radio City and Stieglitz's interest in Norman, she suffered from severe headaches, chest pains, and chronic fatigue from early December 1932 to early February 1933. On 1 February she was admitted to the Doctor's Hospital in New York for "psychoneurosis." She did not fully recover for over a year.

O'Keeffe's 1933 exhibition, titled "Paintings—New and Some Old," opened at An American Place on 7 January and closed 22 February 1933.

Hunter had written to O'Keeffe on 23 November 1932 (GOK) telling her that he was going to suggest to the Amarillo Art Association that they buy one of her paintings, and he asked the price of her small canvases. Although Amarillo "is indeed very poor, both in spirit and purse," he wrote, "the fact that you were once there and that you are now what you are is a little amazing to them."

In his "Note on Georgia O'Keeffe" Hunter wrote, "time is an element which is present in the works of this artist and it has rarely, if ever otherwise, been achieved through the medium of paint." He felt time was present particularly in her paintings of bones. "The skull is fixed in space," he wrote, "it is suspended by nothing, resting upon nothing. It exists before a planed bosom sagging as with time yet it is as though it were moving mysteriously away from this sagging plane into an eternal dimension where time is not."

65. *Russell Vernon Hunter*, 21 October 1933, GOK

Hunter wrote to O'Keeffe on 6 July 1933 (GOK), describing a mural he had painted for a radio station in Amarillo. He wrote, "if the big fish of Radio City were like the little fish of that town I can understand why you did not do a mural there."

The "maid" was Margaret Prosser, housekeeper for the Stieglitz family in Lake George for eighteen years. Stieglitz often photographed Prosser toward the end of his career; see, for example, Stieglitz photograph, accession number 1949.3.809, The Alfred Stieglitz Collection, National Gallery of Art.

From 14 October to 27 November 1933 Stieglitz exhibited "Twenty-Five Years of John Marin, 1908–1932" at An American Place. Following that, from 20 December 1933 to 1 February 1934, Stieglitz showed eighteen watercolors and three oils by Marin from 1932 and 1933.

In the spring of 1933, following her release from Doctor's Hospital, O'Keeffe went to Bermuda with Marjorie Content, a friend of the Stieglitz family. She stayed there until the end of May.

In his letter of 6 July 1933 (GOK) Hunter had told O'Keeffe that Mary Hudspath, who had taught Spanish and mathematics with O'Keeffe at the West Texas State Normal College, had given a "small but beautifully designed" art gallery to the town of Canyon.

In this same letter, Hunter also wrote that "windmills as rather fantastic monuments have been holding my interest steadily; a statuesque restlessness is there with a nervousness at the top and utter plantedness at the bottom that is intriguing to grasp." In 1916 O'Keeffe had also been intrigued with windmills, painting *Morning Sky with Houses and Windmill*, watercolor, private collection.

66. *Paul Strand*, 26 December 1933, CCP

In December 1933 O'Keeffe went to New York for the first time in several months. There she saw Jean Toomer (1894–1967) and invited him to come back to Lake George with her. Recently widowed, Toomer was a black American author who had first met Stieglitz and O'Keeffe in 1923, shortly after the publication of his highly acclaimed book *Cane*. Both Stieglitz and O'Keeffe were very impressed with the lyrical account of black life that Toomer depicted in *Cane*. Toomer visited Stieglitz and O'Keeffe at Lake George in 1925, at which time Stieglitz made many photographs of him; see, for example, Stieglitz photographs, accession numbers 1949.3.640–652, The Alfred Stieglitz Collection, National Gallery of Art.

Toomer's article on Stieglitz appeared in *America and Alfred Stieglitz: A Collective Portrait*, edited by Waldo Frank, Lewis Mumford, Dorothy Norman, Paul Rosenfeld, and Harold Rugg (New York, 1934), 295–302. Titled "The Hill," it included an account of Toomer's time with Stieglitz and O'Keeffe at Lake George in December 1932. "Feeling," Toomer wrote, "is the center of [Stieglitz's] life. Whatever he does, he does through feeling—and he won't do anything unless feeling is in it. Whatever he thinks, he thinks with feeling."

Paul and Beck Strand were divorced in 1933.

O'Keeffe went with Paul Rosenfeld to hear "La Création du Monde," composed by the French musician Darius Milhaud in 1923.

Constantin Brancusi (1876–1957), the Rumanian sculptor who had his first one-man show at 291 in 1914, had a one-man show at the Brummer Gallery in New York from 17 November 1933 to 13 January 1934.

Marcel Duchamp (1887–1968), the French painter, sculptor, theoretician, and chess player, was a good friend of both Stieglitz and O'Keeffe and was greatly admired by them.

67. *Jean Toomer*, 3 January 1934, YCAL

On 4 January 1934 Toomer wrote to O'Keeffe from Chicago, sending "Greetings to: My background! and to the kitten-cats . . . and to the frozen ford . . . and to the bundling-bed" (GOK).

Margaret Prosser was the Lake George housekeeper; see note 65.

68. *Jean Toomer*, 10 January 1934, YCAL

When O'Keeffe wrote to Toomer that she believed that his center was in his mind, whereas hers was not, she was reiterating her belief that men and women understood and responded to the world in very different ways, that men were more analytical and women were more subjective. Toomer agreed with her. In his unpublished drama "The Sacred Factory" his thesis was the same, that women were "heart" and men were "mind and logic"; see Darwin T. Turner's introduction to the 1975 reprint of *Cane*, xiv. Turner points out that Toomer was not being condescending to women; he did not mean to imply that women were flighty or irrational. The women in *Cane* were strong, independent, passionate, and instinctive, in no way inferior to their male counterparts. Toomer, like many artists and writers of the 1920s, such as Stieglitz, Dove, Frank, Anderson, Rosenfeld, or Hart Crane, placed a far greater value on intuitive, subjective expression than analytical thought.

On 21 January 1934 Toomer responded to this letter and, while he agreed with her about the location of their "centers," he also perceptively remarked that there was a certain "unconscious stinginess" in O'Keeffe's life. Noting that she never asked anyone for anything, he wrote that he believed two things accounted for this reluctance: one was that she did not need much, as she had "a rich inner supply to draw upon." But the other reason, he suggested, was that if she did not take anything from other people she would not feel obligated to give them anything in return. He concluded that if he suffered from "aggressive egotism," she suffered from "defensive egotism." He wanted to influence people. "You," he wrote, "do *not* want to influence people" (GOK).

69. *Jean Toomer*, 8 February 1934, YCAL

O'Keeffe's retrospective show of forty-four paintings from 1915 to 1927 opened at An American Place on 29? January and closed 17? March 1934.

"There is a painting I made from something of you": In a later letter of 12 March 1934 (YCAL) O'Keeffe told Toomer that the warmer colored of the two paintings of trees in her 1934 show was a portrait of him. Installation photographs show that *Birch and Pine Tree No. I*, 1925, oil on canvas, Estate of Georgia O'Keeffe, and *Birch and Pine Trees—Pink*, 1925, oil on canvas, private collection, were both exhibited in 1934; the latter was probably the portrait of Toomer. From the beginning of her career O'Keeffe had made abstract portraits of her friends; see *Portrait—W—No. III*, 1917, cat. 26, a study of a Texas friend, Kindred M. Watkins, a mechanic. Echoing these words to Toomer, she wrote in *Georgia O'Keeffe* (New York, 1976), unpaginated, "there are people who have made me see shapes—and others I thought of a great deal, even people I have loved, who make me see nothing. I have painted portraits that to me are almost photographic. I remember hesitating to show the paintings, they looked so real to me. But they have passed into the world as abstractions—no one seeing what they are."

70. *Jean Toomer*, 5 March 1934, YCAL

O'Keeffe left for Bermuda in early March 1934 to visit some people she had met there the previous year. She returned to New York early in May.

On 20 February 1934 Toomer wrote to O'Keeffe that he had a bad cold in his eye and had to rest (GOK).

When O'Keeffe wrote, "my coming out here to these toy like islands . . . is only an evasion," perhaps she recognized that with Toomer's help she was ready to resume her normal life.

71. *Rebecca Strand [James]*, 26 April 1934, YCAL

"I think I'll probably not go to Taos. . . . I do not want to go to Marie's": In the summer of 1934 O'Keeffe and Marjorie Content drove out to New Mexico. Content had met Toomer in the spring of 1934, and by the time of O'Keeffe's return from Bermuda the two were engaged. Toomer joined Content and O'Keeffe after they were settled at Marie Garland's H & M

Ranch in Alcalde, New Mexico. Shortly afterward O'Keeffe discovered Ghost Ranch, a dude ranch outside the small village of Abiquiu. Perhaps because of her desire for more privacy and perhaps too because she felt out of place with the romantic couple, O'Keeffe spent the rest of the summer—and most summers thereafter for the rest of her life—at Ghost Ranch.

72. *David H. McAlpin*, 24 December 1936, Collection of Mr. and Mrs. David H. McAlpin

David H. McAlpin (b. 1897), a lawyer and investment banker by profession, is an important photography collector and patron. A friend of Ansel Adams, he subsidized the Museum of Modern Art's pioneering exhibition *Photography 1839–1937*, assisted Adams and Beaumont Newhall in founding the Department of Photography at the Museum of Modern Art, and later endowed a chair in the history of photography at Princeton University.

In 1936 Elizabeth Arden (1891–1966), the cosmetic executive, commissioned O'Keeffe to paint a large study of white blossoms for her exercise salon: *Jimson Weed*, 1937, oil, estate of Elizabeth Arden.

O'Keeffe most likely sent McAlpin a copy of E.M. Benson's book *John Marin: Watercolors, Oil Paintings, Etchings* (New York, 1936).

73. *Helen Torr and Arthur Dove*, January 1938, YCAL

Helen ("Reds") Torr (1886–1967) and Arthur Dove (1880–1946), who were both artists, met in 1919 and married in 1930. Dove had been associated with Stieglitz's galleries since 1910, and the two were close friends for the rest of their lives. After meeting Reds in the early 1920s, both Stieglitz and O'Keeffe became fond of her and encouraged her work; O'Keeffe selected her paintings for an exhibition she curated at The Opportunity Gallery in New York in 1927, and Stieglitz organized a joint exhibition of Torr and Dove at An American Place in 1933. O'Keeffe greatly admired Dove's work. His imagery and appreciation of color were similar to hers. They shared a pantheistic appreciation of nature, and both stripped away extraneous and irrelevant details to construct visual equivalents of emotional states.

On 29 December 1937 Dove wrote to Stieglitz that O'Keeffe's letters, published in her 1937–1938 catalogue, were "beautiful. And as I told her I hardly knew that she could read and write" (YCAL).

74. *Cady Wells*, 3? February 1938, AAA

Cady Wells (1904–1955), a Massachusetts native, arrived in New Mexico in 1932 and, entranced by the beauty of the Southwest, decided to become a painter. Andrew Dasburg was his primary mentor, although he was also influenced by O'Keeffe and Raymond Jonson.

Stieglitz wrote Wells on 3 February 1938, noting that he had seen his watercolors but did not feel that he was ready for an exhibition at An American Place.

O'Keeffe's annual exhibition at An American Place opened on 26 December 1937 and closed 12 February 1938.

Robert Walker was a New Mexican artist; see note 57.

75. *Cady Wells*, late February 1938, AAA

Wells' letters to O'Keeffe do not appear to have survived.

76. *William Einstein*, 19 July 1938, YCAL

William Einstein (1907–1972) was a painter and distant cousin of Stieglitz whose work was exhibited at An American Place in 1936. O'Keeffe liked him and in later years invited him and his wife to stay with her in New Mexico. She wrote, "He is the only painter that I really enjoy talking with about painting"

(introduction to an exhibition of Einstein's work at the Associated American Artists, New York, 5 January–24 January 1953).

On 22 April 1938 Stieglitz had a major heart attack, followed by pneumonia.

Dave McAlpin: See note 72.

Godfrey Rockefeller, David McAlpin's cousin, was a New York businessman.

Ansel Adams (1902–1984) was one of the last photographers to be championed by Stieglitz; he had a show at An American Place in 1936. In a letter to Stieglitz of 10 September 1938 Adams described this trip to the high Sierras with O'Keeffe, Rockefeller, and McAlpin, writing, "I met O'Keeffe at Merced and drove her into Yosemite Tuesday. She likes our country, and immediately began picking out white barns, golden hills, oak trees. As we climbed through the mountains the scene rapidly changed and as we entered Yosemite she was practically raving, 'Well, really, this is too wonderful!' " (quoted in *Ansel Adams: An Autobiography*, with Mary Street Alinder [Boston, 1985], 227).

Cary Ross (1902–1951) was an art critic.

77. *Cady Wells*, Spring 1939, AAA

The identity of the "old friend" with whom O'Keeffe quarreled is unknown.

"Reading some old letters": In all likelihood, O'Keeffe was reading her letters to Anita Pollitzer, written from 1915 to 1917.

78. *Henry McBride*, 22 July 1939, YCAL

For several months after O'Keeffe returned from Hawaii in April 1939, she was not well, apparently suffering from exhaustion.

Throughout her life, O'Keeffe enjoyed McBride's reviews, see letters 27, 33, and 39.

O'Keeffe probably went to the opening of "Art in Our Time: Tenth Anniversary Exhibit" at the Museum of Modern Art on 10 May 1939.

79. *Russell Vernon Hunter*, October–November 1939, GOK

On 15 October 1939 a Marin exhibition, titled "Beyond All 'Isms'—Thirty Selected Marins (1908–1938)," opened at An American Place.

The "San Francisco Fair" was the Golden Gate Art Exhibition, which was open for most of 1939 in the Palace of the Legion of Honor, Fine Arts Museums of San Francisco. A huge show, it included work by Alexander Brook, Charles Burchfield, David Burliuk, Paul Cadmus, John Steuart Curry, Andrew Dasburg, Guy Pene Du Bois, Reginald Marsh, Charles Sheeler, Niles Spencer, and Maurice Sterne.

The "sorry show at the Metropolitan" may have been "Life in America for Three Hundred Years."

Hunter married Virginia McGee in 1934.

80. *Ettie Stettheimer*, 15 August 1940, GOK

Felix Greene was a British journalist and cousin of Graham Greene.

Carl Van Vechten (1880–1964) had three careers: as a literary and music critic; as an author of, among other things, *Peter Whiffle, The Tattooed Countess*, and *Parties*; and as a portrait photographer of such celebrities as Matisse, Noguchi, O'Neill, Dreiser, Faulkner, Dali, and Gertrude Stein.

In October 1940 O'Keeffe bought the house at Ghost Ranch that she had been renting for the last six summers.

Frieda Lawrence (1879–1956) was the wife of D.H. Lawrence. After Lawrence's death in 1932, she continued to live in New Mexico.

At first O'Keeffe referred to New Mexico in general as "the Faraway," but as she came to understand the differences in

its terrain, population, and character, she began to call her northwest corner of the state around Abiquiu "the Faraway."

The "girl" may have been Maria Chabot, a young woman originally from Texas who was O'Keeffe's companion and housekeeper for several years.

81. *Maria Chabot*, November 1941, GOK
On the typed carbon copy of this letter in O'Keeffe's estate is a note in O'Keeffe's handwriting, "This was copied to use as catalogue foreword then I forgot."

A few years later O'Keeffe would make several paintings inspired from scenes she had seen while flying, including *Sky Above Clouds II*, 1963, cat. 119; *Sky Above Clouds III*, 1963, cat. 118; and *Sky Above Clouds IV*, 1965, cat. 120.

82. *Frank Lloyd Wright*, May 1942, GOK and The Frank Lloyd Wright Foundation
Frank Lloyd Wright (1869–1959), author of *The Nature of Materials*, *The Disappearing City*, and *Architecture of Modern Life*, was a preeminent architect when O'Keeffe met him in the late 1920s. In both age and outlook, Wright was very similar to Stieglitz: born within a few years of the end of the Civil War, both were able to break free of their nineteenth-century schooling and create a truly modern art for the twentieth century. O'Keeffe and Wright shared much in common: greatly influenced by Oriental art, they both simplified form and reduced it to its essence, and both believed, as Stieglitz also did, that the external form of an object could reveal its inner character.

In May 1942 O'Keeffe went to Madison, Wisconsin, to receive an honorary degree from the University of Wisconsin, and while there she visited Wright and his wife Olgivanna.

"My sister [and] . . . her husband" were probably Anita and Robert Young.

"Your book" may have been *An Organic Architecture*, 1939, or *Frank Lloyd Wright on Architecture*, 1941.

In 1947 after Stieglitz's death, O'Keeffe gave Wright her painting *Pelvis with Shadows and the Moon*, 1943, cat. 99. When she sent it, she wrote that it "represents only a small gesture of appreciation for something I feel about you" (O'Keeffe to Wright, 11 February 1947, The Frank Lloyd Wright Foundation). After Wright's death, she called him "one of my favorite people of our time" (O'Keeffe to Olgivanna Lloyd Wright, 1 April 1966, The Frank Lloyd Wright Foundation).

83. *Arthur Dove*, September 1942, YCAL

84. *Ettie Stettheimer*, August? 1943, GOK
The "same girl" was Maria Chabot; see note 80.

The Penitentes, a secret religious organization that once practiced flagellation and continues to dramatize the Passion of Christ during the Holy Week, is active in Abiquiu and elsewhere in New Mexico.

A "morada" is a small meeting house that is the center of the Penitentes' activities.

85. *Eleanor Roosevelt*, 10 February 1944, GOK
This handwritten letter is probably a copy or first draft of the original.

The New York Times reported on 1 February 1944, page 24, that the "First Lady Fights Equal Rights Plan." The article noted that while Eleanor Roosevelt declared herself against a constitutional amendment for Equal Rights, she did suggest that the "whole list of discriminating laws be reviewed." She felt that the present laws "have been helpful to women in industrial work," and that it would "be a mistake to remove such legislation until we are quite sure standards as good have been established for both men and women."

Anita Pollitzer undoubtedly encouraged O'Keeffe to write this letter. As an active member of the National Woman's Party, Pollitzer had campaigned for several years for the passage of the Equal Rights Amendment.

86. Carl Zigrosser, April 1944, UPA
Carl Zigrosser (1891–1975), print curator and author of *The Expressionists: A Survey of Their Graphic Art*, 1957, and *The Complete Etchings of John Marin: A Catalogue Raisonné*, 1969, organized the 1944 exhibition of the Stieglitz collection at the Philadelphia Museum of Art.

Strand had only one show at 291 in 1916.

The Strand photograph that O'Keeffe referred to as *Dishes No. 41* may be *Abstraction—Bowls*, 1916.

See note 60 for a discussion of why Stieglitz was "mad" at Strand.

O'Keeffe had ambivalent feelings about Stieglitz's sponsorship of her work. Although she was profoundly grateful for the support he had given American artists in general and herself specifically, she also resented the idea that she was Stieglitz's creation or that he only exhibited her art because they were married.

"You men" probably refers to Zigrosser, Henry Clifford (who co-authored the exhibition catalogue with Zigrosser), and Fiske Kimball, director of the Philadelphia Museum of Art.

87. *Ettie and Carrie Stettheimer*, April–May 1944, GOK
Florine Stettheimer was sick and in pain for the last two years of her life.

On Marie Chabot, see note 80.

88. *Ettie and Carrie Stettheimer*, 10 June 1944, GOK
Florine Stettheimer died on 11 May 1944.

See note 35 for a discussion of the Stettheimers' world.

89. *Maude and Frederick Mortimer Clapp*, 9 June 1945, YCAL
Maude Clapp was an artist, and her husband, Frederick ("Tim") Mortimer Clapp (1879–1969), was the founding director of the Frick Collection in New York.

James ("Jim") Johnson Sweeney (1900–1986), an art critic, historian, museum curator, and director of the Guggenheim Museum and the Museum of Fine Arts in Houston, was a curator at the Museum of Modern Art in 1945.

Mary Wheelwright (1878–1958) was born in Boston and went to New Mexico in the early 1900s. She became interested in the Indian culture and founded the Wheelwright Museum of the American Indian in Santa Fe in 1937.

90. *James Johnson Sweeney*, 11 June 1945, GOK
The American Art Association was part of the Anderson Galleries, although it was located on 57th Street in New York.

Jim Sweeney organized a retrospective exhibition of O'Keeffe's work at the Museum of Modern Art, opening on 14 May 1946. Sweeney planned to write a monograph on O'Keeffe, and to assist him, O'Keeffe gave him scrapbooks of clippings and typed transcriptions of many of her letters. The monograph was never published.

The last page of this letter may be missing.

91. *James Johnson Sweeney*, 28 July 1945, GOK and the Museum of Modern Art
Andrew Droth did odd jobs for Stieglitz at An American Place.

See note 90 for a discussion of the "clippings" and "letters."

Daniel Catton Rich (1904–1976), director of The Art Institute of Chicago from 1943 to 1958, met O'Keeffe in New Mexico and in 1943 mounted her first museum retrospective at the Art Insti-

tute. For his research for the exhibition catalogue, O'Keeffe lent him several boxes of clippings and transcriptions of some letters.

92. *Caroline Fesler*, 24 December 1945, AAA

Caroline Fesler (1878–1960) began collecting art in the 1940s. Her first purchases were seventeenth-century Dutch landscapes, but she quickly broadened her scope to include works by O'Keeffe, Picasso, Van Gogh, and Braque. In 1943 she wrote an article on O'Keeffe's painting *Grey Hills*, which she and her husband James had recently given to the Indianapolis Museum of Art, *The Bulletin of the Art Association of Indianapolis* 30 (June 1943), 5–6.

O'Keeffe's annual exhibition at An American Place was in February and March 1946.

In 1945 O'Keeffe bought a house and three acres of land in Abiquiu, a small village sixteen miles south of Ghost Ranch. She spent the next several years restoring the house.

93. *Cady Wells*, early 1940s, AAA

Marian Anderson (b. 1902) was a highly acclaimed American contralto singer.

94. *Henry McBride*, early 1940s, YCAL

95. *Albert Barnes*, 22 June 1947, GOK and The Barnes Foundation, Merion, PA

Dr. Albert Barnes (1872–1951), inventor of Argyrol, collector of Cézanne, Matisse, Picasso, Renoir, and others, author of *The Art of Cézanne*, *The Art of Henri Matisse*, and *The French Primitives and Their Form*, met Stieglitz and O'Keeffe in the late 1920s.

In the spring of 1947, O'Keeffe and Jim Sweeney organized two simultaneous exhibitions for the Museum of Modern Art. The first consisted of paintings, prints, drawings, and photographs from Stieglitz's collection of works by leading American and European artists; the second was entirely of Stieglitz's own photographs. After opening in New York in the summer of 1947, the exhibition traveled to The Art Institute of Chicago.

Ever since the 1913 Armory Show Stieglitz had sought to put American art on the same level as European art. One way he tried to do this was to price works by American artists as high as those by Europeans. Thus in 1927 he claimed to have sold one Marin watercolor to Duncan Phillips for $6,000, when in fact he had consummated the sale by including two other watercolors as "gifts." Another reason for Stieglitz's high prices, especially for paintings by O'Keeffe, was that he hated to part with certain works.

Barnes' collection was (and still is) housed in his private museum in Merion, Pennsylvania. In 1930 he bought, but subsequently returned, two paintings by O'Keeffe.

96. *Margaret Kiskadden*, Fall 1947, GOK

Margaret ("Peggie") Bok Kiskadden (b. 1904) met O'Keeffe in New York in 1935 and the two quickly became close friends. For many summers thereafter, Kiskadden visited O'Keeffe at Ghost Ranch.

When Stieglitz died, he left O'Keeffe no instructions on how to dispose of his collection. They had discussed the matter, however, and although Stieglitz had at first wanted the entire collection to go to one museum, O'Keeffe convinced him that no institution would accept it (which at the time was probably true). Eventually O'Keeffe decided to split the collection among several American museums: the Boston Museum of Fine Arts, The Metropolitan Museum of Art, the Philadelphia Museum of Art, the National Gallery of Art, The Art Institute of Chicago, Fisk University, and the San Francisco Museum of Modern Art. She deposited his papers at the Beinecke Rare Book and Manu-

script Library, Yale University. It was a huge undertaking, one that consumed O'Keeffe and her assistant Doris Bry for several years.

"None of those 'sitters' at the Place did anything but make trouble": The precise meaning of this statement is unclear; however, Stieglitz's friends and family all had their own ideas about what he would have wanted done with his collection, and they did not hesitate to tell O'Keeffe.

Judith Anderson (b. 1898) was an Australian actress who in 1947 was starring in a highly acclaimed production of Euripides' *Medea*, adapted by Robinson Jeffers.

97. *Henry McBride*, 19 July 1948, YCAL

O'Keeffe was not being fair to McBride when she described his last review as "a specimen of a notice." In an article on her exhibition at the Museum of Modern Art, McBride wrote that she had achieved "stardom." He did note that her "road to fame" was "softened . . . by a romantic and lucky marriage," but he continued that anyone could be a sensation for a day whereas O'Keeffe's art had been of consistently high quality for over twenty years (*The Sun*, 18 May 1946, 9).

James Thrall Soby, "To the Ladies," *The Saturday Review* 29 (6 July 1946), 14, wrote, "throughout her work is a dual conception of nature: a nature as the painter herself; and nature as an unfailing companion with whom she converses in terms of wonderful precision, intimacy, and shades of meaning."

98. *Russell Vernon Hunter*, 30 October 1948, GOK

From 1948 to 1952 Hunter was the administrative director of the Dallas Museum of Art.

O'Keeffe did not give the Dallas Museum of Art a set of *Camera Work*.

Virginia was Hunter's wife; Kim was their son, born in 1937.

99. *Daniel Catton Rich*, 13 November 1949, AIC

O'Keeffe gave Fisk University in Nashville, Tennessee, a large part of Stieglitz's collection (see note 96). She chose Fisk both because it was in the South (whereas all the other institutions, with the exception of The Art Institute of Chicago, were in major east or west coast cities) and because Carl Van Vechten had recently given Fisk his own extensive collection of music, musical literature, and books on the fine arts. In 1949 O'Keeffe and Doris Bry organized an exhibition of the collection.

The New York architect may have been Charles Carsten Platt (d. 1967).

Gaston Lachaise (1882–1935), a sculptor, had an exhibition at M. Knoedler and Company Gallery in 1947.

The "very black girl" may have been Anita Bracy, shown in a photograph with O'Keeffe in "Fisk University Dedicates Alfred Stieglitz Collection," *The Crisis* 57 (March 1950), 158.

The last page of this letter, beginning with "From your letter I believe," does not appear to belong with the other pages. Not only is its subject different, but the pen and handwriting are unlike the rest of the letter. In this final page, O'Keeffe is referring to copy prints of Stieglitz's photographs, used to identify photographs in his estate.

100. *William Howard Schubart*, 6 April 1950, GOK

William Howard Schubart (1893–1953), the son of Stieglitz's sister Selma and her husband Louis Schubart, was an investment counselor and banker and managed O'Keeffe's financial affairs for several years. Despite the fact that she found his mother difficult, O'Keeffe enjoyed Howard's company and that of his wife, Dorothy.

101. *William Howard Schubart*, April–July 1950, GOK

102. *William Howard Schubart*, 28 July 1950, GOK

From 16 October to 25 November O'Keeffe exhibited her paintings at An American Place. Her show, the first since Stieglitz's death, included thirty-one works from 1946 to 1950 and was the last exhibition at An American Place.

In the years after Stieglitz's death O'Keeffe was busy settling his estate and did not paint very much. Possibly Schubart was concerned that she did not have enough material for a good show. It was not widely reviewed, although Henry McBride called it "the cleanest, neatest art show in New York," *Art News* 49 (November 1950), 56.

103. *William Howard Schubart*, 4 August 1950, GOK

104. *Margaret Kiskadden*, 3 September 1950, GOK

Angelino Ravagli was Frieda Lawrence's lover; on 31 October 1950 they were married.

Helmut DeTerra, an anthropologist, was married to the daughter of Leopold Stieglitz's (Alfred's brother) second wife, Amanda Hoff.

105. *William Howard Schubart*, 26 October 1950, GOK

O'Keeffe had recently returned from opening her last show at An American Place.

Emelia Cordova was O'Keeffe's cook for fifteen years.

106. *William Howard Schubart*, 23 December 1950, GOK

O'Keeffe painted several pictures of her Abiquiu patio, including *In the Patio I*, 1946, cat. 109; *Patio Door*, c. 1946, cat. 108; *My Last Door*, 1954, cat. 111; and *White Patio with Red Door*, 1960, cat. 110.

Jo Ferran, president of the Abiquiu grant at the time, built furniture.

At the winter solstice the Zuni Indians perform their house-blessing ceremony, the *shalako*. Giant masked figures, messengers of the gods, bless six new houses.

107. *William Howard Schubart*, 19 January 1951, GOK

When O'Keeffe closed An American Place in December 1950, she shipped to New Mexico many books, papers, and paintings she had been storing there.

Edith Halpert (1900–1970) studied at the Art Students League and was a dealer and the founder of the Downtown Gallery. After Stieglitz's death Halpert represented O'Keeffe, Marin, and Dove; after the closing of An American Place she also showed their work.

108. *William Howard Schubart*, 27 March 1951, GOK

Diego Rivera (1886–1957), the Mexican artist best known as a muralist, in 1929 began a series of frescoes on the history of Mexico in the National Palace, the Hospital de la Raza, the Palace of the Fine Arts, Del Prado Hotel, and the Ministry of Education. He drew his subjects from the Toltec, Mayan, and Aztec civilizations as well as from the Mexican revolution.

José Clemente Orozco (1883–1949), a Mexican modernist painter, was considered one of that country's top four artists, along with Rivera, Tamayo, and Siqueiros. Influenced by José Posada, Orozco painted many murals of the hungry and poor.

David Alfaro Siqueiros (1898?–1974) was a Mexican painter influenced by Rivera and Orozco who also used his art to further political revolution and reform in his country.

Miguel Covarrubias (1904–1957) was a Mexican caricaturist, painter, and author who worked for newspapers in New York and Mexico.

109. *Edith Halpert*, 10? September 1951, GOK

Noting that O'Keeffe's sales had dropped significantly in the last year, Halpert wrote to O'Keeffe on 1 August 1951, suggesting that she organize a "theme" show in November.

110. *Donald Gallup*, 31 March 1952, YCAL

Donald Gallup (b. 1913), curator emeritus of the Collection of American Literature, Beinecke Rare Book and Manuscript Library, Yale University, directed the organization of the Alfred Stieglitz Archive. He is also the author of *Ezra Pound Bibliography*, 1983, and *T. S. Eliot and Ezra Pound*, 1970, and editor of *The Flowers of Friendship*, 1953, *Eugene O'Neill, Inscriptions*, 1960, and *Eugene O'Neill Poems*, 1979.

The Rönnebeck material consisted of several letters, diaries, and sculpture by Arnold Rönnebeck (1885–1947), given to the Collection of American Literature by Louise Emerson Rönnebeck.

Witter Bynner (1881–1968) was a New Mexican poet, playwright, and translator of Chinese and American Indian poets.

Doris Bry was attempting to create a fund for Yale University to buy from O'Keeffe fifty Stieglitz photographs and five paintings (one each by O'Keeffe, Dove, Demuth, Hartley, and Marin); O'Keeffe subsequently gave the Stieglitz photographs to the Beinecke Library.

111. *William Howard Schubart*, 25 July 1952, GOK

O'Keeffe's reference to a "moon gilder" is not clear; however her praise of Schubart's business skill is obvious.

112. *William Howard Schubart*, 2 April 1953, GOK

113. *Anita Pollitzer*, 24 October 1955, YCAL

In preparation for a monograph on O'Keeffe, Anita Pollitzer asked her for the names and titles of some of her friends (2 October 1955, GOK).

Bo and Chia were O'Keeffe's chow dogs.

Jackie Suazo, a young man from Abiquiu, was befriended by O'Keeffe in the early 1950s.

Clyde C. Honnaker made frames for O'Keeffe for many years.

Betty Pilkington went to Europe with O'Keeffe in 1954.

Constance Friess was O'Keeffe's doctor in New York.

Robert and Maggie Johnson were the people O'Keeffe visited in New Jersey. She had met them at Ghost Ranch in the 1930s.

Richard Pritzlaff, a friend from Sapello, near Las Vegas, New Mexico, gave O'Keeffe her dogs.

114. *Caroline Fesler*, 5 February 1956, AAA

Dr. Ida Rolf (1896–1979), originally a biologist, invented "rolfing," a form of massage therapy designed to relieve tension through spinal alignment and posture control.

Alexander Schneider (b. 1908) is a Russian-born American violinist and conductor.

Alan Priest (1898–1969) was curator of Far Eastern art at the Metropolitan Museum of Art from 1928 until 1963. In 1951 he went to Japan and helped select works for a major exhibition in 1953 of Japanese painting and sculpture at The Metropolitan Museum of Art and the National Gallery of Art.

115. *John I.H. Baur*, 22 April 1957, GOK and The Whitney Museum of American Art

John I.H. Baur (b. 1909) was, at the time he wrote to O'Keeffe in 1958, curator at the Whitney Museum of American Art; subsequently he was associate director and then director.

This letter from O'Keeffe was quoted in part in Baur's book *Nature in Abstraction* (New York, 1958), 68.

116. *John I.H. Baur*, 8 May 1957, GOK and The Whitney Museum of American Art

117. *Frederick Mortimer Clapp*, 27 January 1961, YCAL

In 1959 O'Keeffe traveled around the world for three and a half months.

118. *Todd and Lucille Webb*, 22 December 1963, CCP

Todd (b. 1905) and Lucille Webb had been friends of O'Keeffe for many years. Todd Webb first met O'Keeffe in 1945 when, as a young photographer recently discharged from the Navy, he brought his photographs to An American Place to show Stieglitz.

119. *Adelyn Dohme Breeskin*, 26 November 1965, AAA

Adelyn Dohme Breeskin (1896–1986), curator at the Baltimore Museum of Art from 1930 to 1938, and acting director and director from 1942 to 1962, became curator of contemporary art at the National Collection of Fine Arts, now the National Museum of American Art, Smithsonian Institution, in 1962.

O'Keeffe's largest retrospective to date opened on 17 March 1966 at the Amon Carter Museum of Western Art.

Breeskin's show was titled "Roots of Abstract Art in America, 1910–1930" and included seven works by O'Keeffe.

Jim Sweeney's show was titled "The Heroic Years: Paris 1908–1914" and was open from 20 October to 8 December 1965.

120. *Aaron Copland*, 19 July 1968, Collection of Aaron Copland

Aaron Copland (b. 1900), the renowned American composer, was inducted into the American Academy of Arts and Letters in 1963, the same year that O'Keeffe was honored with a membership.

121. *Joseph H. Hirshhorn*, 29 November 1972, Collection of Olga Hirshhorn

Joseph H. Hirshhorn (1900–1981), the Russian-born American art collector, amassed large holdings of twentieth-century American art. These, reinforced with a broad sampling of modern European art, became the core of the Hirshhorn Museum and Sculpture Garden, Smithsonian Institution, in Washington, D.C.

O'Keeffe thought that Jim Sweeney, who by 1972 was retired from the Houston Museum of Fine Arts, should organize the opening exhibition at the Hirshhorn Museum in October 1974. Instead Abram Lerner (b. 1913), who had been curator of the Hirshhorn collection and would be its first director, selected and hung "The Hirshhorn Inaugural Exhibition of Its Permanent Collection."

Gordon Bunshaft was the architect of the Hirshhorn Museum. Olga was Joseph Hirshhorn's wife.

The original letter is typewritten.

122. *Derek C. Bok*, late June 1973, GOK

Derek C. Bok (b. 1930), president of Harvard University, is the son of O'Keeffe's old friend Margaret Bok Kiskadden; see note 96.

In June 1973 O'Keeffe, along with the anthropologist Margaret Mead and the pianist Rudolf Serkin, received an honorary degree from Harvard University.

The "two girls and the boy" are Bok's children, Hilary, Victoria, and Tomas. Sissela Ann Myrdal is his wife.

The "Chinese man speaking Latin" was Kimball Christopher Chen.

One of the commencement speakers denounced Watergate as "the bottom of a long decline in the integrity and competence of the American government"; *New York Times* 15 June 1973, 75.

The original letter is typewritten.

123. *Juan Hamilton*, 1976, Collection of Juan Hamilton

Juan Hamilton (b. 1945), a potter and sculptor, first met O'Keeffe in the fall of 1973 when he began doing odd jobs for her. The two quickly became friends. Hamilton helped her with the production of her 1976 book, *Georgia O'Keeffe*, and thereafter was her companion, assistant, and representative. Until her death in 1986 at the age of ninety-eight, Hamilton encouraged O'Keeffe to remain active and involved with her art, friends, and the world around her.

Ida Archuleta was O'Keeffe's housekeeper for several years.

124. *Todd Webb*, 20 November 1981, CCP

The "show" for the Museum of Modern Art was O'Keeffe's 1946 retrospective exhibition.

For many years Andrew Droth and Emil Zoler assisted Stieglitz in his galleries, packing and hanging paintings and running errands.

Richard Pritzlaff gave O'Keeffe her chow dogs.

The original letter is typewritten.

125. *Cady Wells*, undated, AAA

This letter may have been written during the Second World War while Wells was in the Army.

Chronology

1887
November 15: Born near Sun Prairie, Wisconsin, to Ida (Totto) and Francis O'Keeffe, the second of seven children.

1887–1903
Lives on farm near Sun Prairie, Wisconsin. Attends one-room grammar school near home; Sacred Heart Academy, Madison; and Madison High School. Lives with aunt after family moves to Williamsburg, Virginia, in 1902.

1903
Spring: Joins family in Williamsburg, Virginia.

Fall 1903–Spring 1905
Attends Chatham Episcopal Institute, Chatham, Virginia.

Fall 1905–Spring 1906
Attends School of The Art Institute of Chicago and studies with John Vanderpoel.

Summer 1906–Fall 1906
Long illness, typhoid fever, and recuperation in Williamsburg.

Fall 1907–Spring 1908
Attends Art Students League of New York, and studies with William M. Chase, F. Luis Mora, and Kenyon Cox. Visits Alfred Stieglitz's Little Galleries of the Photo-Secession at 291 Fifth Avenue, New York, and sees Auguste Rodin and Henri Matisse exhibitions in January and April 1908.

Summer 1908
Awarded Chase Still Life Scholarship to spend summer at the League Outdoor School at Lake George, New York.

Fall 1908–1910
Works as free-lance commercial artist in Chicago, drawing lace and embroidery for advertisements, until eyesight affected by measles. Returns to family home, now in Charlottesville, Virginia.

1911
Teaches art at Chatham Episcopal Institute.

1912
Summer: Attends drawing class at University of Virginia, Charlottesville, summer school, taught by Alon Bement, a student of Arthur Wesley Dow.

Fall 1912–Spring 1914
Works as art supervisor and teacher in Amarillo, Texas, public schools.

1913–1916
Summers: Teaches drawing at University of Virginia.

Fall 1914–Spring 1915
Attends Teachers College, Columbia University, New York, to study with Dow. Sees Georges Braque, Pablo Picasso, and John Marin exhibitions at 291.

Fall 1915–March 1916
Teaches art at Columbia College, Columbia, South Carolina.

1916
January: Anita Pollitzer shows O'Keeffe's drawings to Stieglitz at 291.
March–June: Receives an offer from West Texas State Normal College, Canyon, Texas, contingent on completion of additional courses with Dow; leaves Columbia College to study at Teachers College.
April: Sees Marsden Hartley exhibition at 291.
May: Death of mother.
23 May–5 July: First exhibition at 291, with Charles Duncan and Réné Lafferty.
September: Appointed head of art department at West Texas State Normal College, Canyon, Texas.
November–December: Included in a group show at 291 with Hartley, Marin, Stanton Macdonald-Wright, and Abraham Walkowitz.

1917
April: Stieglitz enters two works by O'Keeffe in Society of Independent Artists exhibition.
3 April–14 May: First one-person exhibition at 291, the last show before gallery closes in July.
25 May–1 June: Arrives in New York; Stieglitz rehangs exhibition for O'Keeffe and photographs her for first time.
Summer: Travels to Colorado and returns through New Mexico.

1918
February–May: Influenza; leave of absence from teaching position at West Texas State Normal College; lives in Waring and San Antonio.
June: Returns to New York at Stieglitz's prompting; resides at Stieglitz's niece's studio on 59th Street.
July: Stieglitz moves into the studio and photographs O'Keeffe often.
August: Resigns from West Texas State Normal College in order to stay in New York.
November: Death of father.

1919
March: Two works in exhibition of modern art at Young Women's Hebrew Association arranged by Stieglitz.

1920
Spring: Makes the first of many annual trips to York Beach, Maine.
December: With Stieglitz, moves to his brother's house on 30 East 65th Street, where they live until 1924.

1921

7–14? February: Stieglitz's photographs of O'Keeffe are shown in an exhibition of his work at The Anderson Galleries, New York.

16 April–15 May: Three works in exhibition of modern art at Pennsylvania Academy of the Fine Arts, Philadelphia.

1922

June: Two works in exhibition of modern art at the Municipal Building, Freehold, New Jersey, arranged by Stieglitz.

1923

29 January–10 February: First solo exhibition in six years of 100 works, organized by Stieglitz, at The Anderson Galleries.

1924

3–16 March: Joint exhibition with Stieglitz at The Anderson Galleries; O'Keeffe shows fifty-one pictures.

September: Stieglitz is divorced from his wife.

November: With Stieglitz, moves to apartment at 35 East 58th Street.

December: O'Keeffe and Stieglitz are married.

1925

March: In *Seven Americans* exhibition, organized by Stieglitz, at The Anderson Galleries, along with Marin, Hartley, Stieglitz, Arthur Dove, Charles Demuth, and Paul Strand.

November: O'Keeffe and Stieglitz move to Shelton Hotel (Lexington Avenue between 48th and 49th Streets).

December: Stieglitz opens The Intimate Gallery.

1926

February: O'Keeffe addresses the National Woman's Party Convention, Washington, D.C.

11 February–11 March: Exhibition at The Intimate Gallery.

1927

11 January–27 February: Exhibition at The Intimate Gallery.

June–September: Small retrospective at the Brooklyn Museum.

16 December–12 January: Arranges group exhibition at the Opportunity Gallery.

1928

9 January–27 February: Exhibition at The Intimate Gallery.

Spring: Travels to Bermuda, Maine, Lake George, and Wisconsin.

May: Six calla lily paintings by O'Keeffe shown at The Intimate Gallery.

September: Stieglitz has first severe angina attack.

1929

4 February–17 March: Exhibition at The Intimate Gallery.

April–August: Visits New Mexico, as guest of Mabel Dodge Luhan in Taos.

June: Stieglitz closes The Intimate Gallery.

November: Five paintings in group show at Museum of Modern Art, New York.

December: Stieglitz opens An American Place; five paintings by O'Keeffe included in *Paintings by Nineteen Living Americans*, the second exhibition at the newly opened Museum of Modern Art.

1930

7 February–17 March: Exhibition at An American Place.

June–September: Travels to New Mexico; stays with the Luhans in Taos.

1931

18 January–27 February: Exhibition at An American Place.

April–July: In New Mexico, rents a cottage on the H&M Ranch in Alcalde.

1931–1932

27 December–11 February: Exhibition at An American Place.

1932

April: Accepts commission to paint mural for Radio City Music Hall in New York.

3–31 May: Included in group exhibition of murals at the Museum of Modern Art.

May–September: To Lake George instead of New Mexico; travels to Canada.

November: Stops work on Radio City Music Hall mural project when technical problems arise; stops painting for over a year.

1933

7 January–22 February: Exhibition at An American Place.

February–March: Hospitalized in New York.

March–May: Recuperates in Bermuda.

May: Stays at Lake George for rest of year.

1934

17 January–9 February: Exhibition with Marin at the Society of Arts and Crafts, Detroit.

29 January–17 March: Exhibition at An American Place.

March–May: Travels to Bermuda.

June–September: To New Mexico for the first time in three years; stays at H&M Ranch in Alcalde, then at Ghost Ranch, sixteen miles northwest of Abiquiu.

1935

27 January–11 March: Exhibition of paintings at An American Place.

June–November: To New Mexico; stays at Ghost Ranch.

1936

7 January–27 February: Exhibition at An American Place.

Spring: Commission for flower painting for Elizabeth Arden's New York salon.

June–September: Stays at Ghost Ranch.

October: With Stieglitz, moves to penthouse apartment at 405 East 54th Street.

27 November–31 December: Exhibition with Demuth, Dove, Hartley, Marin, and Rebecca Strand at An American Place.

1937

27 January–14 February: Included in exhibition, *Five Painters*, at University of Minnesota gallery.

5 February–17 March: Exhibition at An American Place.

July–December: To New Mexico; first of many summers at adobe house three miles from Ghost Ranch headquarters; travels to western New Mexico, Arizona, and Colorado.

27 October–27 December: Included in large group show, *Beginnings & Landmarks–291–1905–1917*, at An American Place.

Winter: Stieglitz stops taking photographs.

1937-1938
27 December–11 February: Exhibition at An American Place.

1938
April: Stieglitz has heart attack, which is followed by pneumonia.
May: Honorary Doctor of Fine Arts degree from College of William and Mary, Williamsburg.
August–November: Stays at Ghost Ranch; travels to Yosemite.

1939
22 January–17 March: Exhibition at An American Place.
February–April: Paints in Hawaii, as guest of Dole Pineapple Company.
April: Selected one of twelve most outstanding women of the past fifty years by the New York World's Fair Tomorrow Committee; painting, *Sunset, Long Island,* chosen to represent New York State at the world's fair.
April–July: Returns to New York and becomes ill; stops painting until October.
August–September: Stays at Lake George with Stieglitz; does not go to New Mexico.

1940
1 ? February–17 March: Exhibition at An American Place. Travels to Nassau.
June–December: At Ghost Ranch, stays at the adobe house that she will buy in October.
17 October–11 December: Exhibition with Marin and Dove at An American Place.

1941
27 January–11 March: Exhibition at An American Place.
May–November: In New Mexico.
17 October–27 November: Exhibition with Dove, Marin, Stieglitz, and Picasso at An American Place.

1942
2 February–17 March: Exhibition at An American Place.
May: Honorary Doctor of Letters degree from University of Wisconsin.
October: With Stieglitz, moves to smaller apartment at 59 East 54th Street.

1943
21 January–22 February: First large retrospective at The Art Institute of Chicago, with catalogue by Daniel Catton Rich.
27 March–22 May: Exhibition at An American Place.
April–October: In New Mexico.

1944
11 January–11 March: Exhibition at An American Place.
April–October: In New Mexico.
1 July–1 November: Exhibition of Stieglitz's collection of modern American and European art and photography at Philadelphia Museum of Art, organized by O'Keeffe, Carl Zigrosser, and Henry Clifford.

1945
22 January–22 March: Exhibition at An American Place.
May–October: In New Mexico; buys abandoned house on three acres of land in Abiquiu; with Maria Chabot, spends next three years remodeling the house.

1946
4 February–27 March: Exhibition at An American Place.
14 May–25 August: Retrospective at the Museum of Modern Art, organized by James Johnson Sweeney.
June–July: Stays in Abiquiu.
10 July: Flies back to New York when Stieglitz has massive stroke and is hospitalized.
13 July: Death of Stieglitz.
Autumn: Stays in Abiquiu.

1946-1949
Organizes and disperses Stieglitz's large art collection; spends most of each year in New York and summers in New Mexico; paints little.

1947
10 June–31 August: Exhibition of Stieglitz's collection, which O'Keeffe helped organize, at the Museum of Modern Art; show later travels to The Art Institute of Chicago in 1948.

1949
Spring: Moves permanently to New Mexico; lives in Abiquiu house in winter and spring, and at Ghost Ranch during summer and autumn. Elected to National Institute of Arts and Letters.
Fall: To Fisk University, Nashville, Tennessee, to install an exhibition of its Alfred Stieglitz Collection.

1950
16 October–25 November: Exhibition at An American Place, the last show held at An American Place before the gallery closes; Edith Gregor Halpert of The Downtown Gallery, New York, becomes her dealer.

1951
February: Travels to Mexico, where she sees Diego Rivera and Miguel Covarrubias.

1952
19 February–8 March: Exhibits pastels from 1915 to 1945 at Edith Halpert's Downtown Gallery.
June: Honorary Doctor of Letters degree from Mount Holyoke College, South Hadley, Massachusetts.
November: Honorary Doctor of Letters degree from Mills College, Oakland, California.

1953
1–22 February: Exhibition at Dallas Museum of Art, which travels to Mayo Hill Galleries, Delray Beach, Florida.
Spring: First trip to Europe; travels to France and Spain.
22 September–17 October: Exhibition at The Downtown Gallery.

1954
Returns to Spain for three months.

1955
29 March–23 April: Exhibition at The Downtown Gallery.

1956
Spring: Spends three months in Peru.

1957
2–30 March: Exhibition at The Downtown Gallery.

1958

25 February–22 March: *Watercolors, 1916–17* exhibition at The Downtown Gallery.

1959

Three-and-a-half-month trip around the world to the Far East, Southeast Asia, India, Middle East, and Italy.

1960

4 October–4 December: Retrospective exhibition at the Worcester Art Museum.

Autumn: Six-week trip to Japan, Formosa, Philippines, Hong Kong, Southeast Asia, and Pacific Islands.

1961

11 April–6 May: Last exhibition of her work at The Downtown Gallery.

1962

December: Medal from the American Academy of Arts and Letters.

1963

Receives the Creative Arts Award, Brandeis University; ends association with The Downtown Gallery; Doris Bry becomes her agent; travels to Greece, Egypt, and Near East.

1964

February: Honorary Doctor of Fine Arts degree, University of New Mexico, Albuquerque.

1965

Paints her largest work, *Sky Above Clouds IV* (cat. 120), eight by twenty-four feet.

1966

17 March–8 May: Retrospective exhibition at the Amon Carter Museum of Western Art, Fort Worth, Texas, which travels to the Museum of Fine Arts, Houston, Texas.

Wisconsin Governor's Award for Creativity in the Arts; travels to England and Austria.

1967

June: Honorary Doctor of Fine Arts degree, The Art Institute of Chicago.

1969

Distinguished Service Citation in the Arts from the Wisconsin Academy of Sciences, Arts and Letters; named Benjamin Franklin Fellow by the Royal Society for the Encouragement of Arts, Manufactures, and Commerce, London. Travels to Austria.

1970

May: National Institute of Arts and Letters gold medal for painting.

8 October–29 November: Retrospective at the Whitney Museum of American Art, New York, which travels to The Art Institute of Chicago and San Francisco Museum of Art.

1971

June: Honorary Doctor of Humane Letters degree, Columbia University, New York; Honorary Doctor of Fine Arts degree, Brown University, Providence, Rhode Island.

October: M. Carey Thomas Award from Bryn Mawr College; citation for distinguished contributions to the visual arts from the National Association of Schools of Art.

Loses central vision, retaining only peripheral sight; stops painting.

1972

May: Honorary Doctor of Fine Arts degree, Minneapolis College of Art and Design.

August: Edward MacDowell Medal from the MacDowell Colony in New Hampshire.

October: Certificate for an Honorary Membership to the American Watercolor Society.

1973

May: Skowhegan School of Painting and Sculpture: Medal for Painting, Certificate, and Gold Medal.

June: Honorary Doctor of Arts degree from Harvard University.

Fall: Meets Juan Hamilton, a young potter, who helps her make hand-built pots. He is her assistant and constant traveling companion thereafter.

1974

January: To Morocco.

October: First annual Governor's Award from Bruce King of New Mexico.

Some Memories of Drawings, a portfolio of drawings with short texts by O'Keeffe, published.

1975

Exhibition at Governor's Gallery, Santa Fe. Begins to work again.

1976

January: To Antigua.

Georgia O'Keeffe, a book with 108 reproductions and texts by the artist, published.

1977

January: Medal of Freedom Award from President Gerald R. Ford.

May: Honorary Doctor of Visual Arts degree, College of Santa Fe.

Perry Miller Adato film about O'Keeffe is shown on television.

1978–1979

16 November–14 January: Exhibition of photographs, *Georgia O'Keeffe: A Portrait by Alfred Stieglitz*, at The Metropolitan Museum of Art, New York, with catalogue introduction by O'Keeffe.

1979

June: To Pacific coast of Costa Rica and Guatemala.

1982

May: To Hawaii.

1983

November: To Pacific coast of Costa Rica.

1984

Moves to Santa Fe where she lives with Juan Hamilton and his family.

1985

April: National Medal of Arts from President Ronald W. Reagan.

1986

6 March: Death in Santa Fe.

Bibliography

1916

"New York Art Exhibitions and Gallery News," *Christian Science Monitor* (2 June 1916), 10

"Georgia O'Keeffe—C. Duncan—Réné Lafferty," *Camera Work* 47 (October 1916), 12–13

1917

"New York Art Exhibition and Gallery Notes: Esoteric Art at '291,' " *Christian Science Monitor* (4 May 1917), 10

William Murrell Fisher, "The Georgia O'Keeffe Drawings and Paintings at '291,' " *Camera Work* 49–50 (June 1917), 5

"Exhibitions at '291'—Season 1916–1917," *Camera Work* 49–50 (June 1917), 33

1921

Marsden Hartley, "Some Women Artists in Modern Painting," *Adventures in the Arts* (New York, 1921, reprinted New York, 1972), 112–119

Paul Rosenfeld, "American Painting," *The Dial* 71 (December 1921), 649–670

1922

"The Female of the Species Achieves a New Deadliness," *Vanity Fair* 18 (July 1922), 50

Paul Rosenfeld, "The Paintings of Georgia O'Keeffe," *Vanity Fair* 19 (October 1922), 56, 112, 114

Georgia O'Keeffe, "To MSS. and its 33 subscribers and others who read and don't subscribe!" letter to the editor, *Manuscripts* 4 (December 1922), 17–18

"I Can't Sing, So I Paint! Says Ultra Realistic Artist, Art Is Not Photography—It Is Expression of Inner Life! Miss Georgia O'Keeffe Explains Subjective Aspect of Her Work," *The New York Sun* (5 December 1922), 22

1923

Alfred Stieglitz Presents One Hundred Pictures: Oils, Water-Colors, Pastels, Drawings by Georgia O'Keeffe, American [exh. brochure, The Anderson Galleries] (New York, 29 January–10 February 1923). Includes statement by Georgia O'Keeffe. Photocopy in NGA, Gallery Archives, rg 17b

Alexander Brook, "February Exhibitions: Georgia O'Keefe [sic]," *The Arts* 3 (February 1923), 130, 132

Allan Burroughs, *The New York Sun* (3 February 1923), 9

Henry McBride, "Curious Responses to Work of Miss O'Keefe [sic] on Others," *The New York Herald* (4 February 1923), 7

Henry Tyrrell, "High Tide in Exhibitions Piles Up Shining Things of Art," *The World* [New York] (4 February 1923), metropolitan section, 9

Henry Tyrrell, "Exhibitions and Other Things," *The World* [New York] (11 February 1923), metropolitan section, 11. Includes a letter from Paul Strand about Georgia O'Keeffe

Herbert J. Seligmann, "Georgia O'Keeffe, American," *Manuscripts* 5 (March 1923), 10

1924

Sheldon Cheney, *A Primer of Modern Art* (New York, 1924)

Paul Rosenfeld, "Georgia O'Keeffe," *Port of New York: Essays on Fourteen American Moderns* (New York, 1924), 198–210

Alfred Stieglitz Presents Fifty-One Recent Pictures: Oils, Water-Colors, Pastels, Drawings by Georgia O'Keeffe, American [exh. checklist, The Anderson Galleries] (New York, 3–16 March 1924). Includes statement by Georgia O'Keeffe. Photocopy in NGA, Gallery Archives, rg 17b

Helen Appleton Read, "Georgia O'Keefe [sic] Again Introduced by Stieglitz at the Anderson Galleries," *The Brooklyn Daily Eagle* (9 March 1924), 2B

Henry McBride, "Stieglitz, Teacher Artist; Pamela Bianco's New Work: Stieglitz, O'Keefe [sic] Show at Anderson Galleries," *The New York Herald* (9 March 1924), 13

Forbes Watson, "Stieglitz–O'Keeffe Joint Exhibition," *The World* [New York] (9 March 1924)

Virgil Barker, *The Arts* 5 (April 1924), 219–223

Helen Appleton Read, "Georgia O'Keeffe—Woman Artist Whose Art Is Sincerely Feminine," *The Brooklyn Sunday Eagle Magazine* (6 April 1924), 4

"We Nominate for the Hall of Fame," *Vanity Fair* 49 (July 1924), 49

Paul Strand, "Georgia O'Keeffe," *Playboy* 9 (July 1924), 16–20

1925

Alfred Stieglitz Presents Seven Americans: 159 Paintings, Photographs & Things, Recent & Never Before Publicly Shown by Arthur G. Dove, Marsden Hartley, John Marin, Charles Demuth, Paul Strand, Georgia O'Keeffe, Alfred Stieglitz [exh. cat., The Anderson Galleries] (New York, 9–28 March 1925). Photocopy in NGA, Gallery Archives, rg 17b

Margaret Breuning, "Seven Americans," *The New York Evening Post* (14 March 1925), section 5, page 11

Henry McBride, "The Stieglitz Group at Anderson's," *The New York Evening Sun* (14 March 1925), 13

Royal Cortissoz, "A Spring Interlude in the World of Art Shows: '291'—Mr. Alfred Stieglitz and His Services to Art," *New York Herald Tribune* (15 March 1925), section 4, page 12

Helen Appleton Read, "Alfred Stieglitz Presents 7 Americans," *The Brooklyn Daily Eagle* (15 March 1925), 2B

Forbes Watson, "Seven American Artists Sponsored by Stieglitz," *The World* [New York] (15 March 1925), 5M

Edmund Wilson, "The Stieglitz Exhibition," *The New Republic* 42 (18 March 1925), 97–98

Helen Appleton Read, "Seven Americans," *The Arts* 7 (April 1925), 229, 231

Glen Mullin, "Alfred Stieglitz Presents Seven Americans," *The Nation* 120 (20 May 1925), 577–578

1926

Katherine S. Dreier, *Modern Art* (New York, 1926, reprinted in *Selected Publications: Société Anonyme*, New York, 1972)

Waldo David Frank, *Time Exposures by Search Light* (New York, 1926), 31–35

Henry McBride, "New Gallery for Modern Art: Valentine Dudensing Shows Paintings by Foujita—O'Keefe [sic] and Mezquita Exhibitions," *The New York Sun* (13 February 1926), 7

Murdock Pemberton, "The Art Galleries," *The New Yorker* 2 (20 February 1926), 40

Helen Appleton Read, "Georgia O'Keefe [sic]," *Brooklyn Daily Eagle* (21 February 1926), E7

Blanche C. Matthias, "Georgia O'Keeffe and the Intimate Gallery—Stieglitz Showing Seven Americans," *The Chicago Evening Post Magazine of the Art World* (2 March 1926), 1, 14

Murdock Pemberton, "The Art Galleries," *The New Yorker* 2 (13 March 1926), 36–37

Louis Kalonyme, "Art's Spring Flowers," *Arts and Decorations* 24 (April 1926), 46–47

Henry McBride, "Modern Art," *The Dial* 80 (May 1926), 436–439

1927

Georgia O'Keeffe Paintings, 1926 [exh. checklist, The Intimate Gallery] (New York, 11 January–27 February 1927). Photocopy in NGA, Gallery Archives, rg 17b

Henry McBride, "Georgia O'Keeefe's [sic] Work Shown," *The New York Sun* (15 January 1927), 22B

L. K., "In New York Galleries: Georgia O'Keeffe's Arresting Pictures," *The New York Times* (16 January 1927), section 7, page 10

Helen Appleton Read, "Georgia O'Keefe [sic]," *Brooklyn Daily Eagle* (16 January 1927), 6E

Murdock Pemberton, "The Art Galleries," *The New Yorker* 2 (22 January 1927), 62–65

Louis Kalonyme, "Scaling the Peak of the Art Season," *Arts and Decorations* 26 (March 1927), 57, 88, 93

Henry McBride, "Modern Art," *The Dial* 82 (March 1927), 261–263

Lewis Mumford, "O'Keefe [sic] and Matisse," *The New Republic* 50 (2 March 1927), 41–42

Dorothy Adlow, "Georgia O'Keeffe," *Christian Science Monitor* (20 June 1927), 11

Frances O'Brien, "Americans We Like: Georgia O'Keeffe," *The Nation* 125 (12 October 1927), 361–362

1928

O'Keeffe Exhibition [exh. checklist, The Intimate Gallery] (New York, 9 January–27 February 1928)

Louis Kalonyme, "Georgia O'Keeffe: A Woman in Painting," *Creative Art* 2 (January 1928), 35–40

Henry McBride, "Georgia O'Keefe's [sic] Recent Work," *The New York Sun* (14 January 1928), 8

Murdock Pemberton, "The Art Galleries," *The New Yorker* 3 (21 January 1928), 44–46

Edward Alden Jewell, "Georgia O'Keeffe, Mystic," *The New York Times* (22 January 1928), section 10, page 12

Marya Mannes, "Gallery Notes: Intimate Gallery," *Creative Art* 2 (February 1928), 7

"Art," *Time* 11 (20 February 1928), 21–22

"Artist Who Paints for Love Gets $25,000 for 6 Panels," *The New York Times* (16 April 1928), 23

Alfred Stieglitz, "O'Keefe [sic] and the Lilies," letter to the editor, *The Art News* 26 (21 April 1928), 10

B. Vladimir Berman, "She Painted the Lily and Got $25,000 and Fame for Doing It!" *New York Evening Graphic Magazine Section* (12 May 1928), 3M

Lillian Sabine, "Record Price for Living Artist," *The Brooklyn Eagle Sunday Magazine* (27 May 1928), 11

Helen Appleton Read, "The Feminine View-Point in Contemporary Art," *Vogue* 71 (15 June 1928), 76–77, 96

"We Nominate for the Hall of Fame," *Vanity Fair* 30 (August 1928), 63

1929

Georgia O'Keeffe Paintings, 1928 [exh. checklist, The Intimate Gallery] (New York, 4 February–17 March 1929). Photocopy in NGA, Gallery Archives, rg 17b

Henry McBride, "Paintings by Georgia O'Keefe [sic]," *The New York Sun* (9 February 1929), 7

Murdock Pemberton, "The Art Galleries," *The New Yorker* 4 (9 February 1929), 73–74

Edward Alden Jewell, "Lost Chord Retrieved," *The New York Times* (24 February 1929), section 10, page 18

Dorothy Lefferts Moore, *The Arts* 15 (March 1929), 185–187

Murdock Pemberton, "Mostly American," *Creative Art* 4 (March 1929), l–lii

Robert M. Coates, "Profiles: Abstraction-Flowers," *The New Yorker* 5 (6 July 1929), 21–24

1930

Clarence J. Bulliet, *Apples and Madonnas: Emotional Expression in Modern Art* (New York, 1930)

Samuel M. Kootz, *Modern American Painters* (New York, 1930)

Arthur Strawn, "O'Keeffe," *Outlook* 154 (22 January 1930), 154

Georgia O'Keeffe: 27 New Paintings, New Mexico, New York, Lake George, Etc. [exh. checklist, An American Place] (New York, 7 February–17 March 1930). Photocopy in NGA, Gallery Archives, rg 17b

Henry McBride, "The Sign of the Cross," *The New York Sun* (8 February 1930), 8

Murdock Pemberton, "The Art Galleries," *The New Yorker* 5 (15 February 1930), 47–50

"Georgia O'Keeffe: An American Place," *The Art News* 28 (22 February 1930), 10

Ralph Flint, "Around the Galleries," *Creative Art* 6 (March 1930), supp. 61

Dorothy Lefferts Moore, "In the Galleries: An American Place," *The Arts* 16 (March 1930), 495

Marty Mann, "Exhibitions," *International Studio* 95 (March 1930), 76–77

Gladys Oaks, "Radical Writer and Woman Artist Clash on Propaganda and Its Uses," *The World* [New York] (16 March 1930), women's section, 1, 3

1931

Thomas Craven, *Men of Art* (New York, 1931)

Lewis Mumford, *The Brown Decades* (New York, 1931)

Duncan Phillips, *The Artist Sees Differently* (Washington, D.C., 1931)

Harold Rugg, *Culture and Education in America* (New York, 1931)

Georgia O'Keeffe: Recent Paintings, New Mexico, New York, Etc.—Etc. [exh. checklist, An American Place] (New York, 18 January–27 February 1931). Photocopy in NGA, Gallery Archives, rg 17b

"Exhibitions in New York—Georgia O'Keeffe—An American Place," *The Art News* 29 (24 January 1931), 9

Margaret Breuning, "Georgia O'Keeffe," *New York Evening Post* (24 January 1931), 6D

Henry McBride, "The Georgia O'Keefe [sic] Exhibition," *The New York Sun* (24 January 1931), 10

H. E. Schnakenberg, "Georgia O'Keefe [sic]," *The Arts* 17 (March 1931), 426–427

Paul Rosenfeld, "Art: After the O'Keeffe Show," *The Nation* 132 (8 April 1931), 388–389

Mabel Dodge Luhan, "Georgia O'Keeffe in Taos," *Creative Art* 8 (June 1931), 406–410

"The Paintings of Georgia O'Keeffe in Taos," *The Studio* 101 (June 1931), 438–440

Edward Alden Jewell, "Art: Georgia O'Keeffe Shows Work," *The New York Times* (29 December 1931), 26

Ishbel Ross, "Bones of Desert Blaze Art Trail of Miss O'Keeffe," *New York Herald Tribune* (29 December 1931), 3

1932

"Exhibitions in New York: Georgia O'Keeffe, An American Place," *The Art News* 30 (2 January 1932), 9

Henry McBride, "Skeletons on the Plain," *The New York Sun* (2 January 1932), 8

Elizabeth McCausland, "Georgia O'Keeffe Exhibits Skulls and Roses of 1931," *The Springfield Sunday Union and Republican* (10 January 1932), 6E

Inez Cunningham, "Miss O'Keeffe a Victim of Her Myths," *Chicago Evening Post* (19 January 1932), art section, 1

Frank Crowninshield, "A series of American artists—in color, No. 1 Georgia O'Keeffe," *Vanity Fair* 38 (April 1932), 40–41

"Two O'Keeffes Acquired by the Whitney Museum," *The Art News* 30 (9 April 1932), 7

Elizabeth McCausland, "Murals and Photo–Murals at Museum of Modern Art's New Home," *The Springfield Sunday Union and Republican* (1 May 1932), 6E

Vernon Hunter, "A Note on Georgia O'Keeffe," *Contemporary Arts of the South and Southwest* 1 (November–December 1932), 7

1933

Georgia O'Keeffe: Paintings—New & Some Old [exh. checklist, An American Place] (New York, 7 January–22 February or 15 March 1933). Photocopy in NGA, Gallery Archives, rg 17b

Edward Alden Jewell, "Georgia O'Keefe's [sic] Paintings Offer Five–Year Retrospect at An American Place," *The New York Times* (13 January 1933), 13

Ralph Flint, "1933 O'Keeffe Show a Fine Revelation of Varied Powers," *The Art News* 31 (14 January 1933), 9

Henry McBride, "Georgia O'Keeffe's Exhibition," *The New York Sun* (14 January 1933), 10

Lewis Mumford, "The Art Galleries," *The New Yorker* 8 (21 January 1933), 48–49

Elizabeth McCausland, "O'Keeffe Exhibition Shows Progress from 1926 to 1932," *The Springfield Sunday Union and Republican* (22 January 1933), 6E

Margaretta M. Salinger, "Gallery Notes—Georgia O'Keefe [sic]—An American Place," *Parnassus* 5 (February 1933), 22

Louis Kalonyme, "The Arts in New York," *Arts and Decorations* 38 (March 1933), 44–45, 59–60

Edwina Spencer, "Around the Galleries," *Creative Art* 12 (April 1933), 315

1934

Thomas Craven, *Modern Art: The Men, The Movements, The Meaning* (New York, 1934)

Waldo Frank, Lewis Mumford, Dorothy Norman, Paul Rosenfeld, and Harold Rugg, *America & Alfred Stieglitz: A Collective Portrait* (New York, 1934)

Georgia O'Keeffe at "An American Place," 44 Selected Paintings 1915–1927 [exh. brochure, An American Place] (New York 29 January–17 March or 27 March 1934). Photocopy in NGA, Gallery Archives, rg 17b

Edward Alden Jewell, "Georgia O'Keeffe in an Art Review," *The New York Times* (2 February 1934), 15

Lewis Mumford, "The Art Galleries: Sacred and Profane," *The New Yorker* 9 (10 February 1934), 47–49

Elizabeth McCausland, "O'Keeffe Retrospective Shows Artist's Growth," *The Springfield Sunday Union and Republican* (18 February 1934), 6E

"Life is Painting for Artist Who Reveals Woman's Soul on Canvas," *Newark Evening News* (21 March 1934), 18

"Metropolitan Buys 3 Works in City Art Show," *The New York Herald Tribune* (26 March 1934), 17

William Schack, "On Abstract Painting," *Magazine of Art* 27 (September 1934), 470–475

1935

"Georgia O'Keeffe is 'Practical,' Too," *The Springfield Daily Republican* (16 January 1935), 3

Georgia O'Keeffe: Exhibition of Paintings (1919–1934) [exh. checklist, An American Place] (New York, 27 January–11 March 1935). Photocopy in NGA, Gallery Archives, rg 17b

Henry McBride, "Attractions in the Galleries," *The New York Sun* (2 February 1935), 33

E. C. Sherburne, "Georgia O'Keeffe's Paintings," *Christian Science Monitor* (2 February 1935), 6

"16 Years of Georgia O'Keeffe's Art Shown," *The Art Digest* 9 (15 February 1935), 17

Elizabeth McCausland, "Georgia O'Keeffe from 1919 to 1934," *The Springfield Sunday Union and Republican* (17 February 1935), 6E

Laurie Eglington, "O'Keeffe—An American Place," *The Art News* 33 (23 February 1935), 11

James W. Lane, *Parnassus* 7 (March 1935), 23

"Georgia O'Keeffe Canvas Bought by Fine Arts Museum," *The Springfield Daily Republican* (27 March 1935), 14

Elizabeth McCausland, "Georgia O'Keeffe's Flower Paintings," *The Springfield Sunday Union and Republican* (28 April 1935), 6E

1936

James W. Lane, *Masters in Modern Art* (Boston, 1936)

Georgia O'Keeffe: Exhibition of Recent Paintings, 1935 [exh. checklist, An American Place] (New York, 7 January–27 February 1936). Photocopy in NGA, Gallery Archives, rg 17b

Edward Alden Jewell, "Georgia O'Keeffe Gives an Art Show," *The New York Times* (7 January 1936), 17

Jerome Klein, "O'Keeffe Works Highly Spirited," *New York Post* (11 January 1936), 4

Henry McBride, "Paintings by Georgia O'Keeffe," *The New York Sun* (11 January 1936), 28

Royal Cortissoz, "From Old Venetians to Various Moderns," *New York Herald Tribune* (12 January 1936), 10

Edward Alden Jewell, "Three One-Man Shows," *The New York Times* (12 January 1936), section 9, page 9

Elizabeth McCausland, "A Painter's Development: Georgia O'Keeffe's Annual Exhibition," *The Springfield Sunday Union and Republican* (12 January 1936), 6E

E. C. Sherburne, "M. Rothenstein—G. O'Keeffe," *Christian Science Monitor* (14 January 1936), 10

Lewis Mumford, "The Art Galleries: Autobiographies in Paint," *The New Yorker* 11 (18 January 1936), 29, 30

E. M. Benson, "Exhibition Reviews: New Paintings by O'Keeffe at An American Place," *Magazine of Art* 29 (February 1936), 112

1937

The Work of Georgia O'Keeffe: A Portfolio of Twelve Paintings (New York, 1937)

Georgia O'Keeffe: New Paintings [exh. checklist, An American Place] (New York, 5 February–17 March 1937). Photocopy in NGA, Gallery Archives, rg 17b

Edward Alden Jewell, "Georgia O'Keeffe Shows New Work," *The New York Times* (6 February 1937), 7

Allan Keller, "Animal Skulls Fascinate Georgia O'Keefe [sic], but She Can't Explain It—Not in Words," *New York World-Telegram* (13 February 1937), 2A

"Two Original Artists: Recent Works by Henry Mattson and Georgia O'Keeffe," *New York Herald Tribune* (14 February 1937), section 7, page 8

Edward Alden Jewell, "South by Southwest," *The New York Times* (14 February 1937), section 10, page 9

Elizabeth McCausland, "New York Realists at Whitney Museum," *The Springfield Sunday Union and Republican* (14 February 1937), 6E

Emily Genauer, "Two Schools Meet in Her Art," *New York World-Telegram* (16 February 1937), 14

Jerome Klein, "The Critic Takes a Glance Around the Galleries," *New York Post* (20 February 1937), 24

"Skulls & Feathers," *Time* 29 (22 February 1937), 50, 52

M. D., "New Exhibitions of the Week: O'Keeffe's Latest Decorative Paintings," *The Art News* 25 (27 February 1937), 13

Margaret Breuning, "Current Exhibitions," *Parnassus* 9 (March 1937), 34–35

William M. Milliken, "White Flower by Georgia O'Keeffe," *The Bulletin of the Cleveland Museum of Art* 4 (April 1937), 50–53

Edward Alden Jewell, "An O'Keeffe Portfolio," *The New York Times* (31 October 1937), 10

Beginnings and Landmarks: "291" 1905–1917 [exh. cat., An American Place] (27 October–27 December 1937)

Margaret Breuning, "Art in New York," *Parnassus* 9 (December 1937), 24

Georgia O'Keeffe: Catalogue of the 14th Annual Exhibition of Paintings with Some Recent O'Keeffe Letters [exh. cat., An American Place] (27 December 1937–11 February 1938). Includes eight letters written in 1937 by Georgia O'Keeffe to Alfred Stieglitz. Photocopy in NGA, Gallery Archives, rg 17b

1938

Elizabeth McCausland, "Georgia O'Keeffe Shows Her Latest Paintings," *The Springfield Sunday Union and Republican* (2 January 1938), 6E

Alice Graeme, "Miss O'Keeffe's Desert Scenes Evoke Careful, Critical Study," *The Washington Post* (16 January 1938), section 6, page 5

Robert S. Frankel, "A Show of the Most Recent Paintings of Georgia O'Keeffe," *The Art News* 36 (5 February 1938), 15

"Georgia O'Keeffe Turns Dead Bones to Live Art," *Life* 4 (14 February 1938), 28–30

"Alfred Stieglitz Made Georgia O'Keeffe Famous," *Life* 4 (14 February 1938), 31

James W. Lane, "Notes from New York," *Apollo* 27 (April 1938), 209

Helen Appleton Read, "American Paintings of Today: *Morning Glory* Painted by Georgia O'Keeffe," *Woman's Home Companion* 55 (September 1938), 26–27

1939

Georgia O'Keeffe: Exhibition of Oils and Pastels [exh. checklist, An American Place] (New York, 22 January–17 March 1939). Includes statement by Georgia O'Keeffe. Photocopy in NGA, Gallery Archives, rg 17b

Henry McBride, "Sees Mountains Red: Georgia O'Keeffe Accused of Misdemeanor in the Southwest," *The New York Sun* (28 January 1939), 9

Robert M. Coates, "The Art Galleries," *The New Yorker* 14 (4 February 1939), 36–38

M. D., "New Exhibitions of the Week," *The Art News* 37 (11 February 1939), 11

1940

"Advertising Art Lures Brush of Miss O'Keeffe," *New York Herald Tribune* (31 January 1940), 10

Georgia O'Keeffe: Exhibition of Oils and Pastels [exh. checklist, An American Place] (New York, 1 or 3 February–27 March 1940). Includes statement by Georgia O'Keeffe. Photocopy in NGA, Gallery Archives, rg 17b

Henry McBride, "Georgia O'Keefe's [sic] Hawaii, She Annexes the Islands with a Glorified Fishhook," *The New York Sun* (10 February 1940), 10

"Pineapple for Papaya," *Time* 35 (12 February 1940), 42

James W. Lane, "The Flora of Hawaii by Georgia O'Keeffe," *The Art News* 38 (24 February 1940), 11

Elizabeth McCausland, "Georgia O'Keeffe," *Parnassus* 12 (March 1940), 42

"The I.B.M. Shows," *The Art Digest* 14 (1 May 1940), 13

"Art from All U.S. to be in Two Fairs," *The New York Times* (9 May 1940), 21

Contemporary Art of the United States [exh. checklist, International Business Machines Corporation, Gallery of Science and Art, World's Fair 1940] (New York, 1940)

"I.B.M. Stages Impressive American Art Show at New York Fair," *The Art Digest* 14 (1 June 1940), 9–10

Some Marins, Some O'Keeffes, Some Doves [exh. checklist, An American Place] (17 October–11 December 1940). Photocopy in NGA, Gallery Archives, rg 17b

Edward Alden Jewell, "Autumn Art Show at American Place," *The New York Times* (18 October 1940), 18

"Nat'l Art Week, Nov. 25–Dec. 1," *Independent Woman* 19 (November 1940), 347

Jeanette Lowe, "Reunion of Marin, Dove and O'Keeffe," *The Art News* 39 (30 November 1940), 11

1941

"Georgia O'Keeffe," *Current Biography: Who's News and Why* (New York, 1941), 634–636

Exhibition of Georgia O'Keeffes [exh. checklist, An American Place] (New York, 27 January–11 March 1941). Photocopy in NGA, Gallery Archives, rg 17b

Edward Alden Jewell, "Georgia O'Keeffe Shows Art Work," *The New York Times* (29 January 1941), 15

Henry McBride, "Georgia O'Keeffe's Heaven: The Theory Is if You Got One You'd Better Hold On to It," *The New York Sun* (1 February 1941), 8

"Delicate Brushwork By Georgia O'Keeffe," *New York World-Telegram* (1 February 1941), 9

Carlyle Burrows, "Contemporary Types in Art: Some New Paintings of the West by Georgia O'Keeffe and Recent Work by Esther Williams," *New York Herald Tribune* (2 February 1941), section 6, page 8

Georgia O'Keeffe, "Opinions Under Postage," letter to the editor, *The New York Times* (23 February 1941), art section, page 9

Arthur G. Dove, John Marin, Georgia O'Keeffe, Pablo Picasso and Alfred Stieglitz [exh. checklist, An American Place] (New York, 17 October–27 November 1941). Photocopy in NGA, Gallery Archives, rg 17b

Howard Devree, "Alfred Stieglitz Opens Art Show," *The New York Times* (18 October 1941), 17

Sterling Sorensen, "America's Foremost Woman Artist Born in Sun Prairie," *The Capital Times* [Madison, Wisconsin] (19 October 1941), 10

1942

Georgia O'Keeffe: Exhibition of Recent Paintings, 1941 [exh. checklist, An American Place] (New York, 2 February–17 March 1942). Photocopy in NGA, Gallery Archives, rg 17b

"Miss O'Keeffe's New Paintings Put on Display," *New York Herald Tribune* (3 February 1942), 15

Henry McBride, "Georgia O'Keeffe's Bones: Readings from Tea Leaves and the Sands," *The New York Sun* (6 February 1942), 32

"Among One-Man Shows," *The New York Times* (8 February 1942), section 10, page 9

"Georgia O'Keeffe Honored," *The Art Digest* 16 (1 August 1942), 25

1943

Ralph Flint, "Lily Lady Goes West," *Town and Country* 98 (January 1943), 34, 64–65

Daniel Catton Rich, *Georgia O'Keeffe* [exh. cat., The Art Institute of Chicago] (Chicago, 21 January–22 February 1943)

"Woman from Sun Prairie," *Time* 41 (8 February 1943), 42, 44

"O'Keeffe in Review," *The Art Digest* 17 (15 February 1943), 14

Georgia O'Keeffe: Paintings—1942–1943 [exh. checklist, An American Place] (New York, 27 March–22 May 1943). Photocopy in NGA, Gallery Archives, rg 17b

Ernest W. Watson, "Georgia O'Keeffe," *American Artist* 7 (June 1943), 6–11

Caroline Marmon Fesler, "Grey Hills, Georgia O'Keeffe," *The Bulletin of the Art Association of Indianapolis, John Herron Art Institute* 30 (June 1943), 5–6

1944

Sidney Janis, *Abstract & Surrealist Art in America* (New York, 1944). Includes statement by Georgia O'Keeffe

Daniel Catton Rich, "The New O'Keeffes," *Magazine of Art* 37 (January 1944), 110–111

Georgia O'Keeffe: Paintings—1943 [exh. checklist, An American Place] (New York, 11 January–11 March 1944). Includes statement by Georgia O'Keeffe, "About Painting Desert Bones." Photocopy in NGA, Gallery Archives, rg 17b

Henry McBride, "Miss O'Keeffe's Bones: An Artist of the Western Plains Just Misses Going Abstract," *The New York Sun* (15 January 1944), 11

Art News 42 (1–14 February 1944), 22

Georgia O'Keeffe, "A Letter from Georgia O'Keeffe," *Magazine of Art* 37 (February 1944), 70

Margaret Breuning, "O'Keeffe's Best," *The Art Digest* 18 (1 March 1944), 26

"Philadelphia Honors Alfred Stieglitz, Pioneer in Modern Art," *The Art Digest* 18 (1 July 1944), 7

1945

Georgia O'Keeffe: Paintings 1944 [exh. checklist, An American Place] (New York, 22 January–22 March 1945). Photocopy in NGA, Gallery Archives, rg 17b

Robert M. Coates, "The Art Galleries," *The New Yorker* 20 (3 February 1945), 45

"Money is Not Enough," *Time* 45 (5 February 1945), 86

Margaret Breuning, "O'Keeffe's Latest," *The Art Digest* 19 (15 February 1945), 19

Carol Taylor, "Miss O'Keeffe, Noted Artist, Is a Feminist," *New York World-Telegram* (31 March 1945), second section, page 9

Janette Hollis, "Two American Women in Art—O'Keeffe and Cassatt," *The Delphian Quarterly* 28 (April 1945), 7–10, 15

"An American Collection," *The Philadelphia Museum Bulletin* 40 (May 1945), 66–80

1946

Filmer Stuart Cuckow Northrop, *The Meeting of East and West* (New York, 1946)

Georgia O'Keeffe [exh. checklist, An American Place] (New York, 4 February–27 March 1946). Photocopy in NGA, Gallery Archives, rg 17b

Robert M. Coates, "The Art Galleries: Contemporaries, Including the Whitney," *The New Yorker* 22 (16 February 1946), 82, 84

Ben Wolf, "O'Keeffe Annual," *The Art Digest* 20 (1 March 1946), 15

"The Passing Shows," *Art News* 45 (March 1946), 53–54

Edward Alden Jewell, "Exhibition Offers Work by O'Keeffe: Modern Art Museum Presents a Chronological Showing of Woman Artist's Paintings," *The New York Times* (15 May 1946), 19

Mary Braggiotti, "Her Worlds Are Many," *New York Post* (16 May 1946), 45

Henry McBride, "O'Keeffe at the Museum," *The New York Sun* (18 May 1946), 9

Carlyle Burrows, "Paintings by O'Keeffe in Large Review at the Modern Museum," *New York Herald Tribune* (19 May 1946), section 5, page 7

Edward Alden Jewell, "O'Keeffe: 30 Years: Museum of Modern Art Presents a Full View of Her Work," *The New York Times* (19 May 1946), section 2, page 6

Robert M. Coates, "Mostly Women," *The New Yorker* 22 (25 May 1946), 73, 75

Elizabeth McCausland, "Famous American Painter: Georgia O'Keeffe in A Retrospective Exhibition," *The Springfield Sunday Union and Republican* (26 May 1946), 6C

"O'Keeffe's Woman Feeling," *Newsweek* 27 (27 May 1946), 92, 94

"Austere Stripper," *Time* 47 (27 May 1946), 74–75

"Reviews and Previews," *Artnews* 45 (June 1946), 51

Jo Gibbs, "The Modern Honors First Woman—O'Keeffe," *The Art Digest* 20 (1 June 1946), 6

Clement Greenberg, "Art," *The Nation* 162 (15 June 1946), 727–728

James Thrall Soby, "To the Ladies," *The Saturday Review* 29 (6 July 1946), 14

Alfred M. Frankfurter, "American Art Abroad," *Artnews* 45 (October 1946), 21–30, 78

1947

Mabel Dodge Luhan, *Taos and Its Artists* (New York, 1947)

Robert M. Coates, "The Art Galleries," *The New Yorker* 23 (21 June 1947), 43–45

1949

Catalogue of the Alfred Stieglitz Collection for Fisk University. Foreword by Georgia O'Keeffe (Nashville, 1949)

Exhibition of Work by Newly Elected Members and Recipients of Grants [exh. checklist, The American Academy of Arts and Letters and the National Institute of Arts and Letters] (New York, 27 May–3 July 1949)

"Many Ways," *Time* 54 (14 November 1949), 50

Georgia O'Keeffe, "Stieglitz: His Pictures Collected Him," *The New York Times Magazine* (11 December 1949), 24–26, 28–30

Daniel Catton Rich, "The Stieglitz Collection," *The Art Institute of Chicago Bulletin* 43 (15 November 1949), 64–72

1950

"Fisk University Dedicates Alfred Stieglitz Collection," *The Crisis* 57 (March 1950), 157–159

Georgia O'Keeffe: Paintings 1946–1950 [exh. checklist, An American Place] (New York, 16 October–25 November 1950). Photocopy in NGA, Gallery Archives, rg 17b

Margaret Breuning, "Georgia O'Keeffe," *The Art Digest* 25 (1 November 1950), 19

Henry McBride, "Georgia O'Keeffe of Abiquiu," *Artnews* 49 (November 1950), 56–57

Anita Pollitzer, " 'That's Georgia,' " *Saturday Review of Literature* 33 (4 November 1950), 41–43

1952

Doris Bry, "Georgia O'Keeffe," *Journal of the American Association of University Women* 45 (January 1952), 79–80

Henry McBride, "Georgia O'Keeffe in Pastel," *Artnews* 51 (March 1952), 49

Margaret Breuning, "Georgia O'Keeffe," *The Art Digest* 26 (1 March 1952), 18–19

1953

Georgia O'Keeffe [exh. checklist, Dallas Museum of Fine Arts and Mayo Hill Galleries, Delray Beach, Florida] (Dallas, 1953)

1955

Contemporary American Painting and Sculpture [exh. cat., University of Illinois, Urbana] (27 February–3 April 1955). Includes statement by Georgia O'Keeffe, 226

Howard Devree, "About Art and Artists," *The New York Times* (30 March 1955), 32

Emily Genauer, "O'Keeffe, Nicholson Have Solo Shows," *New York Herald Tribune* (3 April 1955), section 6, page 13

Margaret Breuning, "Georgia O'Keeffe," *Art Digest* 29 (15 April 1955), 21

Robert M. Coates, "The Art Galleries," *The New Yorker* 31 (16 April 1955), 111

Fairfield Porter, "Georgia O'Keeffe," *Artnews* 54 (May 1955), 46–47

1956

"The Age of Experiment," *Time* 67 (13 February 1956), 62–67

1957

James Thrall Soby, "Georgia O'Keeffe," *New Art in America*, ed. John I. H. Baur, 108–111

1958

John I. H. Baur, *Nature in Abstraction* [exh. cat., Whitney Museum of American Art, Phillips Collection, Fort Worth Art Museum, Los Angeles County Museum, Fine Arts Museums of San Francisco, Walker Art Center, and City Art Museum, Saint Louis] (New York, 1958). Includes statement by Georgia O'Keeffe

"Nature in Abstraction," *Arts* 32 (February 1958). Includes statement by Georgia O'Keeffe, 32–33

J. R. M., "Georgia O'Keeffe," *Arts* 32 (March 1958), 60

Eleanor C. Munro, "Georgia O'Keeffe," *Artnews* 57 (March 1958), 38, 57

Stieglitz Circle [exh. cat., Pomona College] (Claremont, California, 1958). Includes statement by Georgia O'Keeffe and letter from Georgia O'Keeffe to Peter Selz

Henry J. Seldis, "The Stieglitz Circle Show at Pomona College," *Art in America* 46 (winter 1958–1959), 62–65

1960

Katharine Kuh, *The Artist's Voice: Talks with Seventeen Artists* (New York, 1960)

Dorothy Norman, *Alfred Stieglitz: An American Seer* (New York, 1960)

Daniel Catton Rich, *Georgia O'Keeffe—Forty Years of Her Art* [exh. cat., Worcester Museum of Art] (Worcester, Massachusetts, 1960)

" 'My World is Different...,' " *Newsweek* 56 (10 October 1960), 101

"Wonderful Emptiness," *Time* 76 (24 October 1960), 74–75, 77

Frank Getlein, "In the Light of Georgia O'Keeffe," *The New Republic* 143 (7 November 1960), 27–28

The Precisionist View in American Art [exh. cat., Walker Art Center] (Minneapolis, 1960)

1961

Hilton Kramer, "The American Precisionists," *Arts* 35 (March 1961), 32–37

Brian O'Doherty, "Art: O'Keeffe Exhibition," *The New York Times* (11 April 1961), 75

Emily Genauer, "Art and Artists: Have You Ever Been All Blue," *New York Herald Tribune* (16 April 1961), section 4, page 19

Robert M. Coates, "The Art Galleries," *The New Yorker* 37 (22 April 1961), 160, 163

Jack Krall, "Georgia O'Keeffe," *Artnews* 60 (May 1961), 13

Vivien Raynor, "Georgia O'Keeffe," *Arts* 35 (May/June 1961), 88

1962

Sarah C. Faunce, "American Abstraction 1903–23," *Artnews* 61 (April 1962), 17

Dore Ashton, "Earlier American Avant-Garde," *The Studio* 164 (July 1962), 6–9

Vivien Raynor, "The Figure," *Arts* 36 (September 1962), 45

1963

Art USA Now 1, ed. Lee Nordness. Includes statement by Georgia O'Keeffe

Taos and Santa Fe: The Artist's Environment 1882–1942 [exh. cat., Amon Carter Museum of Art, La Jolla Art Center, and Art Gallery, University of New Mexico, Albuquerque] (Fort Worth, 1963)

"People in the Arts," *Arts* 37 (January 1963), 8

The Decade of the Armory Show [exh. cat., Whitney Museum of American Art, City Art Museum, St. Louis, The Cleveland Museum of Art, The Pennsylvania Academy of the Fine Arts, The Art Institute of Chicago, and Albright-Knox Art Gallery] (New York, 1963)

Laura Gilpin, "The austerity of the desert pervades her home and her work," *House Beautiful* 105 (April 1963), 144–145, 198–199

Exhibition of Newly Elected Members and Recipients of Honors and Awards [exh. checklist, The American Academy of Arts and Letters and The National Institute of Arts and Letters] (New York, 1963)

Van Deren Coke, "Taos and Santa Fe," *Art in America* 51 (October 1963), 44–47

Charlotte Willard, "Portrait: Georgia O'Keeffe," *Art in America* 51 (October 1963), 92–96

American Modernism: The First Wave, Painting from 1903–1933 [exh. cat., The Rose Art Museum, Brandeis University] (Waltham, Massachusetts, 1963)

1964

Donald Judd, "In the Galleries," *Arts* 38 (April 1964), 27

1965

Henry Geldzahler, *American Painting in the Twentieth Century* (New York, 1965)

Ralph Looney, "Georgia O'Keeffe," *The Atlantic Monthly* 215 (April 1965), 106–110

Garnett McCoy, "The Artist Speaks: Reaction and Revolution 1900–1930," *Art in America* 53 (August/September 1965), 68–87. Includes letters from Georgia O'Keeffe to Henry McBride, 79–80

"Five Famous Artists in Their Personal Background: Georgia O'Keeffe," *House and Garden* 128 (December 1965), 176–177

1966

Herbert J. Seligmann, *Alfred Stieglitz Talking* (New Haven, 1966)

Georgia O'Keeffe [exh. cat., Amon Carter Museum of Western Art and Museum of Fine Arts, Houston] (Fort Worth, 1966)

Alfred Frankenstein, "The Shapes of O'Keeffe's America," *This World: San Francisco Sunday Examiner and Chronicle* (17 April 1966), 23–24

Peter Plagens, "A Georgia O'Keeffe Retrospective," *Artforum* 4 (May 1966), 27–31

Georgia O'Keeffe [exh. checklist, University of New Mexico Art Museum] (Albuquerque, 1966)

1967

Barbara Rose, *American Art Since 1900: A Critical History* (New York, 1967)

Henry Seldis, "Georgia O'Keeffe at 78: Tough-Minded Romantic," *Los Angeles Times WEST Magazine* (22 January 1967), 14–17

Eugene Goosen, "O'Keeffe" *Vogue* 149 (1 March 1967), 174–179, 221–224

1968

Lloyd Goodrich, *Georgia O'Keeffe Drawings* (New York, 1968)

Dorothy Seiberling, "Georgia O'Keeffe in New Mexico: Stark Visions of a Pioneer Painter," *Life* 64 (1 March 1968), 40–50, 52–53

1969

"Images," *Arts* 43 (March 1969), 23

Alicia Drweski, "Artificial Paradise," *Art and Artists* 4 (April 1969), 50–53

1970

George Heard Hamilton, "The Alfred Stieglitz Collection," *Metropolitan Museum Journal* 3 (1970), 371–392

"Letters from 31 Artists," ed. Ethel Moore, *Albright-Knox Gallery Notes*, 31–32 (spring 1970). Includes letter from Georgia O'Keeffe, 28

Exhibition of Work by Newly Elected Members and Recipients of Honors and Awards [exh. checklist, The American Academy of Arts and Letters and The National Institute of Arts and Letters] (New York, 1970)

Lloyd Goodrich, "Retrospective for Georgia O'Keeffe," *Art in America* 58 (September/October 1970), 80–85

Douglas Crimp, "Georgia Is a State of Mind," *Artnews* 67 (October 1970), 48–51, 84–85

Ralph Fabri, "O'Keeffe Retrospective at the Whitney," *Today's Art* 18 (1 October 1970), 18–19

John Canaday, "O'Keeffe Exhibition: An Optical Treat," *The New York Times* (8 October 1970), 60

Lloyd Goodrich and Doris Bry, *Georgia O'Keeffe Retrospective Exhibition* [exh. cat., Whitney Museum of Art, The Art Institute of Chicago, and San Francisco Museum of Art] (New York, 1970)

John Canaday, "Georgia O'Keeffe: The Patrician Stance As Esthetic Principle," *The New York Times* (11 October 1970), section 2, page 23

Robert Hughes, "Loner in the Desert," *Time* 96 (12 October 1970), 64, 67

Douglas Davis, "Return of the Native," *Newsweek* 76 (12 October 1970), 105

Grace Glueck, " 'It's Just What's In My Head . . .' " *The New York Times* (18 October 1970), section 2, page 24

Bill Marvel, "Georgia O'Keeffe's World: She Re-creates an Awesome Nature," *The National Observer* (19 October 1970), 1, 9

John Gruen, "Georgia On Our Mind," *New York Magazine* 3 (19 October 1970), 60

Barbara Rose, "Georgia O'Keeffe: The Paintings of the Sixties," *Artforum* 9 (November 1970), 42–46

Barbara Rose, "Visiting Georgia O'Keeffe," *New York Maga-zine* (9 November 1970), 60–61

Lawrence Alloway, "Art," *The Nation* 211 (14 December 1970), 637–638

1971

Charles Child Eldredge III, "Georgia O'Keeffe: The Develop-ment of an American Modern" (Ph.D. dissertation, Univer-sity of Minnesota, 1971)

Beth Coffelt, "A Visit with Georgia O'Keeffe," *San Francisco Sunday Examiner and Chronicle* (11 April 1971), 18–24

Leo Janos, "Georgia O'Keeffe at Eighty-Four," *The Atlantic* 228 (December 1971), 114–117

1973

Christopher Andreae, " 'You don't paint what you see,' " *Christian Science Monitor* (15 August 1973), 15

Robert Doty, "The Articulation of American Abstraction," *Arts* 48 (November 1973), 47–49

1974

Susan Cohn, "An Analysis of Selected Works by Georgia O'Keeffe and a Production of Drawings by the Researcher Relating to the Work of the Artist Studied" (Ph.D. disserta-tion, New York University, 1974)

Georgia O'Keeffe, *Some Memories of Drawings* (New York, 1974)

Van Deren Coke, "Why Artists Came to New Mexico: 'Nature Presents a New Face Each Moment,' " *Artnews* 73 (January 1974), 22–24

Calvin Tompkins, "The Rose in the Eye Looked Pretty Fine," *The New Yorker* 50 (4 March 1974), 40–66

1975

Daniel Catton Rich, *The Flow of Art: Essays and Criticisms of Henry McBride* (New York, 1975)

Avant-Garde Painting and Sculpture in America 1910–25 [exh. cat., University of Delaware and Delaware Art Museum] (Wil-mington, 1975)

1976

Katherine Hoffman, "A Study of the Art of Georgia O'Keeffe" (Ph.D. dissertation, New York University, 1976)

Georgia O'Keeffe, *Georgia O'Keeffe* (New York, 1976)

Nancy Heller and Julia Williams, "Georgia O'Keeffe: The American Southwest," *American Artist* 40 (January 1976), 76–81, 107

Thomas Lask, "Publishing: Georgia O'Keeffe," *The New York Times* (25 June 1976), C24

Sanford Schwartz, "When New York Went to New Mexico," *Art in America* 64 (July/August 1976), 93–97

"First Book Ever Devoted to Art of Georgia O'Keeffe Published by Studio Books," *Publishers Weekly* 210 (4 October 1976), 57–58

American Master Drawings and Watercolors [exh. cat., Whitney Museum of American Art] (New York, 23 November 1976–23 January 1977)

Women Artists: 1550–1950 [exh. cat., Los Angeles County Mu-seum of Art, The University of Texas, Austin, Museum of Art, Carnegie Institute, and The Brooklyn Museum] (Los Ange-les, 1977)

Hilton Kramer, "Georgia O'Keeffe," *The New York Times Book Review* (12 December 1976), 1, 30–32

1977

Verna Posever Curtis, *Georgia O'Keeffe* (Milwaukee, 1977)

William Innes Homer, *Alfred Stieglitz and the American Avant-Garde* (Boston, 1977)

Jan Butterfield, "Replacing Women Artists in History," *Artnews* 76 (March 1977), 40–44

Barbara Rose, "O'Keeffe's Trail," *New York Review of Books* 24 (31 March 1977), 29–33

Katherine Hoffman, "Books in Review," *Art Journal* 36 (spring 1977), 264–265

Georgia O'Keeffe [exh. checklist, First State Bank] (Abilene, Texas, 1977). Photocopy in NGA, Gallery Archives, rg 17b

Judith L. Dunham, "Georgia O'Keeffe, Painter of Essences," *Artweek* 8 (1 October 1977), 1

Tom Zito, "Georgia O'Keeffe," *The Washington Post* (9 Novem-ber 1977), C1, C3

Tom Zito and Amei Wallach, "Georgia O'Keeffe," *Albuquerque Journal* (13 November 1977), C1, C3–C4

"The Art of Being O'Keeffe," *The New York Times Magazine* (13 November 1977), 44–45

Mary Lynn Kotz, "Georgia O'Keeffe at 90," *Artnews* 76 (De-cember 1977), 36–45

Amei Wallach, "Under a Western Sky," *Horizon* 20 (December 1977), 24–31

1978

Donna G. Bachmann and Sherry Piland, *Women Artists: An His-torical, Contemporary and Feminist Bibliography* (Metuchen, New Jersey, and London, 1978)

Bram Dijkstra, *Cubism, Stieglitz, and the Early Poetry of William Carlos Williams: The Hieroglyphics of a New Speech* (Princeton, New Jersey, 1978)

Marilyn Hall Mitchell, "Sexist Art Criticism: Georgia O'Keeffe —a Case Study," *Signs* 3 (1978), 681–687

Sanford Schwartz, "Georgia O'Keeffe Writes a Book," *The New Yorker* 54 (28 August 1978), 87–90, 93

"The Eye of Stieglitz" [exh. cat., Hirschl & Adler Galleries, Inc.] (New York, 1978)

Georgia O'Keeffe by Alfred Stieglitz, Introduction by Georgia O'Keeffe [exh. cat., The Metropolitan Museum of Art] (New York, 1979)

Ben Lifson, "O'Keeffe's Stieglitz, Stieglitz's O'Keeffe," *The Voice* (11 December 1978), 107

1979

Eleanor Munro, *Originals—American Women Artists* (New York, 1979)

Janet Malcolm, "Photography: Artists and Lovers," *The New Yorker* 55 (12 March 1979), 118–120

1980

Jane Downer Collins, "Georgia O'Keeffe and the New Mexico Landscape," (M.A. thesis, The George Washington Univer-sity, 1980)

Laurie Lisle, *Portrait of An Artist: A Biography of Georgia O'Keeffe* (New York, 1980)

Georgia O'Keeffe and Her Circle [exh. cat., McKissick Museums, University of South Carolina] (Columbia, South Carolina, 1980)

Georgia O'Keeffe: An Exhibition of Oils, Watercolors and Drawings [exh. cat., Sheldon Memorial Art Gallery] (Lincoln, Ne-braska, 1980)

1981

Abraham A. Davidson, *Early American Modernist Painting 1910–1935* (New York, 1981)

Sharyn Rohlfsen, "Modernist Painting in New Mexico," (Ph.D. dissertation, University of New Mexico, 1981)

Frank Israel, "Architectural Digest Visits: Georgia O'Keeffe," *Architectural Digest* 38 (July 1981), 77–85, 136, 138

Patterson Sims, *Georgia O'Keeffe: A Concentration of Works from the Permanent Collection of the Whitney Museum of American Art* [exh. cat., Whitney Museum of American Art] (New York, 1981)

Vivien Raynor, "Art: Whitney Displays Its 10 Georgia O'Keeffes," *The New York Times* (14 August 1981)

1982

Katherine Hoffman, "Georgia O'Keeffe and the Feminine Experience," *Helicon Nine, The Journal of Women's Arts and Letters* 6 (spring 1982), 6–15

Susan Fillin Yeh, "Innovative Moderns: Arthur G. Dove and Georgia O'Keeffe," *Arts* 56 (June 1982), 67–72

Celia Weisman, "O'Keeffe's Art: Sacred Symbols and Spiritual Quest," *Woman's Art Journal* 3 (fall 1982/winter 1983), 10–14

Images of America: Precisionist Painting and Modern Photography [exh. cat., San Francisco Museum of Modern Art, City Art Museum, Saint Louis, The Baltimore Museum of Art, Des Moines Art Center, and The Cleveland Museum of Art] (San Francisco, 1982)

1983

Sue Davidson Lowe, *Stieglitz: A Memoir/Biography* (New York, 1983)

The Lane Collection [exh. cat., Museum of Fine Arts, Boston, San Francisco Museum of Modern Art, and Amon Carter Museum, Fort Worth] (Boston, 1983)

Constance Schwartz, *Nevelson and O'Keeffe* [exh. cat., Nassau County Museum of Fine Art] (Roslyn Harbor, New York, 1983)

Andy Warhol, "Georgia O'Keeffe & Juan Hamilton," *Interview* 13 (September 1983), 54–56

Nancy Scott, "The O'Keeffe-Pollitzer Correspondence, 1915–1917," *Source* 3 (Fall 1983), 34–41

O'Keeffe: A Selection of Paintings by American Artist Georgia O'Keeffe from Area Collections [exh. cat., Minnesota Museum of Art] (Saint Paul, 1983)

1984

Katherine Hoffman, *The Enduring Spirit: The Art of Georgia O'Keeffe* (Metuchen, New Jersey, and London, 1984)

Lisa Mintz Messinger, "Georgia O'Keeffe," *The Metropolitan Museum of Art Bulletin* 42 (fall 1984), entire issue

Sharyn Rohlfsen Udall, *Modernist Painting in New Mexico 1913–1935* (Albuquerque, New Mexico, 1984)

Georgia O'Keeffe: The Artist's Landscape, Photographs by Todd Webb, ed. J. Woody (Pasadena, California, 1984)

Reflections of Nature [exh. cat., Whitney Museum of American Art] (New York, 1984)

Georgia O'Keeffe at the Madison Art Center: Paintings 1919–1977 [exh. cat., Madison Art Center] (Madison, 1984)

1985

Jan Garden Castro, *The Art and Life of Georgia O'Keeffe* (New York, 1985)

Elizabeth Duvert, "Radiator Building," *Places* 2 (1985), 3–17

Sasha Newman, *Georgia O'Keeffe* (Washington, D.C., 1985)

Georgia O'Keeffe at the Albany Museum [exh. checklist] (Albany, Georgia, 1985)

Georgia O'Keeffe & Her Contemporaries [exh. cat., Amarillo Art Center] (Amarillo, 1985)

David Turner and Barbara Haskell, *Georgia O'Keeffe, Works on Paper* [exh. cat., Museum of Fine Arts, Museum of New Mexico] (Santa Fe, 1985)

Amy Laurent, "Images of an Artist," *Artweek* 16 (19 October 1985), 13

Kenneth Baker, "The World in a Drop of Water," *Artforum* 24 (December 1985), 56–59

1986

Beverly Gherman, *Georgia O'Keeffe: The "Wideness and Wonder" of Her World* (New York, 1986)

Edith Evans Asbury, "Georgia O'Keeffe Dead at 98; Shaper of Modern Art in U.S.," *The New York Times* (7 March 1986), 1, 17

Art in New Mexico 1900–1945: Paths to Taos and Santa Fe [exh. cat., National Museum of American Art, Smithsonian Institution, Cincinnati Art Museum, The Museum of Fine Arts, Houston, and The Denver Art Museum] (Washington, D.C., 1986)

Mark Stevens, "The Gift of Spiritual Intensity," *Newsweek* 107 (17 March 1986), 77

Robert Hughes, "A Vision of Steely Finesse," *Time* (17 March 1986), 83

Georgia O'Keeffe: Selected Paintings and Works on Paper [exh. cat., Hirschl & Adler Galleries, Inc., and Gerald Peters Gallery, Dallas] (New York, 1986)

Ora Lerman, "From Close-Up to Infinity: Reentering Georgia O'Keeffe's World," *Arts* 60 (May 1986), 80–83

Barbara Rose, "Georgia O'Keeffe 1887–1986," *Vogue* 225 (May 1986), 290–293

Hunter Drohojowska, "Georgia O'Keeffe 1887–1986," *Artnews* 85 (summer 1986), 119, 121

The Spiritual in Art: Abstract Painting 1890–1985 [exh. cat., Los Angeles County Museum of Art, Museum of Contemporary Art, Chicago, and Haags Gemeentemuseum, The Hague] (Los Angeles, 1986)

1987

David Turner, *Georgia O'Keeffe: Paintings* [exh. cat., Museum of Fine Arts, Museum of New Mexico] (Santa Fe, New Mexico, 1987)

Sarah Whitaker Peters, "Georgia O'Keeffe and Photography: Her Formative Years," (Ph.D. dissertation, City University of New York, 1987)

Julie Schimmel, "Georgia O'Keeffe," *New Mexico* 65 (March 1987), 28–35

American Women Artists 1830–1930 [exh. cat., National Museum of Women in the Arts, Minneapolis Institute of Arts, Wadsworth Atheneum, Hartford, San Diego Museum of Art, and Meadows Museum, Southern Methodist University, Dallas] (Washington, D.C., 1987)

Other archival sources include: notebooks compiled by Rosalind Irvine, updated by Doris Bry, at the Whitney Museum of American Art; materials in the Archives of American Art and the Beinecke Rare Book and Manuscripts Library, Yale University; and papers in the Estate of Georgia O'Keeffe.

Index of titles, and names and places in letters

A

Abiquiu, New Mexico, 80n, 84, 106n; letters written from, 80, 83, 84, 86–91, 93, 97–111, 113–122, 124
Abstraction, Blue, cat. 55
Abstraction IX, cat. 8
Abstraction #77 (Tulip Fragment), cat. 40
Adams, Ansel, 72n, 76, 76n
airplanes, letters written from, 81, 123
Alcalde, New Mexico, 48, 48n, 57, 57n; letter written from, 56
American Academy of Arts and Letters, 120, 120n
Amon Carter Museum, 119n
An American Place, 48n, 55n, 57n–60n, 64n, 65n, 69n, 73n, 76n, 83fn, 86fn, 92n, 102, 102n, 105n, 107, 107n
Anderson, Sherwood, 28n, 29n, 30n, 32n, 68n; letters to, 28–32
Anderson Galleries, 25n, 26n, 27n, 30n, 33n, 36n, 90
Apollinaire, Guillaume, 2n
Apollo, 15
Apple Family III, cat. 38
Arden, Elizabeth, 72, 72n
Ariail, James M., 9, 9n
Armory Show, 18n, 95n
The Art Institute of Chicago, 57n, 91n, 95n, 96n, 99n
Art Students League, 1n, 2, 2n, 23n, 107n

B

Bakst, Leon, 9, 9n
Barnes, Albert, 95n; letter to, 95
Barringer, Anna, 2, 2n
Baur, John I.H., 115n; letters to, 115, 116
Bell, Clive, 16, 16n
Bement, Alon, 1, 1n, 2, 2n, 3, 3n, 7, 7n, 18, 18n
Bermuda, letter written from, 71
Black Abstraction, cat. 54, 89fn
Black and White, cat. 77
A Black Bird with Snow-Covered Red Hills, cat. 107
Black Cross, Arizona, cat. 73, 52n
Black Iris III, cat. 49, 38n, 89fn
Black Place—III, cat. 101
Black Spot No. 2, cat. 32
Blue, Black and Grey, cat. 117
Blue Hill No. I, 12n
Blue Hill No. II, 12n
Blue Hill No. III, 12n
Blue Lines X, cat. 9
Blue No. III, cat. 12
Blue No. IV, cat. 13
boat, letter written from, 70
Bok, Derek, 122n; letter to, 122

Bragdon, Claude, 36, 36n
Brancusi, Constantin, 66, 66n, 99
Breeskin, Adelyn Dohme, 119n; letter to, 119
Brett, Dorothy, 44n, 48, 48n, 53n, 54n, 80; letters to, 53, 54, 60, 62
The Broken Shell—Pink, cat. 91
Bry, Doris, 96n, 99, 99n, 102, 105, 110, 110n
Bywaters, Jerry, 63, 63n

C

Caffin, Charles H., 15, 15n, 16, 16n
Camera Work, 1, 1n, 6, 6n, 17n, 18, 18n, 20, 20n, 98, 98n
Canyon, Texas, 7, 11, 65, 65n; letters written from, 13–16, 18–23
Canyon with Crows, cat. 20, 15n
Chabot, Maria, 80n, 84n, 87, 93, 96, 114; letter to, 81
Charlottesville, Virginia, letters written from, 1, 2, 12
Chicago World's Fair, 43, 43n
Clam and Mussel, cat. 65
Clapp, Frederick Mortimer "Tim," letter to, 117
Clapp, Maude and Frederick Mortimer, 89n; letter to, 89
Closed Clam Shell, cat. 52
Collier, Charles, 48, 48n, 53
Columbia, South Carolina, 2, 6, 8, 10, 12n; letters written from, 3–11
Columbia University Teachers College, 1n, 2, 2n, 5, 7n, 11, 11n, 25n
Copland, Aaron, letter to, 120, 120n
Corn, Dark I, cat. 41
Cornell, Katherine, 34, 34n
Cousins, R.B., 7n, 11n
Covarrubias, Miguel, 108, 108n
Covarrubias, Rose, 108
Cow's Skull with Calico Roses, cat. 75, 56n
Cross with Red Heart, 62fn

D

Dallas Museum of Art, 57n, 98, 98n
Dark Iris No. 3, cat. 47
Dark Iris No. II, cat. 48, 38n
Davidson, Elizabeth Stieglitz. *See* Stieglitz, Elizabeth.
Davidson, Jo, 53, 53n
Deer Horns, 77fn
Dell, Floyd, 2, 2n
Demuth, Charles, 35n, 43, 43n, 66, 110n
DeTerra, Helmut, 104, 104n
DeZayas, Marius, 2n, 16, 16n
The Dial, 25, 25n, 26, 26n

Dole Pineapple Company, 76fn
Dove, Arthur, 33n, 36n, 68n, 73n, 89, 107n, 110, 110n; letters to, 73, 83
Dow, Arthur Wesley, 1n, 3, 3n, 4, 11n, 15, 15n
Downtown Gallery, 107n, 109fn
Drawing III, cat. 112
Drawing V, cat. 113
Drawing IX, cat. 114
Drawing No. 14, 7n
Drawing No. 15, 15n
Duchamp, Marcel, 35n, 66, 66n
Duncan, Charles, 12fn

E

Eagle Claw and Bean Necklace, cat. 92
East River from the Shelton, cat. 61, 41fn, 41n
East River, New York, No. 2, cat. 60
Eddy, Arthur Jerome, 2, 2n, 16, 16n
Einstein, William, 76n, 110; letter to, 76
Engelhard, Georgia, 62n
Evening Star No. IV, cat. 14
Evening Star No. VI, cat. 15

F

Fesler, Caroline, 92n; letters to, 92, 114
First Drawing of Blue Lines, cat. 6
Fisk University, 96n, 99, 99n
Flower Abstraction, cat. 44
Four Yellow Apples on a Black Dish, 41n
Frank, Tom, 37, 37n
Frank, Waldo, 37n, 38n, 66n, 68n; letters to, 37, 38
From a Shell, cat. 62
From the Faraway Nearby, cat. 84
From the Lake, No. I, cat. 42
From the Plains, I, 115fn
From the Plains, II, 115fn

G

Gaisman, Henry J., 18, 18n
Gallup, Donald, 110n; letter to, 110
Garland, Marie Tudor, 48, 48n, 57n, 71n
Gaspé Peninsula, 62, 62n, 63, 64
Ghost Ranch, 71n, 80, 80n, 92n, 96n, 118, 122; letters written from, 80, 104, 113
Goat's Horn with Red, cat. 104
Grapes on White Dish—Dark Rim, cat. 36
El Greco, 15, 15n
Green, John Richard, 21n
Green Corn No. 1, 41n
Greene, Felix, 80, 80n
Green Hill, 17n
Grey Hills, cat. 100, 92n
Grey Tree, Fall, 98fn

H

Halpert, Edith, 107, 107n, 109n; letter to, 109
Hamilton, Juan, 123n; letter to, 123
Hapgood, Hutchins, 26, 26n, 48
Hapgood, Miriam, 26 48, 48n
Hardy, Thomas, 2
Hartley, Marsden, 12n, 17n, 26, 26n, 33, 33n, 35n, 48n, 86, 110, 110n
Haviland, Paul, 2n
Hawaii, 76fn, 76n, 105
Heliconia, 76fn
Herzig, Katherine, 29n
Heubsch, B.W., 29, 29n
Hill, Stream and Moon, 12n
Hills—Lavender, Ghost Ranch, New Mexico II, cat. 87
Hirshhorn, Joseph H., 121n; letter to, 121
Hofmann, Josef, 43, 43n
Homer, Winslow, 90
Horse's Skull with Pink Rose, 79
Horse's Skull with White Rose, cat. 82, 56n
Hudspath, Mary, 65, 65n
Hunter, Russell Vernon, 57n, 58n, 61n, 63n–65n, 79n, 98n; letters to, 57–59, 61, 63–65, 79, 98

I

In the Patio I, cat. 109, 106n
International Studio, 15
Intimate Gallery, 26n, 36n, 38n, 41n, 43n, 57n, 90
It Was Red and Pink, cat. 116

J

Jack-in-the-Pulpit, cat. 78
Jack-in-the-Pulpit No. III, cat. 79
Jack-in-the-Pulpit No. IV, cat. 80
Jack-in-the-Pulpit No. V, cat. 81
James, Rebecca "Beck" Strand. *See* Strand, Rebecca "Beck."
Johnson, Willard "Spud," 47, 47n, 48, 80, 110

K

Kandinsky, Wassily, 2, 2n
Katchina, 56n
Katchina Doll, 77fn
Kennerley, Mitchell, 26n, 41n; letters to, 26, 41
Kiskadden, Margaret "Peggie" Bok, 96n; letters to, 96, 104
Kreymborg, Alfred, 35, 35n
Kreymborg, Dorothy, 35, 35n, 68

L

Lachaise, Gaston, 99, 99n
Lafferty, Réné, 12fn, 13, 13n
Lake George, cat. 43, 32n
Lake George, New York, 28n, 49n, 63n, 71, 103; letters written from, 24, 25, 28, 29, 31, 32, 35, 37, 40, 50–52, 57, 65–69, 76

Lake George Window, 90fn
Lawrence, D.H., 34n, 40, 40n, 44n, 48n, 53n, 110
Lawrence, Frieda, 48n, 60, 80, 80n, 104
The Lawrence Tree, cat. 76, 47fn, 48, 52n, 56, 56n
Light Coming on the Plains II, cat. 16
Light Coming on the Plains III, cat. 17
Lily—White with Black, cat. 68
Lowe, Sue Davidson, 28n, 35n
Luhan, Mabel Dodge, 34n, 44fn, 44n, 45, 46n, 48, 48n, 50n, 53, 53n, 56, 56n, 71, 74, 110; letters to, 34, 46, 47, 50, 51
Lumpkin, Katherine, 13, 13n

M

Macdonald-Wright, Stanton, 15n, 18, 18n, 57n
Macmahon, Arthur Whittier, 2, 2n, 16
Marin, John, 8, 8n, 10, 10n, 17n, 18, 27, 27n, 36n, 37, 44, 44n, 63, 65, 65n, 66, 72, 72n, 79, 79n, 90, 95, 95n, 99, 107n, 110, 110n
Martin, Charles, 2, 2n, 3, 18
The Masses, 2, 2n, 10
Matthias, Blanche, 36n; letters to, 36, 43
McAlpin, David H., 72n, 76; letter to, 72
McBride, Henry, 27n, 30n, 33n, 35n, 42n, 78n, 97n, 102n; letters to, 27, 33, 39, 42, 44, 56, 78, 94, 97
McGee, Virginia, 79n, 98n
McMurdo, Doris, 25n; letter to, 25
The Metropolitan Museum of Art, 15, 79, 79n, 96n, 114n
Meyer, Agnes Ernst, 2n
Milliken, William M., 55n; letter to, 55
Morning Sky with Houses and Windmill, 65n
Murray, Elizabeth "Peggy" Davidson, 35n
Museum of Fine Arts, Boston, 96n
Museum of Modern Art, 58n, 72n, 78, 78n, 89n, 90n, 95n, 97, 97n, 124, 124n
Music, Pink and Blue, II, cat. 35
My Last Door, cat. 111, 106n

N

Nadelman, Elie, 6, 6n
Nature Forms, Gaspé, cat. 45, 62n
New York, Night, cat. 59
New York City, 2, 6, 7, 11, 15, 18, 25, 30, 31, 33, 56, 60, 62, 62n, 66, 69, 71, 90, 98, 105; letters written from, 26, 27, 30, 33, 34, 36, 38, 39, 41, 42, 43, 53–55, 58–61, 63, 64, 72–75, 77–79, 85, 92, 94, 95
Norman, Dorothy, 57n, 64n, 66n
Nude Series, cat. 27
Nude Series VIII, cat. 24
Nude Series XII, cat. 25

O

O'Keeffe, Alexius, 17, 17n, 35, 48, 48n
O'Keeffe, Anita Natalie, 25, 25n, 82, 82n
O'Keeffe, Claudia, 13, 13n, 15, 19

O'Keeffe, Ida Ten Eyck, 5n, 25, 25n, 29, 29n, 48, 48n
Open Clam Shell, cat. 53
An Orchid, cat. 97
Oriental Poppies, cat. 71
Orozco, José Clemente, 108, 108n

P

Painting No. 21 (Palo Duro Canyon), 15n
Paris, letter written from, 112
Patio Door, cat. 108, 106n
Pattern of Leaves, cat. 39, 30n
Peach and Glass, cat. 67
Pedernal, cat. 105
Pelvis—I, cat. 102
Pelvis—III, cat. 103
Pelvis Series—Red with Yellow, cat. 106
Pelvis with Distance, 92fn
Pelvis with Shadows and the Moon, cat. 99, 82n
Pennsylvania Academy of the Fine Arts, 4n
Philadelphia Museum of Art, 86n, 96n
Picasso, Pablo, 2n, 6, 6n, 17n, 18, 92n, 95n
Pineapple Bud, 76fn
Pink and Green Mountain, No. 1, 17n
Pink Moon and Blue Lines, cat. 34
Pink Sweet Peas, cat. 51
Plums, cat. 37
Pollitzer, Aline, 18, 18n,
Pollitzer, Anita, 1n–7n, 18, 77n, 113n; letters to, 1–7, 9–11, 14–16, 18, 113
Portrait—W—No. III, cat. 26
Priest, Alan, 114, 114n

R

Radiator Building, Night, New York, cat. 58
Radio City Music Hall, 62, 62n, 63, 64, 64n
Ranchos Church, cat. 72, 52n
Ranchos Church, cat. 74, 56
Rauh, Ida, 53, 53n
Red and Orange Streak, cat. 33
Red and Pink Rocks, cat. 94
Red and Pink Rocks and Teeth, cat. 95
Red Barn, Wisconsin, 41fn, 41n
Red Canna, cat. 23
Red Cannas, cat. 22
Red Hill and White Shell, cat. 89
Red Hills and Bones, cat. 86
Red Hills and the Sun, Lake George, 90fn
Red Hills and White Flower, cat. 96
Red Mesa, cat. 21
Red Poppy, cat. 69
Reid, James W. "Ted," 22, 22n
Rhoades, Katherine N., 2n
Rib and Jawbone, cat. 90
Rich, Daniel Catton, 91, 91n; letter to, 99
Rivera, Diego, 58, 58n, 86, 108, 108n
Robertson, Forbes, 4, 4n
Robinson, Helen Ring, 10, 10n
Rodakiewicz, Henwar, 48, 48n
Rodin, Auguste, 1n
Rolf, Dr. Ida, 114, 114n

Rönnebeck, Arnold, 110, 110n
Roosevelt, Eleanor, 85n; letter to, 85
Rosenfeld, Paul, 25n, 26, 26n, 35, 66, 66n, 68n
Ross, Cary, 76n

S

San Francisco Museum of Modern Art, 56, 96
Schneider, Alexander, 114, 114n
Schubart, Selma, 35, 35n
Schubart, William Howard, 100n, 102n, 111n; letters to, 100–103, 105–108, 111, 112
Seaweed, cat. 63
Seaweed and Sea Bean, 77fn
Series I, No. 1, cat. 31
Series I, No. 4, cat. 29
Series I, No. 8, cat. 30
Series: Near Abiquiu, New Mexico—Hills to the Left, cat. 98
The Shelton with Sun Spots, New York, cat. 57, 36n, 38n
Shirley, Willena, 16n
Single Lily with Red, 41fn, 41n
Siqueiros, David Alfaro, 108, 108n
Sky Above Clouds II, cat. 119, 81n
Sky Above Clouds III, cat. 118, 81n
Sky Above Clouds IV, cat. 120, 81n, 119fn
Skyscrapers, 60
Slightly Open Shell, cat. 66
Small Purple Hills, cat. 85
Soby, James Thrall, 97, 97n
Some Memories of Drawings, 7n
Special No. 2, cat. 1
Special No. 4, cat. 2
Special No. 5, cat. 3
Special No. 9, cat. 5
Special No. 13, cat. 4
Special No. 14, 7n
Special No. 15, cat. 10
Special No. 16, cat. 28
Special No. 21, cat. 11
Special No. 32, 7n
Special No. 33, 7n
Special No. 40, cat. 46
Spring, 97fn
Starlight Night, cat. 18
Steichen, Edward, 1n, 2n, 35n
Stein, Gertrude, 6, 6n, 34n, 35n, 80n

Stettheimer, Carrie, 35n, 49, 84; letters to, 87, 88
Stettheimer, Ettie, 35n, 40n, 97; letters to, 35, 40, 49, 80, 84, 87, 88
Stettheimer, Florine, 35, 35n, 40, 49, 66, 84, 87, 87n, 88, 88n
Steuben glass, 76fn
Stieglitz, Alfred, 1n, 3, 3n, 6, 8n, 12n, 16, 18, 24, 24n, 26, 27, 28, 28n, 29, 30, 30n, 31–33, 33n, 34n, 35, 35n, 36, 36n, 37, 37n, 40, 40n, 41, 41n, 43, 43n, 44, 45n, 47, 48, 48n, 49–53, 56, 57n, 60, 60n, 61n, 65, 66, 66n, 67, 73fn, 73n, 74, 74n, 76, 78, 79, 82, 82n, 84, 86, 86n, 89, 90, 92, 94–98, 102–104, 124; letters to, 8, 12, 13
Stieglitz, Elizabeth, 23n, 35n; letters to, 23, 24
Strand, Paul, 1, 17n, 18, 19n, 20n, 36n, 48, 60n, 66n, 86, 86n; letters to, 17, 19–22, 45, 66
Strand, Rebecca "Beck," 44n, 45, 48n, 60, 60n, 66n, 80; letters to, 48, 52, 71
Street, New York No. 1, cat. 56, 36n, 38n
Sunrise and Little Clouds I, 12n
Sunrise and Little Clouds II, cat. 19, 12n
Sweeney, James Johnson "Jim," 89, 89n, 90n, 95, 95n, 96, 119, 119n, 121, 121n; letters to, 90, 91

T

Tan Clam with Seaweed, cat. 64
Taos, 34n, 44, 44n, 48, 51, 52n, 53, 54, 54n, 58, 71, 71n, 80; letters written from, 44–47
Thigh Bone on Black Stripe, cat. 83
Three Small Rocks Big, cat. 93
Tolstoy, Leo, 17n
Toomer, Jean, 66, 66n, 67n, 68n, 69n, 70n, 71n; letters to, 67–70
Torr, Helen "Reds," 73n, 83; letter to, 73
Train at Night in the Desert, 17n
Train in the Desert, cat. 7
trains, letters written from, 17, 48, 49, 62, 82, 96, 125
Trees and Picket Fence, 17n
True, Dorothy, 1, 1n, 2, 3, 4, 7, 9, 11, 15, 18
Two Calla Lilies on Pink, cat. 70

291 (gallery), 1, 1n, 2, 6, 6n, 7, 8, 8n, 12fn, 12n, 16n, 17n, 18, 18n, 21, 21n, 25, 25n, 36, 86, 86n
291 (journal), 2, 2n, 9, 10, 16n, 48n
Tyrrell, Ethel, 43, 43n

U

University of Virginia, summer school, 1n, 2n, 3n, 12n, 13n, 16, 16n, 18, 18n

V

Vanity Fair, 25, 25n
Van Vechten, Carl, 35n, 80, 80n, 99n
Varnum, Fred, 31, 31n

W

Walker, Robert, 57, 57n, 74, 74n
Walkowitz, Abraham, 2n, 18, 18n, 19
Webb, Todd, letter to, 124
Webb, Todd and Lucille, 118n; letter to, 118
Wells, Cady, 74n; letters to, 74, 75, 77, 93, 125
West Texas State Normal College, 7n, 11n, 15, 18, 22n, 45n, 65n
Wheelwright, Mary, 89, 89n
White Canadian Barn No. II, 95fn
White Flower, New Mexico, 55fn, 55n
White Patio with Red Door, cat. 110, 106n
White Shell with Red, cat. 88
White Sweet Peas, cat. 50
Whitney Museum of American Art, 41, 115
Winter Road I, cat. 115
Wright, Frank Lloyd, 82n; letter to, 82
Wright, Willard Huntington, 15, 15n, 16, 16n

Y

Yale University, Beinecke Rare Book and Manuscript Library, 12n, 96n, 110n
Yellow Hickory Leaves with Daisy, 41fn, 41n
Young, Anita Natalie O'Keeffe. *See* O'Keeffe, Anita Natalie.

Z

Zigrosser, Carl, 86n; letter to, 86

This book was produced by the Editors Office, National Gallery of Art,
Washington. Editor-in-chief, Frances P. Smyth.
Edited by Mary Yakush.
It was composed in English Monotype Baskerville and printed by offset lithography
at A. Colish, Inc., in Mount Vernon, New York.
The vellum text paper was specially made by Mohawk Mills, Inc.,
the illustration paper, Lustro Dull coated, by S.D. Warren Company.
The binding was by Zahrndt's, Inc., Rochester, New York.
Designed by Bert Clarke.

LIBRARY OF CONGRESS CATALOGING-IN-PUBLICATION DATA

O'Keeffe, Georgia, 1887–1986
 Georgia O'Keeffe, art and letters.
 Catalog of an exhibition held at the National Gallery and other
institutions, 1987–1989.
 Bibliography: p.
 Includes index.
 1. O'Keeffe, Georgia, 1887–1986—Exhibitions. 2. O'Keeffe, Georgia,
1887–1986—Correspondence. 3. Artists—United States—Correspond-
ence. I. Cowart, Jack. II. Hamilton, Juan. III. National Gallery of
Art (U.S.) IV. Title.
N6537.O39 1987 759.13 87-15405
ISBN 0-8212-1686-4 (New York Graphic Society Books)
ISBN 0-89468-102-8 (National Gallery of Art : pbk.)